D0131590

WITHDRAWN
UTSA LIBRARIES

Carnal Art

Orlan's Refacing

C. Jill O'Bryan

University of Minnesota Press
Minneapolis • London

Library
University of Texas
at San Antonio

Portions of an early version of chapter 2 were published in "Saint Orlan Faces Reincarnation," *Art Journal* 56, no. 4 (1997): 50–56, and in *Medicine and Art: Sixth Biennial Symposium at the Center for Arts and Technology* (New London: Connecticut College, 1997). Portions of chapter 6 were published in "Penetrating Layers of Flesh: Carving in/out the Bodies of Orlan and Medusa, Artaud and Marsyas," *Women and Performance: A Journal of Feminist Theory* 11, no. 1 (1999): 49–63, and in "Carving in/out Bodies: Orlan and Medusa," in "The Monstrous Woman," a special issue of *Massage* (October 1999), http://www.nomadnet.org/massage.

Copyright 2005 by the Regents of the University of Minnesota

All rights reserved. No part of this publication may be reproduced, stored in a retrieval system, or transmitted, in any form or by any means, electronic, mechanical, photocopying, recording, or otherwise, without the prior written permission of the publisher.

Published by the University of Minnesota Press
111 Third Avenue South, Suite 290
Minneapolis, MN 55401-2520
http://www.upress.umn.edu

Library of Congress Cataloging-in-Publication Data

O'Bryan, C. Jill.
 Carnal art : Orlan's refacing / C. Jill O'Bryan.
 p. cm.
 Includes bibliographical references and index.
 ISBN 0-8166-4322-9 (hc : alk. paper) — ISBN 0-8166-4323-7 (pb : alk. paper)
1. Orlan—Criticism and interpretation. 2. Body art—France. 3. Performance art—France.
4. Surgery in art. I. Title.

NX549.Z9O7535 2005
700'.92—dc22

2004024173

Printed in the United States of America on acid-free paper

The University of Minnesota is an equal-opportunity educator and employer.

12 11 10 09 08 07 06 05 10 9 8 7 6 5 4 3 2 1

Library
University of Texas
at San Antonio

Dedicated to my sister, Ann,
and in memory of my parents,
Pat and Connie O'Bryan

Contents

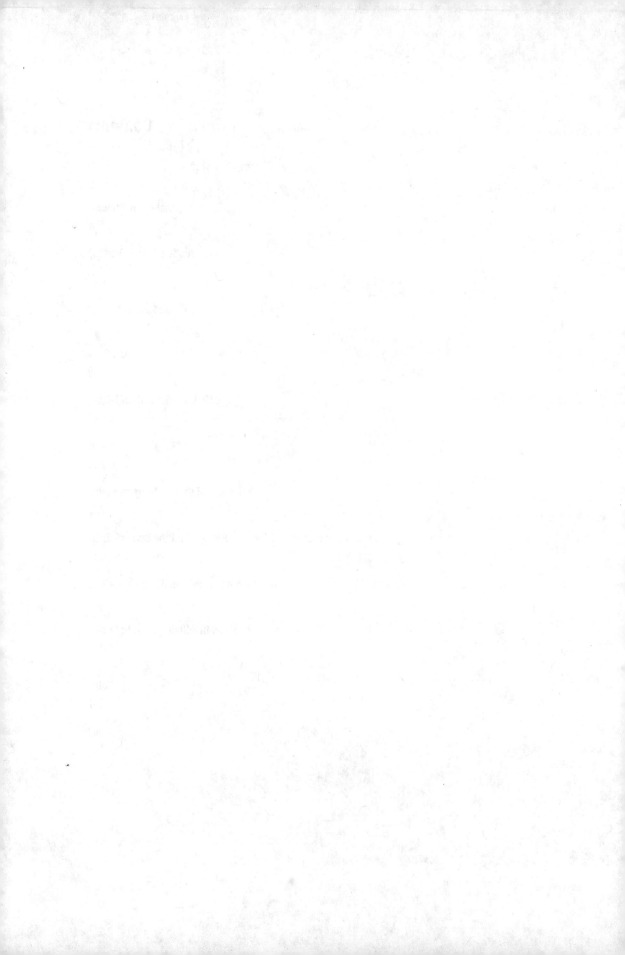

Acknowledgments

As a scholar, I am committed to careful and critical examination of women artists' work. This book is a contribution to the growing body of critical writing that actively receives woman-made art into the world. Immersing myself in Orlan's work has been both enlightening and, as Mary Russo writes, "grotto-esque." I now begin to emerge from a grotto—the grotto of Orlan's body.

Throughout several years of research, I have become acquainted with Orlan. As a researcher, I initially felt I needed to maintain distance, to be "objective," but I also felt that, because she herself is also the art (thereby scrambling issues of subjectivity and objectivity), I had to come in close for a closer look. I learned many things about her: she spends a lot of time writing, and she and her husband are very much in love and enjoy being with each other tremendously. Like most artists who garner fame, she spends a substantial amount of time dealing with administrative responsibilities and traveling, and she is frustrated by how little time is left over to make art. She is obsessed with making her art, with managing her image, with not being misunderstood, and with managing her career. She struggles with financing her work. And yet she was very generous with her time with me; for this I am greatly appreciative and thank her tremendously. I also thank her husband, Raphaël Cuir, an art historian, for spending many hours reading and offering suggestions about this book.

Special thanks go to Tanya Augsburg for reading the manuscript numerous times and offering her keen perceptions regarding Orlan's work—perceptions that profoundly influenced my own understanding of Orlan's performances. Between 2001 and 2003 Dr. Augsburg and I collaborated on several informal interviews with Orlan that inform EXTRActions. Dr. Augsburg's ideas are an inspiration to me, and her

writing is frequently referenced in *Carnal Art*. I thank her for her continuous support: it was always there, even through the disappointments and rough times.

Another special thank-you goes to Joanna Frueh, who read the manuscript several times and offered constructive and invaluable insights. It is an honor to have this amazingly talented writer and scholar believe in this book.

I very much thank Douglas Armato for his enthusiasm and curiosity about this topic. He is always there, inquisitive, helpful, and happy to facilitate the writing process.

From New York University I must begin by thanking my doctoral advisors, Judith Weissman, Joy Boyum, and Chris Straayer, for the endless hours of discussion I had with each regarding this research. I cannot thank them enough for their valuable insights into Orlan's work, for the encouragement they offered throughout my doctoral tenure, and for the large blocks of time they gave to reading and critiquing my work. I also thank Benjamin Binstock for his insightful comments and tremendous encouragement and enthusiasm. I thank Peggy Phelan for encouraging this research, begun under her directive, and Avital Ronell for teaching me to understand the performance of close reading—exploring the readability of texts through rigorous examination. I perceive this close reading of Orlan's work as a mirror reflection of what Orlan is doing with her body. As such, the close reading intrinsically connects the theory that grows from Orlan's performances with the performances themselves.

I thank Kirby Gookin for our discussions, which took place while I was beginning this research. He helped me to hone in on my objectives at a time when they were vast, overwhelming, and vague. And thanks to Martha Wilson for publishing the first article I wrote on Orlan and for giving me thoughtful feedback and encouragement.

Judith Weissman deserves large thanks for recommending me as a graduate assistant in the art department at New York University. Without an assistantship I would not have been able to consider doctoral research. I thank Kathleen MacQueen, Chris Straayer, and Joy Boyum for inviting me to deliver guest lectures, and Leonard Lehrer and Kirby Gookin for allowing me to teach in a department that does not normally provide teaching opportunities to doctoral students. Many thanks to Chris Straayer for her diss-write groups, which provided deadlines and constructive discussions focusing on each student's work.

Special thanks to my partner, Charles Ross, for being ceaselessly supportive throughout the despair, frustration, and exhaustion; and to my mother, Connie O'Bryan, and my sister, Ann O'Bryan, for constant encouragement, care packages, and generous emergency financing. Without my family I would have had to abandon my research long ago. Special thanks to Ann for reading this book and making valuable suggestions; her vast knowledge and love of philosophy are always an endless source of pleasure, and our discussions of Hegel helped to structure some of my thoughts about self/other.

Finally, a thank-you to all of the friends and colleagues, too many to list, who have listened to me, read parts of the book, and offered criticism. All of these discussions were valuable, and I am eternally grateful.

Shape-Shifting

Throughout history people have knocked their heads against the riddle of the nature of femininity. . . . Nor will you have escaped worrying over this problem—those of you who are men; to those of you who are women this will not apply—you are yourselves the problem.
—Sigmund Freud, "Femininity," *New Introductory Lectures on Psycho-analysis*

Identities seem contradictory, partial, and strategic. . . . [P]ost-modern identity [is constructed] out of otherness, difference, and specificity, and is definitively linked to the social upheavals of advanced capitalism, which has destroyed the "individual" or Cartesian subject as previously understood.
—Amelia Jones, *Body Art / Performing the Subject*

What do we see when we look at depictions of the female body in art? What is the relationship between our interior understanding of consciousness and our exterior form? What does it mean to have an identity: does the body determine the identity, or is identity constructed? What does a change to our body mean to our identity? What does it mean to enact a live performance of body-morphing as art?

The French artist Orlan's surgically manipulated face is a collage of features appropriated from art: Greek goddesses painted by Botticelli, Gérard, Moreau, and an anonymous school-of-Fontainebleau artist; also included, Leonardo da Vinci's *Mona Lisa*. But what really sets Orlan apart from others who repeatedly engage in cosmetic surgery is that, for Orlan, there is no "before" and "after." Rather, there is a continuance of change, an enactment of difference, and an unveiling of the slippery nature of identity. In her statement defining her performance surgeries (*La réincarnation de Sainte-Orlan* [The Reincarnation of Saint Orlan], 1990–95) as "carnal art," Orlan emphasizes that she is not interested in the final results of her reincarnation. Rather, as a venue for public debate, carnal art emphasizes the process revealed during the surgical performances and the significance of the modified and remodified body. To interrogate art historical equations that link constructed beauty and female identity, Orlan performs ever-fluctuating reconstructions of her face. To execute *La réincarnation de Sainte-Orlan,* nine times she has publicly de- and reconstructed her face by surgically implanting male-made Western art historical attributes of feminine beauty.

In *La réincarnation de Sainte-Orlan* a paradox exists with regard to the iconography derived from Western art history. Orlan references five paintings that are an inspiration to her, symbolically located deep inside her work and heavily relied on by the artist.[1] But it is important to Orlan that there be no misinterpretation. She is not trying to resemble any one or any combination of these painted images: this is apparent when looking at her. She has deliberately failed to clearly acquire recognizable features of the five idealized females she references:

> I do not want to resemble Botticelli's *Venus.*
> I do not want to resemble the *Europa* of Gustave Moreau—who is not my favorite painter, I chose this painting because she figures in an unfinished painting, just like so many of his works!
> I do not want to resemble Gérard's *Psyche.*
> I do not want to resemble the *Diana* of the Fontainebleau School.
> I don't want to resemble the *Mona Lisa,* as I have said and continue to say in certain newspapers and on television programs despite what I have said on numerous other occasions![2]

But Orlan's relationship to art history is as ironic as her relationship to beauty. She is reconstructing her own face by appropriating features of fictive women created by male artists to exemplify sublime feminine beauty. She is reincarnating herself by utilizing an industry that promises beauty to women and men by enhancing their features and reconstructing youth. She is not becoming, nor is she claiming to make herself, more youthful or more beautiful either in the modern notion of beauty exemplified in film and advertising or in the Renaissance notion of beauty portrayed in the paintings she references. The uniqueness and the irony of *La réincarnation de Sainte-Orlan*—that in the name of individual identity she appropriates physical attributes associated with others; that in an attempt to unite an interior image with an exterior physique she acquires a fragmented appearance; that in the face of standards of beauty she circumnavigates these standards—create questions pertaining to the conceptual nature of her work.

What happens during Orlan's surgical performances? As the other, one can witness a material tampering with the relationship between the face and individual identity, the original and the constructed, the real and the imagined. One witnesses the possible disruption of identity in accordance with the flaying of the face, the possibility and meaning of an individual identity that is in flux, and the im/possibility of ontological universality. So then, visually, historically, and ontologically, what is the relationship of the interior to the exterior of the body, and how does this relationship wreak havoc and/or organize layers of identity? Within Orlan's critique of ideal beauty lies the grotesque, and within her appropriation of art history lies the futuristic cyborg body. Exactly how and why do these binaries collide, and why do they seem to insist on the existence of each other?

Orlan's performance surgeries deconstruct binary codes by viscerally tampering with epistemological truths, and, from the point of view of the spectator, a deconstruction of Orlan's identity comes into play as well. Taking the necessity of this performed deconstruction into account, what is the relation between Orlan's work and the binary structures: self/other, interior/exterior, and feminine beauty / the monstrous feminine? Informing these discussions are Luce Irigaray's feminist psychoanalytic analysis of women's relationship to the self/other binary; Gilles Deleuze's, Félix Guattari's, and Camilla Griggers's discussions of facialization; Antonin Artaud's description of the body without organs; Jacques Derrida's definition of deconstruction as a double affirmation; and Elizabeth Grosz's appropriation of deconstruction into feminist theory.

Regarding identity and faciality: What is a woman's identity with regard to the interior of the body from both medical and mythological perspectives? (How can we compare Orlan's surgeries to Renaissance depictions of self-dissection?) What is Orlan's work within the context of the carnivalesque? I will review a history of the performance of opening the body beginning with Renaissance anatomy theaters and continuing to contemporary medical theaters; and I will review Orlan's work as deconstruction, a performed collision of the self/other binary, and a performance that touches upon the ontological status of woman.

THE PERFORMANCE OF SHAPE-SHIFTING: EMBODIMENT AS IMAGE, EMBODIMENT AS TEXT

Lacan believes that the subject is completely caught inside of language, that language constitutes the subject. (This is contrary to Saussure, who believed that the subject could step outside of language.) Lacan insists that words convey multiple meanings and that, because of the human ability to use metaphor and metonymy, we often use words to indicate things other than those being literally articulated. Also, signifiers slide in a chain of meanings, because they are determined only by other signifiers. No signifier is locked within one meaning.[3] Referring to Lacan, Terry Eagleton explains this phenomenon as he demonstrates that nothing is ever fully present in signs, including and especially the speaking or writing subject:

> The "subject of the enunciating," the actual speaking, writing human person, can never represent himself or herself fully in what is said: there is no sign which will, so to speak, sum up my entire being. I can only *designate* myself in language by a convenient pronoun. The pronoun "I" *stands in* for the ever-elusive subject, which will always slip through the nets of any particular piece of language; and this is equivalent to saying that I cannot "mean" and "be" simultaneously.[4]

Orlan substitutes her body for language so that she performs this fiction as though a live signifier; shifting shape, her face does not literally articulate a fixed identity: "I make myself into a new image in order to produce new images."[5] Derrida's term

auto-affection—a substitute for self-presence, that which, he claims, we can never purely know—comes closest to describing human experience at this level.

Derrida has partially revealed deconstruction within Husserl's and Heidegger's phenomenology, which has brought to the fore the impossibility of experiencing the world phenomenologically. Here Derrida not only facilitates an understanding of how one experiences the world but also articulates some of the possible complications that exist in experiencing Orlan's performance art. For example, Husserl's phenomenology relies on a place of certainty that is immediately available in the present. In other words, we rely on the fact that the immediate world that we are experiencing in the present is a certainty. Derrida undermines this certainty by questioning the possibility of self-presence. This is perhaps best described in terms of Derrida's definition of *auto-affection,* which is the illusion of self-presence and the substitute for the lack of self-presence. Auto-affection is the state of giving-oneself-a-presence. It is a speculative state within which a phantasm of immediacy and self-presence exists.[6] Even so, for Derrida, auto-affection is essential and irreplaceable, because it structures experience, thereby making it accessible to the self, as far as experience is of presence.[7] Specifically regarding phenomenology, Derrida writes:

> The intuition of time itself cannot be empirical; it is a receiving that receives nothing. The absolute novelty of each now is therefore engendered by nothing. . . . "Time" cannot be an absolute subjectivity precisely because it cannot be thought on the basis of a present and the self-presence of a present being. . . . [T]emporalization is at once the very power and limit of phenomenological reduction. Hearing oneself speak is not the interiority of an inside that is closed in upon itself; it is the irreducible openness in the inside; it is the eye and the world within speech. *Phenomenological reduction is a scene, a theater stage.*[8]

Derrida also maintains that no sign can refer to anything other than itself, and therefore a realm of meaning does not exist which can be distinguished from the marks that point to it.[9] Further, Derrida questions the binary opposition subject/object, which is fundamental to the possibility of objective description. The subject's desire intercedes and contaminates any possibility of objectivity.[10]

The close reading that Derrida performs upon previous philosophical texts (and that he demands as an interaction between the reader and his own texts) is in itself a performance of rigorous philosophical thinking and therefore a place of intersubjectivity, a place of human interrelations. The complication here arises in the meaning of Derrida's decentering of self-presence with regard to the experience of art. An intrinsic relationship exists between Derrida's defined "auto-affection" and Orlan's investigation into the certitude/flexibility of her own self-presence, which possibly culminates in the erasure of one auto-affection—with regard to a self/other relationship—and simultaneously the discovery of the possibility of other constructed auto-affections within the realm of the same self/other relationship.

Orlan also emphasizes the decentering of her own self by complicating the temporal frame of her work. *La réincarnation de Sainte-Orlan* is only partially contingent upon experiencing a here-and-now performance. Because the entire project takes place over an extended period of time and many operations, one is forced to conceptualize the work within the context of this continuance. Orlan does not offer the simplicity of one resolved image or finishing point in time. Rather, she challenges us to imagine the possibility of multiple auto-affections, which are also in flux. Regarding the multiplicity of auto-affections that occur across an expansive period of time, the live surgical events exist within the linear temporality equated with human mortality; the reliquaries that house her own flesh venture into the more abstract temporal zone of immortality. The reliquaries accomplish this by negating the loss of the body.

Orlan's work, however, is also about the materiality, the perception, and the experience of embodiment. These are not the same, given that the indicator of each takes place as experience. In other words, I have no way of knowing that my experience of embodiment is in any way comparable to that of any other being. Our experience of embodiment is also contingent on the structure of the body. This is at the crux of Orlan's experimental art making. Merleau-Ponty writes:

> [I]nteriority no more precedes the material arrangement of the human body than it results from it. What if our eyes were made in such a way as to prevent our seeing any part of our body, or if some baneful arrangement of the body were to let us move our hands over things, while preventing us from touching our own body? Or what if, like certain animals, we had lateral eyes with no cross blending of visual fields? Such a body would not reflect itself; it would be an almost adamantine body, not really flesh, not really the body of a human being. There would be no humanity.[11]

The experience of the other is therefore contingent on the knowledge of one's own embodiment, which evokes self-presence. The pursuit of the experience of embodiment is something reflected a thousand times over: in each other, in the mirror, through photography, through painting, sculpture, theater, music. Art, which at best investigates this experience of being, creates an experience of embodiment for the seer. Orlan accomplishes this. Her body in all of its states—whole, lacerated, represented as twenty grams of fat and blood—is presented as an investigation of her embodiment. In other words, she literalizes her own embodiment by threatening the security of her body's enclosure. As a result, an encounter with her lacerated, interior body or extracted body fluids has the potential to lend new meaning to any viewer's own experience of being embodied. Orlan intends her performances to be painful to watch. "These images plunge in and strike directly where it hurts, without passing through the habitual filters, as if the eyes no longer had any connection with the brain," she says.[12] Orlan pushes the visceral intersubjective encounter as performance to an extreme because she intends for the viewer to have a physical response to her work. (Artaud's "theater of cruelty" was also based on this mode of encounter.) Within this encounter

and because her performances are also *of* the body, Orlan performs Merleau-Ponty's point that knowledge of embodiment evokes the knowability of self-presence, or, to use Derrida's term, auto-affection, the necessary substitute for self-presence.

With regard to performance, exclusive sets of dilemmas occur as the critic retells the experience of viewing. Peggy Phelan writes, "[O]ne of the deepest challenges of writing about performance is that the object of one's meditation, the performance itself, disappears."[13] Phelan goes on to explain that within performance theory and criticism the text has largely adopted the very conservative mode of detailed historical documentation. But she indicates that we should resist the desire to merely document, "[f]or what one otherwise preserves is an illustrated corpse, a pop-up anatomical drawing that stands in for the thing that one most wants to save, the embodied performance."[14]

The loss of the embodied performance exists in the unrepeatability of that performance. Orlan creates a type of stand-in, a repeatable video documentation of her performances. However, the documentation does not exclude the qualities of unrepeatability and loss from Orlan's surgical performances. The footage is an archive of Orlan's lost original body and the unrepeatable processes of changing that body. Also, the footage is public. The live surgical performances, which take place in an operating room, are not. So, the videos allow an audience to witness her lost original body and her lost performances.

What Phelan writes in *Mourning Sex* is the creation of something new from loss.[15] This is also a demonstration of Derrida's auto-affection, because self-presence is something always lost, and the desire for the manifestation of self-presence is inscribed in auto-affection: "My hunch is that the affective outline of what we've lost might bring us closer to the bodies we want still to touch than the restored illustration can. Or at least the hollow of the outline might allow us to understand more deeply why we long to hold bodies that are gone."[16] For Orlan, the outline of the hollow keeps changing shape. Her changing body is a performance of exchange—loss and gain. Within this exchange Orlan creates images of herself that no longer fit inside the hollow of the original body. Also, the original body is one and the new bodies multiple: nine times flayed during surgery, swollen and bruised during recovery, healed with altered features.[17] What is the meaning of her disappeared original body and the multiplicity invoked in her emerging body as an experience of loss and gain?

Phelan's performative writing, another level of experiencing performance, investigates the relationship of the spectator to the now-disappeared live body in performance: "The events I discuss here sound differently in the writing of them than in the 'experiencing' of them, and it is the urgent call of that difference that I am hoping to amplify here. . . . To name this 'performative writing' is redundant since all good critical writing enacts something in excess of the thing that motivates it."[18] This emphasis on the difference is also an emphasis that Derrida calls for.[19] Thus, a close reading of a performance in which the difference between "the writing of [it]" and "the experiencing of [it]" is emphasized bears a relationship to Derrida's pronouncement,

"Phenomenological reduction is a scene, a theater stage."[20] The theater stage is an apt metaphor. At least the emphasis on the retelling of the performance is acknowledged as being a performative act in and of itself, alluding to, but different from, the original performance.

What is the relationship between the event and the aftermath of the event, between the *writing about* the event and the *being in* the aftermath of the event? In Orlan's performances these temporal positionings are always in relation to the artist, who stages events, then lives the results while anticipating yet another event. Orlan's is a performance of incompletion. This book is dedicated to the exploration of the effects of witnessing Orlan's body (of work) that is as resistant to completion as it is to creating one identity.

Chapter 1 includes an overview of Orlan's work; a detailed description of *Omnipresence*, the seventh performance surgery in *La réincarnation de Sainte-Orlan;* and a contextualization within the context of feminism and body art. Chapter 2 is devoted to an inquiry into the history of the performance of publicly opening the human body. Within this chapter both scientific and mythological examples are discussed in relation to Orlan's surgical performances. These include the Renaissance dissection theater, the myth of Medusa, and the biblical story of Eve.

Orlan's interrogation of identity is unique and ardently feminist; that is, Orlan *performs* a form of poststructuralist feminism. One of the signposts of poststructuralist theory is its commitment to obliterating binary oppositions,[21] because the binary structure creates a hierarchy within itself: good is better than bad, male is better than female, spirit is better than body. Orlan utilizes the concept of ideal beauty to construct her live Frankensteinian body—a deconstruction of the real to expose it as a fiction that serves the construction of ideal beauty. In addition, her feminism, first and foremost, ignores the essentialist Cartesian association of nature and woman's body—the idea that woman is equated with the body (childbirth), whereas man is equated with the (superior) mind.[22] An addendum to this association is that the natural body tends to be privileged over the manufactured body. Orlan is thus unsympathetic to the feminist aversion to the use of cosmetic surgery. Hers is a challenge to feminists to see beyond her use of medical intervention in order to fathom the more complex issues of identity that her performances provoke.

In *Carnal Art* I identify and probe questions derived from the conceptual nature of Orlan's work regarding beauty and the grotesque, art history, medicine, identity, and feminist strategies. Orlan's work plays a significant role in exposing the constructedness of representation both *within* art historical images of women and *within* contemporary *constructed* beauty (literally constructed by surgeons). Thus, she does not acknowledge validity in an external point of view. Rather, she works from within contemporary systems of (surgical and art historical) constructions of feminine beauty in order to deconstruct them from the inside. She recognizes that it is necessary to place herself inside a situation to participate in its dismantling, and that dismantling the idealized female form is a feminist political strategy.

Chapter 3 includes a discussion of feminist psychoanalytical theory as it pertains to Orlan's artwork, particularly in relation to the topic of identity. Here some of the complex philosophical issues of Orlan's work are also addressed, including an analysis of deconstruction as it pertains to Orlan, issues concerning the performed collision of the self/other binary, the ontological status of women, and an exploration of Orlan's woman-to-woman transsexuality.

In the fourth chapter the interior/exterior binary is explored with relation to the spectator of Orlan's work. Orlan's performances are compared to Antonin Artaud's "theater of cruelty" and discussed in relation to Artaud's notion of the body without organs; the myth of Marsyas is described to illustrate the relationship between identity and the interior and exterior of the body; and the filmic close-ups in Orlan's video *Omnipresence* are examined within the context of feminist film theory.

Chapter 5 is dedicated to the beauty / monstrous feminine binary. It begins with a definition of facialization with regard to texts by Gilles Deleuze, Félix Guattari, and Camilla Griggers. Then, with regard to facialization, Orlan's work is elaborated upon with regard to the myths of Medusa and Baubo. The chapter concludes with a comparison of Orlan's self-images to images of women portrayed by Hans Bellmer and Cindy Sherman. The sixth chapter concludes the discussion of the meaning of Orlan's work within the context of theory and is written as a performative piece. Here I articulate the aporia that Orlan is performing.

Chapter 7 is an investigation of the carnivalesque qualities in *Self-hybridations* (1998–), a series of computer-manipulated photographic self-portraits, Orlan's most recent work. Finally there is "EXTRActions," a performative dialogue I have with Orlan. It is inspired by an interview Tanya Augsburg and I conducted with Orlan in March 2001 at Arizona State University in Phoenix—and ensuing dialogues held over several years between the three of us. References to the 2001 interview are included in "EXTRActions."

Orlan's Body of Work

Orlan's earliest photographs, a series of small black and whites, target overt art historical themes. Several feature her challenging pictorial conventions of the female nude as she awkwardly bends her torso, arms, and legs, reshaping her curvy bare body into angular abstractions. In another black and white the masked beauty transforms herself into a grotesque hag. In yet another she voraciously escapes convention by climbing out through an ornate picture frame. And Orlan's very first photograph, *Orlan accouche d'elle m'aime* (1964; translated both as Orlan Gives Birth to Herself and as She Loves Herself), articulates later themes of doubling, cloning, androgyny, and prostheses as a nude Orlan gives birth to an androgynous double (Figure 1).[1] It resonates with Orlan's motifs—the body as sculptable material, the multiplicity in individual identity—and sets the stage for *La réincarnation de Sainte-Orlan,* begun twenty-six years later.

Orlan participated in a feminist protest in Saint-Étienne in 1968, during which she carried placards that read "Je suis une homme et un femme" (I am a [feminine *a*] man and a [masculine *a*] woman), indicating the possibility of shifting gender.[2] In the same year she began to work with her trousseau.[3] The trousseau, a traditional collection of white linens (*toile,* translated as both "linens" and "artists' canvases") was embroidered by a bride-to-be and used upon marriage. In *Étude documentaire nº1: Couture-clair-obscur ou plaisirs brodés* (1968), the blindfolded Orlan is featured in a series of framed black-and-white photographs embroidering her flowing white trousseau. The sheets have already been taken to a rendezvous with a lover or lovers. The results are displayed in the last picture frame, where a portion of the trousseau (*trou sot,* "foolish hole") sheets are covered with spermy "wet spots" and Orlan's messy embroidery outlines their shapes.[4] Sarah Wilson writes:

A violent and symbolic confrontation led to Orlan's snatching of the trousseau lovingly amassed by her mother; on those sacred sheets bestowed to symbolize the "giving away" of the daughter to another patriarchal nexus, Orlan exultantly, euphorically, received her lovers, tracing their sperm trails with pen and then with savage, enraged embroidery, again a d'etournement of the womanly skills she had been taught "to please."[5]

Orlan baptized herself Saint Orlan in 1971 by adorning her body in mounds of draped white leatherette or black vinyl, then exhibited these sculpted costumes in Milan in 1972, and created *Les draps du trousseau (Les tableaux vivantes: Situations-citations)* from 1967 to 1977. Referencing Bernini's *Saint Teresa in Ecstasy,* Orlan toyed with images of female ecstasy and maternity from the perspective of the new *écriture feminine.*[6] She also reversed gender roles in several powerful images: her *Origin of War* is man just as Courbet's *Origin of the World* is woman. In her *Déjeuner sur l'herbe* (Manet) she is dressed and all of the men are nude.

Occasional Strip-Tease Using the Fabric of the Trousseau (1974–76) begins with Orlan dressed as Madonna with child; then, throughout eighteen black-and-white photos, she disrobes, transforming herself into a Botticelli-like birth of Orlan without a shell. This transformation articulates a connection between the archetypes Madonna and

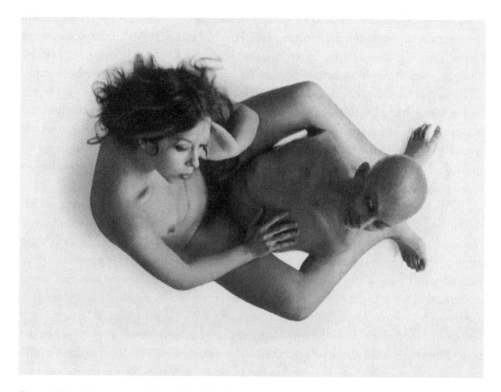

Figure 1. Orlan, *Orlan accouche d'elle-m'aime* (Orlan Gives Birth to Herself, and She Loves Herself) (1964). Black and white photograph, 81 × 76 cm with frame. Copyright 2003 Artists Rights Society (ARS), New York / ADAGP, Paris.

whore, not by opposing them but by enacting their connection to one another. The final frame of the series depicts only the trousseau fabric in folds on the floor, like a shed skin.

In 1977 Orlan played out *Le baiser de l'artiste* (The Kiss of the Artist) (Figure 2). This is one of several performances in which Orlan exposed herself as a woman/artist, stripped of subjectivity to become an objectified commodity. This posture is twofold. "In the name of art,"[7] she presents her performance/installation in the form of two life-size photographs of herself on a platform with a bouquet of white lilies. She is seated behind a photo of her life-size nude torso, which doubles as an automatic kiss-vending slot machine. She gives kisses in exchange for five francs. Next to her is her photographed image as the Virgin draped in mounds of cloth with exposed breasts, to which one can offer candles for the same price, five francs. Orlan set up the installation by the entrance of the Grand Palais in Paris, where the International Contemporary Art Fair (FIAC) was taking place, and, as hawker, yelled, "Cinq francs, cinq francs!" Passersby inserted five francs into the slot between her breasts and watched the money fall into the box—at her crotch. In response Orlan jumped off her pedestal and offered the slot player a kiss while several bars of Bach's Toccata in B Minor played on a tape recorder. A screeching siren sounded at the end of the kiss.

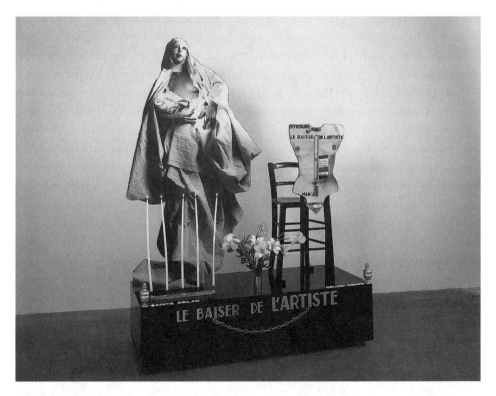

Figure 2. Orlan, *Sculpture et piédestal du Baiser de l'artiste* (Sculpture and Pedestal from *Kiss of the Artist*) (1977). Collection of Fonds régional d'art contemporain (Frac) des Pays de la Loire, France. Copyright Frac des Pays de la Loire, France.

In "Facing a Society of Mothers and Merchants," Orlan writes, "At the foot of the cross, two women: Mary and Mary Magdalene . . . Mother or prostitute, private woman . . . or public woman, duty and pleasure, respect and disdain."[8] By uniting these two female archetypes, Orlan asserted her right to use her body as she pleased.[9] While unabashedly critiquing the art world for insisting that she become a commodity (as both artist and female), she became one. As a political strategy she spotlighted the art world's particular brand of sexual discrimination by publicly enacting it. Ironically, but not surprisingly, by advertising herself as a commodity, Orlan gained recognition (albeit infamous) as an artist. Catherine Millet describes the scandal that this performance created but also offers further insight into the content of this piece: "[T]his sexual union [between the artist and the spectator purchasing a kiss] was like an x-ray of the frenzy of exchange of contact in the contemporary art world where the merchandising of the artist's personality replaces the merchandising of art."[10] Orlan repeated the performance in Lyon a month later, where *Le baiser de l'artiste* captured the attention of the media. Eight days after the Lyon performance, she received a telegram from the Atelier des trois soleils, where she taught art, stating that her extracurricular activities were incompatible with her teaching duties.[11] Orlan was not rehired in spite of her students' loud protests.

Orlan's 1977 Art and Prostitution exhibition at Ben Vautier's gallery, la Différence (in Nice), continued this theme.[12] During the exhibition Orlan invited three of the leading gallery dealers in Nice to join her in having sex on sheets as part of the performance. "As an artist, I have only one choice: to sell myself. One has to face up to this situation. I launch myself as an artist. I go [to] the meeting with Mr. Untel, offer him my body while I show him my work: stain the sheets of my trousseau to exhibit them. Mr. Merchant provide me with paint."[13] All three dealers declined. However, Wilson points out that the exposure of the artist as promiscuous—willing to sleep her way to the top, on the condition that it be public—politicized the male-dominated business of art. As long as the female artist / sex object was handled in secret, the dealings of the empowered male dealer were legitimate; both male and female agreed to such a secret contract.[14] Orlan exhibited the sheets even though the dealers refused to take part.

In 1978, invited by Jean Dupuy, Orlan performed *A poil / sans poil* (Naked / without Hair) at the Louvre.[15] Standing in front of Jacques Blanchard's *Venus and the Three Graces Surprised by a Mortal,* Orlan began with a paintbrush between her teeth, her friends seated on the floor between her and the guards so they would not be able to easily reach her. She opened a coat to disclose a dress upon which was rendered the image of her nude body. Tearing from the dress a geometric pubic triangle, she then revealed her own pre-shorn and reglued pubic hair covering her genital area. Orlan pulled out this reglued hair and then painted her nude genital area black. (The genital areas of those in the painting are nude but in dark shadow.) She then held a white palette (as though it were a fig leaf) over her painted genitals. Orlan next inserted the paintbrush into the hole of the palette. Slowly she turned her back to the audience;

with her body in profile, the brush appeared to be an erect penis. Tanya Augsburg points out that "for a brief instant Orlan unveiled what could be called 'an impossible figure of totality,' in which she presented herself as both being and having the phallus."[16]

MesuRAGEs (1972–83) revealed Orlan's body to be a political unit of measure.[17] In a given *MesuRAGEs* performance, Orlan wears a white tunic made from the fabric of her trousseau, and high-heeled boots. She lies down on the ground, marks a chalk line above her head, gets up, and repeats the action as many times as it takes to discover how many Orlan-*corps* fit into selected male/institutional spaces (e.g., the Centre Georges Pompidou in Paris). In the process of the *MesuRAGEs,* Orlan sullies her white trousseau garment. In a final gesture Orlan removes the trousseau garment, washes it, and then bottles the dirty water, making it a relic of her female assertion smudged with male institutionalization. In conclusion Orlan triumphantly holds up the jar of dirty water, posing like the Statue of Liberty.[18] The filthy water, of sweat and dirt, is then put into containers sealed with wax as relics. Sarah Wilson assesses the performance:

> The Virgin, conceived "immaculately," without stain, counters the tradition of the bride's display of bloodied linen after the wedding night; we are brought back to the central motif of the trousseau for Orlan. Her "measuring" performances provoked violently sexual reactions: she was spat upon, insulted as "a woman of the streets"; the trial of measurement passes through filth: "L'epreuve de la mésure passe par la souillure."[19]

So, how many Orlan-*corps* make up the Georges Pompidou Center (measured in 1977)? A brass floor plaque commemorating the event proclaims 69 x 24 Orlan-*corps.* The numbers add up to yet another impressive "figure" to consider. Orlan physically situates herself, and her art, squarely inside the art museum while simultaneously insisting on the symbolic importance of the female body throughout the history of art. She performs a solid critique of the lingering patriarchal biases still operating within art institutions.[20]

Throughout all of Orlan's work this balancing act exists: on one hand, there is the banality of narcissism—the artist is desperate to be recognized as such; her body and face are the sole objets d'art. On the other hand, the artist's body performs an iconic political critique by troping male-made, and male-scaled, Western art and art history. This dichotomy has appeared before in the work of artists scrambling through the nexus between individuality and societal / art historical molds that shape "woman's body." Both Hannah Wilke and Carolee Schneemann were originally criticized for narcissism while claiming higher conceptual ground. But Orlan's *MesuRAGEs* is truly successful at rendering a woman forcefully figuring herself into the male equation.[21]

Kate Ince, who focuses her study of Orlan's work on the notion of skin as dress and fashion, aptly points out that units of measure such as the foot or the cubit (the

forearm) are derivative of the male body and that Orlan interrupts this language of measure as perhaps a contribution to the construction of a "female universal . . . perhaps . . . a double universal, as in the thinking of Luce Irigaray."[22]

Incorporated into the length of her body like prostheses are the high-heeled boots Orlan always wears when performing her *MesuRAGEs*. This is important to Orlan and lends insight into the meaning of her body as unit of measure. High heels are a politicized and sexualized item of fashion. The standard feminist party line, of course, is that they are worn for the male gaze, they inhibit movement, and so they metaphorically enslave women. So why wear them while interpreting male-scaled architecture with female units of measure? The chalk lines she leaves behind are traces of Orlan-*corps*. Viewed as a whole, one after another, with the numbers added between each, the chalk lines appear to be inscribed, standardized, spatial markings. So a more critical feminist perception of *MesuRAGEs* might be that just by participating in a measuring process Orlan is already subscribing to male construction and constructedness. But one of Orlan's most powerful feminist political strategies is that she participates in male constructions of femininity and masculinity in order to deconstruct them from within. The *MesuRAGEs* contributes to Saint Orlan's hagiography—but the difference that she inscribes onto the architecture includes the sexualized female and her unkempt, boundary-less (and extended) sexuality. The high heels signify the sexual identity always activated when close to the trousseau. Sexualized femininity is forcefully present, not excommunicated from the scene. She is there because historically she has always been there, and so must participate in the deconstruction of her form, which has also always been shaped by the Western cultural imaginary. Orlan is not trying to "fit" into male-scaled institutionalized space. Rather, she is rescaling it to include herself, also a trope for the female body. She allegorizes the scaling process by creating an event and by giving it representation.

With Ben Vautier a "measuring" took place in Nice (1976). In addition to the one at the Centre Pompidou (1977), others took place in Aix-la-Chapelle at the Neue Gallery (1978), in Strasbourg at the Strasbourg Museum, (1978), and at the Musée Saint-Pierre in Lyon (1979).[23] Aside from museums and galleries, Orlan also measured churches, convents, and streets bearing the names of other artists (e.g., Victor Hugo), measuring herself against their legacies. Augsburg's discussion of this work establishes the relationship of the measuring movements to martyrdom:

> Martyrdom as a self-conscious loss of self is nevertheless the result of free choice—even if that act of choice stems from a sense of obligation or duty. Artists can be viewed as secular martyrs to the extent that they must defer to their institutional sponsors as well as to the critics who compare their works with the works of other artists for the sake of their art. In other words, artists must comply with constant surveillance and evaluation before they can be "officially" recognized as artists by institutions. In her performance series *MesuRAGEs,* Orlan turned the table on art institutions by using her body as a measurement device to measure them.[24]

In fact, when she "measured" Saint Peter's Square in Rome, Orlan was forced to tell Vatican security that she was doing the performance for penance in order to complete it.[25]

The *toile* was a continuing motif in Orlan's work, and she began to tear and assemble it into a series of soft sculptures. In Lyon Orlan exhibited *1001 Reasons Not to Sleep* (1979), seven large stuffed pillows (the largest, nine square meters) suspended on meat hooks from high-tension cables. Four huge artificial ears, also attached to meat hooks, hung in each corner of the space, accentuating the relationship between *oreiller* (pillow) and *oreille* (ear), particularly in the myth of Scheherazade. Once again, "each pillow was symbolically associated with the accursed trousseau."[26] The image of Orlan as Ingres's *Grand Odalisque* was projected onto each pillow, accompanied by these words:

> For a moment I freeze my own reality
> and my living body
> On which I inflict the coldness of marble
> the density of an object.
> And for an instant I feel, in this complete alienation of my
> substance
> solemnity, ossification.
>
> My will is to battle with myth
> To measure myself against it
> To mystify it in turn
> To appropriate its legend.
>
> By espousing the work of art I cite
> I experience its narcissism.
> I steal its theatricality.
> The spectator's gaze, reserved for Ingres,
> Is all for me.[27]

The naked live female body reanimating Ingres's work not only revived the nude in art but also gave it a sexual charge. Orlan stated clearly her ambition at the *Mesu-RAGEs* symposium in 1979:

> To make the Odalisque glow with sweat . . .
> To restore the scent of sperm to the sea-spray surrounding Venus . . .
> To pass from artifact to being . . .
> The eternal, the petrified pose a mere point of departure.
> ORLAN's reality surpasses myth.[28]

The *toile* of her trousseau, now exposed as something not innocent, played a large role in the subsequent images of Saint Orlan. In 1979 at the Palazzo Grassi in Venice,

she performed *The Draping, the Baroque,* a disrobing of the ecstatic Saint Teresa.[29] Orlan describes this performance, acted out several times:

> The most important performances *The Draping, the Baroque,* were done dressed up in my trousseau as a Madonna (Centre Georges Pompidou, Paris; Halles de Skarbek, Brussels; Pinacothéques, Ravenna; Bologna Theatre; Arc Biennale, Paris). These slow-moving performances were constructed as an enfolding and unfurling. At the end, I unswaddled a bundle resembling a little child made of a forty meter ribbon of the same fabric. Inside was a painted bread sculpture with a blue crust and red crumb, which I ate in public often to the point of vomiting.[30]

In *Portugal* (1981) Orlan attached a photographic representation of her nude body to a black dress and ran up and down crowded streets.[31] A police officer wanted to arrest her for indecent exposure, but she convinced him that what she was wearing was not illegal but highly fashionable.[32]

The images that she created of herself as Saint Orlan emphasized profanity of the sacred—the female image split into Madonna and whore. She also incorporated the warrior into her work. She performed *Mise-en-scène pour une sainte* (1981), a baroque extravaganza that was filmed, videotaped, and photographed. This performance depicted Orlan draped in her mounds of *toile,* one breast exposed, alluding to both the nursing Virgin Madonna and mythical Amazon warriors, who were said to have only one breast in order to better shoot arrows from their bows. She was the centerpiece inside a chapel that she created with mirrors, columns, doves, a faux marble sculpture, lasers, holograms, a massive number of white plastic flowers, fifty cutout cherubs, and a video screen.[33]

Also in 1981, Orlan moved to Ivry-sur-Seine, the industrial suburb of Paris. Throughout the following decade Saint Orlan's hagiography was enhanced with images such as *Skaï and Sky et Vidéo,* with first a white virgin and then a black one perched atop a video monitor projecting close-up images of her face and breast (Plates 1 and 2). Between 1984 and 1988, Orlan published a pioneering contemporary art magazine online called *Art Access Revue.* In 1983 the Lacanian psychoanalyst Eugénie Lemoine-Luccioni published *La robe.* Orlan was included in the chapter "Essai psychanalytique du vêtement," which had sections on cutting, the nude, the mask, and the veil.[34] In this essay Lemoine-Luccioni discussed Orlan's anger with her mother, who had wanted to "'sell' Orlan as a bride."[35] The text eventually became seminal to Orlan's creative work, because Lemoine-Luccioni also described *la robe (toile)* as synonymous with the skin, an (open) envelope of the body, a descriptive, manipulative cover that distinguishes the interior of the body from its exterior: "Skin is disappointing. . . . But it does nonetheless suggest something to do with being"; and then, "The body is not closed. Nor is the garment which envelops it."[36] Another Lemoine-Luccioni passage (quoted later in my description of *Omnipresence*) became a mantra for Orlan; she recited it at the opening of each of her subsequent surgical performances.

At the end of the 1980s, Orlan went to India and studied the cult of Kali. While there, she collected sacred texts that referred to the body as a sack to be shed. (At one time Orlan said that she planned to read these texts at her tenth surgery, in which her nose would be transformed into a long and pointed silhouette. Orlan also expressed the desire to include a classical Indian dancer during the tenth performance.)[37] While in India, she obtained enormous billboards where she advertised herself and supporting dancers and actors in fake films. The credits included such names as Achille Bonito Oliva and Hans Haacke, ardent supporters of Orlan's work.[38] In the 1990 exhibition *Les vignt ans de pub et de ciné de Saint Orlan*, a series of faux billboards advertised Saint Orlan as a film star. This series is the first of several that evoke the film-advertising motif, a continuation of the Warholian marketing of the artist's personality rather than the artist's work. In *Art Makes Your Mouth Water* (1990), images of Saint Orlan as baroque virgin were juxtaposed with images of Orlan in armor (Joan of Arc?) to which was attached the slot machine used in her 1977 performance *Le baiser de l'artiste*.[39]

Orlan's work is generally carnivalesque, and sometimes it's overtly humorous. *Will You Take Some . . . Contents Monsieur Greenberg* (from *The Idiots* series, 1998) targeted Clement Greenberg, who maintained that art was to be without content, even though the artists he endorsed occupied a contrary position. Orlan found this rather incredible and created a photographic image of herself with curlers in her hair, wearing a scarf, and carrying a black and yellow teapot and bowl, poised as if about to pour some tea. A motion detector inside the image allowed her to say to approaching viewers, "Would you like a bit of content, Mr. Greenberg?"

A clownlike Orlan appears in photographs such as *Peau d'asne* (The Donkey's Skin) (1990), a series of nine photographs of a topless Orlan in a variety of military, clergy, and animal headgear. The reference is to Charles Perrault's "Donkey's Skin," a fairy tale that has to do with female identity, beauty, and incest.[40] Very briefly, it goes like this: A grieving, recently widowed king is searching for a new wife more beautiful than his previous one. He is unable to find her until one day he looks at his adopted daughter and sees that her growing beauty is beginning to resemble that of her mother, so he decides to marry her. She is horrified that her father wants to make her his bride, so she makes a demand on him (to prove his love) that she believes he will never fulfill: she insists that he kill his donkey and give her its skin. The donkey is precious to the king; it creates gold throughout each night and is the source of the king's wealth. Much to her dismay, however, he carries out her demand. That night she wraps herself in the donkey's skin and escapes the palace unseen. She wanders far and wide and eventually settles as a farm girl in a faraway land. She continues to wear the skin to hide her beauty, but she is spotted without the skin by a passing prince. He falls in love with her, returns to his palace, and becomes lovesick. Not believing that she is the ugly "Donkey's Skin," he asks that she bake a cake for him. She does this, but during the process her ring falls off into the cake batter. He finds the ring and insists that all of the maidens in the land line up to see who fits the ring. She comes forward in

her donkey skin and as the ring is put on her finger she is revealed in all of her beauty, and marries the prince.

Although this tale was frequently included in collections in the late nineteenth and early twentieth centuries, it was often omitted from popular collections for children in the late twentieth century, probably because of the incestuous overtones. However, it certainly mirrors a few motifs articulated in *La réincarnation de Sainte-Orlan:* beauty and ugliness; and the idea that molding one's own skin means shaping one's destiny.

In Orlan's two recent large-format photograph series of pre-Columbian and African *Self-hybridations* (1998–), she comically warps conventions of beauty in non-Western civilizations at various times in history. The first series is inspired by pre-Columbian masks and sculptures (Plates 3–6). Onto her own visage Orlan appropriates enlarged craniums, Mayan square noses, and an image of the Olmec god Xipe Totec rendered as a predator who wears the skin of his victims. The colors in this first series are bold and carnivalesque, in contrast to the quite elegant African series, done in color and

Figure 3. Orlan, *Self-hybridation Africaine: Profil de femme Mangbetu et profil de femme Euro-Parisienne* (African Self-Hybridation: Profile of Mangbetu Woman and Profile of Euro-Parisian Woman) (2000). Digital photograph on color photographic paper, 1.25 × 1.56 m. Digital treatment: Jean-Michel Cambilhou. Copyright 2003 Artists Rights Society (ARS), New York / ADAGP, Paris.

black and white. The black and whites refer to the historical anthropological documentation of African tribes as the Western eye looks on (Figures 3–6).[41]

Orlan's two slightly-larger-than-life African *Nuna* statues (2000) are adorned with scarification bumps that resemble machine knobs. One black and one white breast are displaced onto a Nuna/Orlan head, suggesting a reorganized sexuality. The garish statues grossly caricature the appearance of the artist and whimsically drive home Orlan's point: that beauty is relative.[42]

At her 2003 retrospective at Fonds régional d'art contemporain (Frac) in Carquefou, the first and last images the viewer saw were located in the museum entrance, which could easily have been mistaken for a movie theater lobby. Orlan's latest work, *Le plan du film* (2002) (Plate 7), consisted primarily of a series of back-lit film posters advertising proposed films with titles such as "Body" and "Catharsis." In what was apparently a carryover of her large faux-film billboards from the late 1980s, the clever Godard-like concept here was to reverse the filmmaking process. Orlan worked backward, creating the film posters first, announcing films that had yet to be made—a

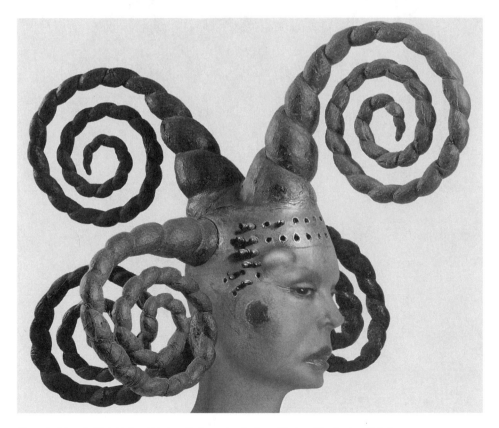

Figure 4. Orlan, *Self-hybridation Africaine: Cimier ancien de danse Ejagham Nigeria et profil de femme Euro-Stéphanoise* (African Self-Hybridation: Old Ejagham Dance Crest, Nigeria, with Face of Euro-Saint-Étienne Woman) (2000). Digital photograph on color photographic paper, 1.25 × 1.56 m. Digital treatment: Jean-Michel Cambilhou. Copyright 2003 Artists Rights Society (ARS), New York / ADAGP, Paris.

contemporary annunciation that recalled a once-popular theme in painting. Images from Orlan's work since 1990 were mixed together with images of her husband, friends, and places visited. Quite frankly, *Le plan du film* made little sense in this exhibition without two more vital contextualizations: the aforementioned painted film billboards, and some reference to David Cronenberg's screenplay "Painkillers," which envisions a future in which people can experience orgasm only by having their bodies opened up via surgery. Cronenberg has offered Orlan the chance to play herself should

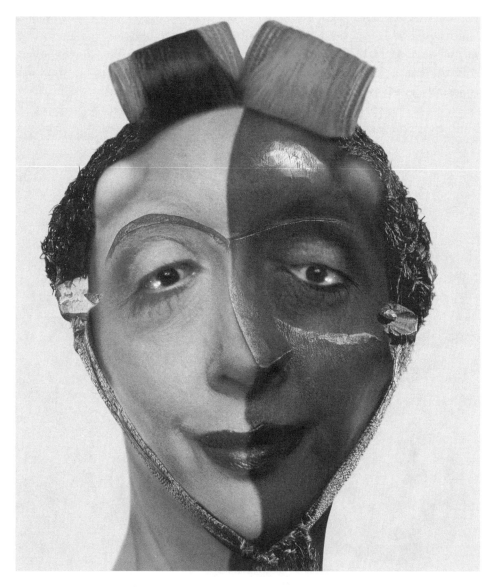

Figure 5. Orlan, *Self-hybridation Africaine: Masque Mbangu moitié noir moitié blanc et visage de femme Euro-Stéphanoise avec bigoudis* (African Self-Hybridation: Half-White, Half-Black Mbangu Mask with Face of Euro-Saint-Étienne Woman in Rollers) (2002). Digital photograph on color photographic paper, 1.25 × 1.56 m. Digital treatment: Jean-Michel Cambilhou. Copyright 2003 Artists Rights Society (ARS), New York / ADAGP, Paris.

"Painkillers" ever be realized as a film. Supposedly, during the film Orlan will perform a final surgery in which her body will be surgically opened and then closed. Her film posters project her as the star of her "body" of work, as she solipsistically interacts with others. An imaginary trailer for "Oscillations" contains all the trappings of Hollywood—dramatic music, seductive lighting, slick editing, and a star.[43]

LA RÉINCARNATION DE SAINTE-ORLAN (1990–95)

Orlan's performative surgical interventions did not begin with *La réincarnation de Sainte-Orlan*. In 1978, during a performance symposium Orlan had been organizing for five years in Lyon, she was rushed to the hospital because of an extrauterine pregnancy. Orlan explains:

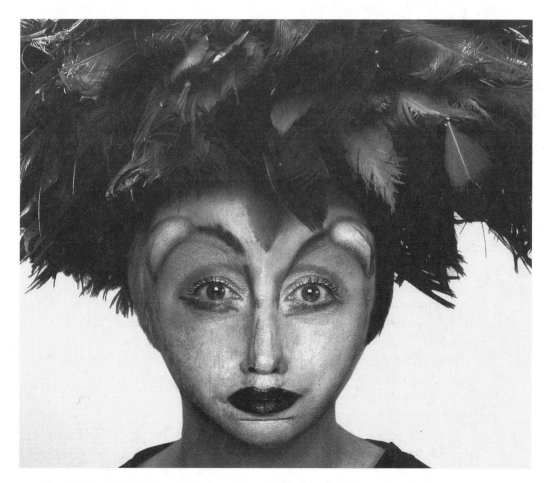

Figure 6. Orlan, *Self-hybridation africaine: Masque de société d'initiation Fang Gabon et Photo de femme Euro-Stéphanoise* (African Self-Hybridation: Fang Initiation Group Mask, Gabon, with Face of Euro-Saint-Étienne Woman) (2003). Digital photograph on color photographic paper, 125 × 156 cm. Digital treatment: Jean-Michel Cambilhou. Copyright 2003 Artists Rights Society (ARS), New York / ADAGP, Paris.

I had to be operated on urgently: my body was a sick body that suddenly needed attention. I decided to make the most of this new adventure by turning the situation on itself, by considering life an aesthetically recuperable phenomenon: I had photography and video brought into the operating room, and the videos and photographs were shown as if it had been a planned performance.

Being operated on is not frivolous; the experience was very intense: I was certain that one day, somehow, I would work again with surgery.[44]

She had the videotape delivered to the symposium in an ambulance.[45]

La réincarnation de Sainte-Orlan began on May 30, 1990, Orlan's forty-third birthday, when she exhibited *Imaginary Generic: Successful Operations* at the Newcastle Festival in All Saints' Church, Newcastle, England. This rendering sketched out the plans for a series of surgical performance art pieces in which she would appropriate facial features from five historical paintings. It showed Orlan's face fused with the chin of Sandro Botticelli's Venus in *The Birth of Venus* (ca. 1480), the nose of François Pascal Simon Gérard's Psyche in *Le premier baiser de l'amour à Psyche* (ca. 1820), the eyes of Diana in the anonymous school-of-Fontainebleau sculpture *Diane chasseresse*,[46] the lips of Gustave Moreau's Europa in *L'enlévement d'Europe* (ca. 1876), and the brow of Leonardo's *Mona Lisa* (ca. 1503–5).

It is important to remember that even though Orlan repeatedly references attributes of beauty associated with these five paintings, she insists that she is not literally appropriating any of them. Rather, she highlights these paintings in order to conceptually orient her reincarnation within the realms of Western art history, male-made idealized images of feminine beauty, and performances of artistic creation.

La réincarnation de Sainte-Orlan is one of many performances in which Orlan places her body in the center of the piece, exposing it as material to be examined and manipulated. She works from the Duchampian premise that her own body is a readymade:

I am a multi-media, pluri-disciplinary and inter-disciplinary artist. I have always considered my woman's body, my woman-artist's body, privileged material for the construction of my work. My work has always interrogated the status of the feminine body, via social pressures, those of the present or in the past. I have indicated certain of their inscriptions in the history of art. The variety of possible images of my body has dealt with the problem of identity and variety.[47]

On July 21, 1990, two months after the announcement in Newcastle, the first surgical performance, *Art Charnel*, was enacted. Liposuction from the face and thighs took place in an operating theater decorated with hundreds of white plastic flowers, a mounted photo of Orlan as Botticelli's Venus, three fluorescent wigs, and a Madonna's robe. Charlotte Caldeburg designed the costumes.

Following the surgery the removed fat was sealed in reliquaries of transparent resin that were molded into the shape of Orlan's own arms and legs. Saint Orlan's reliquaries, like those of early Christian saints, housed body parts that would not rot or decay. In the Christian tradition, rather than placing emphasis on dismemberment or the partitioning of the body, the parts housed in reliquaries indicated the whole of the saintly body.[48] Thus, Orlan's body, as sculptable matter, was able to be reorganized into a multiplicity of being in and of many bodies.

Orlan's surgeon, Chérif Kamel Zaar, protested the excessive decor and documentary equipment used in the first surgery, so only one photographer was present at the second surgery, which took place six days later, on July 27, 1990. Orlan read from Lemoine-Luccioni's *La robe* and Julia Kristeva's *Pouvoirs de l'horror (Powers of Horror)*, and a prosthesis was inserted into her chin (Botticelli's Venus).

In September 1990, the third operation occurred. It included liposuction of legs and ankles, and retouches to the face and eyelids. The increasingly problematic Dr. Zaar insisted that Orlan receive general anesthesia instead of local anesthesia, which would have allowed her to remain a conscious participant in the performance. So a video of the first operation was projected onto the operating table during the event, and the texts of dialogues with surgeons who had refused to operate on Orlan were written on the walls of the operating room.

Dr. Zaar was replaced with the art collector Dr. Bernard Cormette de Saint-Cyr for the fourth surgical performance, *Opération réussie* (Successful Operation), which took place in December 1991 (Plate 8). Paco Rabanne designed silver-spangled costumes, and bowls overflowing with plastic fruit and lobsters adorned the operating theater. Orlan exposed one breast throughout the performance surgery. This saintly trademark, one exposed breast, was repeated in a huge image of Orlan draped in white with one breast exposed, which was displayed in the operating theater. During the surgery, Orlan held a white cross and a black cross, at one point turning the white cross upside down. She also blotted her lipstick-covered lips onto a piece of transparent white cloth. This surgery was to embellish her lips (the plump abundant lips of Europa).

On July 6, 1991, *The Cloak of Harlequin*, the fifth operation,[49] was performed (Plate 9). Orlan was dressed in a hat and a vast multicolored cloak resembling that of a jester. The event involved liposuction from the thighs and feet. Postoperative reliquaries were then created to contain the removed fat. These reliquaries, a continuation of her saintly persona, were covered with layers of heavy glass. In the center of each glass plate was a receptacle that contained several grams of Orlan's flesh "preserved in special liquid." The plates were then encased in a welded metal frame "giving an impression of inviolability."[50] Twenty reliquaries were created, with a text by Michel Serres engraved in a different language on each (Plate 10). Orlan says, "The aim of this series is to produce as many reliquaries as possible, all presented in the same manner, always with the same text but each time translated into another language, until

the body is depleted; each time in a different language until there is no more flesh to put in the center of the reliquary."[51] The text read as follows:

> [W]hat could the common freak, that ambidextrous, mestizo hermaphrodite, now show us beneath his skin? Of course: his flesh and blood. Science refers to organs, functions, cells and molecules, ultimately admitting that, in the end, lab people never talk about "life" any more; indeed, science never even refers to "flesh," which precisely entails a mixture in a specific site of the body, a here and now of muscle and blood, of skin and hair, of bones and nerves, and various functions. "Flesh" recombines what specialized science dissects.[52]

This text also became the libretto for an opera, which was composed, performed, and danced by Jimmy Blanche. Video stills from the surgery were made into triptychs, which incorporated the outline of the white cross and revealed a monstrous Orlan, with horrifically scarred skin, juxtaposed with what might be interpreted as the horned skull of the devil. A ceiling video installation for the 1992 Sydney Biennale in Australia was also created using the cross, images of the surgery, and incorporating words of Christ's passion: "A little time and you shall see me no longer . . . a little time again and you will see me."[53]

The sixth operation, held in February 1992, was enacted during a performance festival in Liège, Belgium. This time Antonin Artaud's concept of the body without organs was referenced as Orlan read passages from *To Have Done with the Judgment of God* (1947). Three skulls adorned the operating room as liposuction from the face and belly took place.[54]

The triumphant seventh performance surgery, *Omnipresence,* was performed on November 21, 1993, in New York and is described in greater detail in the next section of this chapter. This surgical performance was filmed for CBS News and broadcast live to the Sandra Gering Gallery in New York; the McLuhan Centre in Toronto, Ontario; the Banff Centre in Banff, Alberta; and the Centre Pompidou in Paris, where the roundtable of watching intellectuals were also filmed as they uncomfortably reacted to the performance. Orlan stated that she wanted "to do a performance that would be like a bomb in intellectual society."[55]

The eighth surgical performance was a follow-up surgery to *Omnipresence* and occurred one week later. Sanskrit texts were read and *Saint suaire n° 9,* a holy shroud– like imprint was revealed (Plate 11). The ninth operation also took place in New York in 1993, in order to gather fat for neon and Plexiglas reliquaries and to do some touch-ups (Plate 12). Drawings, which were made with Orlan's blood, were blown up and displayed in the operating room.[56]

Orlan's reincarnation is changing as it develops. At this point it is unclear whether there will be other surgeries, but, as mentioned earlier, she is currently in discussion with filmmaker David Cronenberg about incorporating a new surgical performance in one of his upcoming films.

OMNIPRESENCE (NOVEMBER 21, 1993; NEW YORK CITY)

In this, Orlan's seventh in the series of surgical performances titled *La réincarnation de Sainte-Orlan (1990–95)*, Orlan performs as follows (Plates 13–20):

A woman lies down on an operating table

Close-up:
The woman's face is marked. A thick red line outlines each cheekbone.
Two broken red lines reach from the corners of her mouth to her ears.
Her chin and temples are circled in red.

Extreme close-up:
Her head turned to the right, a long flexible injection needle punctures the skin.
The skin's shape conforms to the needle's frantic probing actions underneath.
A scalpel slices along a marked line that traces her hairline, traverses the folds of the front
 of her ear, then continues behind the ear.
A pronged instrument penetrates the incision.
The instrument, when flexed, pries the skin away from the muscle.
The woman is being flayed.
Her body rebels.
Her face begins to swell almost instantly.
The woman smiles . . .
 on the operating table.

The camera pulls back:
The surgeon, also a woman, wears a green surgical gown.
Two women who look like wizards hover near the operating table. One woman wears a green
 turban, the other a black hat; both wear floor-length black gowns.
A fax comes into the operating room from Paris. It says, "Let's give Orlan a hand."

The operating room, freshly painted bright green, contains a new technology nook that has
 been built into its corner, housing phones and fax machines, video cameras and broad-
 casting equipment. Other props include clocks labeled
 TOKYO, TORONTO, PARIS, NEW YORK.

The woman on the operating table is small and attractive. She wears bright red lipstick and
 eye makeup, has chin-length hair parted in the middle, one side dyed white, the other
 side dyed blue, and wears a black Lan Vu dress and a black Issey Miyake corset over
 her dress.[57]

When the surgeon is partially through making her incisions, Orlan demands that the yellow
 sheets she is lying on be held up and shown off. The bloody patches drip.

At last one of five blue cups that have carefully been placed on the temples, cheeks, and
 chin of a skeleton (at the foot of the operating table) is inserted into Orlan's left brow.

"I am very pretty?" the woman asks.

A female voice asks, "Are you in pain?"
It is coming from the woman in the black hat and gown. It is repeated in sign language by
the woman in the green turban standing next to her.

Orlan's response to the question about pain is that "[t]he initial injection hurts. . . . [A]fter that the painful part is lying on an operating table for six hours."[58] This is one of many responses she will give to phoned and faxed queries during the course of this performed surgery. The performance continues with more injections, more incisions, and the insertion of four more implants into her face. The suffering, as you might be experiencing with this somewhat graphic but still mild description, is experienced in the spectator—the artist has a numb body, created with local anesthesia, which allows her to direct her performances.

Orlan's installation at the Sandra Gering Gallery, in New York, coincided with *Omnipresence* and included reliquaries that held containers of her blood and body fat; Dr. Cramer's surgical gown; and a diptych portraying forty-one photographs taken daily to document Orlan's face recovering from the surgery, juxtaposed with forty-one computer composites of her face fused with the images that she is appropriating (Plates 18–20). Orlan explains:

- Diana was chosen because she is subordinate to the gods and men; because she is active, even aggressive, because she leads a group.
- Mona Lisa, a beacon character in the history of art, was chosen as a reference point because she is not beautiful according to present standards of beauty, because there is some "man" under this woman. We now know it to be the self-portrait of Leonardo da Vinci that hides under that of La Gioconda (which brings us back to an identity problem).
- Psyche because she is the antipode of Diana, invoking all that is fragile and vulnerable in us.
- Venus for embodying carnal beauty, just as Psyche embodies the beauty of the soul.
- Europa because she is swept away by adventure and looks toward the horizon.[59]

Orlan further explains:

I constructed my self-portrait by mixing . . . representations of goddesses from Greek mythology: chosen not for the canons of beauty they are supposed to represent, but for their histories. . . . These representations of feminine personages have served as an inspiration to me and are there deep beneath my work in a symbolic manner. In this way, their images can resurface in works that I produce, with regard to their histories.[60]

After constructing this self-portrait, Orlan then integrated the composite into her own physiognomy through cosmetic surgeries. Feminist art theorist Sarah Wilson writes, "The *Omnipresence* was not that of the world, questioning, interactive at the site of incision, but a statement, of course, of Orlan's quasi-divine ubiquity."[61] Cheekbone

and chin implants were set into Orlan's head. Forehead implants were positioned as well, inspired by Mona Lisa's brow, which has distinct protruding temples. Orlan's temples resulted "in symmetrical horns—a brave new brow of Mosaic gravitas."[62] In the beginning of all of her performance surgeries, Orlan reads from the Lacanian psychoanalyst Eugénie Lemoine-Luccioni:

> Skin is deceiving. . . . [I]n life, one only has one's skin. . . . [T]here is a bad exchange
> in human relations because one never is what one has. . . . I have the skin of an angel,
> but I am a jackal . . . the skin of a crocodile, but I am a puppy, the skin of a black
> person, but I am white, the skin of a woman, but I am a man; I never have the skin
> of what I am. There is no exception to the rule because I am never what I have.[63]

"Regarding this text," Orlan continues, "I thought that in our time we have begun to have the means of closing this gap; in particular with the help of surgery . . . that it was thus becoming possible to match up the internal image with the external one." Lemoine-Luccioni's writing has inspired Orlan to move "from the reading to the carrying out of the act."[64]

After examining modes of representation of the female form throughout Western art history, Orlan has chosen to venture into the cave of her own body in order to understand it from the inside. Her exploration into the essence of representation is enacted by transforming her own live body into a representation. As Saint Orlan, she reincarnates herself by altering her mind (she underwent psychoanalysis for seven years),[65] her face, and her body. Barbara Rose says, "In her effort to represent an ideal formulated by male desire, she does not strive to improve or rejuvenate her original appearance but uses her body as a medium of transformation."[66]

Rose, however, makes an error in assuming that Orlan's goal is "to represent an ideal." Orlan's experiment does pertain to a gap between nature and the ideal as portrayed in art, identity, and communication between ontology and the materiality of the human body, but within this technological experiment Orlan *interrogates the realm of the ideal* rather than attempting to achieve an ideal physique.[67] Orlan states:

> My work is not a stand against cosmetic surgery, but against the standards of beauty,
> against the dictates of a dominant ideology that impresses itself more and more on
> feminine (as well as masculine) flesh.
>
> Cosmetic surgery is one of the areas in which man's power over the body of
> woman can inscribe itself most strongly. I would not have been able to obtain from
> the male surgeon what I obtained from my female surgeon; the former wanted, I
> think, to keep me "cute."[68]

Orlan believes "there are as many pressures on women's bodies as there are on the body—on the physicality—of works of art."[69] Her interrogation into the meaning of the ideal as it pertains to beauty in the female form not only marginalizes the question

as to whether or not she has attained ideal beauty, but also makes her unique among cosmetic surgery recipients.

Orlan is a multimedia performance artist who places her body into the center of beauty technology "in order to expose and question those techniques of gender that simultaneously construct and discipline 'beauty-conscious' female identity."[70] In other words, she makes public her woman-to-woman transformation and in doing so critiques traditional notions of beauty and prevailing Western concepts of identity. The skin she regards as a costume. She views the body as obsolete, describing it as a badly adapted machine that can no longer keep up with its own creative software but which nonetheless must remain in continuous communication with it.[71] Sarah Wilson comments on the relationship between the ideal and Orlan's flesh: "Orlan insists that interrogation of the ideal, not the ideal itself, is her aim; hers is a quest through martyrdom that strips away flesh, as meaning seeks itself in a terrifying 'mis-en-abyme.'"

As Saint Orlan, her flesh is her medium, reincarnation her aim. She combines baroque iconography, medical technology, theater, and mass media. She choreographs and directs each surgical performance, including the reading of psychoanalytic and literary texts. Wilson writes in her "Histoire d'O, Sacred and Profane" that *La réincarnation de Sainte-Orlan* is "a Passion Play for our times, with all the drama, mystery and anxiety generated by surgical procedure, followed by the triumphant resurrection of unscarred Flesh."[72] Orlan asserts, "I have given my body to Art. After my death it will not therefore be given to science, but to a museum. It will be the center piece of a video installation."[73]

When asked during *Omnipresence* whether or not she feels that she is conforming to the male conception of the ideally beautiful woman, Orlan replies that she isn't conforming to a man's notion of beauty, that the forehead implants are "taken from the Mona Lisa" not just for the look but for the history behind the image. The art historical context is important; by placing herself inside it, she remains closely connected to it. Orlan defers to the origins of ideal beauty by deconstructing images as well as her own body. But a synergy exists here. The origin of beauty is implicative of its opposite. Female beauty is at one and the same time the monstrous feminine. In the photograph *Official Portrait with Bride of Frankenstein Wig* (1990), taken just after the third surgery,[74] Orlan leans forward, resting her chin on one hand, which wears a black glove and large gold rings (Figure 7). Her plump red lips and smooth, unscarred skin are radiant. Her wig, large, black, wavy, and piled on top of her head, is adorned with two stripes of white hair that emanate from her temples. She is strikingly beautiful in this theatrical portrait. But the evocation of Frankenstein foretells her future forms. The interrogation of ideal beauty will prove to demand that she play between the extremes—ideal beauty and the monstrous feminine. It is for this reason that while Orlan references images of Greek goddesses she also includes Frankenstein and Medusa in her repertoire. She writes: "Saint Orlan offers the kiss of the Medusa to art, science and religion."[75]

The context, in which she places herself as an objet d'art, is emphasized as she performs her transformation seemingly without pain and without emotion. As Augsburg indicates, Orlan does not acknowledge or discuss postoperative suffering; "she admits only to the psychic pain caused by the initial decision to carry out her conceptual project. . . . Orlan's refusal to acknowledge pain is a feminist strategy: she remains silent about her emotional and physical discomfort because she absolutely refuses to be associated with the figure of the sick/mentally ill woman."[76] Augsburg also points out that although the question "Do you feel pain?" might be a bit less undermining than the question "Are you mad?" both questions serve to discredit Orlan's ability to be in control of her decisions about her body. Orlan understands the "insidious intent behind such seemingly innocent questions, [and] resists further diagnosis with disconcerting refusals, silences, and displays of self control. . . . [S]he insists that she is just as curious as we are about how her physical change will affect her—not only on the surface of the body, but also in terms of her self-identity."[77]

Kate Ince, by contrast, insists that, because Orlan's performances utilize cosmetic surgery, she participates in a discourse of masochism: "[D]isavowal of suffering is an important part of the complex social masochism of 'Reincarnation,' and . . . risk is a real and significant dimension of Orlan's surgical practice."[78] Ince's assessment of Orlan's relationship to masochism is, in my view, a bit shortsighted. Here Ince is responding

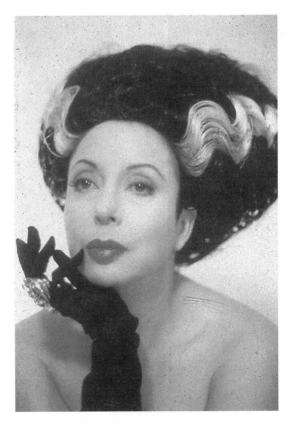

Figure 7. Orlan, *Official Portrait with Bride of Frankenstein Wig* (1990). Cibachrome on aluminum, 110 × 165 cm. Photograph by Vladimir Sichov for Sipa Press. Copyright 2003 Artists Rights Society (ARS), New York /ADAGP, Paris.

to Kathy Davis's inclusion of Orlan's work in what Davis terms "utopian" visions of what surgery claims it can achieve. According to Davis, these visions that are sold to women do not include the suffering of the patient or the risks of surgery. At the same time, however, Davis acknowledges that identity plays a large role in the choice to utilize cosmetic surgery. She asserts that identity has to be understood as "embodied— that is, the outcome of an individual's interaction with her body and through her body with the world around her."[79] Davis also writes that the power play enacted through cosmetic surgery is that of a double-edged sword: cosmetic surgery manifests a means to control women, but at the same time it is a strategy through which women take charge of their own lives.[80] These attributes of cosmetic surgery become a quagmire of the politics in Orlan's performances. She takes charge and directs the surgical performances. Her disavowal of pain is enacted in full view. An important difference between Orlan's surgical performances and others' cosmetic surgery is that the *secrecy* in which most cosmetic surgery is carried out is the locus of pain, and even of surgery itself. Orlan makes her performances public, so her disavowal of pain is a political performance that interrupts the subversive strategy of secrecy. The pain that exists in Orlan's surgical performances is transported through the images to the audience members, who participate in an Artaudian theater of cruelty.

I also have to disagree with Ince's overall assessment of Orlan's motivation: "Orlan's 'Reincarnation' project is most certainly public and political, but her motivation for undertaking it was also, I am convinced, as private and personal as the motivation of the thousands of women who now opt each year to have liposuction, breast enhancement or a face lift."[81] First, this is an assumption upon which Ince has absolutely no grounds. Orlan's surgical enactments are created within a political aesthetics (albeit carnivalesque and gruesome) that informs her oeuvre, her hagiography, and her explorations into fluctuating identity. Second, Ince's assumption becomes even more unfounded when taking into consideration Davis's research, in which she discovers that women have cosmetic surgery not to become more beautiful but, rather, to become more "ordinary, normal, just like everyone else."[82] Orlan clearly is not enacting surgical performances to become more normal.[83]

ORLAN'S "CARNAL ART" AND TWENTIETH-CENTURY "BODY ART"

Orlan defines her work as "carnal art" to distinguish it from "body art." In "Carnal Art Manifesto" she defines carnal art as follows:

> Definition:
> Carnal Art is self-portraiture in the classical sense, but realized through the possibility of technology. It swings between defiguration and refiguration. Its inscription in the flesh is a function of our age. The body has become a "modified ready-made," no longer as the ideal it once represented; the body is not anymore this ideal ready-made it was satisfying to sing.[84]

By centering the live face, the molding and remolding of its features, Orlan aligns herself with self-portraiture. Clearly this distinguishes her art from the "body art" that tests the limits of the body and the psyche, like that of the Viennese actionists:

> Distinction:
> As distinct from "Body Art" Carnal Art does not conceive of pain as redemptive or as a source of purification. Carnal Art is not interested in the plastic-surgery result, but in the process of surgery, the spectacle and discourse of the modified body which has become the place of public debate.[85]

This defines carnal art as political. Orlan emphasizes discourse and public debate as she explores the nether regions of technology's role in fabricating the body. But most important is this passage:

> Freedom:
> Carnal Art asserts the individual independence of the artist. In that sense it resists givens and dictates. This is why it has engaged the social, the media, where it disrupts received ideas and causes scandal, and will even reach as far as the judiciary [to change Orlan's name].[86]

Orlan feels that one is never what one has, and she sets out to correct, or at least play with, this ontological condition via surgical manipulation and, now, digital photography. She also confronts a peculiarity of identity bequeathed to all by their parents and by the law. She was born Mireille Suzanne Francette Porte in Saint-Étienne, France, on May 30, 1947.[87] She baptized herself Sainte-Orlan in 1971. Augsburg points out that there is some speculation that "Orlan" is derivative of Virginia Woolf's Orlando, the immortal transsexual character whose identity shifts over time. Augsburg also makes an insightful comment about Orlan with regard to Sartre's interpretation of Jean Genet, who pronounced himself Saint Genet. Genet cultivated many identities, including that of a thief. Sartre writes that the saint and the thief share one commonality: they both do nothing but consume.[88] Through acts of humiliation and martyrdom the saint produces only grand spectacle. Augsburg comments: "From Sartre's Western Marxist perspective, we can link Orlan's decision in 1971 to baptize herself Saint Orlan to the spirit of Fluxus, as an antibourgeois gesture of extravagant consumerism for its own sake."[89]

Orlan writes:

> When the operations are finished, I will solicit an advertising agency to come up with a name, a first name, and an artist's name; next, I will contract a lawyer to petition the Republic to accept my new identities with my new face. It is a performance that inscribes itself into the social fabric, a performance that challenges the legislation, that moves towards a total change of identity.[90]

The legalization of the name change alters the course of Orlan's shifting shape and will conceptually solidify one new identity. Nevertheless, it will also emphasize the realism in Orlan's work. It is not merely conceptual; Orlan lives her art.

Eleanor Antin, another master of shifting identity, allegorizes each character she creates, giving each a history, a future, a personality, a name. The invention, documentation, and live performances of her personae—the King, the Black Movie Star, the Nurse, and the Ballerina called Eleanora Antinova—she describes as a "mythological machine . . . capable of calling up and defining my self. I finally settled upon a quadripolar system, sort of a magnetic field of four polar-charged images";[91] "My personae, my historical fictions, are actually all the lives that I'm not going to live because I *chose* not to."[92]

Antin's *Carving: A Traditional Sculpture* (1972) is a series of 144 photographs documenting Antin's body changes during the course of a thirty-six-day diet (July 15–August 21, 1972). The diet, like cosmetic surgery, is a means for women to strive toward cultural ideals of femininity and beauty. But the format in which this work appears—lined-up snapshots of both profiles, front, and back—references medical photographs depicting illness, mug shots, and physiognomy charts made in the nineteenth century. They are stark, medical, naked; or, as Antin says, "[W]ithout my life, history, or achievements to give me courage, barely awakened from sleep, hair uncombed, not yet with a face to present myself to the world."[93] As Lisa Bloom points out, *Carving* references Kenneth Clark's *The Nude: A Study in Ideal Form*, in which he distinguishes between the naked and the nude in Western painting. The ideal Clark determines to be the classical Greek white male nude, whereas its counter is the Germanic, dark, medieval, naked female.[94] With regard to this reference, I interpret *Carving* as a depiction of the naked body striving to become the nude.

In the United States one of the first feminist performers was Carolee Schneemann, who experimented with the erotic body as material. In her 1963 *Eye Body: 36 Transformative Actions*, Schneemann covered her naked body with paint, grease, ropes, chalk, plastic, and snakes. She was transgressing new boundaries—as an erotic female nude, she also doubled as artist / object of art. Schneemann says:

> When I first came to New York, I was supporting myself as an artist's model. I was lying naked listening to these terrible men, most of them really ruining their students' drawings. I had to listen to them say all the things that would prevent the students from seeing fully and well. . . . Then I [came] back to the studio where the cultural message was, "You're incredible, but don't really try to do anything." I would just pick up my hammer and start fracturing my materials with a full armswing and focused aim. My work was about motion and momentum and physicality. The next step was to see what would happen if the body went in among my own materials. And would my rage at predictive rejection be supplanted by the gendered form exposed, displaced: active, present, and accusatory!? Once I saw the images, I thought I had done something incredible with *Eye/Body*, but I didn't know exactly what.[95]

The transgressiveness of Schneemann's work exploded into the art world. She was rejected from the Fluxus movement (which she termed the "Art Stud Club"), because founder George Maciunus found her work too "messy."[96] The essentialist feminists of the 1960s challenged her work as a completely narcissistic gesture that debased the goddesses that she alluded to with the snake imagery. The antiessentialists criticized her work as essentialist—as defining woman's body, and thus her identity, as erotic, vaginal, vulval. The materialists of the 1980s critiqued the work as naively political and nostalgic.[97] But Schneemann, through performed representation, was revealing the boundlessness of feminine sexualized identity. In Robert Morris's 1964 action *Site*, Schneemann posed as Manet's Olympia. Eunice Lipton's description of the 1865 scandal caused by Manet's painting is also perfectly apropos to the dismissal of Schneemann's work as too "messy":

> The model surveyed the viewer, resisting centuries of admonitions to ingratiate herself. Locked behind her gaze were thoughts, an ego maneuvering. If later on Freud would ask "What do women want" then this woman's face answered. You know what she wanted. Everything. Or rather she wanted, she lacked, nothing. And that is why in the spring of 1865 men shook with rage in front of *Olympia*. She was unmanageable; they knew she had to be contained.[98]

Rebecca Schneider comments that the representation of women by women is always inclusive of a bipolar performance of power. Schneider asks, Were Schneemann's performances advocating or submitting to an image of the woman's body as low, filthy, and erotic, or was she opposing and criticizing this image of women by crossing the boundary between artist and art object? Schneider writes, "Something very different is afoot when a work does not symbolically depict a subject of social degradation, but actually is that degradation, terrorizing the sacrosanct divide between the symbolic and the literal."[99]

Schneemann's more recent piece *More Wrong Things* (2001) is a site-specific, multichannel video installation (Figure 8). Fourteen video monitors are suspended from the ceiling with extended amounts of tangled cables and cords falling out of them. Video loops seen on the monitors present a compendium of "Wrong Things," juxtaposing Schneemann's visual archives of personal and public disasters. Included are images of her early performance *Interior Scroll*, fucking, her cat tearing up a squirrel, an injection being given to treat cancer. The public disaster images include images she has collected of the Vietnam war and Bosnia. *More Wrong Things* is mentioned here because it inscribes into its political message Schneemann's body as a locus of disaster. While receiving these images, one is also confronted with the technological nightmare that the presentation personifies. The masses of cords are Medusa's hair. Alive with electrical currents, these tendrils transmit horrible images that are personalized by the presence of Schneemann and her work. The experience of interacting with this piece is one of great anxiety, emphasized by the start-and-stop four-second

duration of each shot. However, it is difficult to turn away. This Medusa freezes you in your tracks.

The political edge inhabiting "the sacrosanct divide between the symbolic and the literal" elicits "binary terror"[100] to the degree that the debate around Schneemann's performances locates her in what might even be termed erotic/disaster and feminist/misogynist binaries. Rebecca Schneider defines binary terror:

> The terror that accompanies the dissolution of a binary habit of sense-making and self-fashioning is directly proportionate to the social safety insured in the maintenance of such apparatus of sense. The rigidity of our social binaries—male/female, white/black, civilized/primitive, art/porn—are sacred to our Western cultural ways of knowing, and theorists have . . . pointed to the necessity of interrogating such foundational distinctions to discover precisely how they bolster the social network as a whole, precisely what they uphold and what they exclude.[101]

Similarly, the binaries that come unleashed from Orlan's work include mind/body, sacred/profane, and dominant/submissive (the doctor/patient relationship), as

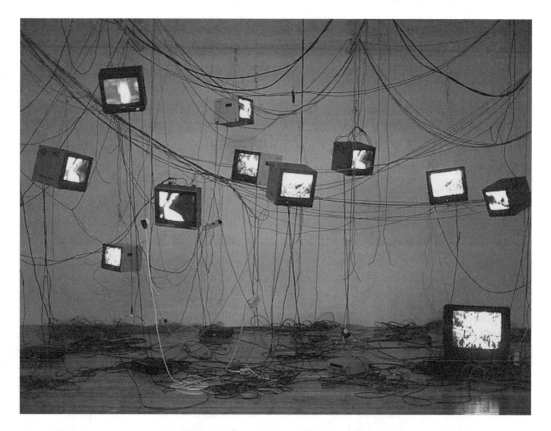

Figure 8. Carolee Schneemann, *More Wrong Things* (2001). Multichannel video installation with suspended cable environment. Cornerhouse Gallery, Manchester, United Kingdom, March 2001. Courtesy of the artist.

well as beauty/ugliness, natural/unnatural, subject/object, material/immaterial, and interior/exterior. The exploding questions that emerge from inside the binaries are provocative. For example, if there is a conflict between what is "man-made" (such as art) and what is "natural" (biologically inherited) in the body, then how can one judge which image should or should not be inscribed onto the body? Considering the contemporary emphasis on body as image, the fact that the process of surgical alteration puts one's body in a state of flux (by altering it, the body must be opened up and then the wounds must heal), and the fact that Orlan is incorporating into her body images of "ideal" beauty, is Orlan's new future form stable? Is the possible instability of her image undermining her attempts to stabilize an altered one? Is Orlan authoring a failure or a success? And finally, specifically addressing the possibility of what might be termed an art/medicine binary,[102] exactly *who* is authoring this work, the surgeons or Orlan?[103]

So what about the Viennese actionists? Orlan's surgical performances do bear similarities to performances of the modernist avant-garde, particularly those which (re)placed the body in the center of performance as one material among many others. Innovators of body performance include the Viennese actionists—Otto Muhl, Hermann Nitsch, Rudolf Schwarzkogler, and Günter Brus[104]—and those who specifically (re)placed the *woman's* body in the center of the performance—Carolee Schneemann and Valie Export.[105]

The Viennese actionists performed between 1962 and 1972. Brian Hatton, in his article "Sensuality and Self-Abuse in Viennese Art," exclaims:

> The Aktionists [*sic*] have repeatedly exclaimed that they have laid waste their bodies only as necessary cleansing, and expiatory prorogation preparatory to radiance. Dissatisfied with the transient commerce of the mind that they feel has flattened all passionate existence into a glassy screen, they have not hesitated to invoke the sacral at every turn towards the Dionysian source.[106]

Hatton describes the actionists as aggressive in their insistence upon making art that spoils art by removing the commodified objet d'art. In 1966 the actionists wrote that direct action meant "throwing the dirt into people's faces, . . . no more eroticism . . . instead anti-pornography, chopped off genitals, bloody ears."[107] For the actionists, the body, reduced to an object, was manipulated, tortured, and mutilated. One of their most legendary ritual performances of body mutilation was the photographically documented amputation of Schwarzkogler's penis (1972). The myth that arose from this event was that Schwarzkogler bled to death as a result of the amputation. In fact, no real amputation took place; it was a staged event. A friend, Heinz Chibulka, was the model, Schwarzkogler the photographer. However, the photographs are visceral and convincing.

The actionists' attack on cultural values was ritualized and subordinated with texts that conjured myth and Dionysian festivities. Nitsch's *Manifest das Lamm* (*The Lamb Manifesto*), which was published in conjunction with the 1964 Venice Biennale, was

reminiscent of Artaud's "theater of cruelty." Here Nitsch's *Orgien Mysterien Theater* (Orgies Mysteries Theater, or simply "o.m. theater") was outlined as a six-day Dionysian festival. Regarding o.m. theater, Roswitha Mueller writes: "According to Nitsch, in Christian mythology the fire of Dionysius is transformed into the death of the lamb of God on the cross which corresponds to a deep seated desire of the collective human psyche for sensual excess, cruelty, and finally catharsis" (Figure 9).[108]

The actionists' point was to obliterate the modernist myth, which they felt was littered with artists producing "endrils [*sic*] and mucous membranes of paint strung out in greenbergian 'optical space,' 'esthetized' because anesthetized," and to break art out of its frame and into life.[109] Thus it was perceptive that the body, discharged from the "greenbergian 'optical space'" would be resuscitated, even if only as an object.

Orlan, the actionists, and others such as Chris Burden and Gina Pane share a desire for antiformalism.[110] Orlan writes, "Carnal Art loves the baroque and parody, the grotesque and free-form because Carnal Art is opposed to social pressures that exert themselves as much on the human body as on the body of artworks. Carnal Art is anti-formalist and anti-conformist."[111] However, Orlan takes a firm stand against motifs of sacrifice, mutilation, and self-abuse. But the very nature of placing the body in the center of performative action in order for it to become a transformative object problematizes the meaning behind the action: Is the artist the author, or is the artist being acted upon; is this a performance of self-assertion or of victimization? That this is not fully understood may lend power to the work, as in the case of the actionists' performances of Dionysian ritual. In Orlan's case she does everything in her power to dispel any question that she is the artist/performer, that she is asserting herself. This is one reason why feminists are divided in their interpretation of Orlan. Orlan has chosen to work *within* the beauty industry in order to perform a critique of ideal beauty. Even so, the very nature of participation within that which should be opposed allows feminists to question her claim of self-assertion.

In this regard Orlan's work can be compared with the feminist work first performed by Valie Export, an artist associated with the Viennese actionists.[112] One of the first women to take a dominant role as a performer, Export defined herself as a feminist actionist in 1970:

> Feminist Actionism seeks to transform the object of male natural history, the material "woman," subjugated and enslaved by the male creator, into an independent actor and creator, object of her own history. For without the ability to express oneself and without a field of action, there can be no human dignity.[113]

Export describes her performance *Body, Sign, Action* (1970), in which she adopted symbols of femininity in order to subvert them:

> [A] photograph shows a tattooed garter on my thigh. The garter is used as a sign of past enslavement, as a symbol of repressed sexuality. The garter as the sign of belonging to

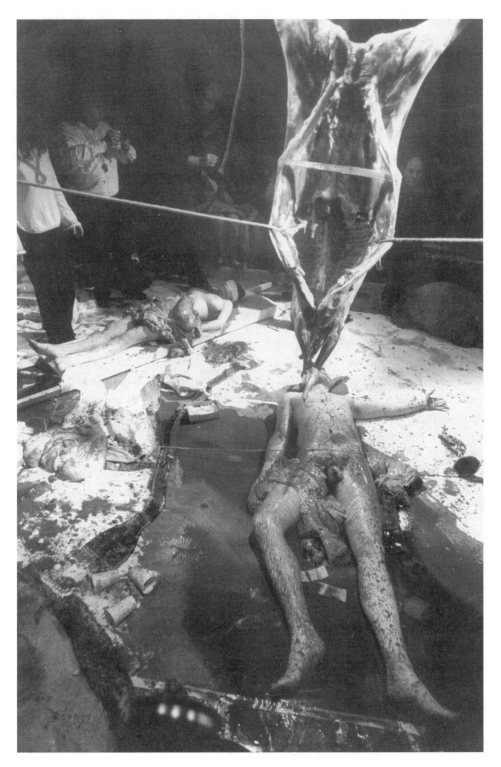

Figure 9. Hermann Nitsch, *43: Action*. Performed at the Modernes Theatre, Munich, on January 15, 1974. Courtesy of the artist.

a class that demands conditioned behavior becomes a reminiscence that keeps awake the problem of self-determination and/or determination of others of femininity. . . . [T]he body becomes a battle field on which the struggle for self-determination takes place.[114]

Presented with the image of the tattooed thigh is this text:

Woman is forced to represent herself through jewelry, make-up, personality and as bearer of fixed sexual symbols which are signs of a phallocratic society in a way that does not correspond to her personal needs. Based on the system of biological differences, a sociological system of repression was erected, which woman can escape only by rejecting the body defined in the manner as feminine.[115]

Within her strategy to reject femininity, Export appropriated cultural signifiers of femininity permanently onto her own body. The concept that enacting is enabling is also one that Orlan employs: "[M]y work is blasphemous. It is an endeavor to move the bars of the cage, a radical and uncomfortable endeavor!"[116]

Although Orlan's work might be termed abject, it could be argued that it is neither radical nor avant-garde, if avant-garde is equated with "attacking the bourgeois construction of social reality."[117] Orlan's means—elective cosmetic surgery and sensational documentary coverage—may belong to a Western, middle-class, Hollywood-like aspiration to fame and beauty, but, in using bourgeois means to enact her experimentation, she is deviating from the radical strategies of the avant-garde. In spite of her means, Orlan counters the *commodity aesthetics* of both art and cosmetic surgery; she "'short-circuit[s]' and explode[s] the conventional artistic/representational system."[118] Richard Murphy notes that some of the common denominators between the avant-garde and postmodern art are that both critique the real, both engage in the sublation of art and life, and both question the authority and the existence of the original:

For the real is now constituted as a constellation of signs and simulacra, whereby the existence of an "original" is opened to doubt—a fact which explains the prominence of the strategies of parody and pastiche in postmodernism, and of analogous forms of re-writing in the expressionist avant-garde, which displace or defer the notion of "origin."

Since with the Nietzschean revolution and its relativization of all cosmological belief systems the possibility of an *external* viewpoint is excluded, expressionism develops certain discursive strategies—related . . . to what is later called "parody" and "pastiche" in postmodernism—which are necessarily aimed at exposing the discursive constructedness of the world and at undercutting this endless circulation of images *from within.*[119]

Orlan's work plays a significant role in "exposing discursive constructedness" both *within* art historical images of women and *within* contemporary *constructed* beauty (literally constructed by surgeons).

Orlan, as artist and as art, also slashes the distance between representation and the real. But she struggles with this polarity in her surgical performances. She directs her surgeries but is sutured and sculpted by another. She speaks throughout the surgeries, the camera focusing on her participation, but the surgeon's knife does not recede into the background. She ardently challenges the expected passivity of both patient and female.

Orlan claims that she does not want to do anything to herself that will alienate her from society, such as sculpt her face into something resembling an animal. Regarding one performance Orlan says:

> It was about, among other things, de-sacralizing the surgical act and making a private act transparent, public. By the same token, in the gallery, the photographic installation depended on two ideas: showing what normally is kept secret, and establishing a comparison between the self-portrait made by the computing machine and the self-portrait made by the body-machine.[120]

Philip Auslander points out that Orlan's work "contributes to the definition of a posthumanist self, a self for which identity is mutable, suspended, forever in process."[121] Mark Dery, in his book *Escape Velocity*, objects to Auslander's view: "[Orlan's] professed feminism and her manifest posthumanism cancel each other out: Those who declare war on *what is natural* are in no position to bemoan *the unnatural standard of beauty imposed by our society.*"[122] Contrary to this perspective, feminists such as Kathryn Pauly Morgan, grappling with the issue of plastic surgery, call for "healthy women who have a feminist understanding of cosmetic surgery . . . to deploy cosmetic surgery in the name of its feminist potential for parody and protest"—in other words, to make themselves uglier in order to defy standards of beauty.[123]

La réincarnation de Sainte-Orlan includes two layers of appropriation. First, Orlan utilizes specific images of women's faces that bring conceptual meaning to her body of work and her body. Second, Orlan's surgical recreation of herself *is* the visceral performance of appropriation. The imagery she creates is of her body in surgery, not of the five representations of women that she references. The appropriated attributes are not necessarily visually identifiable on Orlan's body. One does not look at Orlan's lips and associate them with those of Moreau's depiction of Europa, or note her prominent hornlike temples and associate them with the shape of the Mona Lisa's head. The main question posed in her creation regarding identity is that of her own. What one sees is an altered Orlan. The attributes that are taken from art historical images of ideal women are incorporated into her features, which finally are only conceptually linked to the images from which they are appropriated. Thus, any perceptual reference to an original is obscured.

For most viewers the initial response to Orlan's surgical performances is to recoil in horror. Toward the beginning of my inquiry, Orlan appeared at a performance studies conference at New York University (March 1995). Much controversy ensued. From the primarily feminist audience there were complaints that she was acting like a star and overshadowing the conference.[124] Several postconference discussions (both in and out of classes) focused on how intolerable her performance surgeries were, decadent and mad performances that not only were offensive but also possibly took a step backward in the continuum of feminist political thinking. Although there seemed to be a consensus that her work challenged feminist ideologies, it was received with a profound ambivalence. Through the years I have watched this response reverberate through her audiences. Orlan expects this and excuses beforehand those who cannot watch her performances or tolerate her work.

The uneasiness exhibited by her feminist audience is most likely due to the fact that Orlan's work does not overtly reinforce feminist ideologies by reproducing them in a didactic politicized form that cannot be misinterpreted. She has never communicated "safe" feminist aesthetics. Rather, Orlan's aesthetics deconstructs feminine beauty through the use of her own body as sculptable material. Far from seeking beauty or promotional advertisement for cosmetic surgery, she utilizes medical technology to make herself unattractive. Her highly experimental work takes the form of the *process* of deconstructing body forms, which may also serve to deconstruct identity.

But the relationship between identity and the body is a slippery one that involves gendered, racial, cultural, political, and psychological variables with regard to, first, self-perception and then the gaze of each "other" that's encountered. Orlan writes about her objective to externally manifest internal self-images so that they are / she is more accurately (or perhaps, rather, more creatively) viewed by the other. I believe that politically this is a very solid strategy. By performing identities that shift, she conceptually reveals differences that traverse and possibly transform the variables I have named. How do her surgical performances literally and conceptually interrogate identity?

ORLAN AND PSYCHOANALYSIS: A FEW COMMENTS ON THE INCLUSION OF PSYCHOANALYSIS IN *THE REINCARNATION OF SAINT ORLAN*

As a feminist spectator and critic of art, I believe it is important for women to conduct ongoing investigations of the male-dominated philosophies, theories, literatures, and arts that have shaped representations of women. Most particularly, artists such as Orlan who perform deconstructions of the vast history of male-dominated Western art significantly contribute to this investigation. Also significant are the feminist theorists, such as Luce Irigaray, Jay Prosser, Parveen Adams, Joanna Frueh, and Peggy Phelan, who through discourse examine sociohistorical male/female polarity as a construct that oppresses both sexes (gender is socially constructed and therefore reinforces a denaturalization of oppressive social ideologies) and who dislocate patriarchal perceptions

of women (by, for example, Freud, Nietzsche, Lacan, and Hegel) and replace them with ideas that might refute the notion that women are "other." These feminist theorists disrupt the binary structure male = self / female = other and de-emphasize the notion that all women and men experience life similarly because they share the same biological sexes. In the next chapter I examine historical-physiological perceptions of the female anatomy and the way these perceptions shaped and generalized interpretations of female identity.

Equally valuable to this close reading of Orlan's work is the systematic deconstruction of the "truths" upon which selected philosophical and psychoanalytical texts are based.[125] Feminist theorists such as Luce Irigaray believe that the key to women's oppression exists in her psyche and that, through a series of early childhood experiences, not only do children become psychically gendered but also patriarchal structures that value masculinity over femininity become ingrained. The relationship between psychoanalysis and feminism is a complex one. As Elizabeth Grosz explains:

> Psychoanalytic inquiries into the nature of female identity, libido, sexuality, and development are of major significance to feminism. In spite of whatever problems it may exhibit, psychoanalysis is still by far the most complex, well-developed, and useful psychological theory at hand. It retains an "honesty" or at least an openness about its attitude to women and femininity that is rarely visible in and yet is highly symptomatic of a more general patriarchal, cultural framework. For this reason alone it is difficult to abandon; without viable theoretical alternatives, psychoanalysis still remains the system which says what others simply presume or cover over.[126]

Because feminist psychoanalytical theory is utilized in this book to assist in probing the complexities of identity that Orlan manifests, what follows is a brief description of significant aspects of the theories of Sigmund Freud and Jacques Lacan—aspects that can inform perceptions of Orlan's performance surgeries.

Freud gives two accounts of the ego.[127] Although he never clarifies which account he prefers, what is most important to note for this research is that the ego is the place where the subject becomes internally split between self and other.[128] In "On Narcissism: An Introduction" (1914), the ego is seen as contingent on the direction of libidinal desire and the subject's capacity to make itself (or a part of its body) a libidinal object that can be perceived as external or "other."

Freud makes a distinction between narcissism and autoerotic instincts: "[A] unity comparable to the ego cannot exist in the individual from the start; the ego has to be developed. The autoerotic instincts, however, are there from the very first; so there must be something added to autoeroticism—a new psychical action—in order to bring about narcissism."[129] With a comparison between the healthy body of a subject and its ill body, Freud then establishes that the narcissistic ego is shaped by the libido:

[A] person who is tormented by organic pain and discomfort gives up his interest in the things of the external world, in so far as they do not concern his suffering. Closer observation teaches us that he also withdraws libidinal interest from his love-objects: so long as he suffers he ceases to love. . . . We should then say: the sick man withdraws his libidinal cathexes back upon his own ego, and sends them out again when he recovers.[130]

Thus, the quantity of libidinal energy, which is variable, shapes the contours of the ego, which are also variable. Freud further develops the workings of the narcissistic ego and libidinal cathexis in relation to the body of the subject: "We can decide to regard erotogenicity as a general characteristic of all organs and may then speak of an increase or decrease of it in a particular part of the body. For every such change in the erotogenicity of the organs there might then be a parallel change of libidinal cathexis in the ego."[131]

The subject that is able to establish its body or a part of its body as a libidinal object has chosen him- or herself as the love-object. Freud's analogy of this occurs as a feminine characteristic:

With the onset of puberty the maturing of the female sexual organs, which up till then have been in a condition of latency, seems to bring about an intensification of the original narcissism, and this is unfavorable to the development of a true object-choice. . . . Women, especially if they grow up with good looks, develop a certain self-contentment which compensates them for the social restrictions that are imposed upon them in their choice of object. Strictly speaking, it is only themselves that such women love with an intensity comparable to that of the man's love for them.[132]

The narcissistic ego is not self-contained but, rather, contingent upon a relationship with the other. The subject who takes itself as a love-object (in narcissism), then, is split into both subject and object.

Freud is postulating that the subject's perception of its libidinal relationship to its body equals its ego. As Grosz points out, Freud's equation, which relates the subject's projection of the body's surface to the form of the ego, is a concept that is largely explored by feminists who critique psychoanalysis and the development of notions of sexual difference:[133]

The narcissistic genesis of the ego entails that the subject cannot remain neutral or indifferent to its own body and body parts. The body is libidinally invested. . . . No person lives his or her own body merely as a functional instrument or a means to an end. Its value is never singly or solely functional for it has a (libidinal) value in itself. The subject is capable of suicide, of anorexia (which may in some cases amount to the same thing), because the body is *meaningful*, has significance.[134]

Therefore, the ego, as a construct of the psyche that is contingent upon perceptions of the libidinal surface of the body, is subject to perceptions of the body that are not necessarily based in the demands of reality (as with, for example, the emaciated anorexic who still believes her body is obese).

By contrast, in "The Ego and the Id" (1923), Freud presents the ego as an interlocutor between the instinctual and corporeal id drives and the requirements of external, socialized reality; it filters in both directions. The ego is no longer formed by the arrangement of libidinal cathexis:

> The ego represents what may be called reason and common sense, in contrast to the id, which contains the passions. . . . In its relation to the id, the ego is like a man on horse back, who has to hold in check the superior strength of the horse; with this difference, that the rider tries to do so with his own strength while the ego uses borrowed forces. The analogy may be carried a little further. Often a rider, if he is not to be parted from his horse, is obliged to guide it where it wants to go; so, in the same way the ego is in the habit of transforming the id's will into action as if it were its own.[135]

The ego as a filter is not exclusively a psychic one. Freud establishes that it is informed by the surface of the body, the skin of the body, which is also a sensory filter between the internal and external worlds. More than this, the shape of the ego is formed by the imagined shape of the body as it is perceived according to sensory information:

> The ego is first and foremost a bodily ego: it is not merely a surface entity, but is itself the projection of a surface. If we wish to find an anatomical analogy for it we can best identify it with the "cortical homunculus" of the anatomists, which stands on its head in the cortex, sticks up its heels, faces backwards and as we know, has its speech-area on the left hand side.[136]

This image of the ego and the definition of the cortical homunculus are examples of the subject's internalized image of its body as something other than an exact trace of the material body. This example may lend some insight into the work of Orlan, who claims to be bridging a gap between the internal image of the body and the physical body.

Lacan rejected Freud's theory of the ego postulated in "The Ego and the Id" and appropriated his theory in "On Narcissism." Briefly, for Lacan the ego is an imago, a mutually agreed-upon misrecognition that substitutes for the truth. In other words, the ego is not an outline of the material body but, rather, an imagined projection of the body that is informed by the perceptions of others as well as by the subject's mirror image.

With respect to the question, what is the internal image? it is valuable to clarify a few aspects of Lacan's theory of the mirror stage, as there exists an intimate

relationship between the mirror stage and the body image, or imaginary anatomy.[137] Also, in opposition to Descartes's *cogito*, the mirror stage confirms for Lacan that the "I" is not preexistent but constructed. Elizabeth Grosz compares Descartes's notion of the subject to Lacan's:

> Lacan displaces the ego as the central and most secure component of the individual, unsettling the presumptions of a fixed, unified, or natural core of identity, and the subject's capacity to know itself and the world. The certainty the subject brings with it in its claims to knowledge is not, as Descartes argued, a guaranteed or secure foundation for knowledge. It is a function of the *investment* the ego has in maintaining certain images which please it. Rather than a direct relation of recognition of reality, the ego only retains a pre-medi(t)ated, i.e., imaginary or preconstructed, Real.[138]

What is specifically enacted in the mirror stage is the *problem of self-recognition*, which is crucial to the formation of the imaginary anatomy. Within the problem of self-recognition, the child experiences its anatomy as an imago of a fragmented body[139] and as uncontrollable; it cannot meet its own needs and is dependent on its mother. At one and the same time the child experiences its body as a contained, bounded, and whole anatomy, as seen, for example, through the eyes of its mother or reflected in the mirror. In other words, at the time of seeing its reflection in the mirror, the child is still experiencing its body as fragmented while visually recognizing its specular image as a unified totality. This recognition is also a misrecognition, because the mirrored specular image is merely an image of the subject as seen from the outside; it does not reflect the fragmented life experience of the child:

> The mirror stage is a drama whose internal thrust is precipitated from insufficiency to anticipation—and which manufactures for the subject, caught up in the lure of spatial identification, the succession of phantasies that extends from a fragmented body-image to a form of its totality that I shall call orthopedic—and, lastly, to the assumption of the armour of an alienating identity, which will mark with this rigid structure the subject's entire mental development.[140]

The alienating identity that Lacan refers to here is directly related to the recognition of the distinction between self and other. When one sees oneself in the mirror, one sees only a look; one cannot get nearer to what one is. Lacan termed this "the infinity of reflection."[141] In other words, one never sees a stable image of oneself, because it is contingent upon the perceptions of others. Lacan's reference to the mirror is both literal and metaphorical. The child, for example, experiences itself through the responses of the mother.

The mirror stage also lays the groundwork for the ego-ideal, which is an image of self formed by others. The ego endlessly strives to live up to this ego-ideal.[142] Grosz explains:

The mirror stage initiates the child into the two-person structure of imaginary identifications, orienting it forever towards identification with and dependence on (human) images and representations for its own forms or outline . . . [and] the ego can be seen as the sedimentation of images of others which are libidinally invested, through narcissism, by being internalized.[143]

In other words, the imaginary anatomy is made up of cultural constructs of biology that are independent of biology.[144]

The imaginary anatomy is a crucial form that enables the subject to distinguish itself from the outside world. In addition,

[b]y partitioning, dividing, representing, inscribing the body in culturally determinant ways, it is constituted as a social, symbolic, and regulatable body. It becomes the organizing site of perspective, and at the same time, an object available to others from their perspectives—in other words, both a subject and an object.[145]

By recognizing a relation of both subject and object, the child is recognizing an externalization of self and positioning him- or herself at a distance to this externalization.

There is also a temporal quality crucial to the mirror stage. According to Lacan, because the child's experience of itself is fragmented, when it begins to recognize a total image, a "gestalt" in the mirror, the child seeks in its past an experience of totality that affirms the mirror image of itself, even if the experience of corporeal totality never existed. Thus, the mirror phase is retroactively imposed on the pre-mirror phase. Simultaneously, the child seeks (anticipates) a desired future identity in the cohesiveness of the totalized mirror image.[146]

To put forward a clarification of the imago, Lacan explains that

the *imago* of the human form . . . between the ages of six months and two and a half years, dominates the entire dialectic of the child's behavior in the presence of his similars. . . . The child who strikes another says that he has been struck; the child who sees another fall, cries. . . . [I]t is by means of an identification with the other that he sees the whole gamut of reactions of bearing and display.[147]

The mirror stage constitutes a period of self-awareness that Lacan also deems a stage of misrecognition. Thus, the child's imago is a misrecognition of the boundaries of its body. Grosz explains:

Lacan claims that the child is now enmeshed in a system of confused recognition/ misrecognition: it sees an image of itself that is both accurate (since it is an inverted reflection, the presence of light rays emanating from the child: the image as icon); as well as delusory (since the image prefigures a unity and mastery that the child still lacks).[148]

In other words, the mirror image is both of the self and of another. The subject identifies with itself as a partial, delayed, and anticipated totality. This is because the internal reality of the subject is only incompletely represented in the mirror image. Thus, the formation of the ego, Lacan states, is contingent upon its positioning between two poles: an *affairement jubilatoir* (affirmative recognition) and a *connaissance paranoiaque* (which is the result of the "split, miscognizing subject").[149] Also important to the recognition/misrecognition of the self as a unified totality (as a bounded body) is the positioning of the self inside of the body, which is always the central point within the mirrored image and which is always at a distance from the self.[150]

The nonlinear time frame that Lacan presents as part of the mirror stage is helpful in understanding Orlan's work, which also needs to be lifted out of the traditional linear before (self) and after (other) image of the cosmetic surgery recipient. Lacan states that the ego is split, divided between self and other, and that a denial of this divide is necessary in order for the subject to represent itself as a unified self.[151] He also emphasizes the determinacy of language (the signifier) in the creation of the subject (individual).[152] This relation is quite complicated. Not only is the unconscious constructed like language, but also the subject is constructed by taking up a position in language between the signified and the signifier in order to establish itself as a subject.

Lacan points out in "The Gaze as Objet Petit A: Anamorphosis" that phenomenologists articulate that what one sees is outside the body—"that perception is not in me, that it is on the subjects that it apprehends." Lacan writes, "*I see myself seeing,*" and takes this observation one step further by establishing that, within this reflexive mode, "as soon as I perceive, my representations belong to me."[153] Orlan further expands the economy of ownership within representation and the gaze. She becomes the representation. It is owned by her as her face is transformed into it. Or is it owned by her? Because the transformation occurs on her face, she can never experience it except through a reflected gaze. It is lost to her as a firsthand representation. She also performs other losses. Her original form is gone forever. Her live performances are impossible to repeat. What are gained are multiple substitutions of facial and body form. I believe that the essence of the experientiality of Orlan's work comes into play within this structure of self-loss and self-gain. Her performances confront questions that psychoanalysts have tried to articulate: What is the connection of the body imago to the body? Do they determine each other?

Freud's narcissistic ego is the manifestation of the subject's ability to recognize part of its body as the object. Merleau-Ponty's explanation of embodiment emphasizes the ability to see and feel parts of one's own body.[154] The homunculus described by Freud and elaborated on by Warren Gorman, in his *Body Image and the Image of the Brain*, is also not of the whole body. Gorman's point is that the brain is missing from the homunculus (the self-imago), because it can be neither seen nor felt.[155] In Lacan's essay on the mirror stage, he articulates the complexity of the relationship between the body and the psyche, which is contingent on one's perception of oneself via a reflection in a mirror or through the feedback of the mother.

Looking inside the Human Body

> I read the texts for as long as possible during the operation, even when they are operating on my face, which during the last operations gave the impression of *an autopsied corpse* that continued to speak, as if detached from its body.
>
> —Orlan, "Conference" (emphasis added)

> The beautiful in nature is connected with the form of the object, which consists in having [definite] boundaries. The sublime, on the other hand, is to be found in a formless object, so far as in it or by occasion of it *boundlessness* is represented, and yet its totality is also present to thought.
>
> —Immanuel Kant, *Critique of Judgment*

A historical link exists between Orlan's performance surgeries and the anatomical dissection theaters of the Renaissance. Both were publicly performed outside the exclusive domain of the medical and scientific arena, and *both theaters were designed to draw the gaze of the spectator into the body.* While viewing Orlan's *Omnipresence,* I could not help but recall textual accounts of the Renaissance anatomy theaters, medieval and early Renaissance renderings of "autodissection," and Renaissance paintings documenting anatomists at work carefully dissecting a body (e.g., Rembrandt's *The Anatomy Lesson of Dr. Nicolaes Tulp*).

A macabre quality hangs over the spectatorial dimensions of theatrically performed body viscera. The taboos disturbed include violating the body to view that which should remain invisible and the obliteration of individual identity, if we accept that recognition of an individual, an ontological being, is related to recognizing the other as a reflection of self. Cutting open the human body for the purpose of looking inside shatters any perception of completeness—the body is no longer a contained individual body. The skin, as container, is violated as such, with the result that the body appears to overflow its bounds, to transgress its *self.* With regard to the representation of the grotesque body, Mikhail Bakhtin writes:

> Thus the artistic logic of the grotesque image ignores the closed, smooth, and impenetrable surface of the body and retains only its excrescences (spouts, buds) and orifices,

only that which leads beyond the body's limited space or into the body's depths. . . .
The grotesque image displays not only the outward but also the inner features of the
body: blood, bowels, heart and other organs. The outward and inward features are
often merged into one.[1]

The merging of the outward and inner features into one offers an impossibility of
viewing the other except as the monstrous other, that which is boundless, chaotic,
uncontained, and therefore unrecognizable. In this respect, even when exposed, the
interior of the body resounds with the essence of invisibility.

Orlan's surgical reincarnation may reveal something to the artist about her body
and body of work that we, as other, cannot know. What we can know, as witnesses
there in front of the flayed body, are the shapes, colors, movements, and textures
inside the body that we have but do not see. Our interiors remain interior. The inte-
rior of the body, like female genitalia, is the recipient only of the impossible gaze—
that gaze which is mythologized in the figure of Medusa (Figures 10 and 11). Richard
Selzer explains: "The sight of our internal organs is denied us. To how many men is
it given to look upon their own spleens, their hearts, and live? The hidden geography
of the body is a Medusa's head, one glimpse of which will render blind the presump-
tuous eye."[2]

Perseus, unable to gaze directly upon the grotesque head of Medusa, was given a
polished shield by Athena. By regarding only the refracted image of Medusa, he was
able to decapitate her and place her dreaded head in a bag, its powers to turn men to
stone still intact. Medusa, who represented divine female wisdom and female power,
was the serpent-goddess of the Libyan Amazons. Turned into a Gorgon by Athena for
claiming to possess more beauty than the goddess, Medusa became part of the Triple
Goddess (all that has been, is, and will be). Medusa's specific function was that of
the Destroyer, and simultaneously she represented the Future (all that will be). As the
Future, who always wore a veil, and as the Destroyer, or Death, she claimed "[n]o
mortal . . . able to lift the veil that covers me."[3] The aegis of Athena, made from the
flayed skin of Medusa and adorned with Medusa's head, offered a form of protection
to those upon whom Athena bestowed it.[4] Also, Medusa's moon blood, which was
drawn from veins in her left side (which had the power to raise the dead) and right
side (which had the power to destroy whoever drank it) was given to Aesculapius, the
mythical founder of surgery.[5]

In *The Body Emblazoned*, Jonathan Sawday elaborates on the connection of Medusa
to the flayed and fragmented body:

[T]he attributes of the Medusa—blood, head, and skin—are emblematic of a frag-
mented and dispersed body-interior—a profoundly ambivalent region—whose power
can be somehow harnessed for good or ill. . . . Medusa is the archetypal expression
of body-fear, and one that appears to be linked to our ideas about gender rather than
a common identity which transcends sexual difference.[6]

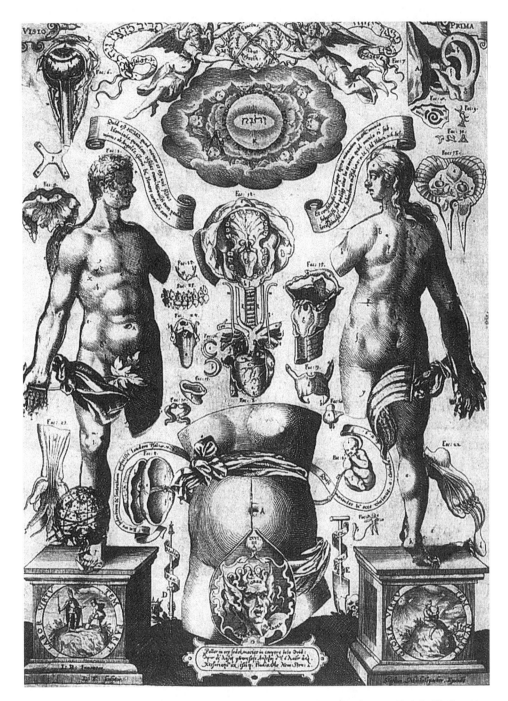

Figure 10. Johann Remmelin, illustration from *Catoptrum microcosmicum* (Augsburg, Germany: Typis Davidis Francki, 1619). Reprinted by permission of the Houghton Library, Harvard University.

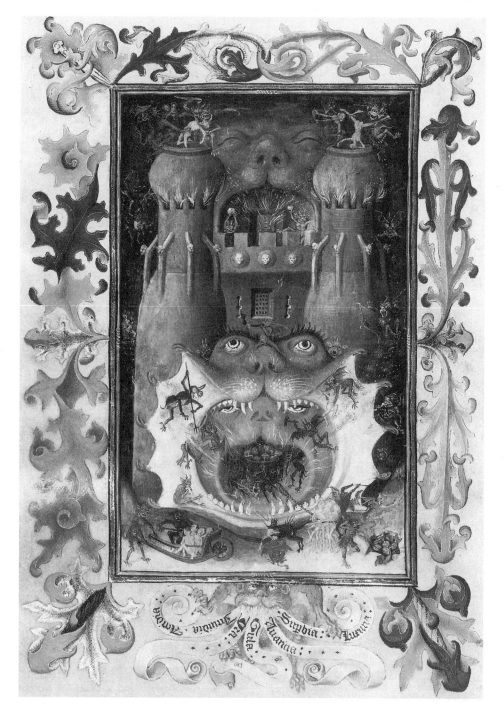

Figure 11. "Hell Mouth," from *The Book of Hours of Catherine of Cleves,* Utrecht, Netherlands (ca. 1440). Courtesy of the Pierpont Morgan Library, New York. M.945, f. 168v.

There is a history of the female body as the locus of gender-determined fears. In premodern cultures, the womb was thought to possess a free will, which induced it to wander throughout the female body. Considered a separate creature, the womb migrated toward the mouth when not regularly satiated by the moisture left through sexual intercourse with a man. According to the ancient Egyptian "Kahun Medical Papyrus" (1825 BC), the symptoms of this migration—for example, shortness of breath—were treated with aromatherapy:

> Examination of a woman who is ill from her womb wandering
> You should say of it "what do you smell?"
> If she tells you "I smell roasting"
> You should say of it "it is wrappings (?) of the womb"
> You should treat it by fumigating her with whatever she smells as roast.[7]

Plato espoused the belief that the womb was a separate animal that wandered, and until the first century AD a woman was regarded as relatively insignificant in comparison to her migrating uterus.[8] Soranus of Ephesus (AD 98–138) countered the theory of the wandering womb and surmised that violent constrictions of the uterus caused hysterical symptoms previously thought to be caused by the migrating womb.[9]

The inferiority of woman in the ancient world was also heavily supported by the fact that she was deemed as having lesser heat than men had. Fire (hot and dry), air (hot and moist), water (cold and moist), and earth (cold and dry) constituted the four elements of the terrestrial sphere. The human body had four humors that reflected these qualities: blood (air) was hot and moist; phlegm (water) was cold and moist; yellow bile (fire) was hot and dry; and black bile or melancholic humor (earth) was cold and dry. Good health was contingent on balancing these four elements, although there was a hierarchy among them. Because heat was the immortal substance of life, things hot and dry were superior to things cold and moist. Since everything in the universe was considered to have a temperament (which also determined sexuality), things hot and dry, such as the sun, were masculine, whereas things cold and moist, like the moon, were determined to be feminine. Masculinity and femininity were determined not by the sexual organs but by the mix of these elements.[10] Aristotle (384–322 BC) further determined that the male caused movement and the female was subject to movement; therefore, the nature of the earth was female and the heavens and the sun male.[11] Galen (AD 129–199) determined that heat was also the property that shaped the male and female genitalia:

> Now just as mankind is the most perfect of all animals, so within mankind, the man is more perfect than the woman, and the reason for his perfection is his excess heat, for heat is Nature's primary instrument. . . . [T]he woman is less perfect than the man in respect to the generative parts. For the parts were formed within her when

she was still a foetus, but could not because of the defect of heat emerge and project on the outside.[12]

Thus, woman lacked the heat to externalize her genitals and become man; her reproductive system was an internalized version of his. Moreover, the invisibility of her genitals and womb rendered her suspicious, because she was anatomically constructed with secretive body parts.

Galen's theory, influential until the eighteenth century, is referred to by contemporary scholars Londa Schiebinger and Thomas Laqueur as the "one-sex theory."[13] Juan Valverde's rendering of female genitals (appropriated from the illustrations in Andreas Vesalius's *De humani corporis fabrica*) clearly illustrates how this one-sex theory was directly correlative (Figure 12). The neck of the womb was the penis turned inward, the bottom of the womb was the scrotum inverted, the ovaries were the testicles, and women produced sperm, just as men did. Laqueur interprets the one-sex theory as proof for these anatomists that "there really were no women after all."[14] He notes that, although the two-sex model became prominent during the Enlightenment,

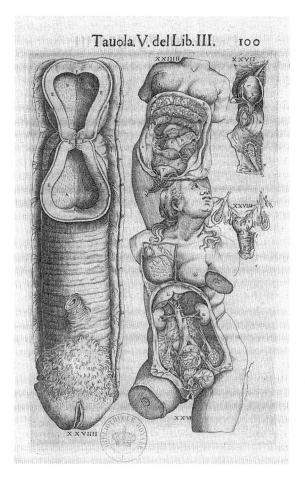

Figure 12. Juan Valverde (d. 1560), *Anatomia del corpo humano*, Rome, A. Salamanca and A. Lafreri (1560). Adapted from Vesalius's *De humani corporis fabrica*. Rare Book Department, Résac. Fol. Ta. 43. F. 64 (218 × 153 mm). Bibliothèque nationale de France.

the one-sex model did not disappear.[15] Even in the pursuit of absolute objective truth, the historical construction of the body as documented by Galen is what was seen and frequently verified.

THE ANATOMY THEATER: EVE

Medusa was not the only mythological figure to represent fear of the secretive female anatomy. Sawday writes that, by the time of the Renaissance, the dissection of the female body was not done exclusively to determine biology. It was also done explicitly to discover the underpinnings of the rebelliousness of woman, as demonstrated in Eve's "death act."[16] So, when confronted with the dissected body, the previously invisible became visible, and the key to woman's rebelliousness against God, man, and destiny was believed to be perceptible within her body. As Sawday suggests, every woman on the dissection table became an Eve and every man an Adam:

> To be an Eve, however, was very different from being an Adam within the patriarchal structure of early-modern culture. If the Renaissance anatomy theatre, in its modes of ritual and representation, offered the suggestion of redemption to the male cadaver, what it offered to the female was the reverse: a demonstration of Eve's sin, a reinforcement of those structures of patriarchal control which, so the argument ran, were necessary to avoid a repetition of that first act of rebellion in the garden of Paradise.[17]

The dissection of the body had far-reaching implications that went way beyond the scientific domain and deeply into the subjective moral and ethical realms guided by Christianity and the law. For example, the frontispiece to Vesalius's *Fabrica* portrays Vesalius as an anatomist attending to the corpse of a woman whose lower abdomen has been flayed (Figure 13). He is surrounded by a large group of men crowding in on him to see the corpse.[18] It is not insignificant that the figure being dissected is female, the onlookers male. Art is the mediator of this scientific illustration in which the male observes and the female is observed.[19] The illustration renders a Neroesque triumph of revealing the womb. Remember that Nero, emperor of Rome (AD 54–68), after murdering his mother, Agrippa the Younger, had her body cut open in order to see "where he had lain" (Figure 14).[20] Now Vesalius, in the name of science, performs this gesture. What is striking about Vesalius's unveiling of the womb is that he validated and illustrated the one-sex theory Galen wrote about in the second century AD.[21]

SELF-DISSECTION: WOMAN AND HER IDENTITY AS DETERMINED BY HER BODY

There is an illustration from *Carpi commentaria* (1521), by Jacopo Berengario da Carpi (a.k.a. Berengarius) that illustrates the notion that woman's identity is determined by her womb (Figure 15). Here the female figure is standing on the floor next to a sculpture pedestal, which she appears to have just left. By stepping off the pedestal, she has

Figure 13. Andreas Vesalius, title page to the first edition of *De humani corporis fabrica* (1543). Courtesy of Dover Publications, Inc.

made a transition from art into life. She holds a draped fabric in her left hand high above her head. The fabric flows down behind her body, framing it. Her body weight is carried on her right leg and foot, as her left foot rests on a stack of books, indicating a shift from the sculptor's pedestal to the texts that contain classical anatomical knowledge. It is significant that these texts are present, but they are not being celebrated.

The woman's abdomen is flayed, but her uterus and vagina have been removed from her body and placed on the sculpture pedestal, indicating deference to these body parts as those that identify the female body. For emphasis, her right arm and hand extend to point to them. But this is not all. The fabric that flows around her also

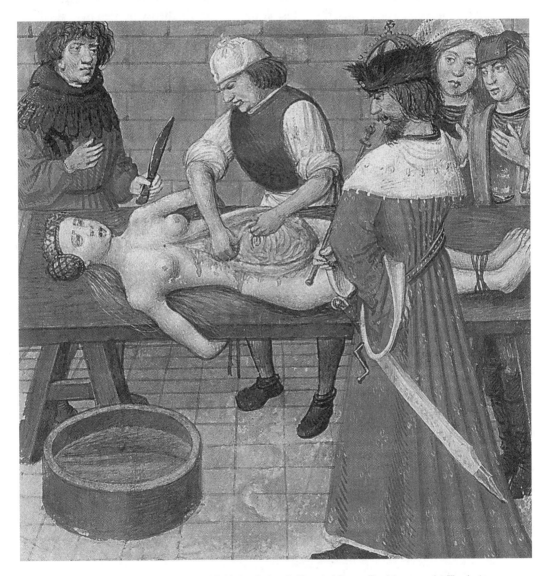

Figure 14. *Nero Watches with Curiosity as His Mother Agrippa Is Dissected*. From a Flemish manuscript (illuminator unknown) of *Le roman de la Rose* (ca. 1500). BL, Harley MS 4425 f. 59. Reprinted by permission of the British Library.

envelops her. Given that the illustration is about the womb, the fabric might be read as a metaphorical reference to the inside of the womb; then the figure would be encased in the womb while having divested her body of it. What would this mean? Sawday determines that the draped fabric that falls behind the figure in this image symbolizes the figure emerging or giving birth to herself. She appears to be revealing her body as her identity. She confirms her anatomical purpose—to house the womb. Sawday also points out that, by exposing the uterus for the anatomist to examine, the image means to demonstrate the primacy of ocular evidence over the written word.[22] However, in spite of Berengarius's belief in ocular verification, the image suggests neither accuracy nor science. It is interesting to note that the vagina on the sculpture stand is in the shape of a penis, thus illustrating the one-sex theory posited by Galen. Prior to the eighteenth century, when the reproductive organs began to be perceived as we now understand them, there was only one sex, that of male.

Figure 15. Jacopo Berengario da Carpi, *Carpi Commentaria cum amplissimis additionibus super Anatomia Mundini* (Bologna: J. de Benedictis, 1521). Wood engraving. Rare Book Department, Résac. 4. Ta. 5f. 226v (150 × 90 mm). Bibliothèque nationale de France.

Complementing the one-sex theory was the belief that upon conception the male contributed form and movement and the female contributed only matter.[23] Susan Bordo points out in *The Flight to Objectivity* that, in the years between 1550 and 1650, there existed "a virtual obsession with the untamed natural power of female generativity [as opposed to sexuality] and a dedication to bringing it under forceful cultural control."[24] Witch hunts aided in eliminating female healers and midwives, placing the woman's medical body in the hands of the masculine scientific and medical professionals. Women at this time were regarded as mere receptacles for the temporary housing and incubation of already formed human beings, which were "originally placed in Adam's semen by God, and parceled out, over the ages to all his male descendants. . . . [T]iny horses and men were actually 'seen' by mechanist scientists examining sperm under their microscopes."[25] Bordo posits that this masculinization existed as a result of the disintegration of medieval thought, which advocated continuity between all things and intricately linked the human being to nature. The Cartesian aspiration toward pure scientific objectivity, coupled with the perception of the universe as infinite, served to alienate nature as sublime and in many regards unfathomable, certainly alien. Nature was equated with the feminine (e.g., mother earth) and therefore became "other." In this regard, the female (by the Cartesian seventeenth century) was an even more acute reminder of what lay outside of the grasp of man.[26]

The transition between the medieval perception of the body as created in the likeness of God and the post-Cartesian *invention* of the body as machine happened roughly between 1540 and 1640. When Vesalius wrote his *De humani corporis fabrica* (1543), it referred to the body as God's divine creation in his likeness. Vesalius's groundbreaking text depicted the body's interior and included illustrations of flayed figures, classically posed and foregrounded in a rural landscape (Figure 16). Vesalius's flayed "musclemen" acknowledged the inevitability of decomposition.

The moral implications of Vesalius's illustrations proved quite relevant in explaining the role of the anatomist. The appropriation of the classical pose was an attempt to imbue the anatomical figures with dignity and divine spirituality. This affirmed the divinity of the human body as created in the likeness of God while also affirming the divinity of the anatomist's skills.[27] Sawday likens this to a form of propaganda that elicited a divine truth—that viewers expected to be present—in order to validate the new science: "The key to that truth—the endlessly repeated defense—was that the anatomist was not disrupting the body. Rather the body willingly allowed the anatomist to assist the general process of decay and dissolution."[28] The dissected individual, appearing to be a willing participant in the anatomist's project, was subject simply to an assisted form of disintegration, and his or her destiny remained intact.

Most important regarding these images of self-dissection is the implication that figures who can gracefully and willingly peel back their skin in order to reveal their interiors are literally interpreting the Greek and subsequently Christian philosophical impetus to self-examination. Foucault points out that the Greek *epimelesthai sautou* ("to take care of yourself") that was one of the main principles for conduct in both

public and private life led to the Delphic principle *gnothi sauton* ("know yourself"). To know oneself was technical advice when in consultation with the oracle. It literally meant "Do not mistake yourself for a god."[29] Foucault goes on to suggest that an inversion of these two principles occurred in Western culture, activated by a Christian belief system that states that the idea of giving oneself more care than anything else is immoral because it implies an escape from the rules.[30] The Delphic and subsequent Christian (including Catholic and Calvinist) *nosce te ipsum* ("know thyself") requires that one scrutinize one's behavior and thoughts and acknowledge and disclose faults to either God or those in the Christian community (i.e., through confession or illumination). It also requires penance, a gesture of self-disavowal.

It is not far-fetched to link the figures of self-dissection to a penitential message that asserts self-knowledge and a looking inward to the simultaneous body and destructive propensity of the martyred saint. Willing participants in the investigation of the interior of the body, the self-dissection figures metaphorically investigate the inner self while simultaneously renouncing the material body by not acknowledging its

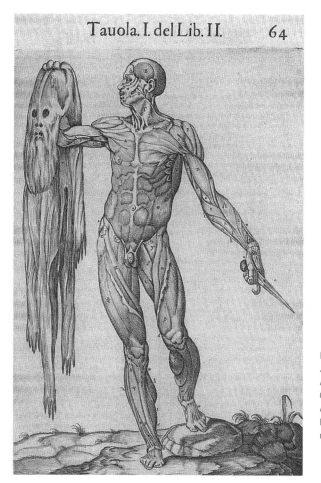

Figure 16. Juan Valverde (d. 1560), *Anatomia del corpo humano*, Rome, A. Salamanca and A. Lafreri (1560). Originally in Vesalius's *De humani corporis fabrica*. Rare Book Department, Résac. Fol. Ta. 43. F. 64 (218 × 153 mm). Bibliothèque nationale de France.

painful demise. Their gestures can be likened to images of saints whose bodies are being mutilated. For example, in the illumination *The Martyrdom of Saint Agatha* (ca. 1300), Agatha's breasts are being cut off (Figure 17). But the saint's expression is serene, her posture almost provocative, an indication that her vision of God protects her from pain, fear, and humiliation. The martyrdom of the saint occurs at the intersection between sovereign authority and divine intervention. Charles Estienne's image of auto-dissection portrays an overtly dramatic and provocative image of female sexuality (Figure 18). The woman is theatrically posed, her arm above her head twisting back over her right shoulder as though she is about to fall back on the bed under her. Her legs are spread open in a suggestive way, her abdomen is flayed—uterus and vagina exposed. She rests her left foot on a wooden chest, an object of containment, possibly to indicate the body as container, but one that has just been opened and perhaps may again

Figure 17. Detail from *The Martyrdom of Saint Agatha* (illuminator unknown), from *The Martyrdom of Saint Agatha, Saint Agnes, Saint Cecilia, Saint Lucy, Saint Catherine* from the *Ruskin Hours*, France (ca. 1300). Tempera colors, gold leaf, and ink on parchment bound between wood boards covered with dark red leather; leaf is 10³⁄₈ × 7¹⁄₄ inches. Courtesy of the J. Paul Getty Museum, Los Angeles.

be closed. This image emphasizes sexual identity and can be spoken of in terms of Eve's allegory: the provocative nature of woman is directly linked to the fact that her genitals are contained inside her body.

Paradoxically, Stefan Lochner's image of *The Martyrdom of St. Bartholomew* (ca. 1430) depicts a man merely tolerating the agony of being flayed alive (Figure 19). This image is peculiar in its rendition of torture. Bartholomew is being subject to a torturous death that also robs him of his identity. St. Agatha's sexual identity is removed, but her body is merely partitioned, also an indicator of saintly hagiography. St. Bartholomew's torture, by contrast, embodies all of the horror inherent in the dissection of the body. Unrecognizable without flesh, the flayed, dissected body loses its identity. In this image Bartholomew looks upward, but the hideousness of his face and its expression of horror seem to project the realization of his demise.

Another figure by Estienne (1545) reveals the monstrous result of dissection (Figure 20). A man's body has been flayed and the skin is now tacked together in various

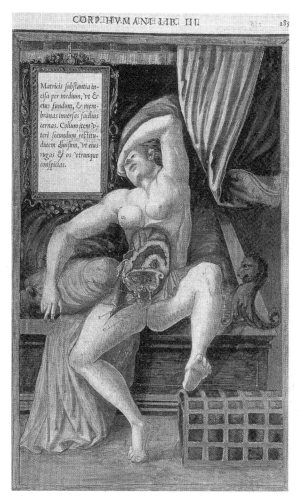

Figure 18. Charles Estienne, *De dissectione partium corporis humani libri tres* (Paris: S. De Colines, 1545). Rare Book Department, Résac. Vélins 512. p. 285 (273 × 177 mm). Bibliothèque nationale de France.

places to hold it on. But it fits badly and he holds open part of his chest skin, revealing a cavernous interior where his heart once was. The mouth and neck remain flayed, and unidentifiable parts are indicated with lines and letters. This figure clearly understands mortality. He looks to be in agony, and it is unclear whether he has taken bites out of himself to facilitate his autodissection. The building he sits on has partially collapsed under his weight, a metaphor for the mortality of his corporeal existence.

TRADITION

Egyptian physicians were much sought after in the ancient world, despite the fact that little was added to their canon of knowledge after the First Intermediate Period (about 2000 BC). The mummifying process required dissection, but it does not appear to have greatly informed Egyptian knowledge or understanding of the inner workings of the human body. However, as early as 3000 BC there is evidence of brain surgery in papyrus writings in Egypt, where the word *brain* is used for the first time in any language. There is also evidence that Egyptian physicians made the connection between pulse and heart, but without understanding the circulation of the blood.[31]

Between the sixth century BC and the first century AD, perceptions of the anatomy evolved alongside philosophical perceptions of the cosmos. Philosophically, intimate examination of the human anatomy allowed one to investigate nature's, and God's, secrets.[32] The earliest evidence of Greek medicine (like that of Egypt and Mesopotamia) reveals that disease was perceived to be superstitiously, magically, and

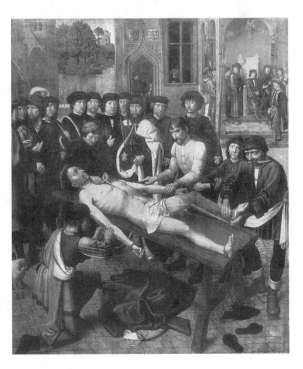

Figure 19. Stefan Lochner, *The Martyrdom of St. Bartholomew* (ca. 1430). Städelsches Kunst Institut, Frankfurt.

ontologically based; it was caused by some sort of external entity, initially separate from the body, that infiltrated the body and made it ill. The response to this was religious medicine; priests catered to the ill, who turned to Gods and demigods for cures.[33]

In the sixth century BC a group of natural philosophers from the Ionian city of Miletus began to ask rationally based questions as a means to explain the environment with regard to its physical properties, rather than the supernatural. Anaximander of Miletus (ca. 550 BC), a pre-Socratic philosopher, presented his theory of the cosmos as self-transformation of the infinite—an infinite, living, extended being. His appeal was to symmetry and balance; for example, the earth occupied the center of the universe completely symmetrically and therefore would never move from its location.[34] The only pre-Hippocratic medical writings that have survived are those of Alcmaeon (fifth century BC). Like Anaximander, Alcmaeon appropriated a belief based on the balance of forces and symmetry. He rejected the supernatural belief that disease was wrought by invading external entities, and formed a hypothesis that disease was caused

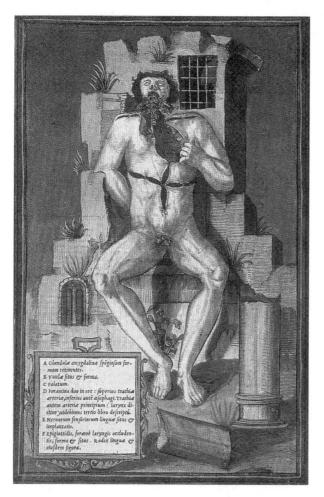

Figure 20. Charles Estienne, *De dissectione partium corporis humani libri tres* (Paris: S. De Colines, 1545). Rare Book Department, Résac. Vélins 512. p. 230 (273 × 178 mm). Bibliothèque nationale de France.

when the body's natural equilibrium was upset. Empedocles, another pre-Socratic philosopher (ca. 495–435 BC), combined Alcmaeon's notion of balance with his four-element theory, which stated that earth, air, water, and fire were the four elements of all matter.[35] Following suit, Empedocles explained that the composition of human blood and flesh was the equal mixture of these four world components and that whenever disequilibrium occurred among them, illness ensued. This rationalism was appropriated into the Hippocratic *Corpus*, a compendium of writings from the fifth and early fourth centuries BC, also written in an Ionian dialect, some of which are directly attributed to Hippocrates (ca. 430 BC). These theories eventually evolved to define the body's four humors: blood, phlegm, black bile, and yellow bile, which needed to be balanced to maintain good health. The four-humor theory was the foundation of Galenic medicine and was widely believed to be true until the middle of the eighteenth century.[36]

According to Galen, Diocles (a contemporary of Aristotle's school) was the first to write a book on anatomy and encouraged animal dissection to study anatomy. During the third century BC, Greek medicine was transferred to Alexandria, where two Greeks began systematic dissections and vivisections of criminals supplied by the government. As a result Herophilus and Erasistratus described the anatomy with enough accuracy to aid Galen in his research four centuries later. Throughout the history of anatomy, Herophilus and Erasistratus are referred to as either scientific heroes or despised, barbaric butchers. According to James Longrigg, by the second century BC dissection and vivisection were again outlawed in Alexandria.[37] However, Andrea Carlino states that dissection continued in Alexandria for a number of centuries, and quotes Galen to support this:

> It must be your assignment and commitment not to learn the form of each bone only from books, but rather to become an assiduous eyewitness observer of human bones. This is easy enough in Alexandria, since the physicians of the place offer to their students teaching accompanied by visual observation. If for no other reason, you must find a way to get to Alexandria at least for this.[38]

Carlino points out that, previous to this time, human dissection was not even thought to be possible. Thus, anatomy was discerned in two ways: first, by assuming an intrinsic link between exterior and interior that allowed one to determine the morphologies of internal structures and organs; and, second, by the dissection and vivisection of animals, which was widely practiced beginning in the fifth and fourth centuries BC.[39] One example of the external form of the body revealing its internal structure: Aristotle suggested that by examining live human bodies that were emaciated, one could clearly observe the vascular system, where "the blood vessels are as visible as the veins of leaves."[40]

Aristotle was involved in the classification of animal species by accumulating in-depth knowledge of the similarities and differences between anatomical structures.

For him dissection was an essential tool. But, in his *De partibus animalium*, Aristotle raised an issue that was later paradoxically used (by the Alexandrian empiricists) to refute the importance of dissection. Aristotle claimed that the body of a dissected dead animal could in no way equal that of a living one, because in a dead anatomy one could not observe its vital spirit.[41] So Aristotle performed vivisections on living animals as well. The empiricists found dissection useless because one could not observe the mechanics of the body, and found vivisection to be morally reprehensible and a waste of time, given that death would probably occur upon the initial incision.[42]

Although previous to Aristotle animal dissection was sporadically practiced, Aristotle was the first to perform animal dissections as a methodology to study anatomy and to discern the differences and similarities between animal species.[43] Carlino points out that Aristotle did voice disgust attributed to the act of dissection: "[I]t is in fact not without a great disgust that we observe what the human species is composed of: blood, flesh, bones, veins and similar parts."[44] However, Aristotle defended the killing of animals for the pursuit of knowledge: "We must not feel an infantile repulsion toward the study of the most humble living beings. There is something marvelous in all natural things."[45]

Aulus Cornelius Celsus (42 BC–AD 37) provides a history of anatomy in his *De medicina*, in which he outlines the conflicting views of the empiricists and the dogmatists (rationalists) regarding the dissections done in Alexandria in the third century BC. There are no surviving documents that indicate why at this time dissections and vivisections were performed on the human anatomy for scientific purposes. The arguments waged for and against dissection consider religious taboos and veneration of the dead, but also the fear of filth and disease, the disgust of the corpse, and the practicality of both dissection and vivisection. The empiricists focused on the medicinal practices of healing disease, based on the practice of balancing the four humors. Therefore, in practice, dissection would be valued only if it were to examine the organs that produced and/or contributed to the distribution of these humors throughout the body. The dogmatists, of whom Celsus was one, believed that a concrete knowledge of the anatomy was required to support healing practices.[46] Celsus writes that it is important to unveil "those parts which nature had previously concealed." And of the organs it was important to know "their position, color, shape, size, arrangement, hardness, softness, smoothness, connection, and the projections and depressions of each, and whether anything is inserted into another thing or whether anything receives a part of another into itself. . . . Therefore it is necessary to dissect the bodies of the dead and to examine their viscera and intestines." But Celsus continues: "Herophilus and Erasistratus, they say did this in the best way by far when they cut open men who were alive, criminals out of prison, consigned to them by kings."[47] Within live bodies one could observe the beating heart, working lungs, blood flow, and so forth. Following Aristotle's belief in rigorous inquiry, Celsus believed vivisections to be much more useful as an epistemological tool.

After Galen and Aristotle, scholarly contributions to anatomical science and

medicine halted until the early Renaissance. Dissection, through to the early Renaissance, was viewed as a tool for teaching. If it took place at all in medical schools, it happened so that students could memorize the sizes, shapes, and placement of organs already mapped out in texts. The dissected body was a verification of already written texts and not an investigative tool for further research and discovery.[48]

During the Middle Ages anatomy was derived chiefly from the texts of Galen, Hippocrates, and Aristotle, but not directly. Except in a few centers—Constantinople, Salerno, and maybe Montpellier—Greek had become an almost extinct language, so interpretations of these texts had been greatly filtered as they were passed down over the centuries. It is because of the Arab fascination with Greek philosophy that the Greek texts were preserved and eventually translated into Arabic. Early in the ninth century a foundation, called the House of Wisdom (*bayt al-hikmah*), which also housed its own library, was established in Baghdad. Its purpose was to support and promote the translation of scientific texts. Hunayn ibn Ishāq (d. 873) translated almost all of the Greek medical books, half of Aristotle's writings, and a Greek version of the Old Testament.[49]

The process of translating Arabic into Latin began in the last three decades of the eleventh century, when a North African monk named Constantine (at Monte Cassino in southern Italy) prepared Latin versions of many Arabic-language medical works (some originally Greek), such as Galen's *Ars parva* and his commentaries on Hippocrates' *Aphorisms* (400 BC) and *Prognostics* (400 BC), and Hunayn ibn Ishāq's *Introduction to Medicine*.[50] Avicenna's eleventh-century medical encyclopedia, *Canon*, was published in many editions and widely used in European medical schools for about four centuries. These texts were derivative of the supremely authoritative writings of Galen, Aristotle, and Hippocrates. The belief in these texts as arbiters of truth is demonstrated in the following incident described by both J. Playfair McMurrich and Andrea Carlino. Apparently, when Vesalius discovered in the sixteenth century that Galen's anatomical knowledge had been discerned largely through the dissection of animals, chiefly monkeys, the undeterred faith in the infallibility of Galen's texts propelled at least one Galenist to determine that the human body had evolved and changed between the time of Galen's observations and those of Vesalius.[51]

The first recorded autopsy occurred late in the thirteenth century in Bologna, performed by the surgeon William of Saliceto on the marchese Uberto Pallavicino's nephew, who had supposedly been poisoned. In 1275 Saliceto published *Cyrurgia*, the fourth book of which was dedicated to Galenic anatomy. Its contents were very similar to those of medieval manuscripts, and the use of Arabic terminology indicated it was based on Arabic translations.[52]

In 1316, in Bologna, Mondino dei Liuzzi wrote an anatomy textbook that remained widely used for more than two centuries. In it the author states that in 1315 he performed autopsies on two female subjects. The format of his book reflects this; it is a manual describing how the autopsy is performed, not the customary theoretical text

describing the anatomy. However, Mondino does not make any new observations and repeats all of the errors recorded in the Arabian treatises. But McMurrich points out that the format of Mondino's text provoked more interest in the study of anatomy. It is also interesting to note that Mondino's text is one of the sources Leonardo initially used.[53]

During the fourteenth century autopsies occurred in both Bologna and Padua.[54] In his *Grande chirurgie*, Guy de Chauliac, a great surgeon who practiced in Montpellier, claims that his Bolognese instructor Bertucci performed many human dissections, also termed anatomies, which he divided into four lessons: "In the first he considered the nutritive organs because they perished soonest, in the second the spiritual organs, in the third the animal organs, and in the fourth the extremities."[55]

Several things here are important to note regarding the obtainment of bodies to dissect and the view of both church and state regarding the act of dissection. On the question of anatomies, there is no known general enactment of the church.[56] Thus, the historical assumption that anatomies were officially prohibited by the church is false. Regarding the obtainment of bodies, however, there were some laws. The bull of Boniface VIII issued in 1300 read, "Those eviscerating the bodies of the dead and barbarously boiling them in order that the bones, separated from the flesh, may be carried for sepulture into their own country are by the act excommunicated."[57] McMurrich points out that although this may have been interpreted by the Parisians to be a ban on anatomies, the Italians did not interpret it this way. He also relates that Alessandro Benhedettim (a contemporary of Leonardo) wrote in his *Historia corporis humani* (1497) that anatomists did prepare skeletons by boiling them, apparently without fear of excommunication.[58]

The Great Council of Venice, in 1368, decreed that an anatomy should be performed once a year in the hospital of Saints Peter and Paul for the benefit of the surgeons and physicians, and in 1376 a similar decree was applied to the university in Montpellier.[59] An illumination from Guy de Chauliac's *Grande chirurgie*, titled *A Lesson in Dissection at the Medical School of Montpellier* (1363), depicts an autopsy being performed (Figure 21). One scholar holds a book while the others looking on discuss what is being revealed.

It is clear that in Bologna and in Padua anatomies regularly occurred in the fourteenth and fifteenth centuries. There are several points to be made here, however, that allow one to visualize the circumstances under which they occurred. At the onset of the universities (the University of Padua was founded in 1222), the students formed guilds and chose their masters, rather than the other way around (the University of Paris eventually became the prototype for the masters' guilds). Instruction was given via personal arrangement, and often it occurred in the home of the master. In the earliest years of the fourteenth century, the acquisition of a body for dissection was the responsibility of the student. Eventually, in 1442, a plan was initiated whereby the podesta of Bologna had to furnish two cadavers for dissections. The condition was that they had to be obtained from a location at least thirty miles from Bologna. In

1495 a similar act was put into play in Padua, where the bodies of one male and one female had to be given annually to the university for dissections.[60]

LEONARDO

McMurrich explains that during the Middle Ages the trade guilds gained enormous power and, as a result, artists, needing pigments from apothecaries, were placed in the same guild as surgeons, physicians, and apothecaries. Because of this professional liaison, McMurrich argues, it is highly probable that Leonardo performed dissections in at least one hospital in Florence after his arrival there in 1470.[61] Charles D. O'Malley and J. B. de C. M. Saunders suggest that he may have initially acquired a cadaver from the Florentine hospital Santa Maria Nuova but that there is no real evidence that he participated in medical school dissections.[62] Later Leonardo noted that he had dissected the body of a two-year-old girl. There is vast evidence that Leonardo also performed numerous dissections on cows, because, particularly in his embryology, he wrongfully places parts of the cow placenta into the human. Leonardo continued his anatomical studies in Milan and later in Rome, at the Ospidale di Santo Spirito. But in Rome a German mirror maker (who shared the same patron as Leonardo) began to spread rumors that Leonardo was practicing unsavory behavior with regard to cadavers. Leonardo fell into disfavor with the pope and was barred from Santo Spirito.[63]

Even though McMurrich implies that there must have been some knowledge within the medical community that Leonardo was creating the first well-rendered, true-to-life images of the parts of the body, it is peculiar that McMurrich doesn't cite Giorgio Vasari, who describes not only Leonardo's images but also their immediate whereabouts:

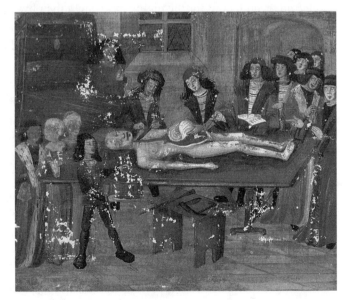

Figure 21. Anonymous, *A Lesson in Dissection at the Medical School of Montpellier*, from the *Grande chirurgie* of Guy de Chauliac (1363). Ms. 184, f. 14v. Musée Atger, Bibliothèque de la Faculte de Medecine, Montpellier, France. Copyright Erich Lessing / Art Resource, NY.

He [Leonardo] then applied himself . . . to the anatomy of man assisted by and in turn assisting in this research, Messer Marc' Antomil della Torre, an excellent philosopher, who was then lecturing at Pavia, and who wrote of this matter; and he [della Torre] was one of the first (as I have heard tell) that began to illustrate the problems of medicine with the doctrine of Galen and to throw true light on anatomy, which up to that time had been wrapped in the thick and gross darkness of ignorance. And in this he found marvelous aid in the brain, work, and hand of Leonardo, who made a book drawn in red chalk, and annotated with the pen, of greatest diligence; wherein he showed all the frame of the bones; and then added to them, in order, all the nerves, and covered them with muscles; the first attached to the bone, the second that hold the body firm, and the third that move it; and beside them, part by part, he wrote in letters of an ill shaped character, which he made with the left hand, backwards; and whoever is not practiced in reading them cannot understand them since they are not to be read save with a mirror.[64]

Vasari goes on to explain that a great number of the anatomical drawings ended up in the hands of Francesco da Melzo of Milan, "who in the time of Leonardo was a beautiful body, and much beloved by him."[65] At the time Vasari is writing, da Melzo is an old man and still holds on to the drawings. The implication here is that if the medical community did know about Leonardo's drawings, they were probably not widely viewed. (For an example of Leonardo's anatomical drawings, see Figure 22. The drawings are now in the Royal Library at Windsor Palace.)

With all of the anatomical investigation going on during this time, one has to ask why there were no anatomical discoveries made until those of Vesalius (and Leonardo). First and foremost, the dissections were carried out explicitly to verify already-written texts. And second, even for the highly motivated, the physicality of handling a corpse proved to be an obstacle. Accounts of the conditions of the anatomy theater (even after being highly formalized) shed some light on the actual performances. The duration of the dissections was limited, because there was no way to arrest putrefaction, especially in the warm Italian climate. The anatomy theaters took place, probably in four lessons, over a period of three or four days at the most, during which there were intermissions and prolonged discussions among the attending scholars. And because of the time shortage and the difficulty of separating body parts from one another for the purposes of observation, shortcuts were taken:

Mondino excuses himself for omitting a discussion of the "simple parts" because these were not perfectly apparent in dissected bodies, but could only be demonstrated in those that had been macerated in running water. He was also accustomed to omit consideration of the bones at the base of the skull, because they were not evident unless they had been boiled, and to do this was to sin. And similarly, he omitted the nerves which issue from the spinal column, because they could be demonstrated only

on boiled or thoroughly dried bodies and for such preparations he had no liking. So too, Guy de Chauliac and Berengarius da Capri maintained that the muscles, nerves, blood-vessels, ligaments and joints could only be studied in bodies that had been macerated in flowing or boiling water, or else thoroughly dried in the sun, and there is no evidence that such preparations were demonstrated at the Anatomies.[66]

Also, the anatomy theater ritual was customized. John of Ketham, in *Fasciculus medicinae*, published in Latin in 1493, organized his book to describe the order in which one would proceed through a dissection.[67] An image in the book reveals the

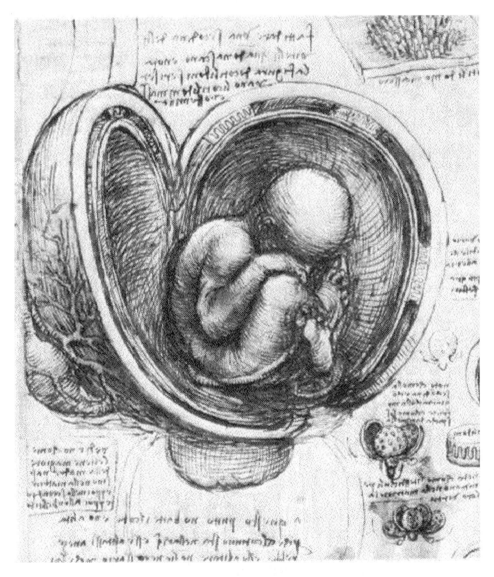

Figure 22. Leonardo da Vinci, *Studies of the Reproductive System* (ca. 1508–9). Pen and ink (two shades) over traces of black chalk, 19.1 × 13.8 cm. RL 1908v. Dover Publications, Inc.

pedantic "quodlibetarian" structure of the anatomy performance (Figure 23), which was as follows: the *lector*, who was placed in a *cathedra*, elevated above and apart from the dissection, either recited from memory or read from anatomical texts that were derived from Galen's *De usu partim corporis humani*. The *ostensor* (demonstrator) translated the lector's recitations from Latin into the vernacular so that they would be understood by the *sector*, who was the hands-on person, most likely either a surgeon or a barber,[68] who would not have understood Latin. In this way the ostensor also instructed the sector regarding the order in which the body parts should be displayed and dissected. The fourth component of the quodlibetarian model was the *disputatio*, the discussion carried out by the onlookers after the dissection and the reading of the text.[69]

By the time Berengario of Carpi published his *Isagogae breves,* in 1522, depictions of the quodlibetarian performance, still intact, show the lector separate from, but at

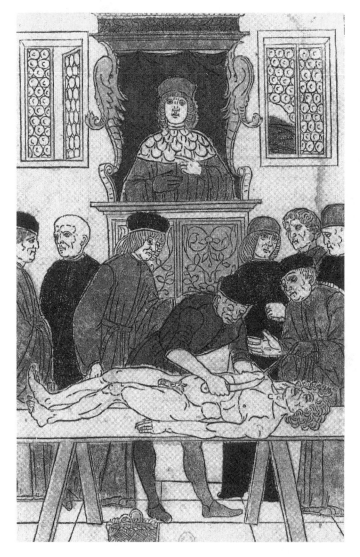

Figure 23. Attributed to Johann von Ketham, *Fasciculo di medicina* (Venice: G. and G. de'Grefori, 1493). Engraving on colored wood. Départements des Estampes et de la Photographie, Eb. 3. a. in-fol. f. f 2v (310 × 200 mm). Bibliothèque nationale de France.

the same level as, the ostensor and the sector. There seemed to be a change of senti-
ment as well. Berengario writes that the good anatomist "does not believe anything in
his discipline simply because of the spoken or written word: what is required here is
sight and touch."[70] This, in fact, reflects the sentiment of Galen. In the early Renais-
sance there were conflicting views regarding the dissection theater. Some argued that
there was no need for it, because the texts that had been relied on for centuries con-
tained all of the knowledge needed and more. The Galenists argued that dissection
was necessary to support the texts. And Vesalius insisted that dissection was essential
for the purposes of investigation and science. He harshly criticized the quodlibetarian
structure of the anatomy theater:

> A detestable ceremony in which certain persons are accustomed to perform a dissec-
> tion of the human body, while others narrate the history of the parts; these latter from
> a lofty pulpit and with egregious arrogance sing like magpies of things whereof they
> have no experience, but rather commit to memory from the books of others or place
> what has been described before their eyes; and the former are so unskilled in lan-
> guages that they are unable to describe to the spectators what they have dissected.[71]

PUBLIC ANATOMIES

Public anatomies were not performed until the beginning of the sixteenth century. Their
development spread quickly throughout the medical centers of Europe—Amsterdam,
Paris, Bologna, Padua, Montpellier, London, and Oxford—where anatomical theaters
were designed and built so that corpses could be dramatically displayed on rotating
wheeled tables:[72]

> The annual public anatomy-theater was set up to accommodate 200 to 300 persons.
> A close study of the expense accounts of the Amsterdam Guild is, I think, reward-
> ing. An anatomy fetched on the average two hundred florins. An exceptionally high
> sum, 315 florins and 8 stuymers, accrued for the dissection of a female. About 50 per-
> cent was pure profit, the excess money was used to finance a sumptuous banquet of
> the guild members and this was followed by a parade. *The show* therefore consisted
> of three parts. The public execution, the public anatomy for which admission was
> charged, and the feast followed by a parade with torches. This was usually an annual
> event that was carried out in the peak of winter, usually sometime around the end of
> January, the anatomy took place at night and the cold allowed it to go on for approx-
> imately five days before the decay in the body made it impossible to work. Men,
> women and any children who could sneak in were allowed to watch.[73]

And specifically regarding women:

> Records show that dissections of female bodies were particularly popular, especially if
> they were pregnant; in that case, the anatomist would have the opportunity to lecture

on the process of embryonic development. The *Anatomie-boek* indicates that female subjects typically brought in more profit and were better attended than the more frequently demonstrated male bodies; this was particularly true during the years that [Frederik] Ruysch served as praelector. . . . Female subjects were often executed prostitutes or thieves; they could also be unmarried pregnant women who had died from syphilis or in childbirth. Subjects also included women hanged for the crime of infanticide.[74]

The male policing of female reproduction most frequently placed women at the mercy of the law. There are indications of women's resistance to the masculine appetite for policing and dissecting their bodies. For example, in May 1658 a woman referred to as "T" was hanged in Oxford for infanticide. Taken by physicians at St. John's College to be dissected, she was found to be still alive. The bailiffs, hearing of her revival, took her out in the middle of the night and rehanged her. The women of the town, upon hearing of this, cut down the hanging tree and "gave ill language to Henry Mallory," the bailiff deemed most responsible for T's hanging.[75]

Public dissections were legally legitimized as the continuation of punishment after death, a literal depersonalization that occurred as a result of the dismembering of the criminal's body. The entire celebration of the annual anatomy was a thorough yet carnal punishment. Francis Barker aptly states: "To execute, to dismember, to eat . . . how much more thorough than this [could] an act of corporeal punishment be."[76] Although there were objections made regarding the barbarism of the public anatomy festival, they were sparse compared to the numbers of participants—audience, surgeons, and criminals.[77] The public dissection points to a vulnerable and agitated moment in history for the body. The body, still perceived as the "fabric of God," was opened in order for sovereign authority to exercise its power to pursue the criminal's flesh even after death: "If the sovereign's power was rooted, ultimately, in God, then the ability of the anatomist to trace the lineaments of the divine in each individual body became an important part of the mechanism by which that power was reinscribed, over and over again, upon society at large."[78] And yet the dissection theater was the precursor of the modern scientific regime of the body. This modern regime of the body, marked also with the writings of René Descartes (1596–1650), activated a system of learning that demanded the primacy of vision and observation still pivotal in modern science. More than that, the dissection theater began the enactment of Descartes's emphasis on observation as sovereign over nature.

Rembrandt's first group portrait and first major commission, *The Anatomy Lesson of Dr. Nicolaes Tulp* (1632), depicts the members of the Guild of Surgeon-Anatomists of Amsterdam dissecting the corpse of the boy Aris Kindt, a criminal who has been freshly executed (Figure 24).[79] Dr. Tulp stands in the central-right foreground of the composition and does not view the corpse, which is supine at a forty-five-degree angle through the center of the canvas. Rather, the doctor's eyes address an audience implicated

outside of the picture-plane. Tulp's right hand holds several arm muscles with forceps. His left hand, thought by Aloïs Riegl in 1902 to be gesturing to the audience, was later described by William Schupbach to be demonstrating the mechanics of the muscles being discussed.[80] Schupbach argues that this is important because it explains the gaze of Mathys Calkoen, the bent-over surgeon directly to the left of Tulp, who appears to have bent over to look closely at the corpse but has just looked up to view Tulp's left hand.[81] More important, Vesalius had previously identified the human hand as one of the most ingenious creations of God, referring to both Galen and Aristotle, who identified the hand, combined with reason, as that which differentiated humans from other species. This would also explain why the three central surgeons in the painting, although extremely experienced, are enthralled with Tulp's demonstration.[82]

In 1639 Casper Barlaeus wrote a poem about Tulp's anatomies, which were intended to reveal the presence of God in humankind.[83] The poem was for the new anatomy theater in Amsterdam, inaugurated in that year:

Evil men, who did harm when alive, do good after their deaths:
Health seeks advantages from Death itself.

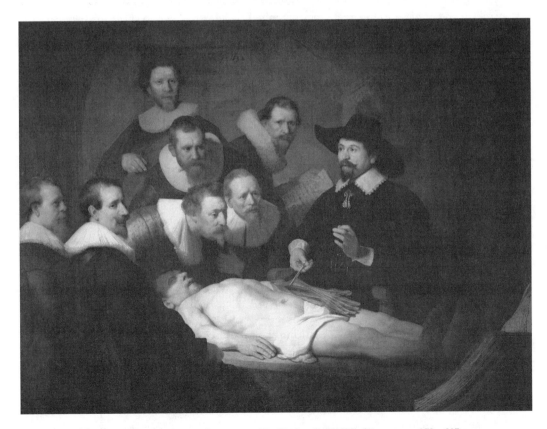

Figure 24. Rembrandt van Rijn, *The Anatomy Lesson of Dr. Nicolaes Tulp* (1632). Oil on canvas, 170 × 217 cm. 3Mauritshuis, the Hague, the Netherlands. Copyright Erich Lessing / Art Resource, NY.

Dumb integuments teach. Cuts of flesh, though dead,
For that very reason forbid us to die.

Here, while with artful hand he slits the pallid limbs,
Speaks to us the eloquence of learned Tulp:

"Listener, learn yourself! And while you proceed through the parts,
believe that, even in the smallest, God lies hid."[84]

The poem reveals a metaphysical emphasis on the human body as the fabric of God. Tulp is celebrated for bringing this element into the civic performances in the anatomy theater. Therefore, Tulp's choice of demonstrating the hand before the viscera makes sense (although it is highly unusual, given that the viscera rot first and therefore need to be removed immediately).[85]

In *The Anatomy Lesson of Dr. Nicolaes Tulp* a number of reactions are represented as occurring simultaneously. Excluding the surgeon at the far left who is in complete profile (because he was later added), Adriaen Slabberaen, the surgeon at the left, looks at an opened book slightly to the left of the corpse's feet. Schupbach notes that the book is almost leaning out of the picture-plane. Thus, Slabberaen looks at the picture-plane, at the book, and in the direction of the beholder.[86] The two surgeons between Slabberaen and Calkoen, one behind the other, clearly look directly at the corpse's arm muscles. Riegl explains that x-rays of the painting also reveal that the list of the names of the depicted surgeons, which is held by the figure directly behind Tulp who looks out at the beholder, was originally an illustration, imitating the illustration style in Vesalius's *Fabrica*, of the muscles of the arm. Thus, this figure initially was verifying Tulp's demonstration. The act of looking at the book rather than at the corpse connotes practical and historical interpretations. It is simply not possible for everyone to see the actual corpse from a close-enough proximity to observe the nuances of the muscles being shown, and thus it is practical to refer to a text. The historical is evident here: that anatomies were done to verify what had already been rendered in texts, peculiarly rendering the body on display symbolically invisible.

The rear figure looks straight out at the beholder, a signifier of baroque intersubjectivity, also reinforced by the distortion and angle of the corpse and the peculiar array of gazes, all of which serve to activate this painting in such a way that the beholder seems to be present in an accidentally chosen locale. In other words, the theatricality of this baroque painting comes from an awareness of the individual viewer as a necessary ingredient both inside the painting looking out and outside looking in. Rembrandt painted this image in the moment. It is composed so that several of the depicted personages respond to us viewers as though we have just interrupted them in midaction. We have just entered their room. They respond to us as we respond to them. One set of observers, therefore, is inside of the painting, and there is a performed interaction between them and the beholder of the painting. Our presence gives reason or rationality and logic to the poses of those portrayed. Our presence also verifies

the primacy of ocular truth, although (as discussed earlier) the text is the actual veri-fier. It is important to note also that because anatomists gained notoriety contingent upon how well they performed anatomies, the performative qualities of the painting that activate all of the participants serve as an advertisement for and a testament to the skills of the anatomist.

In *Neuf visages* (1989), an appropriation of Rembrandt's performative painting cre-ated by the contemporary Japanese artist Yasumasa Morimura, Morimura places his own face inside the faces of each personage in Rembrandt's *The Anatomy Lesson of Dr. Nicolaes Tulp*. He deconstructs this group portrait by creating a multiple self-portrait, re-placing himself inside the faces of others, thereby gaining all perspectives of those inside the painting, including that of the corpse. Partitioning himself into the orator, the observing surgeons, and the corpse, Morimura enacts a peculiar continuation of "I'm looking at you looking at me" and doubles—no, triples—the object of the paint-ing into a reciprocal theatrical event that confuses the audience's identity with those layered in the portrait.

In Orlan's performances the orator, the text, and the subject being flayed are one and the same person. Because of the constant utilization of the camera close-up in Orlan's performances, we have the privileged perspective of seeing into her body as it is performed upon, and, unlike the surgeons in Rembrandt's painting, we remain riveted there in front of the subject, which is also the object of fascination. The spec-tators hear Orlan's recitation of texts that embrace each spectator's own place of sub-jectivity. Lacan's mirror stage, for example, is intended to describe one aspect of the development of the human psyche. Thus, we are all potentially the subjects of his words. Lacan's text therefore aids in the construction of Orlan's feedback loop—the interaction between viewer and subject. To recognize oneself as an activated beholder gives credence to one's experience as a beholder. In other words, one takes note of the effects of the visual and auditory stimuli upon one's self.

NINETEENTH-CENTURY RENDERINGS OF SUPINE, MEDICALIZED WOMEN

Drew Leder, in his essay "A Tale of Two Bodies," makes a very convincing case that medicine is "shaped by the figure of the dead body."[87] By this he means that the diag-nosis of disease is based on the organic damage exposed after death, rather than on the symptoms of the patient while still alive. Leder also equates the treatment of the live patient to that of the corpse:

> The epistemological primacy of the corpse has shaped not only medical technology, but diverse aspects of training and practice. Medical education still begins with the dissection of the cadaver, just as the clinical case ends in the pathologist's lab. In between, the living patient is often treated in a cadaverous or machine-like fashion. We see this, for example in the traditional physical examination. The patient is asked to assume a corpse-like pose, flat, passive, naked, mute.[88]

Leder does not condemn the medical profession for its perception of the live body as a Cartesian machine, but he does identify the dehumanization inherent in this perception of the patient. The term that I use throughout this section to describe the supine patient who is being examined, dissected, or operated upon is *specimen*. Specifically, the specimen is the body whose voice has been bypassed by physicians—bypassed as an unreliable source of information regarding the medical problem at hand. Judith Fryer, in her essay on Thomas Eakins's *The Agnew Clinic* (1889), writes that "the surgical operation is the most perfect way of bypassing the human voice: the patient is anesthetized into total silence; the physician has total control, unlimited possibilities for seeing and knowing."[89] Thus, the posture of the specimen is supine.

Within representation, the corpselike, supine posture indicates powerlessness (because the subject is dead or under anesthesia). Specifically, the female body, as such, can create powerful sexual inferences. In other words, when the female is depicted in this position, the issue of sexuality is immediately significant. The key here is that while the woman is a specimen, she is depersonalized.

As a scientific and medical term, a *specimen* is a sample of a material. It can also refer to one of a species—what exists in *this* body exists in all others of this populace: for example, an ideology, a sexual orientation, a womb. This perspective endorses a tyranny of the same,[90] which does not take into account the particular individual. The reduction of the patient to a specimen is also one upon which scientific research traditionally depends.

The supine and stilled posture of the female medicalized body is present in images scattered throughout the history of Western art. A brief survey of several of these images reveals a fascinating link between the male and the medical gaze upon the female specimen, which doubles as a provocative erotic figure and a flawed and puzzling organism.[91]

Several nineteenth-century images portray gender relations in scientific and medical motifs in which the patient or corpse is a woman and the doctor or scientist is a man. In these images the female body is once again naked, supine, one specimen of the female species.

But first, a story. Bazarov, the main character in Ivan Turgenev's *Fathers and Sons* (1862), is a nihilist ardently involved in science and anatomy. When he falls in love, his initial response to the object of his desire is "What a magnificent body! . . . Shouldn't I like to see it on the dissecting-table!"[92] Bazarov's horrible passion, which voices a desire to depersonalize and paradoxically destroy the sexual object, is inscribed with a desire to examine the interior components of the package that inflames his lust. The dissection table, a place where nakedness and close proximity occur, is also the place where depersonalized eroticism is experienced, as well as, in Sawday's words, "[t]he fantasy of anatomical separation—a vivisection which lays open the . . . body in order to possess its core."[93]

By the nineteenth century, in contrast to the public theatrical dissections of the sixteenth and seventeenth centuries, dissections and also surgery were performed only

for students and scholars inside the medical arena. In the eighteenth century, the medical profession was clinicalized and began to approach disease as something to be identified inside the ill body. By the mid-nineteenth century, puritanical influences deemed public displays of death and dissection vulgar, and the medical industry gained more credibility by keeping its discoveries exclusive.[94] In the eighteenth century, although the clinic and the anatomists were initially divergent in their approach to knowledge (the clinicians were dedicated to perceiving and analyzing surfaces whereas the anatomists were involved in mapping and describing the topography of internal organs), the autopsy, offering an accurate reading of the symptoms of disease, gradually took the place of the dissection. The two forms of knowledge came together, and so the medical gaze which, on the one hand, observed the two-dimensional surfaces of tissues and symptoms also, "in order to reconcile them, itself move[d] along a third dimension. . . . [T]he medical eye must see the illness spread before it, horizontally and vertically in graded depth, as it penetrates into the body."[95] The complication of this process, however, lay in the element of time, for the autopsy had to take place between the "last stage of pathological time and the first stages of cadaveric time."[96] In other words, autopsies had to take place immediately following death in order to distinguish which signifiers inside the body belonged to disease and which signifiers belonged to death. Foucault quotes X. Bichat, writing in 1825:

> Death is therefore multiple, and dispersed in time: it is not that absolute, privileged point at which time stops and moves back; like disease itself, it has a teeming presence that analysis may divide into time and space; gradually, here and there, each of the knots breaks, until organic life ceases, at least in its major forms, since long after the death of the individual, minuscule, partial deaths continue to dissociate the islets of life that still subsist.[97]

The medical gaze became a gaze that crossed the boundaries of life and death. It became established as the gaze that analyzed the human specimen in all of its stages, the gaze that sought to identify the particular characteristics of disease as a part of the human specimen.

The incorporation of death into the schema of human life and medical perception is illustrated rather dramatically in Gabriel von Max's *Der Anatom* (1869), where the romanticized rendering of the dead is illustrated in a private interaction between the doctor and the corpse, between the male persona and the female body (Figure 25). A private, sexualized interaction exists in this painting, partially because the female corpse is still quite beautiful and therefore lies between the "last stage of pathological time" and the "first stages of cadaveric time," a state which, in accordance with the medical gaze, dissociates this female body from the actual moments of morbid death. In this painting the corpse of the female is fully visible in the foreground, supine on a surgical table with only a sheet covering it. The breasts have just been uncovered, as indicated by the anatomist's hand pulling the sheet down and away from the corpse's

body. The anatomist, seated next to the corpse, has at once a relaxed and an antici-patory posture. His privileged medical gaze is not present. Were it not for the title, *Der Anatom,* it would be difficult to recognize him as an anatomist preparing for a postmortem. Elizabeth Bronfen notes:

> In the posture of one meditating or musing upon an enigmatic and desirable object, he [the anatomist] seems to be gazing at the upper part of a young woman's corpse. . . . The moment von Max has chosen to arrest in his painting is one where beauty is defined in its contrast to destruction. On the one hand, the soul has departed from the woman's body, but her beauty has not yet begun to disappear, as it will in the nat-ural process of decomposition. On the other hand, the anatomist has not yet begun his dissection, in the process of which he will cut into and destroy the lines of her perfectly shaped body. The painting enacts a crucial moment of hesitation. . . . The feminine body appears as a perfect, immaculate aesthetic form because it is a dead body, solidified into an object of art.[98]

Explicit in this painting are the male sexualized gaze as a moment of desire and hesi-tation enacted by the anatomist; a tenuous and momentary state of beauty, incarnated

Figure 25. Gabriel von Max, *Der Anatom* (1869). Neue Pinadothek, Munich.

in the form of the female corpse; and the exaggerated sense that we, the beholders, are observing a secret, intimate, erotic moment.

Von Max was specifically interested in the relationship between the moment of death and the mysteries of the woman's capabilities and/or secrets revealed in these moments. His interest lay in the belief that theories about female sexuality could be deciphered with the dissection of the female body.[99] In *Der Anatom* there is also a sense that the realm of secrecy surrounds medical and anatomical knowledge. This is emphasized by the inclusion of books, unbound papers, and a skull on the desk of the anatomist. Bronfen argues that the anatomist is allowed to have sexual knowledge of this female corpse for the purpose of translating it from her body into his text: "[H]e is allowed to have sexual knowledge of this woman's body (touch her) because she is dead, but because she is dead, this form of sexual knowledge is ultimately analytic. The result of his knowledge of her will be scripture rather than progeny, will be a celibate, self-produced and self-referring form of reproduction."[100]

By the nineteenth century, surgical procedures were regularly and successfully carried out in the clinic. Such procedures partially replaced the investigatory process of looking inside the dead body with looking inside the live body. In Thomas Eakins's *The Agnew Clinic*, a woman is being operated on within the medical school theater (Figure 26). In contrast to the von Max painting, there is no anticipatory moment

Figure 26. Thomas Eakins, *The Agnew Clinic* (1889). Oil on canvas, 74½ × 130½ inches. Courtesy of the University of Pennsylvania Art Collection, Philadelphia, Pennsylvania.

in Eakins's painting. Rather, the surgery, a mastectomy, is under way. Judith Fryer describes the painting in blunt and accurate terms: "[T]he male doctors gathered around the anesthetized woman are cutting off one of her breasts while a group of (male) student doctors watch."[101] Fryer writes that the unresisting body creates no boundaries between the doctor and his interpretive knowledge. Michael Fried emphasizes Eakins's placement of himself in this painting (the farthest figure to our right, leaning into the picture-plane to hear the whispered words of another painted audience member), as well as in *The Gross Clinic* (1875) (where he is also the farthest figure to the right), and suggests that what is depicted in these paintings is the male desire to know, as doctor and as artist.[102] Here the Cartesian description of the body as machine is fully illustrated. The anesthetized, stilled patient does not have an identity, her face is not visible, and she is the only person in the painting who is not documented. The only thing known is that she is poor, because a wealthy woman would not have been subjected to a public arena, and she is undergoing experimental surgery.[103] She is a specimen, distinguished only by a woman's naked breast.

In David Lubin's *Act of Portrayal*, he writes, "[T]he instant we recognize this as a female breast, interest is intensified. Regardless of our gender, we cannot but experience shock or excitement upon perceiving this intimate part of anatomy so unabashedly revealed, and in front of so many raptly attentive, fully clothed men."[104] The eroticism is played out as power. The juxtaposition of the clothed men (one holding a scalpel) to the naked breast serves to confirm the control of the doctors over the completely passive, vulnerable body of the patient. In a setting where the female specimen is clearly being cut into, the hyperrealism of this image elicits the horror that one might experience on the occasion of becoming a specimen (giving up all authority over one's own body) and going "under the knife" of another who assumes complete authority over one's body.

SPECIMEN TO ANTISPECIMEN: MAKING ONESELF INTO A BODY OF ART

Within the genre of contemporary body art, several feminist artists have performed their experiences of the medicalized body as what I would call the "antispecimen." Hannah Wilke's work, in keeping with Laura Mulvey's assessment that the female body in Western culture connotes "to-be-looked-at-ness,"[105] first solicits, then confronts and exposes the "male gaze" through the reiterated rhetoric of the pose. For example, in *S.O.S.—Starification Object Series* (1974) (Figure 27), Wilke embodies her concern: "how to make yourself into a work of art instead of other people making you into something you might not approve of."[106] In these twenty-eight photographs of herself, Wilke's postures mimic those of a fashion model. These poses indicate the "starification" of the body as image. However, *scarification* is affixed to her body with a multitude of small bubble-gum sculptures shaped in vulvalike forms. These scars serve to visually externalize the internality of her feminine body.[107] Wilke also describes the bubble-gum vulvas as "male-female gestural sculptures," referring to the visual

similarity of male and female genitalia.[108] The intended androgyny of her scars is meant to emphasize the unreliability of signifiers that mark sexual and ethnic difference.

The collapse of the signifier as an accurate mark of identity is mirrored in Wilke's collapsing of the distance between the subject and the object of art by using her own body. It is apparent that this subject/object collapse, although sometimes interpreted as narcissistic, serves also to point toward beauty as a signifier, a visual mark that is interchangeable (as with fashion models and actors in pornography).[109] Therefore, because Wilke's poses refer directly to the advertising industry, which sells one specific type of beauty, to criticize her for an individual narcissism is implausible. This piece comments on the artifice that is built into both the scar and the pose by visually marking the woman's body as beauty object and biological instrument. Writing about Hannah Wilke, Joanna Frueh observes:

> The Beauty has verified male "genius," and art history names men as geniuses of feminine beauty, inventors through the centuries of a variety of types who, in their own time and perhaps later, can be perceived as models of female attractiveness and desirability. . . . In this light, a woman's choice to deal directly with female beauty in her

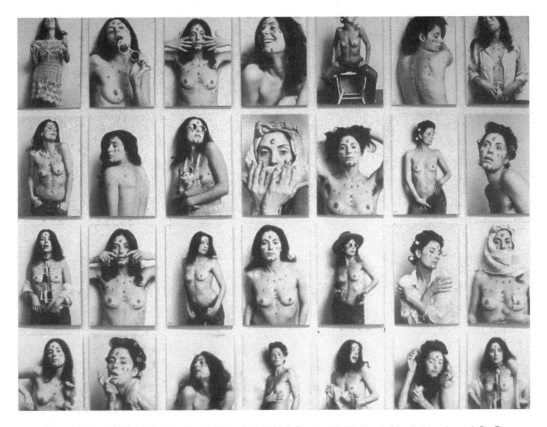

Figure 27. Hannah Wilke, *S.O.S. Starification Object Series* (1974). Twenty-eight black and white photographs, each 5 × 7 inches. Copyright 2002 Marsie, Emanuelle, Damon, and Andrew Scharlatt. Courtesy Ronald Feldman Fine Arts, New York.

art does seem inspired, both as a blunt recognition of the significance of female beauty in Western art and as an indication of willingness to risk proclaiming the pleasures of beauty for the self. That is an erotic choice. The risk entails excoriation, for *society still wants a woman to perform its desires and excitements, not her own.*[110]

Specifically, Wilke's poses were often misinterpreted as obsessively narcissistic because her performance of excoriation was so complete. She performed pleasures of her own beauty, also often posing herself as though in the folds of the fashion market—an institution that markets beauty standards by devaluing beauty that is not institutionalized. Wilke's ability to so perfectly imitate the "'tude" of the fashion model was perfectly foiled by the fact that she was working outside of the marketing institution—in a spoof, as it were. But also here (outside of the fashion market) she performed the erosion of her own beauty, which occurred because hers matched yet mocked that of the fashion model (stereotypical, interchangeable, and objectified).

Frueh suggests that the chewing-gum sculptures, as scarification, allude to the scar designs made on African women's bodies as marks of beauty. The Africans' scarring process is done without anesthesia, and Wilke also alludes to the suffering that Western women choose to endure in rituals of beautification. In this way Frueh identifies the starification as stigmata that "make the model woman into a martyr."[111] But by making starification the subject of her work, Wilke exposed it as stigmata, thereby politicizing it and participating in its disempowerment.

Frueh points out that feminists (Robin Lakoff and Raquel Scherr, for example) have been ashamed to examine the topic of beauty, because they might have been misconstrued as vain and self-indulgent, but they subsequently began to think of it as "the last great taboo, the anguish that separates women from themselves, men and each other."[112] Specifically with regard to Wilke's work, Frueh sites Lucy Lippard: Wilke's "confusion of her roles as beautiful woman and artist, as flirt and feminist, has resulted at times in politically ambiguous manifestations that have exposed her criticism on a personal as well as on an artistic level."[113] Wilke, like Orlan, worked from inside representations of beauty (by becoming them, but by also parodying them) as a political strategy in order to deconstruct them from the inside. This strategy is misinterpreted as "ambiguous," because it presents a paradox rather than presenting safe politics. In other words, the artist is not taking a direct stance, one that would clearly delineate opposing positions and would position the artist in opposition to the subject at hand. For Wilke, as well as Carolee Schneemann, the work highlighted not only female beauty but also female erotics. Frueh writes that Wilke, Schneemann, and Joan Semmel "originated a feminist visual erotics . . . to liberate women from the male gaze as theoretical orthodoxy and as actual hatred and misunderstanding of women's sensual and visual pleasures. These [erotics], Wilke understood, might differ from male-dominant erotic dogma if women explored and released them."[114]

The gaze gained a new kind of meaning as Wilke confronted the diseased female body. In *Portrait of the Artist with Her Mother, Selma Butter* (1978–81, from the series

So Help Me Hannah), Wilke juxtaposes her perfect and beautiful body with her mother's body, ravaged by cancer, radiation, and chemotherapy treatments (Figure 28). Amelia Jones notes in her essay on Hannah Wilke that in this diptych "Wilke explores the shallowness of our culture's conception of feminine appeal which focuses on visual appearance as beauty's guarantee."[115] The overt connection between health and erotic appeal is magnified in Wilke's photographs of her own diseased body several years later. Wilke's series entitled *Intra-Venus* (1992–93) is made up of photographs that continue to explore the pose, confront the gaze, and jar it. She projects herself outward by challenging the submission required of hospital patients. She becomes an activist, an anti-specimen. Her own body, ill and exhausted, is no longer an example of idealized beauty; it is antierotic. But Frueh disagrees: "The *Intra-Venus* series is an astounding assertion of erotic will, which proves that erotic-for-women is courageous and radical. *Intra-Venus* is a rite of passage for illness and aging."[116] Wilke observes us observing her (ex)posed, medicalized body as she sits slumped on a hospital toilet with her mouth open and an intravenous needle hanging from her chest. Having once said, "Even while I am sleeping I pose," in the wake of her fatal illness,[117] Wilke chooses to portray herself as a subject of interminable puncturing and penetration by the scalpel. She assumes the poses of a woman confronting (and, as best as possible, refusing to submit to) an illness. Or, as Frueh writes: "*Intra-Venus* records Wilke's rite of passage and provides a terrifying enlightenment for the initiate-viewer. Wilke continued her auto-erotic self-portrait focus in an attempt to 'treat' herself with love during what she called her 'beauty to beast' transformation."[118]

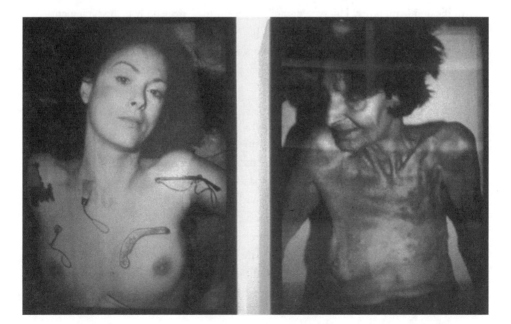

Figure 28. Hannah Wilke, *So Help Me Hannah* series, *Portrait of the Artist with Her Mother, Selma Butter* (1978–81). Copyright 2002 Donald Goddard. Courtesy Ronald Feldman Fine Arts, New York.

Orlan's performance surgeries nudge the politics of feminism by indulging her audiences with uncensored images of the interior of her own live body while engaging in what might be termed the decadence of cosmetic surgery. Unlike the previously cited nineteenth-century depictions, where the stilled and naked female body was portrayed as the subject of scientific investigation, Orlan refuses to be stilled or naked. Note also that Orlan's surgeon in *Omnipresence* is a woman, although she has also had male surgeons. Conscious throughout her surgical performances, giving direction, reciting quotes, and responding to phoned and faxed inquiries from the media center set up inside the operating room, Orlan asserts herself as an antispecimen, taking control of her destiny as a "struggle against the innate, the inexorable, the programmed, Nature, DNA (which is our direct rival as far as artists of representation are concerned), and God!"[119]

Orlan performs the surgical opening of her body as the process of creating a self other than herself. Orlan says, "My work is not a stand against cosmetic surgery, but against the standards of beauty, against the dictates of a dominant ideology that impresses itself more and more on feminine . . . flesh."[120] Ironically, this statement circles back upon itself, because the industry of cosmetic surgery is guilty of supporting and inflicting contemporary notions of beauty upon the feminine flesh. Carole Spitzach suggests that the cultural mechanisms of "inscription, surveillance and confession" are deployed in cosmetic surgery.[121] The surgeon's medical gaze

> is a disciplinary gaze situated within apparatuses of power and knowledge that constructs the female figure as pathological, excessive, unruly, and potentially threatening of the dominant order. This gaze disciplines the unruly female body by first fragmenting it into isolated parts—face, hair, legs, breasts—and then redefining those parts as inherently flawed and pathological. When a woman internalizes a fragmented body image and accepts its "flawed" identity, each part of the body then becomes a site for the "fixing" of her physical abnormality.[122]

This physical abnormality is inscribed as an illness. Mary Ann Doane writes, "Disease and the woman have something in common—they are both socially devalued or undesirable, marginalized elements which constantly threaten to infiltrate and contaminate that which is more central, health or masculinity."[123] The woman's failure to accept this, to confess to her "flaws," is equated with a preference for illness over health. In addition to this, the body that has emerged as a result of a very progressive medical industry does not normally apply to cosmetic surgery. The true inner essence of the healthy internal body is not brought to the surface of the body. Rather, culturally determined notions of beauty are inscribed onto (just below the surface of) the body.

Orlan forces us to witness the unrepresentable as she sacrifices herself to the experience of it. It is a decadent sacrifice, horrible in its artistic excesses. It is the excess of the artist and antispecimen, Orlan. Orlan's performances invite audience participation, by reaching outside the frame of the video camera with phone and fax, but her

theater goes one step further. Not only is Orlan challenging the boundaries of medical technology, art, performance, and her own (self-)identity, she is challenging the boundaries of identity itself.

FRAGMENTATION AND APPROPRIATION

The motif of the scientist dismembering and investigating the body is reflected in both modern and postmodern agendas concerning art. Orlan's deconstruction of art history, of her own body, of the body of woman, participates in this recurring motif of fragmentation present throughout art history. For example, the previously cited images of self-dissection incorporated the motif of decaying Greek architecture and sculpture as indicators of art and civilization that describe mortality.

To fragment the contents of art history is to do so partially to understand our contemporary relationship to it. It is also an indulgence in the process of fragmentation begun with the advent of modernism. Linda Nochlin, in *The Body in Pieces: The Fragment as a Metaphor of Modernity*, discusses images of the fragmentation of the body and their relationship to modernity. She begins with an image of Henry Fuseli, *The Artist Overwhelmed by the Grandeur of Antique Ruins* (1778–79), which is of an artist bent in sorrow and grief at the great losses of antiquity. The artist is embracing a huge foot (much larger than him), a fragment of antiquity placed on a pedestal and flanked on the other side by a huge sculpted hand, also severed from its original body. The fragments signify the loss of a whole, the loss of a body, the loss of a body of work that is presumed to have been invaluable, judging by the technical perfections displayed in the foot and the hand. Nochlin notes that "the loss of the whole is more than a tragedy. Out of this loss is constructed the Modern itself. In a certain sense, Fuseli has constructed a distinctively *modern* view of antiquity-as-loss—a view, a 'crop,' that will constitute the essence of representational modernism."[124] Nochlin also points out that Fuseli's drawing, made ten years before the French Revolution, is nostalgic for the past. Yet, Nochlin argues, Fuseli's fragmented pieces of sculpture, representing the loss of antiquity, also represent the ushering in of modernism, preceded by the deliberate break from the past that the French Revolution sought.[125]

Nochlin's essay continues with the advent of the fragmented image in the nineteenth century. Baudelaire suggested that the modern painter focus on portraying the severed moment in which suggestions of eternity were contained.[126] The impressionists composed their paintings with a notion of fragmentation that included the cropped body, the cropped picture, and the rendering of one particular moment as a fragment of time. Nochlin cites a prime example of this phenomenon in Manet's *Bar at the Folies-Bergère* (1882).[127] Layering several cropped planes, a motif of cutoff figures actually serves to unify the image. Cutoff trapeze-artist legs in the upper left corner and the twice-cutoff figure of the barmaid, once as she faces the painter and once in the mirror, expand the visual possibilities not only of the moment but also of the world outside the canvas. Just as in photography, Manet invokes the fragmentation of time,

bodies, and spaces, which implicate a frozen moment. It is the juxtaposition of this frozen moment with the inevitable passage of time and therefore the inevitable notation of mortality that guarantees our fascination with this image as with a photograph, which has the capacity to reproduce not only a moment but also another image.[128]

The postmodern agenda is founded on eliminating any remaining isolation of cultural attitudes and deconstructing any sanctity associated with the histories that preserved these cultures. As a part of the postmodern climate, contemporary art making is subjecting its own history to scrutiny.

Images that appropriate other art historical images often reveal the quest for a new perspective, as well as something unique about the artist's connection to the utilized historical imagery. Several contemporary artists (e.g., Orlan, Yasumasa Morimura, Cindy Sherman, Sherrie Levine, and Bill Viola)[129] are interrogating Western art history and refusing to allow it to be left untouched. For example, Orlan's interrogation includes the utilization and the dissection of some of the most renowned Western images, in order to manipulate them into a contemporary frame—her body. This handling of historical imagery can be seen as a refreshing one, because it recontextualizes relics while critiquing both the relevance of the works of art in a contemporary context and the status given these masterpieces that is reinforced by the discipline of art history. Another way of saying this is that the recontextualizing of these images serves to critique the context in which they are held by art history: the context of the revered, original masterpiece.

In Orlan's work the theatrical invoking of historical imagery serves to confront us with not only the images but also the historical value structures behind the images. She is specifically focused on the historical traces that may reside inside contemporary value structures, particularly with regard to woman's body and woman's body as the subject of art. In order to question the notions that created images of ideal feminine beauty in, for example, Botticelli's *Venus*, Orlan is creating a narrative for us that involves the conceptual inscription of this (man-made) goddess's features into her body.

The layers of this narrative fall in an unkempt pattern. First of all, this dismantling of the unique image ironically runs in tandem, for example, with the dismantling of beauty as a unique, rather than interchangeable and generic, quality (e.g., the interchangeability of the fashion model). Cosmetic surgery is also a form of inscription. Although its promise is that of enhanced beauty and youthfulness, its recipients carry the traces of its narrative. In other words, one can often read traces of cosmetic surgery. There is an archaeology of cosmetic surgery and a spectatorship that accompanies it. This particular narrative is readable because of the repetition of like features that are appropriated. This codification not only "keeps the female body positioned as a privileged object of a normative gaze"[130] but also crosses racial boundaries: "Whereas the quantified proportions of white faces are the taken-for-granted foundation for the construction of ideal surgical goals, black and Asian facial features are defined as abnormal, sometimes requiring special 'corrective' surgery, as in the case of the 'oriental

eyelid.'"[131] Orlan's narrative is ironic: although the valuation of beauty in contemporary society shows up as something interchangeable—one can acquire this or that feature through surgery—Orlan, participating in this surgical process, does not acquire the normally prescribed features. The paradox here is that she chooses to render herself an original by appropriating parts of others' creations.

Second, Orlan's process of appropriation produces a fragmentation of art history, which coincides with an unsettling dislodging of the status of the masterpiece. Paintings such as the *Mona Lisa*—which is being appropriated by Orlan and by Morimura, and which was also appropriated by Marcel Duchamp and Andy Warhol, not to mention the many times it has been used in advertising—when reframed in other contexts, become dislodged from their status as unique originals.

It is important here to distinguish between the image and the original object. The image is what can be appropriated, dissected, reused, reproduced. The original object/painting remains intact, insofar as we can view it as the original by separating this viewing experience from the experience of viewing reproductions. The degree to which the original is affected by its many reproductions and appropriations is perhaps immeasurable, but the derivative work is proof only of the devaluation of the image, not the original object.

This idea is in total concordance with the writing of Walter Benjamin (1892–1940), who felt that with the reproduction of the original, the image lost its aura:

> [T]hat which withers in the age of mechanical reproduction is the aura of the work of art. . . . By making many reproductions it substitutes a plurality of copies for a unique existence. And in permitting the reproduction to meet the beholder or listener in his own particular situation, it reactivates the object reproduced. These two processes lead to a tremendous shattering of tradition which is the obverse of the contemporary crisis and renewal of mankind. . . . Its social significance, particularly in its most positive form, is inconceivable without its destructive, cathartic aspect, that is the liquidation of the traditional value of the cultural heritage.[132]

The devaluation of the replicated image is for this reason embedded in the work of those artists who appropriate historical images. To a certain degree, the aforementioned artists readily appropriate images simply because they can. Sherrie Levine's first demonstration of photographing the original photographs of Edward Weston sent shock waves through the art world. It was a demonstration of the question, This is now possible; we have the image, so why value the original so highly? Such devaluation of the original is a crucial part of the process of this postmodern fragmentation; the fragmentation of art history, the fragmentation of the image, the fragmentation of a body of work, and, most specifically in the case of Orlan, the fragmentation of her own body. Her body fragmentation, to a certain degree, represents not only the fragmentation of the art historical image but also the symbolic fragmentation of ideal

beauty as conceptualized by male artists. This is a political as well as an aesthetic act. Each of these forms of fragmentation is revolutionary in the sense that it participates in pulverizing past repressive traditions that upheld values now being scrutinized,[133] values that have influenced the historicization, assessment, and institutionalization of art and culture.

Between Self and Other

Only a shameless, indecent saintliness can lead to a sufficiently happy *loss of self*.
—Georges Bataille, "The Practice of Joy before Death"

"Binary terror," as defined by Rebecca Schneider, identifies the binary structure as "sacred to our Western cultural ways of knowing."[1] Schneider points to the necessity of interrogating binary codes to discover their nature—what they sustain and what they expel. Taking the necessity of this interrogation into account, Orlan *performs* self/other, interior/exterior, and beauty / the monstrous feminine in *La réincarnation de Sainte-Orlan.* She viscerally tampers with epistemological truths such as the positioning of the ideal above the real; she performs an undoing of ideal feminine beauty in Western art because the attributes that she appropriates from images of idyllic feminine beauty contribute to monstrous images of herself.

Elizabeth Grosz writes that Derrida's deconstruction

> provides a way of rethinking our common conceptions of politics and struggle, power and resistance by insisting that no system, method, or discourse can be as all-encompassing, singular, and monolithic as it represents itself to be. Each is inherently open to its own undoing, its own deconstruction (deconstruction is not imposed from outside a discourse or tradition but emerges from its own inner dynamics).[2]

Derrida insists that deconstruction is not a system of critique but, rather, a double affirmation that acknowledges that within each structure exists its own resistance.[3] Grosz translates this double affirmation into the context of feminism, which, she believes, includes an affirmation of the overcoming of patriarchy and phallocentrism while also affirming patriarchy and phallocentrism:[4]

[T]he inherited nature of feminist discourse, a discourse that is not, or not yet, a dis-
cipline, and its location within "patriarchal" institutions, knowledges, and languages;
the ways in which feminist self-help projects and equal opportunity commitments
must negotiate with patriarchal institutions of the capitalist state for funding, the
implication of Western feminism in neocolonialism, indeed the very investment of all
of us in the West to a kind of cannibalization of the imperialized other—all illustrate
our necessary, indeed constitutive immersion in the very systems from which we seek
to distance, and against which we seek to position, ourselves. Without both moments
in this affirmative investment, however, feminism remains in danger of repeating and
being unable to recognize the very implications it believes it has repudiated.[5]

Derrida contends that within each canon, text, and/or ideology lie undermining com-
ponents. Grosz utilizes this structure to argue that, fundamentally, within phallocen-
trism exists feminism. To extend this: within ideal beauty exists the monstrous; within
the self, the other; within the interior, the exterior; and vice versa.

Grosz makes the point that the activity of double affirmation involves performing
the unthinkable for most feminists: the affirmation of patriarchy. Part of what makes
Orlan's work so disturbing is that she fully embraces the double affirmation of the
just-mentioned oppositions. She performs the unthinkable by becoming monstrous,
by making the interior of her body exterior, by performing a process of becoming
other, and by doing all of this within an industry of beauty that has marketed the
natural healthy body as flawed in order to market also the elimination of those flaws,
including surgery. In this way Orlan has built into her own process its deconstruction.
By working within this industry, Orlan rides a fine line between subverting and
applauding cosmetic surgery. Even though she has exposed the extent of the inva-
siveness of surgical procedures, has mocked the surgical theater by turning the oper-
ating room into a carnival, and has mocked the industry by turning herself into a
monster, her use of cosmetic surgery and her willingness to allow herself to be muti-
lated marginalize her from the feminist community.

Grosz's assessment recognizes that one's struggle, in this case feminist politics, is
"always already impure," because it is inherently bound up inside of that which it
struggles against. Understanding the impurity of one's struggle by acknowledging its
boundaries is not an antifeminist gesture but "a measure of the maturity of feminism
to accept its internal limits and to use them in enabling and productive ways."[6] By
saying this I acknowledge my own acceptance of the integration of deconstruction
and feminism, also a synthesis that Orlan utilizes as an artist working within the very
structures that she deconstructs: the parameters of feminine ideal beauty in Western
art history and the contemporary beauty industry.[7]

In "Positions" (1972), and in "Choreographies" (1982), Derrida describes decon-
struction as being contingent on a two-phase program. This program is based on
the notion that "traditional binary pairing (as in the opposition of spirit to matter or
man to woman) no longer functions by the privilege given to the first term over the

second."[8] The first phase is described as the reversal of privilege in each binary pairing. Thus, for example, woman would be privileged over man. However, this phase of the scheme reaffirms the hierarchy inherent within binary structures.

The second phase is much less clear, because it involves a stepping outside of the binary code into a place where possibly neither neutrality nor any identity at all is evoked. Rather, outside the binary structure may exist only a place of difference. To discuss this place, Derrida evokes Heidegger's silence on the specific question of sexual difference, and Heidegger's notion of *Dasein* as that which precedes the inclusion of any identifying signifiers (in this case, sexual orientation).

Heidegger's term *Dasein,* which resists being reduced to a simplified meaning, is essentially "originary being"—being before the dispersal of particularities.[9] Heidegger states that within *Dasein* exists a necessary form of neutrality. However, he also indicates that the neutrality of *Dasein* is not something separate from specificity, including sexual specificity. In other words, within *Dasein* exists the openness to specificity through a type of dispersion: "*Dasein's* facticity is such that its Being-in-the-world has always dispersed itself or even split itself up into definite ways of Being-in."[10] Within *Dasein* exists the possibility of the determination of all things, including human beings, while at the same time *Dasein* is also the neutralization of determinants.[11]

In "Geschlecht: Sexual Difference, Ontological Difference," Derrida cites an instability in Heidegger's notion of *Dasein*. Derrida suggests that what *Dasein* neutralizes is the *prior* sexual marking, that of the binary structure within which male/female is determined:

> [A] sexual neutrality does not desexualize, on the contrary; its *ontological* negativity is not deployed with respect to sexuality itself (which it would instead liberate), but with respect to the marks of difference or more precisely to sexual duality. . . . If Dasein as such belongs to neither of the two sexes, that doesn't mean that its being is deprived of sex. On the contrary, here one must think of a predifferential, rather a predual, sexuality—which doesn't necessarily mean unitary, homogenous or undifferentiated.[12]

Derrida is deconstructing sexuality, which is primordial to the binary structure. His deconstruction suggests the possibility of a neutral sexuality, one that exists prior to the opposition that now determines sexual difference. The point of this example is not only to illustrate the possibility of moving to a place of difference that exists beyond the binary code, but also to illustrate that the roots of the philosophical dialogue regarding difference have evolved from historical, philosophical, and ontological discourse. In other words, it is not simply a feminist political topic; discourses on difference and the relationship of the self to the other extend the parameters of ontological and ethical discourse.[13]

Simone de Beauvoir was the first to ask the question, why is woman the second sex? She did not consider being second advantageous to women at all. By contrast, the

psychoanalytic feminist perspective of Luce Irigaray regards being other—second in the male/female, self/other binary—an advantageous position, one in which "difference" is a healthy political and theoretical base from which to begin to discuss diversity, individuality, identity.[14] This view differs from Derrida's deconstruction of linguistic dualistic structures. Both Derrida and Irigaray, however, undermine the hierarchy inherent in dualism in order to begin to conceptualize a form of difference outside of the binary structure. The questions become, Is it possible to think outside of the logic of binary opposition? and If so, what does this mean in terms of the male/female and self/other binaries with relation to identity? Orlan explodes both of these binary pairs. The male/female binary she explodes by performing a self-proclaimed woman-to-woman transsexualism that focuses on a motif of distinctive identity as sexual identity. She collides the self/other binary by performing the process of becoming other without completing her reincarnation, thus placing her fluctuating identity either between self and other or possibly outside of the binary structure altogether.

ORLAN'S "SPLIT SUBJECT"

Orlan performs a process of making herself other than what she is. Within this dynamic, "other" can refer to an other human being. Also, with reference to the split subject, "other" can refer to the subconscious mind. Here the ego is the self, and the subconscious, the other.

The postulate of logical identity—that is, Descartes's single knowing subject—was a foundation of epistemology and ontology until Nietzsche presented a problematic of difference; namely, that the body is made up of wills that continuously grapple with one another:

> The sphere of a subject [is] constantly growing or decreasing, the center of the system constantly shifting; in cases where it cannot organize the appropriate mass, it breaks into two parts. . . . The assumption of a single subject is perhaps unnecessary: perhaps it is just as permissible to assume a multiplicity of subjects whose interaction and struggle is the basis of our thought and our consciousness in general? A kind of "aristocracy of cells" in which dominion resides? To be sure, an aristocracy of equals, used to ruling jointly and understanding how to command? *My hypothesis*: The subject as multiplicity.[15]

Nietzsche's assertion, *the subject as multiplicity*, served to destabilize the fixed logic of identity and to establish a logic of difference.

During the late nineteenth and early twentieth centuries, the split subject emerged as one constituted by culture rather than one understanding the world through reason. This illustrated a shift from Cartesian empiricism toward a questioning of the existence of empiricism. For example, both Nietzsche and Heidegger questioned the existence of religious truths. This questioning problematized the existence of the only

other as God, who had ensured the existence of truth.[16] Also, late-nineteenth-century and early- to mid-twentieth-century psychoanalytical theories, particularly those of Sigmund Freud and Jacques Lacan, revealed the notion of the split subject (conscious/unconscious) and further decentered the fixed identity. Elizabeth Grosz writes that "Freud's interrogation of the unconscious wishes and impulses fragmenting and interrupting consciousness demonstrated that the presumption of a philosophical subject—the knowing subject—is based on a wishful perfection unattainable by a being who is unaware of its own internal rifts."[17]

Within this decentering of the subject, Freud was embraced by the surrealists, who endeavored to search for the true self via stream-of-consciousness writing and rendering with an emphasis on dream imagery. The power of the irrational that the surrealists touted was also a power being recognized and questioned by many French intellectuals who had been influenced by the devastating effects of World War I.[18]

Most influential to this circle of artists and intellectuals was the Russian émigré Alexandre Kojeve, who gave lectures on Hegel's *Phenomenology of Mind*, specifically the "Master/Slave Dialectic." For Hegel, the meaning of the master-slave relation existed in one individual's conscious realization of self-consciousness, which existed only in and through another's self-consciousness.[19] Kojeve focused on the violence of the life-and-death struggle, rather than on synthesis, and on Hegel's notions of desire and lack, rather than totality and reason. Carolyn Dean notes that, by shifting his emphasis, Kojeve transformed Hegel's positive dialectic of self-recognition into a negative dialectic.[20]

Ferdinand de Saussure, in his lectures from 1907 to 1911, developed the idea that a logic of difference was required to explain the complexities of language. For him, the significations of linguistic identities (signs or texts) were contingent upon existing within a system, which, through difference, identified each signifier by delimiting its meaning. Saussure wrote of language as a structured system of difference:

> [I]n language there are only differences *without positive terms*. Whether we take the signified or the signifier, language has neither ideas nor sounds that existed before the linguistic system, but only conceptual and phonic differences that have issued from the system. The idea or phonic substance that a sign contains is of less importance than the other signs that surround it. . . . [M]aintaining the parallelism between the two classes of differences [signified and signifier] is the distinctive function of the linguistic institution.[21]

Heavily influenced by the surrealists, Saussure, and Kojeve's reading of Hegel, Lacan developed a theory that postulated that the true self *is* other: "[T]he ways of what one must do as man or as woman are entirely abandoned to the drama, to the scenario, which is placed in the field of the Other—which, strictly speaking, is the Oedipus complex."[22] Lacan also states that "the unconscious is the discourse of the Other."[23] As other, the self is not severed from its origins, but it is irretrievable:

What I, Lacan, following the traces of the Freudian excavation, am telling you is that the subject as such is uncertain because he is divided by the effects of language. Through the effects of speech, the subject always realizes himself more in the Other, but he is already pursuing there more than half of himself. He will simply find his desire ever more divided, pulverized, in the circumscribable metonymy of speech. The effects of language are always mixed with the fact, which is the basis of the analytic experience, that the subject is subject only from being subjected to the field of the Other, the subject proceeds from his synchronic subjection in the field of the Other.[24]

Grosz writes that the other (small *o*), for Lacan, is the real other, that is, the mother. The Other (capital *O*) is the subconscious, which is embodied in the symbolic realm of male language, the Law of the Father.[25]

A PLACE OF DIFFERENCE: ONTOLOGY

Luce Irigaray links ontology closely to the form of the body. She argues that, because Western systems of knowledge have privileged the primacy of ocular verification, what is present has been privileged over what is not present. Thus, the phallus has been elevated to a ludicrously high position, and women, as other, have been defined in terms of a lack, and of having no being. Specifically with regard to Lacan's mirror stage, Irigaray questions Lacan's use of the flat mirror, which "reflects the greater part of women's sexual organs only as a hole."[26] Instead she advocates the use of a curved surface as a mirror, the speculum that is used by gynecologists to examine the cavities of a woman's body.

Within the male/female binary, Irigaray writes about the state of being other as a state of nonbeing:

Woman, for her part, remains an unrealized potentiality—unrealized at least, for/by herself. *Is she, by nature, a being that exists for/by another?* And in her share of substance, not only is she secondary to man but she may just as well not be as be. Ontological status makes her incomplete and incompletable, she can never achieve the wholeness of her form. Or perhaps her form has to be seen—paradoxically—as mere privation: But this question can never be decided since woman is never resolved by/in being, but remains the simultaneous co-existence of opposites. *She is both one and the other.*[27]

How does all this relate to Orlan's performance? Essentially, *La réincarnation de Sainte-Orlan* is a performance of incompletability. Orlan leaves behind one originary being, her natural body, yet does not complete the process of becoming other. Theoretically this makes her neither one nor the other; her performance is a divestiture of the self in lieu of the possibility of becoming other(s). A place of difference might occur during an in-between moment—meaning, for Orlan, a place where neither the original

body nor a final body (evoking identity) is defined, and the maximum number of possible future identities exist.

This place of difference is, for Orlan, a place of extreme creativity. Remaining between identities, she prolifically generates possible future images of herself. This performance of difference, combined with Orlan's insistence that hers is a woman-to-woman transsexual alteration,[28] beckons me to explore the relationship between her imagery and the experiences of noteworthy transsexual authors and performers.

Warren Gorman begins his book on the body image with this statement:

> Similar to sex, an intimately private matter which has public consequences, the body image is an intimate personal possession which is constantly in a state of exposure and revelation. The body image is not only a representation of the intimate and the public activities of the body, but also exists within the mind as a concept that affects every bodily action.[29]

This observation supports the notion that the body image is intimately related to the physical body and that it functions within the private/public sphere of the body. The following transsexual narratives also support the intimate link between body image and the physical body.

TRANSSEXUAL NARRATIVES: BETWEEN SELF AND OTHER

Claudine Griggs, author of S/he, is concerned that the gender-reassignment process, which includes hormone treatments as well as surgery, will leave her caught between the fixed body of the male and the fixed body of the female. Her goal is to be seen not as a transsexual but as a woman who is capable of blending into the culture, undetected. Here she expresses her discovery of the extremely public interaction between her self and society:

> My sex change was a consequence of war between internal gender and external body, and I defined my enemy bitterly. The battle was further complicated in that I was essentially the only person who knew of the struggle. Victory and defeat occurred when I faced the ultimatum—Become female or die!—and began sex reassignment. But, like Dorian Gray, I anticipated that only the picture would change. I would soon learn that by rearranging likeness, one rearranges audience response, and a radically modified body transforms life experience. *Society and self interact with image.* . . . [A]ttributed gender is a handshake contract between observer and observed.[30]

Kate Bornstein, a performance artist and transsexual (also male-to-female), is engaged in the fluidity of gender, not the demarcated and polarized borders—male and female. For her, transsexualism is "the in-between place . . . a place that lies outside the border of what is culturally acceptable."[31] In her performance *The Seven Year*

Itch, Bornstein points out that all of our cells are replaced once every seven years. She uses this motif to challenge essentialism by claiming, "[B]y the time the next seven years have come and gone / I'm gonna be new all over again."[32] In *Hidden: A Gender,* Bornstein's characters, designated "One" and "Another," are euphoric only during the in-between stages of the gender-reassignment process.[33] Bornstein defines "gender fluidity" as "the ability to freely and knowingly become one or many of a limitless number of genders, for any length of time, at any rate of change."[34] She implies that this fluidity is more freely engaged in internally when sexual ambiguity is reflected in the material body.

Jay Prosser, in his book *Second Skins,* conveys a profound feeling of discomfort in his transition from female to male:

> [I]n common perception, to name oneself transsexual is to own precisely to being gender displaced, to being a subject in transition, moving beyond or in between sexual difference. . . . Transition provokes discomfort, anxiety—both for the subject in transition and for the other in the encounter; it pushes up against the very feasibility of identity. Yet transition is also necessary for identity's continuity; it is that which moves us on.[35]

Prosser's reference to transition as "identity's continuity" is also reflected in the relief that he experiences as he leaves his female attributes behind while undergoing hormone treatments.[36]

Curious about attitudes regarding the transsexual within feminist discourse (particularly pertaining to the use of cosmetic surgery) and about narratives that potentially describe an interior image mismatched to the material body, I perused Prosser's book with great interest. Intriguingly enough, an assessment of Orlan's performance *Omnipresence* begins chapter 2, "A Skin of One's Own: Toward a Theory of Transsexual Embodiment." Prosser's account of *Omnipresence* is striking in several ways. He was present at the Sandra Gering Gallery for the exhibition, which included the telecast live performance in December 1993. Prosser reiterates Orlan's assessment of the body and the face: "The body is but a costume,"[37] and "Skin is a mask of strangeness, and by refiguring my face, I feel I'm actually taking off a mask."[38] Prosser relays that he was present for the artist's talk at the gallery, when he asked her about "the relation of body and identity in her work." His experience was similar to mine when I asked Orlan about the same topic: she replied that she felt like "une transsexuelle femme-a-femme" (a woman-to-woman transsexual).[39] What did this response feel like to a person undergoing a gender-reassignment procedure? In other words, do Orlan's insistence on the superficiality of the face, the face as changeable mask, and her nonchalant adaptation of transsexualism (even though none of the surgeries have reconstructed any sexual organs) share anything—experientially or theoretically—with the experience of the transsexual? Prosser's response is informative:

Orlan replied . . . that she felt like "une transsexuelle femme-a-femme." It was a strik-ing reformulation. But what was the import of transsexuality here? On the one hand, eliding the element of sex change but nonetheless suggesting a total identity (ex)change (she changed from one woman to another), her identification with a substantial transsexual transition implied that something of her self was indeed invested in the surgery, that the transformations were not simply skin deep. On the other hand, the readiness of her embrace of transsexuality and the ease with which transsexuality translated into a context that made of surgery a spectacle brought to the surface a commonplace assumption about transsexuality: that is, that transsexuality is pre-cisely a phenomenon of the body's surface.[40]

It appears for a moment that Prosser is going to fall into the Lacanian-poststructuralist bind—the unconscious is constructed like language; the body's referentiality is cultur-ally and psychically signified. This position would overlook the materiality of the body and thus would allow one (but not necessitate one) to identify the surface of the body as something *superficial.* But Prosser instead alludes to Didier Anzieu's "skin ego," which states that "the body is crucially and materially formative of the self."[41] Prosser's investigation is loyal to the negation of a mind/body split and roots ontology inside of the body: "[T]he transsexual does not approach the body as an immaterial provi-sional surround but, on the contrary, as the very 'seat' of the self. For if the body were but a costume, consider: why the life quest to alter its contours?"[42]

Prosser's desuperficialization of the surface (skin) of the body can also be carried over to Orlan. That Orlan calls the face a mask also does not imply that the mask is superficial, for although the mask is generally an object that can be worn or removed at will, it invests a complex register of identity; it conceals one identity at the same time that it reveals another. In this regard Bornstein's notion of "fluidity" is a crucial component of identity, because it acknowledges both the experience of being embod-ied and the experience of performing multiple genders (thus, multiple identities). This is directly applicable to Orlan, who corporeally performs (as well as manufactures) the fluidity of her own individual woman-to-woman identity.

Orlan, Bornstein, Griggs, and Prosser each engage in a process of externalizing an interior (thus hidden, invisible) dimension of self-identity. What it means to make visible this representation of oneself is different for each, although the reasons for undergoing radical surgical alterations are clearly related to issues of identity. Of importance to most who undergo any type of surgical alteration is the success of the *after* image at capturing an imagined internal representation. But neither Orlan nor Bornstein engages in the creation of a fixed after image that is not capable of reflect-ing a constantly shifting internal image. Both are most interested in the radical place of in-between, where the body fluidity morphs.

What is this place of in-between? In terms of sexual identification, the possibili-ties for gender are numerous. Chris Straayer writes:

If we apply even the limited information available to us, there are clearly more than two sexes, perhaps an infinite continuum of sexes. Attempts to delineate two distinct categories that together differentiate yet include all people have failed. Incongruent defining systems are arbitrarily applied in particular situations to maintain a maximum of two sexes. The continuing quest to produce a definitive line between the sexes ironically only yields additional evidence of permeability. The two sexes are made, not born.[43]

And Judith Butler comments on both the conservative perception of those in the medical profession that the goal is to construct strictly heterosexual males and females, and the need for cross-gender identification to be included in discourses regarding transsexuality:

I have some trouble with the very conservative gender norms that get reproduced uncritically in some medical discourses and practices governing transsexuality. But what strikes me as extremely interesting is that there's a very *mundane* sense of transsexuality that most people who theorize on gender and sexuality haven't yet taken into account, and it has to do with the possibility of cross-gender identification.[44]

Further, the link between the transsexual body and the medicalized body intersects with Prosser's question, "why the life quest to alter [the body's] contours?" This intersection also looms in every discussion of Orlan. To the argument that the transsexual is merely the construct of medical technology, Prosser replies: "Construction in a more mainstream sense is overtly a means of devaluing and discriminating against what's 'not natural' precisely for desubjectivizing the subject and—in the context of transsexuality—invalidating the subject's claims to speak from legitimate feelings of gendered difference."[45] Prosser is correct in his recognition of a discrimination against what is "not natural." Orlan contends with this criticism as well. However, Prosser includes only "legitimate feelings of gendered difference" as the justifiable reason to employ the aid of the medical industry in altering the body. It seems to me that a more apt argument here would be to critique the stringent medical guidelines that surround the construction of the transsexual body. These guidelines insist that an individual undergoing a sex change do it to construct a correct heterosexual orientation. The guidelines also insist on a system in which the prospective transsexual must *convince* the doctors that he or she really wants or needs the surgery.

Several of the narratives that Prosser explores in his book speak of the anguish that the prospective transsexual experiences when he or she learns of delays or refusals to perform surgeries.[46] In effect, Prosser points out, the medical manufacture of the transsexual is a rite of passage; the pain associated with manufacturing the transsexual body is a significant part of the process:

[D]escriptions of the pain, the shock, the discomfort to the body; the cycle of suffering and recovery, of the wounded body healing; in repetition these features give to

sex reassignment surgery a certain ritualistic structure, so that it does take on the form of the definitive transsexual experience, a transsexual rite of passage, as if it were the surgery that makes the subject most fully a transsexual.[47]

Prosser explores the relationship of the transsexual to the medicalization of the body, but he never allows the gender-reassignment process to exist outside of the parameters of pain, an implication of illness and powerlessness. Although he seems to be arguing against the overt incorporation of the surgical body (in pain) as *the* rite of passage for the transsexual, he overrides his argument by emphasizing the pain of the pre-reassignment body, so that the transsexual must opt for one form of pain in order to override another: "It is as though the experience of . . . surgery and the compulsion to undergo it were the symbolic vehicle for transsexual transformation—the identifying marker of transsexuality—as much as its mechanics; for this corporeal distress is surely nothing next to that of the prereassignment body."[48]

This emphasis on the pain involved in the surgical process is in direct contrast to Orlan's refusal to admit that her surgical woman-to-woman transsexual performances are painful. The question then becomes, are psychic and/or physical pain required in order to legitimate the surgical alteration of the body? In Prosser's text (and among my peers whom I consider progressive feminist thinkers), the presence of pain does seem to legitimate the intervention of surgical transformation. Having now presented my thoughts on Orlan's work in many public forums—classrooms, dissertation groups, lectures, and the like—I have found that the most frequent response to Orlan's work from the feminist community is a profound revulsion toward the use of elective cosmetic surgery.

Orlan's divestment of pain allows her work to move beyond the equation "pain legitimates surgical transformation" and into a more complex register: the body as manipulable art material. Orlan's recognition that one must step out of the register of pain in order to interject her body into the praxis of art is also recognized by Tanya Augsburg. Augsburg says that Orlan's recognition of pain would not allow the focus of her performances to go beyond her individual body, because the recognition of pain would implicate Orlan as hysterical, allowing a dismissal of her work.[49] Orlan's carefully calculated antihysterical stance is directly linked to her refusal to acknowledge pain.[50]

Interior / Exterior

"I" is an other [*Je est un autre*]. I am at the forefront of confrontation.

—Orlan, "Conference"

The body of the sacrifice by definition is perpetually *losing face*—undergoing a process of effacement.

—Camilla Griggers, "The Despotic Face of White Femininity"

While watching Orlan's surgical performance *Omnipresence,* I became acutely aware that as soon as one looked inside of her body, a ubiquitous principle took hold: when an individual's body is opened up, there is a maiming that takes place that crosses the boundaries of the material body.[1] From the point of view of the spectator, a deconstruction of identity comes into play as well.

In 1998 Elizabeth Grosz noted in her lecture "Naked" that representation of any kind is almost like "a second skin."[2] This skin, the skin of the paint, stone, photograph as a container and a boundary between interior and exterior, implores one to become engaged, because it is also a conceptual passageway between the interior and exterior of the image. In other words, although what is materially manifest renders the physical interior of an object of art inaccessible, the exterior of any given image implicates a conceptual interior.

The skin of representation might be defined as the boundary between engaging with an image and simply walking by it, rendering it unnoticed. As beholders, when we engage with an image we conceptually penetrate its skin. The result is that our experiences of it are manifest as authentic, for when one lacerates this skin of representation in order to reveal the secrets that inhabit the interior of the rendering, one reveals layers of meanings that trigger an interaction between viewer and image—a performative interaction.

THE BODY AS RECEPTACLE FOR ARTISTIC INTERVENTION

That Orlan makes the private public is germane to her work. Juxtaposed with the stoic quality she uses to hide suffering and pain—"Saint Orlan's" performance of

martyrdom—she prods the politics of feminism by indulging her audiences with un-
censored images of the interior of her own body while engaging in what might be
termed the decadence of cosmetic surgery. Orlan's sacrifice of herself to art is also auto-
mutilation. As a response to her own automutilation, Orlan expects her audience to
be recalcitrant. She recognizes the difficulty in watching her performances and claims
it is not she, but those who witness, who experience the horror of her automutilation:

> A few words . . . on these images. . . . Sorry to have to make you suffer, but know
> that I do not suffer—unlike you—when I watch these images. Few images force us
> to close our eyes: death, suffering, the opening of the body, certain aspects of pornog-
> raphy (for certain people), or for others, birth. Here the eyes become black holes into
> which the image is absorbed willingly or by force. These images plunge in and strike
> directly where it hurts, without passing through habitual filters, as if the eyes no
> longer had any connection with the brain.[3]

When Orlan shows footage of her work at conferences, she begins with such an expla-
nation and then, when the video footage ends, says, "[I]f there are still some people
left in the hall, we can exchange ideas and have a discussion."[4] She also recites selected
passages during her performances, among them a quotation from Michel Serres, which
distinguishes between those audience members who "will have left the auditorium,
tired out by ineffectual theatrical effects, irritated by the turn from comedy to tragedy,
having come to laugh and deceived at having been made to think" and those audience
members who are "knowledgeable specialists."[5] About Orlan's recitation of this quota-
tion from Serres, Tanya Augsburg's point is apt: Orlan is condescending to those who
cannot endure her performances and mocks "those scholarly types who try to catch
up with Orlan and/or to become experts on her art by virtue of their learning or
authority."[6] Orlan forces the audience members to experience her artwork through an
embodied reaction. As art critic Michelle Hirschhorn writes:

> Like Artaud, who proposed an understanding of consciousness that would reverber-
> ate throughout the entire anatomy, Orlan locates the body as a primary site for both
> the production and reception of artistic intervention. . . . Orlan's practice may be
> extreme, but in a world of extremes such a methodology becomes increasingly imper-
> ative. Orlan's work has effectively entered the minds through the bodies of the audi-
> ence; the resulting dialogue being one of her most important achievements. Rather
> than turn away because her technique makes us uncomfortable, we should use it as
> a catalyst for further debate.[7]

The following discussion indicates how Orlan's technotheater engages (even while she
repels) the audience that she requires.[8]

Before the surgery takes place in the video *Omnipresence,* a large group of re-
porters hover inside the operating room. Connie Chung makes herself visible to the

documenting camera exhibiting a dubious facial expression. When the surgical preparations begin, the press leaves at the request of the surgeon. As they leave Orlan says, "I open the window so that all of the people in the world can share with me in my operation." One of the properties of representation is that viewers are required to experience the representation. In this case, Orlan stages her performances so that viewers' responses to her images act as a mirror to the artist, who is also experiencing being a viewer, as well as a representation, an art object, and an artist/director. Viewers are incorporated into the meaning of this work as part of a feedback system. Designed to incite and incorporate public response both during and after the performance surgeries, the performances would be grossly lacking without this feedback loop. Orlan articulates the importance of dialogue resulting from experiencing *La réincarnation de Sainte-Orlan*: "[M]y present objective is to produce and show the work that has come out of the preceding operations, making known this performance's processes of construction and discussing the issues with as wide a public/audience as possible."[9] The discussions Orlan refers to are a continuation of the feedback loop she is creating. As Augsburg notes, "Her art demands of her audience that we witness her self-awareness not only of her surgery but of *us* looking at her. In other words, Orlan not only returns the viewer's gaze, but expects—if not demands—that her recognition of us be in turn recognized by each individual."[10]

ORLAN AND ANTONIN ARTAUD

Reminiscent of Antonin Artaud's "theater of cruelty," in which he considered the body a resource for as well as a place of revulsion, in Orlan's *Réincarnation* the body collides with performance.[11] Orlan locates the body as a site for the consciousness to resonate as a result of artistic intervention in a performance *of blood*, which does *something bodily* to both the performer and the spectator. The suffering, however, is experienced in the spectator; the artist has a numb body, created with local anesthetic injections, which allow her to speak and give direction to her performances.[12] Artaud, in his poem "To Have Done with the Judgment of God," visualizes the body without organs as a body free from the weight of corporeal existence. Artaud calls out:

—By placing him again, for the last time, on the autopsy table to
 remake his anatomy.
I say, to remake his anatomy.
Man is sick because he is badly constructed.
We must make up our minds to strip him bare in order to scrape
 off that animalcule that itches him mortally,

 god,
 and with god
 his organs.

For you can tie me up if you wish,
but there is nothing more useless than an organ.

When you will have made him a body without organs,
then you will have delivered him from all his automatic reactions
and restored him to his true freedom.[13]

Artaud, claiming that he had "only one occupation left: to remake [him]self,"[14] spoke of the mind as a physiological substance which was volatile and fugitive. His project was tangential to the surrealist belief in the irrational as the truth of consciousness.[15] The surrealist André Breton, for example, believed that the irrational would lead to a new mental continent, whereas for Artaud the irrational molded his martyrdom.[16] Contributing to his martyrdom was Artaud's profound revulsion of his body, "unstable, made out of meat and crazy sperm."[17] His forsaken body, riddled with pain and desire, would achieve purity only as a body without organs—the body that would allow Artaud to both abandon and transcend his corporeality, even while he insisted that he was nothing but a body: "Artaud . . . knew that there is no mind, but a body, that remakes itself like the meshing of a dead man's teeth, in the gangrene, of the femur, within."[18] His body without organs would potentially produce a body without hysteria.

Gilles Deleuze and Félix Guattari, in *A Thousand Plateaus*, expound on Artaud's notion of the body without organs and give it the signifying code "BwO." Their description of a BwO is graphically layered and attacks Freudian psychoanalysis as a generalizing interpretive machine. For example,

[t]he BwO is what remains when you take everything away. What you take away is precisely the phantasy, and significances and subjectifications as a whole. Psychoanalysis does the opposite: it translates everything into phantasies, it converts everything into phantasy, it retains the phantasy. It royally botches the real, because it botches the BwO.[19]

During Orlan's surgical performances, her anesthetized (and ahysterical[20]) body, as "what remains when you take everything away," might be seen as a direct enactment of Deleuze and Guattari's BwO, as well as a literal performance of Artaud's desired body without organs. ("When you will have made him a body without organs, / then you will have delivered him from all his automatic reactions / and restored him to his true freedom.") The anesthetized body, as a sculptural medium, discloses a maximum number of possible forms, manifesting one definition of artistic freedom.

Most importantly, Orlan creates her own version of a body without organs by exhuming a fantasy that doubles back and materially superimposes itself onto her given body to form a multivalent incarnation. In other words, she disinters fragments from art historical images that are both representations of bodies without male organs and

representations of the fantasies of male artists, just as she disinters the interior of her own body as both a personal and a nonpersonal representation of itself. In a gesture of doubling back, she then inters the selected fragments of art historical images, by implanting them into her body. Thus, she creates what might be termed a "bWo," the capital *W* a signifier of the word *without*, doubling back also as a signifier for the word *with*. This double *W* (the second *W* imperfectly slapped over the first *W*) also aptly indicates Orlan's (W)oman-to-(W)oman transsexualism and maps a layered distortion of her physiognomy that occurs as a result of *the superimposition of the material and the fantasized.*

In addition to a temporal facelessness that occurs at the intersection between two moments—the moment the skin is lifted from Orlan's face and the entire duration of her performances (which to date have no completion)—it is during her performance *Omnipresence* that Orlan's facelessness interacts with the bWo. The facelessness, manifest at the moment the skin is removed and revealed as a malleable mask, doubles as an act of unveiling the interior of the live face. From the beholder's perspective, watching various segments of the video documentation, the opened body is sometimes identifiable as Orlan's and sometimes unidentifiable as belonging to one individual. The opened body lies on the cusp of identity. A horror exists in the possibility that Orlan's unique body, publicly flayed, stripped, unveiled, might become unidentifiable not only to the beholders but also to her. In other words, witnessed as a public performance, Orlan's personal body appears to become nonpersonal at the same moment that identity is called into question. The very notion that the human body might *bear* a potentially malleable mask calls up the possibility of the erasure of identity at the instant the potential for identity is revealed, because the mask implies a covering of features in order to conceal one identity while bestowing a new one. It is the trickery of the mask that fosters Orlan's bWo (the collapsing of fantasy into the material realm) which is successfully manifest, and not "botched," in Orlan's surgical-performance videos; via her body, she conjures up a temporal and spatial realm where mask and face—the fantasy of the face and the materiality of the face—interface with one another. In other words, Orlan insists on being recognized as "*more than just a body.*"[21]

ORLAN'S bWo (body With/Without organs)

In characterizing Orlan's bWo, first, Orlan as the defiant, subversive artist creates a bWo by superimposing the material and the fantasized while remaining linked to a conceptual paradigm that is a trajectory of Artaud's vision of transcending his extravagantly martyred body (separating the material and the fantasized).[22] Her body of art explodes the polar opposition between the fantasized body and the material body by insisting on maintaining their superimposition upon one another and thereby acting out a cultural struggle as well as an artistic one. There is still no way to represent the imperfect body without implying the perfect body, even though in thinking about bodies we may no longer accept the notion that God created us in "his" image. As

Nicholas Mirzoeff says, "[T]he tension between the imperfection of the body in itself and the idealized body in representation is a condition of its representation."[23] Most specifically, the female body, rendered as perfection in art, has historically been the literal site of a profoundly male interpretation of imperfection. This dichotomy between the woman's idealized body in art and the natural woman's body as a site of imperfection is one source of Orlan's work.

Second, the stuff of the bWo is the medicalized, anesthetized body that Orlan surrenders to the surgical procedure while at the same time rebelling against surgical protocol by directing the operation as a performance. This body participates in a significant history of the publicly performed dissection and medical theaters, particularly as they pertained to women's bodies, which were cut open in order to *see* the otherwise invisible female organs.[24]

Third, Orlan asserts the image of an alterable identity, which is outside of the bounds of the historical male/female binary. Through excavation and metamorphosis, Orlan's explicit disavowal of the binary system threatens its hegemony. She does this by imposing a visage that can be seen only as variable. Orlan fragments the Cartesian mapping that equates the male gender with the mind and the female gender with the body, in order to rearrange its meaning into one not encoded as a polarized structure.[25] The fragmentation, made from rupturing male bodies of work and rupturing the female body of the artist, produces images of an identity with ripped and blurred edges, particular in its insistence upon remaining unfixed as an image, as an identity, as a body with(out) organs. Orlan's representation of her image outside of the binary structure is of a body that does not flow in a trajectory that establishes the other end of an opposition but, rather, flows in the sense that it always appears to be in the process of forming. Thus, Orlan's enactment, no longer a fantasy, produces a type of resistance to the culturally constructed body by materializing it. Susan Hekman poses this question to Susan Bordo: "[I]f our resistance to the cultural construction of the body cannot appeal to a 'real' or 'natural' body, and thus, that resistance is also a cultural construction, then how can it be effective as resistance?"[26] Bordo replies: "[T]he development of a critical attitude is more important than the question of where resistance originates or what it appeals to." Bordo's response is in keeping with the Foucauldian attitude that one must interrupt entrenched discourses and excavate their "human origins" in order to expose their "necessity" as a lie.[27]

INTERIOR/EXTERIOR: MARSYAS, THE BODY'S RELATIONSHIP TO IDENTITY

Marsyas was a mythological Phrygian demigod who witnessed his own flaying. Sometimes Marsyas is portrayed as a silenus or satyr, sometimes as a young man who played the flute and accompanied Cybele.[28] One day Marsyas found the flute that Athena had invented, tossed away, and cursed when she realized how her face became puffed and contorted while playing. Marsyas, already a skilled musician, soon mastered the beautiful-sounding flute. His seductive flute playing angered Apollo, who challenged

him to a contest, the victor of which could do anything he pleased with the vanquished. Apollo won the contest and had Marsyas flayed alive—his body hung on a pine tree, his skin kept entirely intact and nailed to the tree next to the flayed body. This myth allegorizes the struggle of the Greeks to subdue Phrygia, east of Troy in Asia Minor, where Cybele and Marsyas were worshiped. As the story goes, the flayed skin of Marsyas was consequently hung in a cave where the river subsequently named Marsyas rose. The Phrygians recognized the skin as a resurrection of their god. This is significant because, for the Phrygians, Marsyas's skin, rather than his body, was *recognized* as an indicator of his identity.

Psychoanalyst Didier Anzieu believes that the myth of Marsyas discloses a specific psychological substance that he terms the "skin ego," the tactile envelope of the body.[29] Regarding Marsyas, he writes: "There is in this [myth of Marsyas] . . . the intuition that a personal soul—a psychical Self—subsists so long as a bodily envelope guarantees its individuality."[30] Anzieu's theory is derived from Freud's writings: "The ego is first and foremost a bodily ego: it is not merely a surface entity, but is itself the projection of a surface. . . . The body itself, and above all its surface, is a place from which both the external and internal perceptions may spring. It is seen in the same way as any other object, but to the touch it yields two kinds of sensation, one of which is equivalent to an internal perception."[31] Split in two—between the interior as the projection of the surface, and the exterior as the corporeal surface—the ego exists as an interlocutor between external and internal experience. According to Freud, the stability of this relationship is essential in order to maintain identity.[32]

Marsyas, like Saint Bartholomew, is flayed alive. However, his identity shifts from his still-live body to his flayed skin, the envelope that retains his identity. The skin as identity is emphasized in Ovid's telling of the tale, in which Marsyas cries in agony, "Who is it that tears me from myself?"[33] Here the topic of identity is deemed an attribute that slips or shifts into a realm of unrepresentability. The sublime, as defined by Kant, arrives when the imagination is asked to grasp something it cannot.[34] Thus, the relationship between the idea and its object breaks down in, for example, a moment of great horror. This aspect of the Kantian sublime is enacted in the myth of Marsyas. In essence, the "decrypting" of the internal viscera of the body ensures a death of the body, but it also ensures a transference of identity onto the exterior. There is a betrayal in this transference that is inevitable. The betrayal is rooted in the unrepresentability of the interior. This betrayal of the skin to the interior of the body can be likened to the form of a crypt, whose function is to harbor inside that which cannot be externalized.[35] Likewise, the crypt reveals itself only in its exteriority. As Derrida states in the foreword to Nicolas Abraham and Maria Torok's *The Wolf Man's Magic Word: A Cryptonymy*, "[T]he crypt's parietal surfaces do not simply separate an inner forum from an outer forum. The inner forum is (a) safe, an outcast outside inside the inside."[36] Harboring this thought, one can discern the interior of the body as an outcast when decrypted. As an outcast, the exhumed corporeal interior is unrepresentable simply because it does not remain interior. Also, the body, now torn in two, cannot in and

of itself become two. At this point of separation, the interior, no longer serving as the interior, is eliminated as waste from the identity of the body. The identity of an individual, portraying the self to the exterior, is transferred to that encasement which remains exterior: the skin. Cast out of its skin, cast out of its identity, the interior of the body alone remains the outcast to representability—something that it can never participate in as the interior.

The myth of Marsyas conjures up this connection between identity (which implies the property of representability) and the unrepresentable. Unrepresentability, then, is a key factor in determining the opposition between the exterior and the interior. The relationship of exteriority to interiority is a mimetic revelation of something that can't be revealed. In Deleuzian terms, this relationship is enacted in a surface event that is the revelation of something hidden, because the exterior and the interior exist only relative to one another.[37] Such an event is carried to its opposite extreme in the case of Marsyas, whose skin no longer hides anything. In the myth of Marsyas, the relationship of the interior to the exterior of the body is reversed. This reversal is also enacted in the surgical performances of Orlan.

FILM: WOMEN AND REPRESENTATION

Also worth noting here is the psychoanalytic feminist theory regarding the understanding of the economy of representation, particularly representations of women in art, video, and film. Feminist film theorist Jill Dolan says, "As many feminist film theorists have shown, it is the exchange of women between men—buttressed by psychoanalytic processes that reify gender positioning—that works to deliver gender enculturated meanings through representation."[38] She identifies the basic assumption of feminist criticism: "that all representation is inherently ideological."[39] As materialist feminists Judith Newton and Deborah Rosenfelt explain:

> Ideology . . . is not a set of deliberate distortions imposed on us from above, but a complex and contradictory system of representation (discourse, images, myths) through which we experience ourselves in relation to each other and to the social structures in which we live. Ideology is a system of representations through which we experience *ourselves* as well, for the work of ideology is to construct coherent subjects.[40]

In other words, ideologies construct and enforce societal structures. For example, feminist film theorist Laura Mulvey articulates the position of the spectator: that women are to-be-looked-at and men are to-look, recognition that the (white) male is the privileged spectator in classic Hollywood cinema.[41]

The feminist film theorist Teresa de Lauretis writes that in classic film male desire objectifies women and informs the narrative. Thus, the female spectator has an "untenable" rapport with this representation. If she identifies with the objectified (passive)

woman, she is masochistic, and if she identifies with the male (hero), she is in collusion with her own duplicitous objectification.[42] Dolan explains that the untenable situation of the female spectator makes her a conduit of phallic exchange: "The woman spectator finds herself, once again, the site of the conduit for an identificatory relationship between men, a gift in a male exchange that does not benefit her at all."[43]

Mary Ann Doane, another feminist film theorist, in response to the objectification of women in Hollywood cinema, states that there are three spectatorial relations woman can assume vis-à-vis filmic images of women created for the male spectator: she can adopt the position of the male, she can take on "the masochism of over-identification or [she can enter into] the narcissism entailed in becoming one's own object of desire, in assuming the image in the most radical way." Doane claims there is an "over-presence of the image" for woman—indeed, "she *is* the image."[44] This over-presence exists because, Doane argues, women, unlike men, maintain a pre-oedipal bond with their mothers throughout their lives. Thus, they are unable to distance themselves from images of women created in the filmic context, for the male voyeur. In "Film and the Masquerade: Theorizing the Female Spectator," Doane suggests that feminine masquerade is one way for women to gain distance from their images: "The effectivity of masquerade lies precisely in its potential to manufacture a distance from the image, to generate a problematic within which the image is manipulable, producible, and readable to woman."[45] This occurs because, with the masquerade, femininity is recognized, acknowledged, and performed as a construct.

In her book *Deviant Eyes, Deviant Bodies*, Chris Straayer challenges Doane. Straayer does not question that the female masquerade posits femininity as a construct, but she does ask the question, if it is a construct, "what is behind the mask?" She posits that "a man is behind the mask—not an essential man but rather, *like other men,* one who is constructed":

> I suggest that most if not all women do want to be men, which is not to say they want a penis (that is a sexual matter) but that they want to share men's position in the social realm (which is not simply a sexual matter). Not only do women want to be men, but by this very desire, women are men, men disguised by men as their opposite and thus denied power. The "fact" of sexual difference rests on nothing but the construction of femininity and masculinity. Through femininity, man creates his opposite gender, a nonbeing that psychoanalysis would posit as both mask and womanliness. . . . The woman behind the mask is a man . . . because she consciously manipulates social codes.[46]

Straayer's assertion points toward a confusion between social and sexual difference that often occurs in Doane's theory.

Feminist psychoanalytic theory identifies the gendered gaze inherent to representation and deconstructs the exchange (in film) between the male hero and the male spectator, and the problematic exchange between the objectified female representation

and the female spectator. Psychoanalytic feminist criticisms of representations in film, art, performance, and so on generally include the social and political structures that inform the representation. Thus, the criticism of one representation is inclusive of a cultural analysis.

IDENTITY AND THE CLOSE-UP: WHAT HAPPENS WHEN THE FACE IS FLAYED?

Because Orlan's performance surgeries are always experienced by the viewer as televised live or video-documentary footage, one cannot dismiss the impact of the filmic format, which includes close-ups, pans, zooms, and cuts. The choices made by the cameraperson and editor prove significant in the final outcome of Orlan's work. From a feminist psychoanalytical perspective, what is the meaning of the close-up of the woman's face in cinema juxtaposed with the close-up of Orlan's flayed face in her video footage of *Omnipresence* (Plate 15)?

Psychoanalytic feminist critics such as Mulvey and de Lauretis have identified the spectatorial relationship to filmic representation as gendered and based in ideological structures that reinforce social-sexual dynamics, that is, the female as the object of exchange between men.[47] Feminist critic Dolan writes that feminist performance has confronted the challenge to expose the "gender enculturation promoted through the representational frame and . . . [to] belie the oppressions of the dominant ideology it perpetuates."[48] The feminist performances that have most ruthlessly confronted this challenge include those of artists who have utilized their own bodies for the purposes of severing oppressive gender roles by working within the oppressive structures at hand—for example, Valie Export's *Body, Sign, Action* (1970), Eleanor Antin's *Carving: A Traditional Sculpture* (1972), and Annie Sprinkle's *Post Porn Modernism* (1989) (Figure 30, chapter 5).[49] Orlan also confronts this challenge from within; as she questions the meaning of individual (and gendered) identity, she performs the undoing of her own identity via cosmetic surgery. In *Omnipresence,* the points at which individual identity becomes tenuous occur during the close-up shots of Orlan's flayed face.

Orlan's *Saint suaire n°9* (Holy Shroud No. 9) is a photographic transfer of Orlan's face onto blood-soaked gauze (Plate 11). A derivative of the shroud of Turin, Orlan's face is colorfully replicated on a piece of fine, torn mesh. This image, which is shown during the eighth surgical performance (in 1993), is a visual notation: the face doubles as a veil that can be removed. But, with reference to Orlan, the face might also double as a mask.

So which best refers to the face, the veil or the mask? The veil, a metaphor for the skin—or, rather, a second skin—insinuates that what is under it (the veil/skin) constructs identity. The veil, unlike the mask, does not replace identity with the contours of a new one, it simply obscures what lies beneath it. Therefore, the mask as skin would reverse this equation of identity, because the mask also formulates another identity while obliterating the one that it conceals. However, even this relationship becomes confused: a mask is a type of veil, meaning that both conceal; and a veil is a

type of transparent mask, which does not completely hide the identity of the individual but partially reveals it. Both metaphorically *lift* the face from the body. Orlan, in *Saint suaire*, metaphorically lifts an image of the face from the body.

Orlan's *Saint suaire* is only one of her gestures of "lifting" the face. A turn occurs when the mask / veil-as-skin metaphor becomes a skin-as-mask / veil literalization—Orlan's face is cut from her head and lifted by the surgeon. For the purposes of clarification, the skin of the face does not biologically complete one's face; the skeleton is also required. This is emphasized as the implants that are placed under Orlan's skin reformulate the contours of her face and identity. Visually, however, the images of Orlan's flayed facial skin suggest the momentary (or permanent?) elimination of her face and her identity, in the manner of Marsyas. This bizarre phenomenon is punctuated in the extreme close-up images of the flayed face, when all other references to Orlan's identity—the operating room, her body, and unflayed sections of her face—remain outside of the frame of the video screen (Plate 15). (The specific extreme close-up images that I am describing occur several times within *Omnipresence* and do not include sections of Orlan's face that have not been flayed. Within the frame of the video screen are flayed skin and the interior of the face, muscle and bone generously covered with blood, and the effectively amputated hands of the surgeon who is doing the flaying.) Intellectually, of course, one understands that this mass of interior corpus belongs to Orlan. But the momentary visual viscera, devoid of identity, are striking. More than just sensational, the ripping apart of Orlan's identity is successfully achieved during these close-up moments. In other words, that we are viewing *Orlan's* skin, blood, bone, and muscle does not factor into the visual motif. This phenomenon is a testament to the power of ocular perception, which in this case overrides the circumstantial parameters of the performance. Finally, the fragility of identity is exhibited as a visual motif.

These close-up moments might be described, then, as the opposite of the portrait, traditionally an image of an identity that is created for the sake of preserving that identity throughout time. Likewise, within cinema exists the quite contrary relationship of the close-up of Orlan's flayed face to the notion of the filmic close-up, which serves the function of portraiture insofar as it is meant to be a moment of complete recognition.

So Orlan's performative close-up-of-flayed-face moments complicate the relationship of the spectator to the representation. The complication arises first as a moment of self-reflection. Do the spectators momentarily identify with the subject Orlan as she becomes an unidentifiable object, body stuff? (A possible inner dialogue of any viewer might be, "That could be me. That is not me, but the interior of my body looks like that. It is made of that same stuff.") Or do the spectators keep trying to inform themselves that this body stuff being represented belongs to the artist named Orlan? Regardless of the content of the thoughts, the self-reflexive response of the viewer also takes the form of a body response. The anxiety provoked by the possibility of a biologically removed identity is not dismissible until the skin once more covers

the face.[50] In other words, the anxiety of viewing these flayed-face close-ups, for me, is experienced as a *lack*—a face which *lacks* identity.

Most importantly—and not surprisingly, given that Orlan's work enacts opposition—during the performances, including the flayed-face close-ups, Orlan, while presenting the motif of lack I have described, also rigorously resists this lack. The resistance is present because Orlan is a conscious, thinking presence. She is there, staging a performance of *consciously being inside her body*: speaking, reciting text, giving direction to the translators and technicians working with her, responding to comments from her audience. As a thinking presence, Orlan refuses to allow viewers to obliterate her consciousness. In short, Orlan should be applauded for insisting that consciousness, rather than unconsciousness, be the text of her performance surgeries. Consciousness is her ultimate weapon against psychoanalysis. It allows her to preclude a diagnosis of psychological illness. As a conscious, sentient being, she interacts with her circumstances and demands that her performances not be reduced to the activities of a madwoman.[51]

Feminist film theorist Mary Ann Doane points out that "the visible in no way acts as a guarantee of epistemological certitude. Insofar as it is consistently described as a lure, a trap, or a snare, vision dramatizes the dangers of privileging consciousness. . . . There is a hole in the visible. What consciousness and the cinema both fail to acknowledge in their lust for plenitude is that the visible is always lacking." Doane then juxtaposes this axiom against an opposing axiom of classical cinema—"that the visible equals the knowable, that truth resides in the image." And yet, Doane continues, there does exist a slippage, which occurs in classic cinema where the visible does not equal the knowable. She contends that this specifically occurs in the close-up of the woman's veiled face.[52]

Briefly, Doane's argument goes as follows. The veiled face incorporates the viewer into an unstable position of knowing: "Only the cinema need give the uncertainty and instability of visible form."[53] She contends that the face, not accessible to the subject's own gaze except as a mirror reflection, is for the other. The close-up of the woman's face is, then, for the spectator; it belongs to the spectator, because it is unavailable to the woman herself. Most specifically, it is the *possession* of the male gaze.[54] (Lacan identified woman as the phallus; within the register of desire, she is an object of exchange between men. Within this feminist psychoanalytic-theoretical discussion, Doane is utilizing this Lacanian description of male/female relations, identifying the filmic close-up of the woman as an image to be *possessed* by the male gaze.) *But the veil serves as a protection against possession.* It is a disguise that both hides and reveals. In this regard the veil becomes the register of desire:

> [T]he veil incarnates contradictory desires—the desire to bring her closer and the
> desire to distance her. Its structure is clearly complicit with the tendency to specify
> the woman's position in relation to knowledge as that of the enigma. Freud described
> female sexuality as "still veiled in an impenetrable obscurity." In the discourse of

metaphysics, the function of the veil is to make truth profound, to ensure that there is a depth which lurks behind the surface of things. The veil acts as a trope that allows one to evade the superficial, to complicate the surface by disallowing its self-sufficiency. But what the veil in the cinema makes appear to be profound is, in fact, a surface. . . . [And yet simultaneously] the addition of a veil as secondary or surplus surface results in the annihilation of that depth which hides behind the face.[55]

In her videos, Orlan gives visual form to extreme instances of instability and uncertainty. Her references to her facial skin as both veil and mask are punctuated in the extreme close-ups of the flayed face. These moments are not visually resolvable, because with the filmic close-up we want a specific kind of knowledge—the knowledge of recognition, the moment when the individual is revealed, when the truth is revealed. But what we get is a mass of indecipherable, unknowable, *unpossessable* interior body stuff. Our gaze, and in particular the male gaze (in which females also participate), cannot possess this close-up of the female. Rather than veiling her face, she has unveiled it, and by doing so the trope "face as mask" has been solidified. Once the skin is replaced, Orlan's face continues to be seen as a mask. This phenomenon is due to the temple implants placed under Orlan's skin while it was flayed—the horns on her temples appear so foreign to the human form that her face, as part of her human form, remains unassimilable (a mask). Orlan's face as mask is punctuated in the images after the surgery, when we see her face healing and then finally healed. It has clearly changed. It will change again. And with the traces of surgery visible, the face does become a mask. It is this phenomenon that makes looking at Orlan so extremely unsettling: visually, her face, which we want to see as "face," no longer reads "face" but, rather, reads "mask."[56]

Doane states that the close-up of the veiled face in classic cinema does not allow the possession of that individual woman. This phenomenon triggers the desire to possess. The inclusion of the veil is directly correlative to a slippery dialogue between surface, depth, and truth.[57] Unlike classic cinema, in *Omnipresence,* Orlan's images occur in a real-time documentary format. Also unlike classic cinema, the relationship of the veil to the face is literalized—the veil as surface, facial skin. However, within the registers of lack and desire, surface and depth, possession and truth, Orlan's performances enact an extraordinary filmic moment. The representation of Orlan's flayed face deconstructs both the relationship of the face to female sexualized identity and the relationship of the face to individual identity. The element of sexual desire equated with the close-up of the woman is eliminated. The result is the inclusion of both a lack and an excess—a lack of sexual and individual identity, an excess of noninforming matter. During Orlan's performance surgeries, with the removal of the veil—the skin as veil—there is a total abandonment of the woman as an object of desire or as an object of possession, while at the same time there is an acceptance of the human body as object. This dynamic would tend to support Doane's contention that "[t]he veil, in a curious dialectic of depth and surface, reduces all to a surface

which is more or less removed, more or less accessible. It is not a privileged depth, interiority, or psychology of the woman which is inaccessible but her sexualized, eroticized, and perfected surface, the embodiment of pure form."[58] In the close-ups of Orlan, "the embodiment of pure form" is inaccessible because it is cut, flayed, and visually obliterated.

Thus, in the form of the filmic image, Orlan's work deconstructs the male gaze and the desire to possess the image of the woman by eliminating them in a very meaningful way: she completely desexualizes herself. By lifting the veil that doubles as her skin, Orlan reverses the significance of the close-up. She obliterates rather than reveals her identity.

Orlan's bWo is her gesture of stripping away the face as a superimposition of the material onto the fantasized. But finally, the only alternative is to replace the face. Within the context of individual identity, the live body cannot endure the unrepresentability of the exposed internal viscera portrayed in the myth of Marsyas. Orlan's face is torn in two—skin and visceral facial interior—only momentarily. What is represented is the fragility of identity. Removable and replaceable, within the context of her performance, Orlan's face continues to be understood as mask. Her surgical performance both ratifies and denies the existence of depth within an interior/exterior motif; Orlan sacrifices her body and her identity in these close-ups of her flayed face in order to confirm that interior depth exists as the externally exposed surface. She has nothing to hide. This formulation put within the context of the filmic image relinquishes itself to the topos of the cut—the cut from the scene of the performance to the extreme close-up. This is an aesthetic choice. The cut to the close-up is meant to reveal. But the revelation of what constitutes identity is not revealed in these close-up moments, when, except as a negation of identity, Orlan's face no longer refers to her identity.

Beauty / The Monstrous Feminine

> he struck
> While snakes and Gorgon both lay sunk in slumber,
> Severed the head, and from the mother's bleeding
> Were born the swift-winged Pegasus and his brother.
>
> .
>
> . . . And they wanted
> Still more, and someone asked him why Medusa,
> Alone of all the sisters, was snaky-haired.
> Their guest replied: "That too, is a tale worth telling.
> She was very lovely once, the hope of many
> An envious suitor, and of all her beauties
> Her hair most beautiful—at least I heard so
> From one who claimed he had seen her. One day Neptune
> Found her and raped her, in Minerva's temple,
> And the goddess turned away, and hid her eyes
> Behind her shield, and punishing the outrage
> As it deserved, she changed her hair to serpents,
> And even now, to frighten evil doers,
> She carries on her breastplate metal vipers
> To serve as awful warning of her vengeance."
> —Ovid, *Metamorphoses*

One reason many spectators find Orlan's work offensive and horrifying is that she performs between the boundaries of beauty and the monstrous. Within a binary code, one binary implicates the other. The Medusa myth allegorizes the collision of beauty and the monstrous feminine. Medusa's beauty brings on the rape of Neptune and the subsequent vengeance of Minerva, who transforms her into a Gorgon. The Medusa myth also embraces an alliance between representation and the gaze, which overflows with meaning. One does not endure the gaze unscathed—Medusa's demise begins with Neptune's gaze on her, resulting in his desire; her metamorphosis into a Gorgon then transforms to stone all others who gaze upon her.

FACIALIZATION

What is the relationship of the face to identity? Gilles Deleuze and Félix Guattari make the distinction between the body and the face as separate loci of individual identity:

> We can now propose the following distinction: the face is part of a surface-hole, holey surface, system. This system should under no circumstances be confused with the volume-cavity system proper to the (proprioceptive) body. The head is included in the body, but the face is not. The face is a surface: facial traits, lines, wrinkles; long face, square face, triangular face; the face is a map, even when it is applied to and wraps a volume, even when it surrounds and borders cavities that are now no more than holes. The head, even the human head, is not necessarily a face. The face is produced only when the head ceases to be a part of the body, when it ceases to be coded by the body, when it ceases to have a multidimensional polyvocal corporeal code—when the body, head included, has been decoded and has to be overcoded by something we shall call the Face.[1]

This description of the face as a "holey surface, system" also insinuates that it is a two-dimensional, disembodied fragment: "surface," "square," "triangular," "a map," "the face is produced . . . when it ceases to have a multidimensional polyvocal corporeal code." To eliminate a multidimensional polyvocal corporeal code, in order to still the face so that it can be recognized, Deleuze and Guattari perform a radical reduction. They examine the photographed face, the unchanging image, the filmic close-up, which is merely an abstraction, or mirroring, of the biological face.

Further, Deleuze and Guattari propose, within representation, the "white wall / black hole" as an abstract machine that produces faciality: "[T]he black hole / white wall system is, to begin with, not a face but the abstract machine that produces faces according to the changeable combinations of its cogwheels. Do not expect the abstract machine to resemble what it produces, or will produce."[2] They go on to explain that facialization, the product of the abstract machine that produces faciality, does not necessarily occur exclusively on the face. The landscape, for example, can be facialized. Specifically, Deleuze and Guattari say, "[t]he close-up in film treats the face primarily as a landscape; that is the definition of film, black hole and white wall, screen and camera."[3] Also, the body can be facialized; it "comes to be facialized as part of an inevitable process. When the mouth and nose, but first the eyes, become a holey surface, all the other volumes and cavities of the body follow. An operation worthy of Doctor Moreau, horrible and magnificent. Hand, breast, stomach, penis and vagina, thigh, leg and foot all come to be facialized." But this facialization of the body is not merely a projection of the face onto screens and cavities of the body. It is not anthropomorphism. The machine of facialization is an unconscious, rather than a literal, machine.[4]

Camilla Griggers, in "The Despotic Face of White Femininity," expounds on Deleuze and Guattari's notion of this "white wall / black hole." It is, in her estimation, a system that allows the production of, for example, the white woman's face, the face that is exported and appropriated as the despotic face—the face of the fashion industry. The white woman's face is, as a product of the white wall / black hole machine, a two-dimensional and generic face. Griggers employs several examples of the face as generic surface. Her first example, a 1950 *Vogue* photograph by Erwin Blumenfeld, depicts a white screen with a woman's heavily black-lined left eye and eyebrow, painted lips, and beauty mark just to the left of the lips. This flattened image of the white woman's face connotes a surface, or a map. Her second example is Harry Harlow's scientific verification of the surfaceness of faciality, done in the 1950s. Harlow created a mother for baby monkeys by covering wire mesh with furry fabric to make the body and placing a white disk with black holes in it in place of the eyes, nose, and mouth as the face: "Whereas the proprioceptive body is all volume, the face is all *surface*," Griggers concludes.[5] Both of these examples are literalizations of Deleuze and Guattari's notion of white wall / black hole, the abstract machine of faciality. Placed on a two-dimensional plane, the white screen / black hole machine of faciality exhibits a surface that genericizes. As Griggers concludes, "Faciality is this machinic assemblage. . . . *Subjectivisation is facialization*, a social process that begins with the production of binary facial units."[6] These binary facial units include, for example, white or black, straight or gay, mad or sane.[7] And the binary facial units particularize the face by placing it in the realm of identification and individuation. One of Griggers's points is that the white wall / black hole machine plays a role in specifically naming the white woman as both a generic object and an ideal object that, for example, the fashion industry utilizes to represent beauty.

Griggers also comments that the images of Orlan's flayed face exit both realms of the binary facial unit—beauty and the monstrous—to the degree that she enters the terrain of nonhuman representation:

> Orlan broke away entirely from [the] semiotic overcodings of feminine beauty, whether artistic or popular, entering a realm of signs beyond the biunivocalization of the beautiful and the ugly, perhaps even beyond the register of the human. In her latest "performance," a surgeon lifts the skin of her face from her forehead to her chin off its underlying tissue. On video projection, one strains to see what lies beneath this face of Orlan, beneath the fragile layer of skin. What one finds there is nothing more and nothing less than blood and tissue. Orlan's face, lifted from the skull, bleeds the abjection of the organic.[8]

But, as Orlan's critics are quick to point out, her face also bleeds the abjection of sensationalist horror. I, for one, have never experienced this moment as "organic." Orlan's use of the abject is more elaborate than just an indulgence in sensationalism. Far beyond literally representing visceral and abject body materials, Orlan, as a white woman and

artist, surgically transforms herself into an ambiguous subject, potentially placing herself in an abject and marginalized relationship to society. But then, she does not discard her blood and body fat but frames them in reliquaries. Her recontainment of the body's abject materials enacts an alternative response to the abject—acceptance rather than rejection.

Griggers does go on to explain that the "face is not organic"; rather, it is a "social production, and as such it can be disintegrated from the organic body and reterritorialized as a more perfect expression of a socially constructed code."[9] In the case of Orlan, this socially constructed code includes the nonhuman figure Medusa. Via her exploration of ideal beauty, she embraces sensational representations of the female grotesque.

REPRESENTATION: MEDUSA AND BAUBO

Johann Remmelin, in his *Catoptrum microcosmicum* (1619), created an illustration that incorporates the head of Medusa into the schematic of the body (Figure 10, chapter 2). The artist rendered detachable internal organs that surround classically posed figures with broken-off limbs, atop sculpture pedestals. The placement of each detachable internal organ is significant. The brain sits just below a celebrated reference to Jehovah and above the heart; the womb, the fetus, and the female torso are nearest to the ground.

The burgeoning belief in science illustrated by Remmelin's drawing did not, however, cancel out the use of mythological metaphor. Most notably, the signifiers *male* and *female* are spelled out for us with the "name of the father," "Jehovah," inscribed in Hebrew in the top center of the illustration, counterbalancing the image of Medusa, which is rendered in lieu of the female genitals. Jehovah is in the celestial sphere, Medusa in the monstrous nether regions.[10]

So, what at first might appear to be an illustration of disorganized, dismembered bodies turns out to be categorically organized anatomies. The experience of this discovery—a journey from "the body in bits and pieces" to the complete body—is one that Lacan articulates as a universal human experience of the construction of self, via the mirror stage.[11] This early-seventeenth-century illustration can also serve as a precursor to the words of Freud, who links Medusa's head with the fear of castration:

> To decapitate = to castrate. The terror of Medusa is thus a terror of castration that is linked to the sight of something. Numerous analyses have made us familiar with the occasion of this: it occurs when a boy who has hitherto been unwilling to believe the threat of castration, catches a sight of the female genitals, probably those of an adult, surrounded by hair, and essentially those of his mother.[12]

Lacan describes Medusa as a force that empties the world of meaning when he describes Medusa's head as "[t]his something, which properly speaking is unnamable,

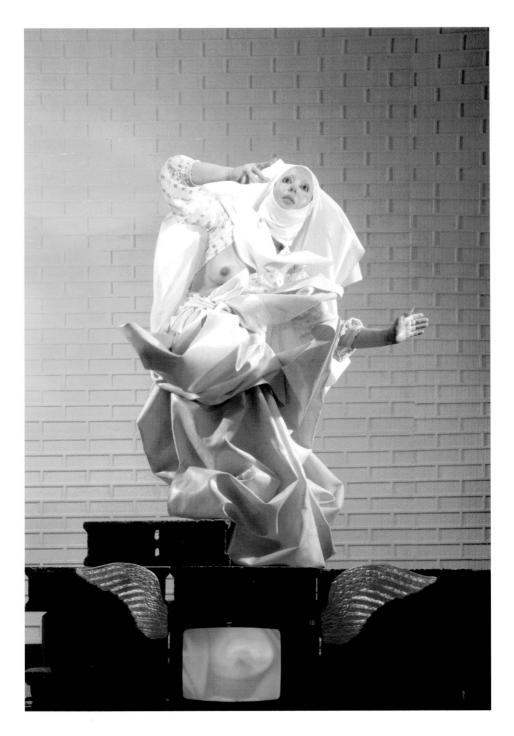

Plate 1. Orlan, *Skaï and Sky et Vidéo: Vierge blanche montrant le deuxième sein sur fond de briques jaunes, Ou Sainte Orlan en assomption sur un moniteur vidéo n°2* (Leather in the Sky with Video: White Virgin Projecting a Second Breast against Yellow Bricks; or, The Assumption of Saint Orlan on Video Monitor No. 2) (1983). Cibachrome on aluminum, 160 × 120 cm. Photograph by Jean-Paul Lefret for the school of photography Ace3P. Copyright 2003 Artists Rights Society (ARS), New York / ADAGP, Paris.

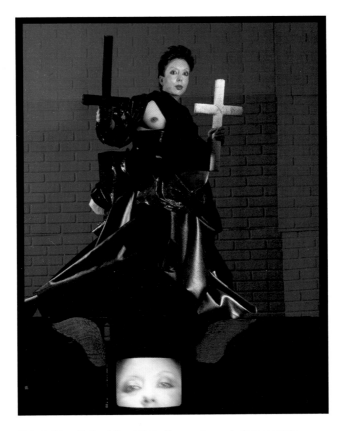

Plate 2. Orlan, *Skaï and Sky et Vidéo: Vierge noire manipulant une croix blanche et une croix noire n°24* (Leather in the Sky with Video: Black Virgin Wielding White Cross and Black Cross No. 24) (1983). Cibachrome on aluminum, 160 × 120 cm. Photograph by Jean-Paul Lefret for the school of photography Ace3P. Copyright 2003 Artists Rights Society (ARS), New York / ADAGP, Paris.

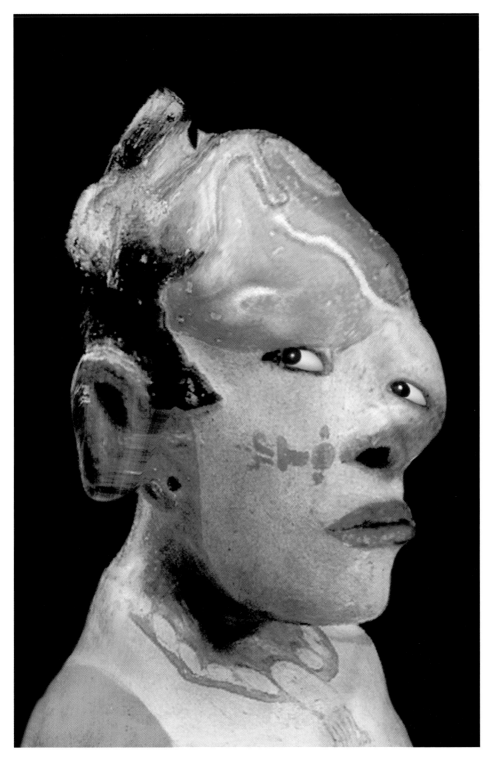

Plate 3. Orlan, *Défiguration-refiguration: Self-hybridation précolombienne n°4* (1998). Digital treatment: P. Zovilé. Cibachrome on aluminum, 100 × 150 cm. Copyright 2003 Artists Rights Society (ARS), New York / ADAGP, Paris.

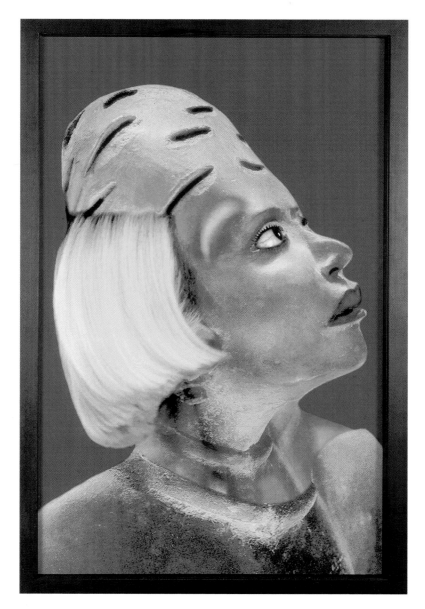

Plate 4. Orlan, *Défiguration-refiguration: Self-hybridation précolombienne n°2* (1998). Digital treatment: P. Zovilé. Cibachrome on aluminum, 100 × 150 cm. Copyright 2003 Artists Rights Society (ARS), New York / ADAGP, Paris. Collection of Fonds régional d'art contemporain (Frac) des Pays de la Loire, France. Copyright Frac des Pays de la Loire, France.

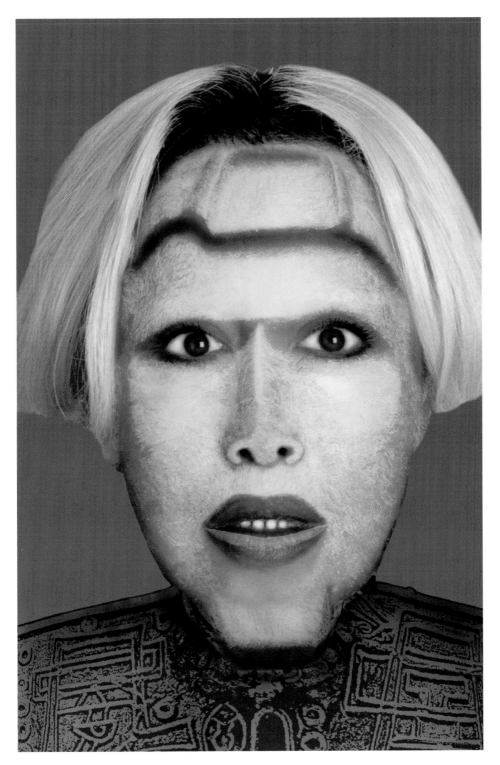

Plate 5. Orlan, *Défiguration-refiguration: Self-hybridation précolombienne n°22* (1998). Digital treatment: P. Zovilé. Cibachrome on aluminum, 100 × 150 cm. Copyright 2003 Artists Rights Society (ARS), New York / ADAGP, Paris.

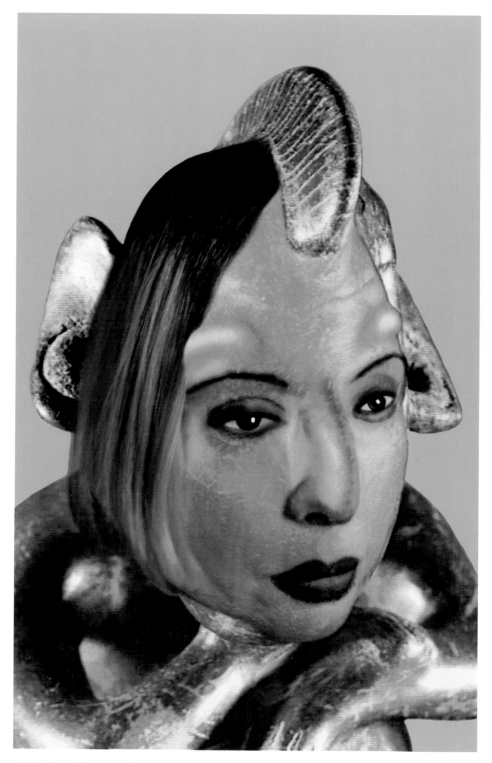

Plate 6. Orlan, *Défiguration-refiguration: Self-hybridation précolombienne n°28* (1998). Cibachrome on aluminum, 100 × 150 cm. Digital treatment: P. Zovilé. Copyright 2003 Artists Rights Society (ARS), New York / ADAGP, Paris.

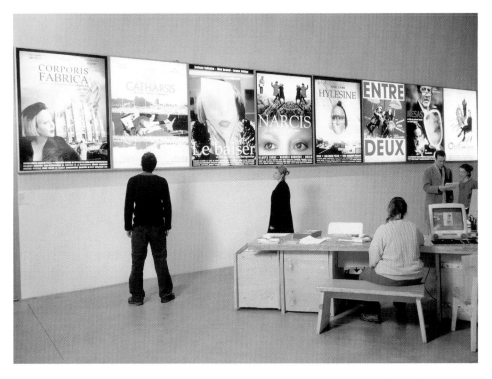

Plate 7. Orlan, *Le plan du film* (A Shot at a Movie) (2002). In Éléments favoris, retrospective exhibition at Fonds régional d'art contemporain (Frac) des Pays de la Loire, France, November 28, 2002–February 9, 2003. Copyright Frac des Pays de la Loire, France.

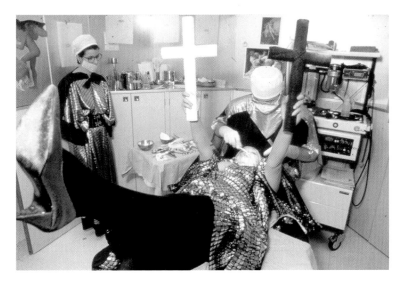

Plate 8. Orlan, *Manipulation de la croix blanche et de la croix noire pendant le geste opératoire* (Wielding the White Cross and Black Cross during the Operation). Photograph taken for the video created from images of the fourth surgical performance, *Opération réussie* (Successful Operation), December 8, 1991, Paris. Set design and props: Orlan. Costumes: Paco Rabanne, Paris. Cibachrome print, 1.10 × 1.65 m. Photograph by Alain Dohmé for Sipa Press. Copyright 2003 Artists Rights Society (ARS), New York / ADAGP, Paris.

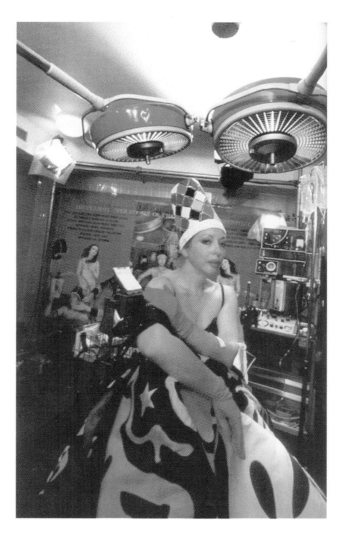

Plate 9. Orlan, images from the video of the fifth surgical performance,
The Cloak of Harlequin, July 6, 1991. Doctor: Chérif Kamel Zaar, Paris.
Set design and props: Orlan. Costume: Frank Sorbier. Orlan read an excerpt
from *Le tiers-instruit*, by Michel Serres. Cibachrome on aluminum, 110 × 165 cm.
Photograph by Alain Dohmé for Sipa Press. Copyright 2003 Artists Rights
Society (ARS), New York / ADAGP, Paris.

Plate 10. Orlan, *Reliquaries: My Flesh, the Text, and Languages* (1993). Soldered metal, burglar-proof glass, 10 grams of Orlan's flesh preserved in resin; each 90 × 100 × 12 cm. Copyright 2003 Artists Rights Society (ARS), New York / ADAGP, Paris.

Plate 11. Orlan, *Saint suaire n°9* (Holy Shroud No. 9) (1993). Photograph transferred to gauze soaked with blood, 30 × 40 cm. Photograph by Georges Merguerditchian. Copyright 2003 Artists Rights Society (ARS), New York / ADAGP, Paris.

Plate 12. Orlan, *Reliquaire de ma chair avec néon* (Reliquary of My Flesh with Neon) (1993). Orlan's flesh preserved in resin, neon, Plexiglas box, transformer, 40 × 40 × 6 cm. Photograph by Georges Merguerditchian. Copyright 2003 Artists Rights Society (ARS), New York / ADAGP, Paris.

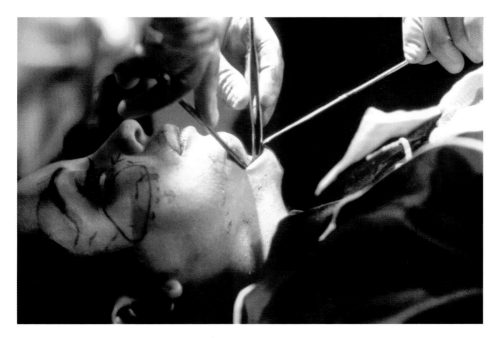

Plate 13. Orlan, *Omnipresence: Le deuxième bouche* (Omnipresence: The Second Mouth), seventh surgical performance, November 21, 1993, New York. Cibachrome in Diasec mount, 120 × 175 cm. Photograph by Vladimir Sichov for Sipa Press. Copyright 2003 Artists Rights Society (ARS), New York / ADAGP, Paris.

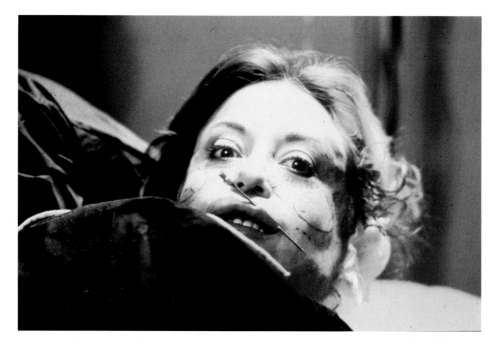

Plate 14. Orlan, *Omnipresence: Needle of Anesthetizing Syringe Sticks in Upper Lip*, seventh surgical performance, November 21, 1993, New York. Cibachrome in Diasec mount, 110 × 165 cm. Photograph by Vladimir Sichov for Sipa Press. Copyright 2003 Artists Rights Society (ARS), New York / ADAGP, Paris.

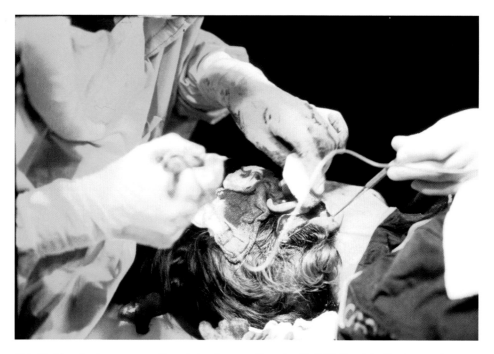

Plate 15. Orlan, *Omnipresence*, seventh surgical performance, November 21, 1993, New York. Cibachrome in Diasec mount, 165 × 110 cm. Photograph by Vladimir Sichov for Sipa Press. Copyright 2003 Artists Rights Society (ARS), New York / ADAGP, Paris.

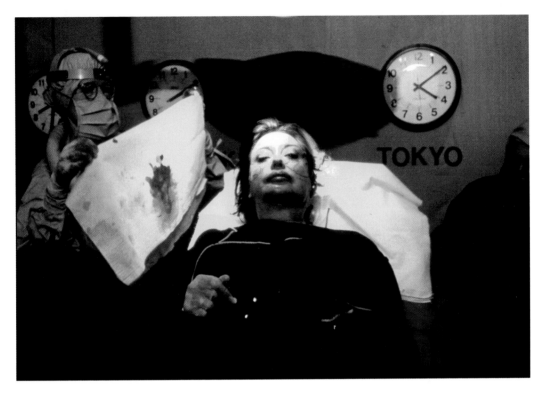

Plate 16. Orlan, *Omnipresence: Presentation by the Doctor of Blood Designs Made on the Yellow Sheet*, seventh surgical performance, November 21, 1993, New York. Cibachrome in Diasec mount, 165 × 110 cm. Photograph by Vladimir Sichov for Sipa Press. Copyright 2003 Artists Rights Society (ARS), New York / ADAGP, Paris.

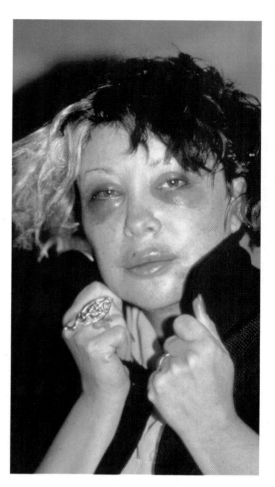

Plate 17. Orlan, *Portrait Produced by the Body-Machine Four Days after the Surgery-Performance*, November 25, 1993. Cibachrome in Diasec mount, 165 × 220 cm. Photograph by Vladimir Sichov for Sipa Press. Copyright 2003 Artists Rights Society (ARS), New York / ADAGP, Paris.

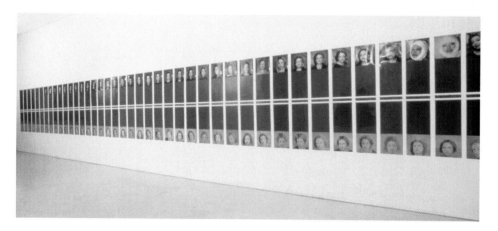

Plate 18. Orlan, *Omnipresence: No. 1* (1993). Forty-one diptychs of metal and eighty-two color photographs. Photographs by Raphaël Cuir (Orlan's face) and Alfons Alf (screens). Version no. 1, a work in progress presented at Sandra Gering Gallery, New York, just after the seventh surgical performance. Top row: daily portraits of Orlan's face as she heals after the seventh surgical performance. Bottom row: *Entre-deux* (Between the Two), forty-one self-portraits digitally morphed with those of classic beauties from the art historical canon. Courtesy of Sandra Gering Gallery, New York.

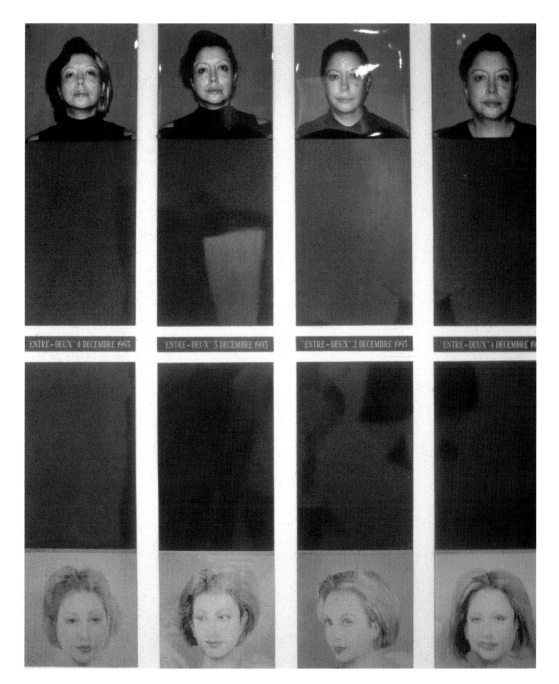

Plate 19. Orlan, *Omnipresence: No. 1* (detail) (1993). Forty-one diptychs of metal and eighty-two color photographs. Photographs by Raphaël Cuir (Orlan's face) and Alfons Alf (screens). Version no. 1, a work in progress presented at Sandra Gering Gallery, New York, just after the seventh surgical performance. Top row: daily portraits of Orlan's face as she heals after the seventh surgical performance. Bottom row: *Entre-deux* (Between the Two), forty-one self-portraits digitally morphed with those of classic beauties from the art historical canon. Courtesy of Sandra Gering Gallery, New York.

Plate 20. Orlan, *Official Portrait after Leaving Quarantine*. Final image from *Omnipresence: No. 1* (1993). Courtesy of Sandra Gering Gallery, New York.

the back of this throat, the complex, unlocatable form, which also makes it into the primitive object *par excellence*, the abyss of the feminine organ from which all life emerges, this gulf of the mouth, in which everything is swallowed up."[13] Medusa's decapitated head signifies an anxiety of sexual difference that traverses the centuries. But the anxiety also traverses the boundaries of sexual difference and flows into the realm of social structures. As David Hillman and Carla Mazzio point out, the un-nameable female part is always a threat to the order of meaning otherwise termed by Lacan the symbolic order of the Name of the Father.[14]

As the myth of Medusa goes, all who view her are turned to stone. This response, literally to be stunned, stilled in mid-action, allegorizes a bodily response to fear and horror. Neil Hertz, in his essay "Medusa's Head: Male Hysteria under Political Pressure," cites anecdotal representations of Medusa that indicate the hysteria of the French Revolution and that simultaneously access individual fears that the image of Medusa induces. His first example is taken from a description by Victor Hugo of the fighting during the June Days in 1848. Hugo begins: "The June uprising, right from the start, presented strange lineaments. It displayed suddenly, to a horrified society, *monstrous and unknown forms.*"[15] Hugo then describes the National Guard storming the first barricade set up at Porte Saint-Denis. After a volley of gunfire that left the road strewn with bodies of guardsmen,

> a woman appeared on the crest of the barricade, a young woman, beautiful, disheveled, terrifying. This woman, who was a public whore, pulled her dress up to the waist and cried to the guardsmen, in the dreadful brothel language that one is always obliged to translate: "Cowards! Fire if you dare, at the belly of a woman!"
>
> Here things took an awful turn. The National Guard did not hesitate. A fusillade toppled the miserable creature. She fell with a great cry. There was a horrified silence at the barricade and among the attackers.

Several correlations with the Medusa myth can be made here. This "beautiful" and "terrifying" woman visually exposes herself, which provokes the guardsmen to kill her. This in turn induces a "horrified silence" on both sides. But it also induces a second woman to attempt defiance:

> Suddenly a second woman appeared. This one was younger and still more beautiful; she was practically a child, barely seventeen. What profound misery! She, too was a public whore. She raised her dress, showed her belly, and cried: "Fire you bandits!" They fired. She fell, pierced with bullets, on top of the other's body.
>
> That was how this war began.
>
> Nothing is more chilling or more somber. It's a hideous thing, this heroism of abjection, when all that weakness contains of strength bursts out; this civilization attacked by cynicism and defending itself by barbarism. On one side, the people's desperation, on the other the desperation of society.

Hertz points out that the gender of the word *uprising (une émeute)* is feminine, so that within Hugo's text, "[w]hat the revolution is said to be doing figuratively ('It [*elle*] suddenly displaying monstrous and unknown forms to a horrified society') is precisely what—in a moment—each of the women will be represented as doing literally."[16] Thus, it is the representation of the woman's body that is uncontainable as just the woman's body. In "all that weakness contains of strength," her strength is manifest when she exhibits her weakness; her lacking, gaping anatomy. This is also an apotropaic act. Medusa's head is on the shield of Athena to ward off evil and danger. Freud writes:

> If Medusa's head takes the place of a representation of the female genitals, or rather if it isolates their horrifying effect from the pleasure giving ones, it may be recalled that displaying the genitals is familiar in other connections as an apotropaic act. What arouses horror in oneself will produce the same effect upon the enemy against whom one is seeking to defend oneself. We read in Rabelais of how the Devil took to flight when the woman showed him her vulva.[17]

This specific horror, induced by the sight of the female organs and signified by the head of Medusa, is performed in the earlier work of Orlan. For example, at the Musée S. Ludwig in Aix-la-Chapelle in 1978, Orlan performed the piece *Documentary Study: The Head of Medusa*:

> This involved showing my sex (of which half my pubic hair was painted blue) through a large magnifying glass—and this, during my period. Video monitors showed the heads of those arriving, those viewing, and those leaving. Freud's text on the *Head of Medusa* was handed out at the exit, stating: "At the sight of the vulva even the devil runs away."[18]

In George Devereux's *Baubo, la vulve mythique*, he describes the Greek mythological character Baubo as the personification of the female sex.[19] Baubo is often depicted like the Celtic Sheila-na-gig, squatting, knees spread apart and exposing her vulva. However, she is also depicted as headless with the face as the abdomen of the body: eyes in the place of breasts, nose in the place of belly button, mouth as vulva. Devereux notes that often the overall shape of this type of representation also doubles as a phallus.[20]

Baubo is one example of the *vagina dentata*. Other depictions are found in Rabelais's character Pantagruel.[21] Bakhtin cites Pantagruel's body as a grotesque body and discusses him at length. The center of the grotesque body is the gaping jaw, a place where the body is not impenetrable but open. Pantagruel at one point covers an entire army with his tongue. The citizens living in his mouth believe their world to be more ancient than earth. Bakhtin emphasizes the equation between the grotesque body and earth, cosmology, and mortality: "[Gaping jaws and depths] also appear in

the open womb of Pantagruel's mother, as well as in the image of the earth that has absorbed the blood of Abel and the image of the underworld. The bodily depths are fertile; the old dies in them, and the new is born in abundance." Lucifer is included in this: "[I]n bodily topography hell is represented as Lucifer's gaping jaws and . . . death swallows up and returns the body to the bosom of the earth. . . . [W]e are still within the sphere of familiar images: the open mouth and womb."[22] In the fifteenth-century illustration of hell from *The Book of Hours of Catherine of Cleves,* the artist renders the threat of being swallowed up and digested by mouths inside mouths (Figure 11, chapter 2).

There is a peculiar motif that figures into Orlan's work here. The vulva, in its form that is so terrifying that at the sight of it even the devil runs away, is seen as something distorted, without shape, the animal part of the body, the *nonface*. To push this notion even further, within Orlan's *Omnipresence* there is the suggestion that one cannot comprehend a creature without a face, because one cannot recognize it. Yet the mask is always suggestive of the empty face, the destroyer of personality. (For example, Jean Cocteau gave his younger actors masks in order to destroy the personality and allow them the freedom to explore something further.)[23]

During *Omnipresence* we are exposed to this very phenomenon as Orlan's skin is lifted off her face. Also suggested is this metaphorical vulva/face correlation within which Orlan's woman-to-woman transformation takes place and a quality of facelessness is enacted. During her surgical performances Orlan's transformation momentarily takes the form of a gaze that comes from us, the audience, into her, the body. The correlation between our gaze and the flayed face we behold *transcends that of the male gaze onto the female body.* Like those who gazed upon Medusa, we respond to Orlan's monstrousness. Likewise, *Documentary Study: The Head of Medusa* directly refers to the gaze that turns the body to stone, the gaze that induces even the devil to run away, or the gaze that informs the boy that the girl has been castrated, which is subsequently something he must fear. But the myth of Medusa and Freud's analysis exhibit a male understanding of female genitalia that culminates in horror—the monstrous feminine. Although I argue that the Medusa figure is inherent in Orlan's work, the occurrence of the transcendence of the male gaze onto the female body in her work also points toward overcoming the male economy of viewing described by Freud, to the degree that Orlan's images begin to redirect the relationship of the female body to language and to representation.

Both Luce Irigaray and Mary Ann Doane articulate the need for the creation of a new imaginary of the body that would enable women to speak the sexual differences of their bodies, a discourse lacking, or suppressed, in philosophy and psychoanalysis.[24] And although, in order for this new imaginary of the body to take place, feminists risk utilizing essentialist generalizations regarding woman's body, these generalizations are necessary in order to respond to the male constructions of identity forged onto women (e.g., Medusa, the erotic female, and so on). What Orlan demonstrates, as her face is lifted, is—translated within a male linguistic and representational economy—

a celebration of the economy of lack. Not only is she a body without male organs, she now lacks a face as well. But this lack serves to gain new images as Orlan's somatic identity becomes diffused. In other words, the masculine is no longer the only subject-position. Deleuze and Guattari state, "Yes, the face has a great future, but only if it is destroyed, dismantled. On the road to the asignifying and asubjective."[25] Orlan, the body artist, is also creating an asubjectified self-representation.

Other artists have participated in dismantling the relationship between the eroticized, filmic image of the female and the male gaze. In *Action Pants: Genital Panic* (1969), Valie Export strolled the aisles of a cinema known for showing pornography, fully clothed except that the front of her pants was cut out (Figure 29). The photograph of this performance shows her carrying a machine gun. Export's gesture is meant to undermine cinematic male voyeurism by taking it out of the realm of the filmic image and making it real. With the machine gun, she makes it clear that she is the one in control of her own body.

Annie Sprinkle medicalized the eventful revealing of her vagina in order to desexualize it. She inserted a speculum into her vagina and invited audience members to come take a look inside. This piece, *Post Porn Modernism: A Public Cervix Announcement,* was put on at the Kitchen in New York in 1989 (Figure 30). Rebecca Schneider recalls Sprinkle's performance:

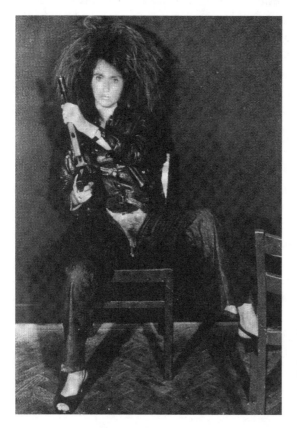

Figure 29. Valie Export, *Action Pants: Genital Panic* (1969). Poster, 66 × 44 cm. Edition of 60. Photograph by Peter Hassmann. Courtesy of the artist.

Playing the scene back, I found myself encountering Sprinkle's cervix as a theoretical third eye, like a gaze from the blind spot, meeting the spectator's—my—gaze. I imagined that gaze as a kind of counter-gaze which instantly doubled back over a field of modernist obsessions. I thought about Bataille's horror and fascination with the envaginated eyeball in his "Story of the Eye," about Freud's inscription of the female genitals as "blinding" in "The Uncanny," and about Walter Benjamin's efforts to "invest" an object or the objectified with its own gaze, as if it might not already possess such capabilities of its own. . . . I tried, in my mind's eye, to hold on to the tactile and viscous pinkness of Annie's cervical eyeball, peering out, effulgent, from the socket of her vagina.[26]

And how does the perspective of looking into the medicalized vagina of Sprinkle or the Medusa-empowered sex of Orlan act on the senses? Sprinkle's performance was also reviewed by C. Carr, who wrote, "[T]o look inside someone's body is to *see too much*."[27] According to Schneider, the notion of having too much to see in regard to these explicit bodies "exposes sexuality as indivisible from social issues of vulnerability and power inscribed in ways of seeing."[28] For Valie Export, this included a very threatening confrontation; she had a machine gun. For Sprinkle, this was not in the least a threatening situation. She smiled at each set of eyes gazing into her vagina with the aid of a flashlight. For Orlan, this meant that each viewer viewed him- or herself

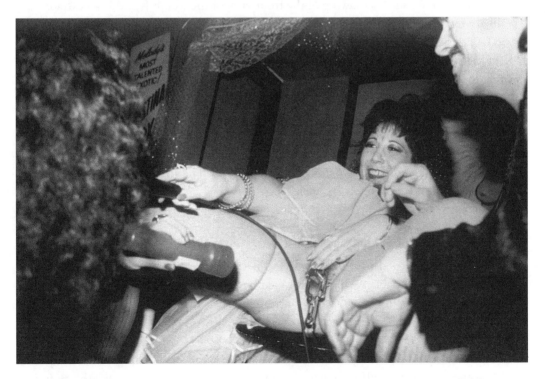

Figure 30. Annie Sprinkle, *Post Porn Modernism: A Public Cervix Announcement* (1989). Photograph by Leslie Barany. Courtesy of the artist.

viewing. Orlan's piece *Documentary Study: The Head of Medusa* makes known to the viewers something about their own reaction to seeing too much that may prove even more terrifying than the actual sight of the magnified vulva. Her Artaudian approach of forcing the audience to feel her work incorporates a reflexive self-awareness that confronts the viewer.

The monstrous quality that exists in the relinquishing of feminine vulnerability is demonstrated once again in Gustave Courbet's painting *Origin of the World* (1866), an almost photo-realistic rendition of a woman's thighs spread to reveal her labia just after having sex. The painting crops the body above the knees, just above the breasts, and just beyond the shoulders. This rendition of a headless, armless, legless woman was once owned by Jacques Lacan. Lacan's second wife, Sylvia Bataille, commissioned André Masson to create an abstract "hiding device" so that the painting could be veiled and revealed at will.[29] The ability of this image to conjure such a strong attraction/repulsion that it would impel one to create a hiding device is uncanny. The implication is that one cannot just turn her or his back on such an image. One must actually *hide* it in order to make it go away, but in such a way that when the urge to look becomes overwhelming, one can also indulge in this activity. There is also one other perspective regarding Masson's hiding device—that if one saw the painting all the time, it would lose its visceral effect. Orlan responded to this image with her *Origin of War*.

Jan van Riemsdyck's drawing of the front view of the womb (1774) is an extraordinary rendering of *hiding* the female sex (Figure 31). It uses nearly the same cropping as Courbet's *Origin of the World*, except the abdomen is flayed, the woman is pregnant (full-term), and the genitals are hidden by an opened book positioned in such a way that they—the genitals—are reading the text. Lingerie and baggy stockings, as well as skin, are folded back. It is an image of exposure, but one in which we can see the artist's anxiety at perhaps having gone too far: he chose to cover the genitals with a book, the symbol of knowledge that also inscribes a historicity into the understanding of the female anatomy. We feel from him that if the genitals as well were exposed, the image would be blinding to him and possibly to us. The artist's choices reveal both the desire and the anxiety of the "male gaze."

HANS BELLMER, CINDY SHERMAN, AND ORLAN

Thus far I have argued that Orlan's surgical performances elucidate the long history of misogynist essentialism equated with identifying the woman's body as inferior and opposed to that of the male; that by making her personal body a public body and placing herself within the trajectory of the public dissection theater, she opens for examination scientific and medical misperceptions about woman's body; that she performs a collapse of a binary structure that polarizes (and hierarchizes) relationships between male/female, self/other, natural/unnatural, real/imaginary, beauty / the monstrous, and so on; and that by rupturing this structure, she performs a conceptual and

literal facelessness. This facelessness may then serve to puncture the dogma of essentialism by disallowing an equation between identity and corporeality. But it also conspires to undermine itself, because (although I have explored the possibility that the male gaze is neutralized by Orlan's explicitly nonsexual imagery) the elimination of the face can serve to blur individual identity, an effect which, given that the body is whole, can turn the body of the faceless woman into a fetishized, anonymous, sexual object (e.g., the mannequin, the model, the doll). Orlan's highly sensationalist performances do yield a scopophilic response from most of her viewers. One might even go so far as to say that Orlan's performances run tandem with hard-core pornography in that "hard core tries not to play peekaboo with either its male or female bodies, [but] it obsessively seeks knowledge, through a voyeuristic record of confessional, involuntary paroxysm of the 'thing' itself."[30] In pornography, segmented parts of the body are fetishized. In the performances of Orlan, the body performs a literal corporal segmentation. The bringing together of these two phenomena—segmented, fetishized body parts and literal corporeal segmentation—creates a link between eroticism and sexual activity that is informed by death. This phenomenon exists as a primary motif in the work of the surrealists, and most particularly in the dolls of Hans Bellmer.

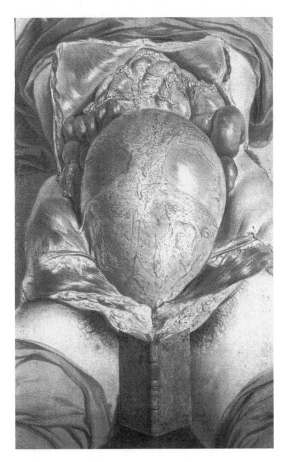

Figure 31. Jan van Riemsdyck, *Drawing for Tab. XXVI*, in William Hunter, *Anatomy of the Human Gravid Uterus* (London, 1774). Black and red chalk, 81.3 × 56 cm. AZ.1.4. Special Collections Department, Glasgow University Library.

Inspired by "The Sandman" (one of the tales of E. T. W. Hoffmann), in which the hero, Nathaniel, is maddened with love for the doll Olympia (which ends up dismembered), Bellmer repeatedly created, destroyed, rearranged, and photographed a doll.[31] The dismemberment and reassembly of female body parts transformed these woman-objects into fetishes that fell prey to sculptural mutilation. Sound familiar? Hal Foster characterizes these dolls as "a summa of . . . surrealism . . . : uncanny confusions of animate and inanimate figures, ambivalent conjunctions of castrative and fetishistic forms, compulsive repetitions of erotic and traumatic scenes, difficult intricacies of sadism and masochism, of desire, diffusion, and death."[32] These bisected, amputated, chopped-up woman-objects also endure literal defacement—the faceless woman as fetishized sexual object—which signifies Bellmer's representations as objects of desire.

Bellmer's "poupées" are "uncanny" evocations of the dismembered, castrated female as the phallus. The most obvious example of this is *La poupée* (1938), which is merely two full-length sets of legs, the first standing, the second mounted upside down on top of the first to form a very tall assemblage of legs with one pair of feet at the base, the other at the top. Both pairs of feet are shod in white bobby socks and black patent-leather Mary Janes (Figure 32). Regarding this image, Rosalind Krauss writes, "This doll's body, coded/female/but figuring forth the male organ within a setting of dismemberment, carries with it the threat of castration. It is the doll as uncanny, the doll as *informe* [formless, shapeless, misshapen]."[33]

With regard to the surrealists, their particular form of binary terror was mostly played out as Freud's "uncanny." Very briefly, *uncanny* (*unheimlich*, literally translated "unhomelike") is derived from the word *heimisch* ("homelike"). Freud's thesis on the uncanny puts forward that the familiar, when repressed, returns as the *unheimlich*:

> The *unheimlich* place, however, is the entrance to the former *heim* of all human beings, to the place where everyone dwelt once upon a time and in the beginning. There is a humorous saying: "Life is homesickness"; and whenever a man dreams of a place or a country and says to himself, still in the dream, "this place is familiar to me, I have been there before," we may interpret the place as being his mother's genitals or her body. In this case too the *unheimlich* is what was once *heimisch*, homelike, familiar; the prefix "un" is the token of repression.[34]

Bellmer once stated that "all dreams return again to the only remaining instinct, to escape from the outline of the self."[35] The image of the female body "escaping the outline of the self," in the form of the mutilated doll, was an exploration by Bellmer of the double (*Doppelgänger*), which for Freud represented a protective figure that, through repression, was transformed into a "ghastly harbinger of death."[36] For Freud, castration and death epitomized the uncanny, the *unheimlich*.[37]

For André Breton, the uncanny was expressed in a form of convulsive beauty: "Everything tends to make us believe that there exists a certain point of the mind at

which life and death, the real and the imagined, past and future, the communicable and the incommunicable, high and low, cease to be perceived as contradictions."[38] Georges Bataille took this much further. He characterized death as the erotic (and violent) extension of life and stated that "[b]eauty is desired in order that it may be befouled; not for its own sake, but for the joy brought by the certainty of profaning it."[39]

There is much written about Bellmer's dolls as an attack on the Nazi fascism that was engulfing Germany at the time he made them. But, as Foster notes, "if we see the dolls as sadistic, then the object of this sadism is clear: woman. But if we see the dolls a representations of sadism then the object becomes less obvious."[40] In the shadows of Nazism, Theodor Adorno and Max Horkheimer wrote that the Nazis "see the body

Figure 32. Hans Bellmer, *La poupée* (1938). Hand-colored print, 2 × 2⅛ inches. Image courtesy of Ubu Gallery, New York. Copyright 2003 Artists Rights Society (ARS), New York / ADAGP, Paris.

as a moving mechanism, with joints as its components and flesh to cushion the skeleton. They use the body and its parts as though they were already separated from it."[41] Bellmer's dolls as illustrations of the fascist use of the body do not ease the problem of looking at his work. The misogynistic problem of his work is also identified.

In Orlan's performance *Le baiser de l'artiste* (1977) she turns herself into a kissing doll / slot machine. Passersby put five francs into the slot of a representation that both contains and reveals her breasts, abdomen, and crotch; she watches the coin fall from a slot between her breasts into a box at her crotch, and then she jumps up and gives the slot-machine player a kiss (Figure 2, chapter 1). Here Orlan remakes her body into that of a doll for the purposes of exposing the crux of the meaning behind the representation of woman as commodity. But this female artist, utilizing her own body, forces this motif into a new register of meaning. Orlan's representation critiques misogyny like that celebrated in Bellmer's work.

Another representation of the female doll exists in the mannequin photos of Cindy Sherman. *Untitled #261* (1992), for example, frames the image of a female mannequin torso with the head severed from the body (Figure 33). The closely cropped head and torso are displayed on the ground, headfirst, upside down, and in the foreground, with the inverted eyes wide open. The crotch is at the top of the image, the vulva lined with toothlike protrusions. The grotesqueness of this image, combined with the overt plasticity of the body, evokes a horror-film quality, yet the politics of this image is very disconcerting. Had Sherman not evoked her own body, she would never have gotten away with it. We would have labeled them, like Bellmer's images, misogynist. But Sherman speaks of them within the context of fantasy:

> In horror stories or in fairy tales, the fascination with the morbid is also, at least for me, a way to prepare for the unthinkable. My biggest fear is a horrible death, and I think this fascination with the grotesque and with horror is a way to prepare yourself psychically if, God forbid, you have to experience something like that. That's why it's very important for me to show the artificiality of it all because the real horrors of the world are unmatchable and they're too profound.[42]

Sherman and Orlan both perform this instinct "to escape the outline of the self."[43] Thus, in spite of the reading of Orlan's work that argues her success at performing the undermining attributes of constructed beauty, the image of the woman's body as an object that is rebuilt, repaired, and rearranged is a problematic concept that inevitably also undermines Orlan's performances. Like Bellmer's dolls and Sherman's mannequins, Orlan's images of her cut and rearranged face forcefully confront us with one of the oldest dilemmas regarding representation: what is behind the image, informing it, inspiring it? The performative relationship between the viewer and the image demands this dilemma and its exploration.

In the work of Orlan, as in the work of Bellmer, images of the woman-object implode on themselves. Bellmer's are striking, violent, sadomasochistic, and although

Figure 33. Cindy Sherman, *Untitled #261* (1992). Cibachrome, 50 × 70 inches. Courtesy of the artist and Metro Pictures.

they might be intended as antifascist statements, they cannot escape a resonance of female mutilation. Orlan's images are self-made, self-informed bridges between one and (an)other self, as one subject/object transformed into another desired subject/object. Yet her images haunt us with their sensationalist body carving even while they reveal some of the misperceptions that accompany living inside of a woman's body; the body that has historically been idealized as well as mutilated, misregarded as well as disregarded, fetishized yet marginalized. Luce Irigaray writes:

> Woman has no gaze, no discourse for her specific specularization that would allow her to identify with herself (as same)—to return into the self—or to break free of the natural specular process that now holds her—to get out of the self. . . . In her case "I" never equals "I," and she is only that individual will that the master takes possession of, that resisting remainder of a corporeality to which his passion for sameness is still sensitive, or again his double, the lining of his coat. Being as she is, she does not achieve the enunciatory process of the discourse of History, but remains its servant, deprived of self (as same), alienated in this system of discourse as in her master and finding some hint of her own self, her own ego, only in another, a You—or a He—who speaks.[44]

But Orlan is not a slave to the discourse of male-created images of women. She seeks for herself some authenticity in these images. She makes them a part of her own history so that she can glean from them something that is a part of her own biology. Orlan gives us something to gaze upon, a gaze inside of the opened female body. Yet it is not the gaze into the woman as such (we do not view her womb); it is a gaze into the face of the distinct human, the lining of *her* coat. And in doing so she enacts the "I" that equals "I." She ensures that we understand, in her individual case, that the "I" equals neither the self nor the other but a synthesis of self and other, which she owns and publicly portrays. She takes her fate into her own hands and plays the role in her gruesome performance of both the master of and slave to her own fate.

Penetrating Layers of Flesh: Carving in/out the Body of Orlan

LAYER I: . . . THAT WE DO NOT WATCH (MEDUSA)

It is not the passing from one body into (an)other that torments;

a passage from beauty to beast.

Although the dimensions of this passage are never wholly discernible to me

inasmuch as I perceive nothing but stone.

Hence I cannot fix the image that is myself. It momentarily exists, they say, in the gazes
of others. "The pupil is the finest part of the eye," Socrates has said. "It is the part
that sees and it is the part where one can find the image of oneself looking."

(Quietly, before the passage, I exchanged such gazes with others.)

Curious that there is a reflection there, in the pupil . . . the pit of the eye.

It is not only that one body-shape overtakes another, it is that the appearance of my
mutating body brings about a disappearance.

To make matters worse, Athena is the ravisher of the eye-pits of all that gaze upon me.

These gazers play out a drama of the grotesque, drawing into their eye-pits my image,
but not (re)turning it to me. It is by this repeated lack of a turn that my mutation
from beauty to beast keeps expanding. As it expands I (dis)appear, . . . while they
are turning to stone.

The pit-fall is also mine.

I disappear because I peer.

But the famous shield of Perseus complicates things. Some say I peered into myself
through that shield only for an instant before I turned myself to stone. Others say
he slew me in my sleep . . . (a beauty and a beast. . . .)

123

Ah, but this is not a fairy tale. If it were, my monstrous veil would have been
extinguished along with life, I would have repossessed my beauty in death, and
Perseus finally would have been able to see clearly.

LAYER II: . . . THAT WE WATCH (ORLAN)

A woman lies down on an operating table, her appearance is surgically altered, she
recovers, she lives in her altered body, and then . . . she lies down on another operat-
ing table. . . . Repeated ten times thus far, Orlan's appearance-altering performance
surgeries produce an unsettled (and unsettling) motif—a live figure who unceasingly
morphs into other forms of the same live figure.[1] Orlan documents her self-induced
"reincarnation" so that we may watch: the videotaped and televised surgeries are *per-
formed* on dressed sets with costumes; glass reliquaries are filled with blood and body
fat collected during the surgeries; photographs of her healing face are juxtaposed with
imaginary portraits of faces that initially seem to serve as guidelines for the surgical
maneuvers.

Orlan's *Entre-Deux* (1993) is a series of forty-one computer composite portraits
paired with forty-one photos of Orlan's healing face after the seventh performance
surgery (Plates 18–20). (*Entre-Deux* was created during the aftermath of Orlan's sev-
enth surgical performance, entitled *Omnipresence.*) Because this piece does not involve
watching the actual flaying and carving of her body nor looking at the encased fluids
of her body, it eliminates (from the viewer) a primordial involvement in immediate
body materials and body-opening procedures, and presents the conceptual backdrop
for *La réincarnation de Sainte-Orlan.* The computer composites are imaginary por-
traits constructed by layering Orlan's face (before any surgery) with, simultaneously,
Leonardo's Mona Lisa, an anonymous school-of-Fontainebleau sculpture of Diana,
Gustave Moreau's Europa, Botticelli's Venus, and Gérard's Psyche. These conflated
portraits, juxtaposed with photographs of Orlan's live, altered, and healing face, reveal
a gap between what is "made by the body-machine" and what is "made by the com-
puting machine."[2] This gap between images of the real body and the imaginary body
becomes treacherous terrain for the viewer to negotiate, given that neither the "real"
photographs nor the "imaginary" computed portraits divulge "fixed" images (affirma-
tions of either a "before" or a final "after" image). Every one of the forty-one com-
puter composites changes, even as one is looking at them, with each layered image
struggling to surface and dominate the others. The juxtaposed portraits of Orlan's live
face, which were taken each day for forty days following the surgery, disclose the
dramatic metamorphosis of a grotesquely bloated, bruised, and bandaged visage. The
forty-first photograph reveals Orlan's fully healed and heavily made-up face, a *tempo-
rary* portrait in *this* series of images—temporary because this image beseeches the next
surgical alteration to take place, given that it fails in its duplication of the presumed
"after" images depicted in the contiguous computer composites (Plate 20). This is
precisely the point. The gap between Orlan's imagined and actual (albeit altered)

body remains. The existence of this gap is reinforced by the fact that the computer composites that serve to inform Orlan's surgeries are as destabilized, transparent, and unfixed as her body seems to be always in the process of becoming.

Cosmetic surgery always anticipates an imagined outcome. The desire for a resemblance between the fully healed "after" image and the anticipated, imagined outcome is inevitable, because inherent in the body-alteration process is the relationship between the *real* and the *imaginary*.[3] In Orlan's work this relationship is kept alive, as she does not claim an "after" image except perhaps as a temporary starting point for further alteration. For Orlan, the body is sculptable matter, and the anticipated imaginary outcome never completes the portrait. The computer composites do not help stabilize a portrait either. They are not frozen images but ones that reveal the layering of features, resulting in spectral and illusive renderings. In other words, the computer composites are not explicit; they do not offer a consistent guide to a final goal.

Orlan performs herself as a fluctuating corporeal form. Our horror at her excessive primary visual motif—her own morphing face—is contingent upon the "normal" body as that which has form—recognizable, identifiable form. However, this contingency in itself problematizes feminist discourses on identity, because its essentialist foundation strictly equates the body with identity (i.e., biological sex is placed above gender). The antagonistic "facing off" of essentialist sentiments against those of anti-essentialists marks only one in a series of oppositions that Orlan exploits.

Through her performances, Saint Orlan sacrifices her *personal* body to become a *nonpersonal* body,[4] by turning herself into a malleable art object in the center of public performance, thereby punctuating the point that the body is (in Carol Bigwood's words) "not an innate human essence or structure guaranteed at birth but [one that] *must be historically constantly reforged*."[5] My concluding comments on *La réincarnation de Sainte-Orlan* begin with the observation that Orlan's publicly displayed, self-induced, fluctuating physiognomy is a hybrid facelessness that is new to the history of the *live* human form.

LAYER III: . . . FACELESSNESS

Anamorphosis is the composition of illusion in representation. It also reveals the gap between the illusion and the representation—two moments, if you will, that divulge themselves depending on the beholder's point of view.[6] In painting, this point of view is physical and refers to different places where the beholder stands. In Orlan's performances, the point of view refers to both a spatial and a temporal sense. Parveen Adams argues that a spatial anamorphosis takes place during Orlan's performance surgeries as a result of the dislodging of the match between the inside and the outside. In other words, that the inside and outside fit one another in an equal and opposite isomorphism is a structure that is revealed as untrue in the performances of Orlan. This occurs as Orlan's face is detached from her head and revealed to be a mask, which purports pure exteriority, a maneuver that Adams contends "casts doubt on representation and

insists on its emptiness."[7] The doubt that Adams refers to is extremely relevant. Throughout this book the discussion has focused on whether or not there exists something more than that which is revealed on the surface. Orlan searches for the answer to this question in her performances. She shows us that there is a visceral interior but also that, as Adams suggests, the interior of the representation—in this case, the face as identity—may be empty.

I agree with Adams's account of a spatial anamorphosis, because, in keeping with Orlan's work, it problematizes the equation that corporeal structure = identity. However, the visual motif that she refers to—the detachment of Orlan's face—constitutes only one conceptual moment in anamorphic representation. There have been ten surgeries, and the number of remaining surgeries is yet to be determined. In fact, the span of the entire reincarnation remains undefined. The second anamorphic moment, then, might be described as the duration of Orlan's project, given that her artistic representation of herself always places her betwixt surgical performances while not actually performing one. In other words, she is performing a reincarnation with no apparent finale. And within the time gap between these two moments lie both Orlan's always-yet-to-be-determined face, which reveals itself to be a literal and conceptual blur in her computer composites, and Orlan's facelessness, which exists in the present as a consequence of the future. In other words, there exists a temporal delay between the present and a future fixed face and fixed identity.

Hence, a powerful disappearance of the isomorphic relation between corporeal interior and exterior plays out as a condition of facelessness, contained in the gap between the immediate climactic moment of the detachment of the face and the incompletion of Orlan's reincarnative process. This facelessness is also the crucial factor that segregates Orlan's work from most cosmetic surgery, in which the "before" and "after" pictures suggest the "closure of refiguration."[8] Adams suggests that "[t]he face which is not original and is not even seeking an end is one that many find difficult to tolerate."[9] However, Orlan's enactment of facelessness might also be seen as a radical artistic venture that challenges body-determined identity, a sort of *antiessentialism par excellence*. As Trinh T. Minh-ha writes, "The Body, the most visible difference between men and women, the only one to offer a secure ground for those who seek the permanent, the feminine 'nature' and 'essence,' remains thereby the safest basis for racist and sexist ideologies."[10] So, although Orlan does not choose to address the issue of sexual identity by, for example, surgically altering her genitalia, her woman-to-woman transsexualism (created with implants) places an anamorphic gap in both representation and identity (identity as the representation of the self), which also serves to "deface" sexual difference, because Orlan has placed her personal corporeal transmutation in the public arena for observation and debate.

Orlan's blurred and faceless face, the anamorphic face as an alternative to the skeletally "fixed" face that most of us live with, *performs* issues of identity. She sculpts her body by means of medical technology to yield female-interpreted art historical (male) referents (her interpretation of images painted by men) into her own praxis

and to mold them into her own form. However, not projecting or indulging in the spectacle of the female body as commodity and object,[11] Orlan's "body of art" investigates and fragments these referents. Even though she utilizes a cosmetic technology that normally facilitates the rearrangement of the "given" body to that of the male-fantasized female other, Orlan performs a deeply penetrating revaluation of art historical images of the male-fantasized female—not in order to create a female-fantasized female but to create the distinctive body artist Saint Orlan.[12]

Hence, Orlan's performances, which successfully destabilize the relationship between the body and identity, are antiphallocentric. That is to say that her performances do not pursue the image of the woman as (objectified) other, the counterpart of the male. Rather, her body sculpting, her woman-to-woman transformation (transsexualism), is of this body artist's imago,[13] outside of the male/female (one/other) binary—a potential answer to the calling of Luce Irigaray.

Orlan's refusal to accept the otherness relegated to her within the male economy—that otherness which could be defined as a body that lacks male organs—is ironically layered with a refusal to contain her praxis safely within the politically correct parameters of feminism. Whether or not Orlan is successful in demonstrating that her body without (male) organs under the knife is not necessarily the docile body, she mimes not the mime of the hysteric; rather, as Elizabeth Grosz writes of Luce Irigaray, "she mimes, and thus exceeds the strategy of the hysteric; she place[s] herself at the pivot point of the speculum's inversion of the subject's relation to its specular image."[14] In other words, the male-made images of the female are always (in some form) self-representational,[15] and Orlan publicly remolds fragments of these male-oriented images (images that are also firmly incorporated into the canon of Western art history) and re-presents them as herself. As the fragments are placed inside her body, she is the continually, newly transforming body artist Saint Orlan. In doing this, she collapses the curve of the reflective speculum (as a video image, her mirror of her public/nonpersonal self reflected back through the eyes of the beholder) so that the subject's relation to its specular image involves also collapsing the space between subject and object.

LAYER IV: . . . HOW THE PERFORMANCE OF FACELESSNESS IS NESTLED INTO THE FANTASTIC, THE MYTHOLOGICAL; OR, IRIGARAY AND GOD'S SHIFTING SELF-IMAGE

Toward the end of Max Ernst's *The Hundred Headless Woman* is an illustration with a caption: "The Eternal Father tries vainly to separate the light from the shadows" (Figure 34).[16] It depicts a harried man running down a long, curved staircase in order to cover the eyes of an ornately dressed and veiled young woman who faces us. Even though the hand of the man is upon her face, she glances at us through an opening between his fingers. He, however, clearly does not want her to see the figure of another woman dressed in black that is ascending the staircase. The man, with a full head of curly hair, beard, and mustache and dressed in white, flowing garments, is out of the

ordinary, the ordinary being the rather formal Victorian attire of the two featured women, as well as the other women and men (in top hats and tails) in the background. Although the illustration depicts the light and the shadow personified in the forms of these two women, the point that I wish to highlight is the struggle of Ernst's satirical God, the Eternal Father, to keep everything under control, to keep the light and shadow separate, as though he were having trouble managing the plan that he created, as though he were experiencing a form of divine anxiety.

Of course, the classic discussion that separates and distinguishes shadow and light is outlined by Plato in his *Republic* (7.514a–521b). He reveals, in his allegorical cave, that shadow images projected onto the back wall of the cave are created by objects

Figure 34. Max Ernst, *The Eternal Father Tries Vainly to Separate the Light from the Shadows* (1927/29). Illustration for *The Hundred Headless Woman = La femme 100 têtes*, trans. Dorothea Tanning (New York: Brasiller, 1981), 305. Collage, 32.7 × 16.9 cm. The Menil Collection, Houston. Copyright 2003 Artists Rights Society (ARS), New York / ADAGP, Paris.

that partially block the light that enters the cave. The internal images, believed to be true and accurate by those inhabiting the cave, have little to do with the real forms of which they are the shadow. Although each man who is chained to the inside of the cave determines the shadows to be true and absolute forms, the man who escapes from the cave sees the actual objects and people who create these shadows. Out in the light of the sun, he sees the truth.

In her section of *Speculum of the Other Woman* entitled "Plato's *Hystera*," Luce Irigaray re-presents Plato's analogy of the cave in order to reinvestigate the relationship of the material world as a representation of the world of ideas.[17] There are multiple layers to Irigaray's theoretical (performative) positing of the possibility of being mismirrored or badly copied. Her specular economy is one in which women act as mirrors to men. Such action allows for the potential for bad copying. In this text she is enacting—with a difference (badly copying?)—a repetition of Plato. An emphasis on this difference supplants the original meaning, and in its stead a female version is created. By changing the rhetoric and spinning the text, she imagines the properties of representation as they are located inside the cave:

> The entrance to the cave takes the form of a long passage, corridor, neck, conduit, leading upward, toward the light or the *sight of day*, and the whole of the cave is oriented in relation to this opening. Upward—this notation indicates from the very start that the Platonic cave functions as an attempt to give an orientation to the reproduction and representation of something that is always already there in the den. The orientation functions by turning everything over by reversing, and by pivoting around axes of symmetry. From high to low, from low to high, from back to front, from anterior to opposite, but in all cases from a point of view in front of or behind something in this cave, situated in the back. Symmetry plays a decisive part here—as projection, reflection, inversion, retroversion—and you will always already have lost your bearings as soon as you set foot in the cave; it will turn your head, set you walking on your hands, though Socrates never breathes a word about the whole mystification, of course. This theatrical trick is unavoidable if you are to enter into the functioning of representation.[18]

The theatrical trickery/topsy-turviness that Irigaray equates here with representation is inevitable. The mortal is opaque to light and always casts a shadow. The mortal is always inside of a body.[19] The striving to go out of the body has historically been performed by saints and mystics; the striving to go inside of the body, by scientists and artists. Orlan stages both. She repeatedly performs a corporeal distortion with the surgical entering and exiting of her material body, *while remaining a conscious, thinking, fully embodied participant*. She is a shape-shifter, expanding and contracting both her form and her shadow. But how does the shifting form relate to the representation of the body?

Irigaray's comments regarding the relationship of repetition and distortion to the

projection of the self-image are directly relevant to Orlan's performances, because they describe a male performance of anxiety generated by the possibility of misrepresentation, contrasted with a female (Irigaray's) investigation of (feminine) identity, built with misrepresentations. Irigaray says that the orientation of both the viewer and the viewed is crucial when examining the representation of the body, the body of representations, the relationship between representation and the body. And she orients us regarding this account. There is always a front side and a back side to the body. However, the body is not three-dimensional but multidimensional, and, reflecting this notion of dimensionality, Irigaray paints another image of anxiety for us that, in essence, is Lacan's mirror stage in reverse.

The following scenario is Irigaray's deconstruction of Plato's fundamental concept of representation: that ideals are universal, created by God, and accessible to the human mind; that all things created by man are singular, imperfect representations of ideals. Specifically, Irigaray confronts Plato's notion that God is the universal ideal of man—that man was created in His image (*Timaeus*, 37c–49). Her exegesis is written as a somewhat comical but crucial performance by God, and it emphasizes an anxiety associated with shifting self-image. Irigaray's deconstruction bears a direct relationship to Orlan's sentient performance of shape-shifting and her insistence that her "work is a struggle against . . . Nature, DNA, . . . and God."[20]

Irigaray posits that God always only "(re)produces himself, only projects himself frontward and, moreover, in his prudence, demands that his 'reflections' be unable to turn inside out." And then she writes, "What extreme confusion would result if God were to perceive himself backward and the wrong way up, thus losing an immutable awareness of the position of right and left."[21] But this is not all. The complexity of this issue is magnified by the projection of God's image, the mirroring of his image, in which man is supposed to have been created. Irigaray notes that this is actually an extraordinary problem. Has God, for example, taken into consideration all of the principles of perspective? Does he reflect himself from one place? Does he take into consideration the fact that "if he paints himself upon . . . surfaces again and again, they are bound to reflect Him, and somewhere a mirror in which his image has formed is bound to be involved"?[22] Does he understand that once these images start to reflect him, his very own image (the original image) may begin to be skewed?

> In order to maintain self-identity, He may still have recourse to a double mirror; the second rectifies the image sent back by the first, in a substitution for the information from the eye of the other that has thereby been appropriated. Could it be that divine representation passes through a double specularization, a duplication of speculation? . . . God would, theoretically, simulate himself (as same) twice in order to ensure the immutability of his reflection. Could his reality be the faking of a fake?[23]

God's fear of being misrepresented preoccupies him with the project of making sure these mirrors are always aligned correctly so that no mistake in identity is made. As

this divine anxiety is enacted by God, it is reflected onto man—in man's fear of being misrepresented. This is in direct opposition to Orlan's reverie in multiplying representations of herself.

And women? Women have always been misrepresented by men. Orlan's performances would suggest, however, that the anxiety of misrepresentation is a male one, because she does not show a fear of the misrepresentation of her own body's exterior, interior, or backside. What she airs by publicly opening her body (bWo) is the history of the misrepresentation of women in art, and the misrepresentation of the inside of their own bodies. She confronts these misrepresentations head-on by making one (a misrepresentation) of her own. Yet there is a correspondence between this divine anxiety and the performed facelessness of Orlan. Neither Irigaray's rendition of God nor Orlan's reincarnation of Saint Orlan places a value on any one of the images that each is mirroring, for fear of being limited (for some duration of time) to that particular identity.

There is also a biological resonance to all of this. Irigaray describes the "trinity" of God and the two reflections—"The One is the One only when mirrored at least twice"[24]—thereby implicating the structure of human reproduction, which also requires two (bodies): "Keeping, for himself [God] alone, the key to this mystery: his frozen hysteria, in which he engenders himself, truly identical to himself, by reproducing himself twice over. At least. Ex-stasy [*sic*] of a primal scene in which two reflections of sameness come together and then give birth to Being itself."[25]

Orlan is also misrepresenting in order to understand representation. She reflects the trope that Plato puts forward (the cave), which is equally a misrepresentation. The distortion that occurs in Orlan's head due to the incision and consequent manipulation of instruments during surgery makes clearly visible the passage from the exterior to the interior of the body. The interior of the woman's body, like the interior of Plato's cave, has historically been a place of shadows, and by opening her body, Orlan sheds light on the shadows of misrecognition (see chapter 2). She performs a relationship between recognition and misrecognition by obscuring a relationship between interior and exterior and by withholding from her audience a final, complete identity. By doing so, the theatrics of the performance surgeries incorporate the viewer into their meaning. Art historian David Moos writes:

Within this [Orlan's] performative evolution memory is always held in suspense. . . . How such memory attaches to states of being will be in the phenomenal sphere of art where perception connects to the physical body—a new type of being that is opened as a horizon to include all distance, both without and within.[26]

Orlan makes us aware that the new type of being is created from the two that are required to form one, the *representation and the beholder of the representation*. And she emphasizes this in an Artaudian gesture by projecting the pain of entering her body onto the viewer, so that the viewer's corporeal involvement completes the performance.

Because Orlan's reincarnation is a performance of incompletion, her future identity remains potential, undefinable. Orlan plays between the past (her original body) and the future (her potential body). She says, "One of my favorite mottoes is, 'Remember the Future.' [*La réincarnation de Sainte-Orlan*] should be a performance radical for myself and beyond myself."[27] Orlan is playing in the gap between words and the unspeakable, between representation and the unrepresentable. This is to say Orlan distorts the vocabulary of representation. She has chosen to experience representation by making herself one. But she is not a fixed representation. Rather, within her exploration of representation is also an exploration of incompletion. To remain faceless; to exist within a place of difference, between self and other, beauty and the monstrous feminine, the interior and the exterior, one distinct woman and another distinct woman, she constantly modifies her physical, and virtual, body.[28]

Finally, if an identity exists inside one, forming one's very viscera and skeleton, is it an identity? Or is it a body? Jay Prosser writes, "[T]he body [is not] an immaterial provisional surround but, on the contrary, . . . the very 'seat' of the self."[29] And even while Orlan declares that the body is but a costume,[30] the skin, the skeleton, the body do have meaning in the formulation of the self. Orlan disturbingly performs this meaning by obliterating her own fixed identity and making her body something in the process of coming about at all times.

A Few Comments on *Self-hybridations*

Self-hybridations précolombienne and *Self-hybridations africaine* are series of computer-manipulated self-portraits in which Orlan inscribes onto herself signifiers of beauty originating outside Western culture (e.g., enlarged cranium, tattooing, scarring) (Plates 3–6; Figures 3–6, chapter 1). She also appropriates physiognomic features of other races; Orlan finally gives herself an exaggerated Mayan nose. (She has for years been wishing to surgically appropriate this nose onto her face. Now she has several versions of her Mayan self constructed virtually.) On her Web site (http://www.orlan.net/), between two Mayan nose manipulations (one in which her face is clearly feminine, a gold crest running across her head, other gold ornaments spiraling down across her neck; and one in which she takes on a very masculine, angular physiognomy, roughly textured skin, and painted hair), she writes, "Je m'auto-scanne/photo-génie/génétique présence sans le sang, sans flash . . . virtuelle." Her statement celebrates the medium she now uses: She autoscans herself. As self-portraiture she becomes a genie/genius by tampering with genetics, but now without blood.

Now that she is venturing outside of Western art history, mythology, and religion and into other cultures (pre-Columbian Mexico, Africa), Orlan is expanding her exploration of varying attributes of beauty but "normalizing" the means for this exploration. She now manipulates images of herself via computer technology. What differentiates Orlan from the other artists exploring (eye)dentity (the interaction between representation and identity)—Yasumasa Morimura, Cindy Sherman, and Eleanor Antin, to name a few—exists in her surgical performances. Here she obliterates the distance between the artist and art by living between the fluctuating edges of representation and identity. Now, outside of the bounds of the body, the *Self-hybridation* digital photographs allow Orlan to continue unrestrictedly to create hybrids. But there is a

struggle here. She insists that Orlan as a virtual self-hybridation is a continuation of the surgical reincarnation, because at the core of her work always lies the premise that beauty is constructed in accordance with historical and cultural standards. In both series of work, she deconstructs and appropriates indicators of beauty into/onto her body—one live, one virtual; this is my body . . . this is my software. The objectives are the same, but the means radically different. This book is about looking into the opened body, the meaning of shifting identity with regard to the shape of the live human body, the relationship between the interior and the exterior of the body. The *Self-hybridation* photographs have no interior, no texture, no body. As elegant and imaginative as some of the images are, they are about digital technology or, at best, costume.

But the difference I am seeking perhaps lies between the virtual and the real. In this regard the equation between the two informs both series of work. They both cross over into imagined and remembered, real and virtual cultures and eras:

> Contrary to what I had attempted with the series of surgical operations, my self hybrids do not inscribe the transformations within my flesh—my "phenomenologi-cal body"—but in the pixels of my virtual flesh, mixed with inorganic matter and my own representation after it has been reworked by surgery. However it would be wrong to separate the "surgical operation performances" from my *Self-Hybridations*, because the former do not belong only to reality and the latter do not purely take place in virtuality.
>
> Georges Didi-Huberman recently pointed out that "in front of an image, we are always in front of time." In front of my African or pre-Columbian Hybridations, we are faced with a virtual time, in which the past of these two cultures merge in a very intricate manner with the recent past of my own photograph, with the future of this image, its future as a work seen by spectators, and eventually with the fantasy of the future which it is able to suggest.
>
> I make images of mutant beings whose presence is thinkable in a future civiliza-tion that would not put the same pressures on bodies as we do today. Such a future civilization could therefore integrate these beings as possible and sexually acceptable, and beautiful.[1]

There are other difficulties to tackle in *Self-hybridations*. Here Orlan demonstrates modes of inscription inherent to non-Western cultures. Out of context, exaggerated, and appropriated by a Western artist, these body inscriptions are completely trans-formed. Politically they reference a performance that crosses cultures, but they are also caricatures of other cultures' signifiers of beauty and frequently appear carnivalesque, somewhat extraterrestrial, and generally misinterpreted. It seems that she is walking a thin line between mocking other cultures' practices and creating quite exotic images that sincerely revere the creativity in constructing the body. This loads the images with potentially racist connotations by reinforcing and exaggerating the otherness of

the other (those outside of Western culture). Whereas some of the images appear to reference the cubist fascination with African art and culture, and others are quite classically beautiful, most are comical and grotesque interpretations of facial inscriptions from other cultures (Figures 3–6, chapter 1). With regard to the face, Orlan's (self-)images render deviations from the norm. Her hybrids are offspring of the carnival freak and the humanoid. But her hybrids also mark the differences between the bounds of the body and the unbounded virtual body—between the reincarnation of Saint Orlan and Orlan as self-hybridation.

Orlan insists that the idea behind her *Self-hybridations* is not to create a horror show:

> I have also wanted to show that beauty can take on appearances that are not reputed to be beautiful. This idea is truly very important for me, it is the reason I created the digital photos for the pre-Columbian and African series *Self-Hybridations*. I have a notebook of interactions, with the technician, the graphic artist and myself, all who aim at making characters whose physical appearances are not renowned as beautiful for our time, but who have the air of being thoughtful, human, intelligent, with the joy of life.[2]

On the face of a European, the cross-cultural context is emphasized in titles such as "Profile of Mangbetu Woman and Profile of Euro-Parisian Woman" (2000) (Figure 3). Always indicated in the hybrids are Orlan's two forehead bumps, which she often refers to as "pigeon eggs." They are there to oppose our current cultural norms. But at the same time, her European face is a stand-in for those same cultural norms:

> The *Self-Hybridations* (materialized by photographs) have been made by connecting works from past and lost civilizations that represented the norms of beauty at the time to my own face, meant to embody the criteria of beauty in our time with the extra irony of the two pigeon eggs that protrude on my temples like two volcanoes erupting against dominating ideology. . . . People talking about these photographs have a tendency to describe me as a "monster" with a strange face, a distorted face; still these two pigeon eggs do not seem to produce the same effect when I am seen in reality.[3]

Orlan's hybrids are the result of her search for rebirth, newness, and mutant bodies. What appears to be most meaningful are the metamorphosis that takes place during body inscription and the facialization that takes place in the creation of Orlan's virtual hybrid humanoids:

> Metamorphosis is an old myth. One has always tried to transform the body. In certain civilizations, those of the Egyptians, or the Merovingians, one elongated the skulls of babies. The pre-Columbians placed a ball of earth between the eyes of the

newborn so it would learn to squint. It was considered to be an attribute of beauty. Until the present one was only able to change the exterior appearance. Tomorrow, genetic manipulations will permit us to change the interior of the body in a fundamental way. Why not create hybrid bodies coupled with the mothers of other breeds of animals? Why not appropriate possibilities, new powers . . . ? Soon human beings will not only constitute one species. There will be several species in the midst of the human family.[4]

SCI-FI

So what is a humanoid hybrid? In 2000, a few children running through the Lyon Biennale Exhibition Hall briefly halted in front of several photographs of Orlan with very large Mayan noses (Plate 3). Their response? From memory, it was something like this: "Cool, it's a humanoid from . . . and here's the enemy, a . . . ! Look, there's Cleopatra!" Then off they went. (The Cleopatra reference was to a black-and-white image of Orlan with a tall hat on, the classical lines of which slightly resemble the famous Egyptian sculpture of Nefertiti [Figure 3, chapter 1].)

The *Self-hybridations* reference a honed and fairly sophisticated visual sci-fi vocabulary regarding fantasy aliens (from other planets?). The rules of engagement, as it were, involve using human physiognomy to size up the intelligence, moral sophistication, and beauty of alien, humanoid, fictional beings. Projected through the eyes of humans, humanoid appearance is marked with modes of recognition that mirror—but not exactly—the human race.

Carried out through extremely imaginative visual concoctions, the visual clues that make up a humanoid go far into the nether regions of the physiognomy lab. Facialization here also garners (earthling-like) indicators of intelligence, sophistication, and moral responsibility. The inclusion of animal-like characteristics, for example, may correspond to warrior-like tendencies and/or extreme injustice (reminiscent of the Klingons in *Star Trek*). Then there is, of course, the representation of the truly evil Darth Vader, who does not have a face at all. This particular rendition of evil has its roots in the myth of Medusa (and accesses the surgical representation of Orlan)—the mutilation of the face and the blinding destruction of an individual's identity that turns that individual into something scary, unfamiliar, evil.

Projected through the eyes of a Westerner, for Westerners, Orlan's images are fantastic, kaleidoscopic, and carnivalesque. They appear more sci-fi than cross-cultural. But this also causes some controversy. I presented *Self-hybridations* at Barnard College's Feminist Art History Conference in 1999. These images yielded accusations of Orlan's overwhelming pretense and racism. The motivations behind *Self-hybridations* were likened to a minstrel's use of blackface, which creates a carnivalesque otherness that serves to exacerbate the gap between the normative and the grotesque (the self and the other). The carnivalesque as grotesque other is definitely present in Orlan's

hybrids. But Orlan speaks about her motivation to explore standards of beauty in other cultures with great deference to those from which she appropriates. I do not believe she intends to make fun of other cultures (although, to say the least, she does have a tendency to shake things up a bit).

The carnivalesque can also refer to an expansion of perception with regard to boundless bodies, or what Mary Russo and Mikhail Bakhtin separately refer to as the grotesque. With regard to the body and the face, the grotesque is defined as otherness that exists outside the bounds of the normative. Mary Russo comments on Foucault's writing:

> As Michel Foucault has argued so forcefully, normalization is one of the great instruments of power in the modern age, supplementing if not replacing other signs of status and rank. "In a sense," he writes, "the power of normalization imposes homogeneity; but it individualizes by making it possible to measure gaps, to determine levels, to fix specialties and to render the differences useful by fitting them into one another." The careful scrutiny and segmentation of female body types, and the measures, cataloguing and segmentation of different "models" for different consumption, separate out individual bodies as exceptions that prove the rule.[5]

Also, women have historically been perceived as other, given that the norm is defined as male. But even beyond female otherness lies the female grotesque, wherein women are perceived to be beyond sexualization. This is sometimes, but not always, the case in *Self-hybridations*. Some of Orlan's hybrids are really quite sexy.

But mostly Orlan's mutating and mutant identities run amok in *Self-hybridations*. Orlan's is a face that regenerates itself. Orlan's is a face from which the peculiar is generated. I contend that her work is more about this than it is about appropriating other cultures' indicators of beauty, or physiognomic attributes of non-Western cultures. Bakhtin writes, "The grotesque body, as we have often stressed, is a body in the act of becoming. It is never finished, never completed; it is continually built, created, and builds and creates another body. More over, the body swallows the world and is itself swallowed by the world."[6] The Orlan body swallows our perceptions as they become tangled in the profundity of the individual trying on multiple faces.

But Orlan also plays with our own prejudices and the often absurd perceptions that Western culture projects onto other cultures. Within this series are black-and-white photographs that are also duplicated in color. The black and whites allude to the genre of documentary photographs taken of non-Western peoples by Western anthropologists. Our preprogrammed visual language does indeed interpret them as documentary, and the qualities of comedy, the grotesque, and the carnivalesque seem to be momentarily lacking in these images. Thus, the children at the exhibition hall identified one black-and-white African image to be that of Cleopatra, a real historical figure, rather than a humanoid. Here Orlan catches us within our own linguistic parameters.

She enacts the language of the documentary image and exposes it as a lie, while the images' colorful counterparts sidle up to becoming carnivalesque sci-fi caricatures.

PORTRAITURE AND THE CARNIVALESQUE

In portraiture, the other (the one rendered) assumes an aura of historicity. Although historical, the other—existing as a portrait—maintains a status of presence/present. Another way to perceive this phenomenon is that the other (in this case the being who is depicted) is immortalized, frozen in perpetual present time.[7] This is because the portrait, when face-to-face with a beholder, is activated by the beholder's experience of presence. The ontological complication here is that the other is experienced as a projection of the self; the portrait is a mirror of the self in terms of the beholder's projection. This means that in the moment of beholding, the face portrayed may be activated to an imagined state of being—or at least a simulation of being.

Emanuel Levinas's face-to-face relation (the self facing the other) is an ontological project that makes the equality between two entities matter. Such a project, as Tina Chanter points out, reveals ethics as merely a search for equality in an idealism that is presupposed between individuals.[8] This presupposed idealism I am interpreting as the fantasized possibility of equality occurring between two beings when face-to-face with one another.

Levinas insists that in the face-to-face relation, ethics precedes ontology. He posits that subjectivity and infinity are integrally related and that separation is linked to the notion of infinity. These elements come together in the face-to-face relation. When one is confronted with the face of the other, separation, not totality, is the result. This separation exists necessarily in order for ideas regarding infinity to exist.[9] It is through this separation and the existence of infinity that the existence of God is presented through the face-to-face relation.

Levinas argues that Western philosophy has neglected the other and has assumed the dominance of ontology at the expense of ethics. He emphasizes the importance of ethics in *Totality and Infinity*. However, this is not ethics in the traditional meaning, which assumes a universal applicability of moral principles. Levinas's ethics occurs in the face-to-face relation, "a relation," Tina Chanter comments, "that involves my recognition of the other's alterity, or irreducible otherness."[10] In the face-to-face relation, the "I" assumes an infinite responsibility toward the other.[11] The ethics involved in the face-to-face relation is contingent upon the differences between myself and the other, rather than the similarities. This dictates an inequality that is the basis of ethics and thus the basis of the face-to-face relation. Further, Levinas says, "To begin with the face as a source from which all meaning appears, the face in its absolute nudity, in its destitution as a head that does not find a place to lay itself, is to affirm that being is enacted in the relation between men, that Desire rather than need commands acts."[12] Here Levinas reveals the impetus to further come to grips with the other (in his version, man-to-man). Desire (for the other, to understand the other, to become

the other) is the quality that demands responsibility for the other. Ultimately we can never know the other. This state of being creates the unrelenting desire to know the other, one manifestation of which is the exploration of portraiture or, in the case of the self-portrait, the desire to know the self as the other.

Yasumasa Morimura performs this ontological curiosity with regard to painting as he places himself inside portraits of the other to look out at the beholder, theatricalizing ontological meaning in painting. In his ongoing series *Self-Portrait as Art History*, he places himself inside portraits by Rembrandt, Leonardo, Cindy Sherman, and Frida Kahlo. He stages these photographs with elaborate sets and costumes rather than exclusively manipulating them with software.

Orlan's *Self-hybridations* confront ontological curiosity by interrupting it. Her renderings are of her face transformed into something alien. I posit that the relationship between self and other is contingent on a mirroring of the human image. When this mirroring is extremely distorted, as in some of the *Self-hybridations*, the relationship of the self (beholder) to the other (representation), as a face-to-face relationship, is radically altered. The experience of this alteration manifests itself as a carnivalesque relationship, a relationship fractured by the recognition that one is confronted with a rendering of a being, other even than the other—an alien.

Orlan's manifestations of the carnivalesque can be seen, then, as a spoof on ontological and ethical self-other relationships. But here Orlan also joins the genre of imaging "freaks." Susan Sontag writes, in *On Photography*, of Diane Arbus's powerful photographs of circus freaks. Here she touches on the politics of this work: "Arbus's work is a good instance of a leading tendency of high art in capitalist countries: to suppress, or at least reduce, moral and sensory queasiness. Much of modern art is devoted to lowering the threshold of what is terrible."[13] Sontag contends that, as a result of this fluctuating threshold of shocking imagery, one truth becomes clear: that the taboos constructed by art and morals are arbitrary. To up the ante on the pain/suffering/violence of photographed subject matter is to challenge the viewer "not to blink," the quotient of visibility/invisibility and of perception.[14]

During her performance surgeries, Orlan challenges us not to blink. Within her carnival of hybrids, she challenges us with her ability to virtually morph over and over and over. And she is amused by the reactions of her audience as they compare the recent *Self-hybridations* with her performance surgeries:

> Some of them [critics] find my current work, because it is achieved through numerical images, all the more remarkable because it leaves behind surgical performances, they applaud what they call my "return to reason."
>
> Some others think that my surgical performances were stronger. They are sometimes precisely those who used to find them impossible to watch. They now find that my new works are too quiet, flat, if not weak—which would find to prove that artists who do not deal with reality only would be weak artists.
>
> Thus, if I resume my surgical performances the former will criticize me once

again, and the latter will encourage me to do more and more, in order to enter the Guinness Book of Records or die on stage. . . .

Some people tend to confuse my *Self-Hybridations* with surgical transformations. During the exhibition of nine *Self-Hybridations* at the Maison Européenne de la Photographie in Paris, I was surprised to hear a certain number of spectators express their surprise at seeing the miracle that plastic surgery could work to disfigure a face! They thought that the nine states of my face were the results of the nine operations.

I find such a naïve reaction flabbergasting, but it also allows me to deduce that my operations and artistic projects, unthinkable as they were some ten years ago, are now accepted.

Thus, thanks to the evolution of our mentality, what used to be anticipated in our reality of those creations that would have been preferably limited to virtuality—because they were judged unthinkable and taboo—is now taken for real, although it manifests itself in a virtual manner.

It should be said that I have tried to make my *Self-Hybridations* as "human" as possible, like mutant beings, but I still did not think that the confusion could be possible.[15]

EXTRActions

A PERFORMATIVE DIALOGUE "WITH" ORLAN

In April 2000, Tanya Augsburg, a scholar and professor at Arizona State University, and I began a dialogue with Orlan that has grown over the years to greatly enrich my understanding of Orlan's work. "EXTRActions: A Performative Dialogue 'with' Orlan" is dedicated to Dr. Augsburg.[1]

JO: *You have spoken and written with great gusto and clarity about identity.*[2]

ORLAN: You speak of identity, I am not for definite identity, but in fact I am for nomadic, mutant, shifting, differing identities. It's here, it seems to me, that our era inscribes itself. We are in a prison from which we should perpetually be trying to remove the barriers, but we aren't yet able to sufficiently succeed. The means of our times still don't allow us to swallow a pill that turns our eyes green or blue or black.[3]

For my part, I would truly wish the body to be a costume—something that is not definitive.[4]

JO: *Is there a dichotomy between the existence of shifting identities and the desire to control how they shift? And how does this shifting identity work with regard to the material body and the gaze of the other?*

ORLAN: I have never done a piece (drawing, photograph, sculpture, video, or performance) without considering it as a body looking for other bodies in order to exist.[5]

The gaze of the other always comes into play. It is the gaze of the mother that constructs the child, and within all civilizations there is a desire to fabricate the body. Every time we declare: "I am, I love, I desire." The "I" that we think is most profoundly at the core of our identity gives the impression that we are at the heart

141

of our deepest self. And in fact, people are very conscious of all this, "I want, I love, I desire" are extracted from models presented to us. But it seems to me that when there is personal maturity, and a certain knowledge of one's self, one should be able to define who one is without being shaken by the gaze of the other. It is this that I have tried to do. Because if I am described as a woman who has two bumps on her head, immediately I am imagined to be an unfuckable monster. But this is not the case when people see me.[6]

JO: *But language fails here with regard to the "I." The desire for "I" to ontologically communicate the core of our being always fails us. As soon as it is spoken, it fails, because it can never completely fulfill our desire. At the same time it is the other that sanctions our identity. But during your surgical performances the experience of viewing the other's body interior defies language on another level. Here the magnitude of the "I" (represented as the visceral core of the body rather than language) shifts from being ontological to being visceral, where the representation of identity may be lost. The indifference of the medical gaze, for example, both facilitates the shock of witnessing identity loss and contributes to its loss (the patient as specimen). By using language during the opening of your body, you defy this position as identity-less other (you take the position of anti-specimen). Even so, there are moments, largely exhibited in your (silent) photographs, during which the viewer is forced to contend with the representation of identity loss.*

ORLAN: The first function of the artist is to pose a question, to disturb the gaze, ways of thinking, modes of thought [*prêt-à-penser*]. The artist is to listen to that which is going to topple over, to transform itself. S/He observes the germs of the future. One of my preferred sayings is to "remember the future." I am very attached to this keen concept—no one is not of this age. We are all inscribed in our time and the artists are those who have the capacity to call it into question.[7]

 I intend to invert the Christian principle of *the word made flesh* to *the flesh made word*, because it is in the flesh that my work inscribes itself as an artist's word. It is necessary to change the flesh into language by performing transgressive acts against the four governing police forces (religion, psychoanalysis, money, and art history).[8]

JO: *You have referred to the shape of your material body as perceived by the other. One always already has to contend with the material body. However, you confront materialism by shape-shifting. If we accept that identity is (linguistically) experienced in the ontological space between one's body and the gaze of the other, how do we understand your claim that the body is obsolete?*

ORLAN: The body is obsolete, Stelarc and I spoke of this at the same time, at the same moment, it's an idea we both agree upon. Effectively, . . . our body is not, among other things, made for speed, is not made in order to speak several languages. Human beings are also profoundly marked by the geographic place in which they are born. Many things in our bodies are obsolete, misused, or could be used more effectively if better conceptualized. We discover, for example, the genes that program the deaths of cells.[9]

JO: *Discourses concerning the morality of cloning and the projection that in the future humans may be genetically programmed, etc., can be really haunting; the ability to manipulate genes may allow us to one day create a "master race." But also, to respond to your idea, our bodies may serve us better, because the ability to map and manipulate the human genome signifies movement further away from an absolute acceptance of what naturally comes into being. You have already stated that your work is "a struggle against the innate, the inexorable, the programmed, Nature, DNA (which is our direct rival as far as artists of representation are concerned), and God!"[10] Do you have any specific notions about genetic research?*

ORLAN: I think we are at a turning point, in which we aren't yet ready. Many great changes are coming about in medicine. I am always amused by the efforts made by people who desire to impede research on cloning, on genetic manipulation, etc. It's absolutely derisory; these changes are inescapable. They will happen anyway. The body is no longer harmonious with itself. The ape, what we are [now], and what we are becoming should be viewed in terms of successive stages. For the moment, we are in this transition between being human, and becoming beings more adapted to, for example, interstellar travel—becoming beings who have bodies playing other roles. . . .[11]

As for genetic manipulations, they are like a hammer: with a hammer I can either kill someone or build my house. The problem is the ideology behind either choice. We can and we must utilize new technologies in order to improve the human body, all while keeping a critical distance. Surgery is also a new technology: it is a way of our times, one of the possibilities. I turn away from surgery that is habitually used—that imprints onto the flesh standards of beauty and the dominant ideology—toward rather a positive utilization. . . . I try to move things forward, to open the eyes onto the world so that human beings accept the other and accept difference.[12]

For the moment, I'm greatly interested in biotechnologies, for example, in growing skin. I've discussed it with scientists in the context of broader conversations on recent advances in the field. But you have to understand that my artistic interest inevitably involves deliberate *détournement* (misappropriation or subversion). I'll briefly explain what I intend to do: another open project, which I was supposed to launch with *Lieu unique* (Unique Site), when Jens Hauser organized that exhibition in biotechnology. The idea is to take cells from my skin and dermis and hybridize them with skin and dermis cells from black people. The hybridized cells will then be grown in the lab. At the moment, I'm in touch with a group that includes artists who feel that I've contributed a lot to their work, a group called Symbiotica. These people have generously opened the doors to their lab in Australia. But the problem is that they've mainly done skin cultures, while I also want to grow the dermis, which is much more difficult to do. . . .[13]

The idea is to obtain pieces of epidermis and dermis, first from someone with black skin, since I'm working on the series of *Self-hybridations africaines* and that's

what interests me most. But I also aim to do it with people with skins of different color, in order to create a patchwork effect. This is yet another example of a crossover between fields, because the theme comes from a text by Michel Serres. [The figure of the Harlequin in Serres's *Tiers-instruit* was used as a motif in Orlan's fifth performance surgery, performed in Paris on July 6, 1993. The Harlequin's multicolored robe is a metaphor for multiculturalism that's inclusive of all skin colors. Serres's Harlequin figure is king of the earth and the moon. At one point this king tells those on earth that he's going to the moon to report back about what's happening there. But when he returns he has nothing to report, and the crowd becomes bored with him and demands that he disrobe.] So he undresses. But like an onion—he peels off a whole series of cloaks, one after another. All the cloaks are of different color and different material, and after he finally takes off the last cloak the audience sees that his skin is made of different colors and his body is tattooed all over. That's where I decided to take up the text which reads, "What could the common freak, that ambidextrous, mestizo hermaphrodite, now show us beneath his skin? Of course: his flesh and blood." So scientific knowledge chops what is called flesh into little pieces. Harlequin's cloak is that flesh.[14]

JO: *Temporality plays a large role in the conceptual nature of your work. The idea of shifting identity is inexorably linked with it. For example, in* La réincarnation de Sainte-Orlan, *your face changes on several temporal planes, both conceptually and materially. You live, as well as create, your art. The face radically changes during the surgical performances, during the post–op healing periods, and then when healed, resurrected, but between two surgeries, about to change again, or now, between virtual hybridizations. (And still, of course, there is the inevitability of the aging process.) Can you speak about the politics of this process of morphing?*

ORLAN: From the beginning of my work the subject is the same: to denounce the pressure put on the status of the body. These surgical operations are not an end in and of themselves.[15]

 Carnal Art is not interested in the plastic-surgery result, but in the process of surgery, the spectacle and discourse of the modified body which has become the place of a public debate.[16]

 These [surgical performances] are the acts that materialize, concretize, render my objective: to show that beauty can include appearances that are not reputed to be beautiful, that all civilizations fabricate the body. That all of this is illusory. To show that our body is completely alienated by religion, work, sports, and even by our sexuality, which is formatted according to set models. It is during these surgical operations that I show surgical gestures that have never been executed, plastic results that have never been envisioned; or in the digital images where I associate my actual face with standards of beauty coming from all countries. . . . I always capture hybrid beings, mutant bodies, potential appearances derived from civilizations that wouldn't have shared our priorities.[17]

JO: *In the surgical performances, you break taboos by disrupting the shape of the natural*

body; opening the body in public; and risking illness, injury, and pain. But you also claim no pain within the context of the surgeries, and you valorize the use of painkillers. In other words, suffering is not a part of Saint Orlan's hagiography. Does your performed absence of pain correspond to your premise that the body is obsolete? Or do you reproach the body for its ability to feel pain?

ORLAN: No. I don't reproach the body for being able to feel pain. . . . I am against the idea [of] suffering and pain, not only in Western cultures but also in other cultures, [where it] is seen as a form of purification and redemption.[18]

My surgical performances are operations of the opening and the closing of the body. These are "poetic" operations in so far as they achieve other ends and show that one can have a body opened while laughing, speaking, reading, playing. The big contribution of our era is the ability to extinguish pain.[19]

JO: *In spite of your disavowal of pain, others associate your surgical performances with masochism, even though you repeatedly say that it is not you who suffers, but the audience. Can you compare your "carnal art" with "body art," for example, that of the Viennese actionists?*

ORLAN: Carnal Art is self-portraiture in the classical sense, but realized through the possibility of technology. It swings between defiguration and refiguration. Its inscription in the flesh is a function of our age, The body has become a "modified ready-made," no longer seen as the ideal it once represented; the body is not anymore this ideal ready-made it was satisfying to sing.[20]

My work is altogether different than that of . . . the Viennese Actionists, who for example played on the trilogy "sado-maso-scato" and shook off all that is moral, and in particular religion conveying: negation of body pleasure, "monstration" of the body with rapport to the sexual. They worked on psychological and physical limits of the human being. My work questions the body and its mutation, the body and beauty in the face of technology.[21]

I wanted to do flesh sculptures the way I did sculptures of lines and folds, with the idea of increasing possibilities and faculties, never reducing them or developing a fascination with self-mutilation. I feel very, very removed from certain artists who work on piercing, blood, tattoos, bodily modifications and cutting into the body, even though I've been called the instigator of all that. In short, I don't at all share the culture of masochistic public sport. For me, pain is of no interest in itself, it's just an alarm signal, or maybe orgasmic, but has nothing to do with art or constructing any thing. Pain just isn't a working hypothesis—on the contrary, I think our bodies have suffered enough over the ages and we're now in a position to curb pain. So it's really very important to demonstrate the opposite—I think pain is anachronistic, we can now alter the body without provoking pain.[22]

JO: *In this book I suggest that artists who bust apart binary oppositions are not only breaking down the grounds upon which identity is formed but also expanding modes of thought and perception into a sort of fluidity (to borrow from Irigaray). Politically I see this as an extremely important strategy. You say, for example, "Remember the future."*

ORLAN: In my work, "And" is an organizing principle that always recurs: "past and present," "public and private," "that which is considered beautiful and that which is considered ugly," "the natural and the artificial," "satellite transmissions and the drawings I did with my fingers and blood in the course of my surgical performances," "the relics sculpted with my body and the works done by computer drawing and morphing . . . and re-elaborated in collaboration with the other end of the world thanks to e-mails that help me to create my numerical images," etc.[23]

[Time is] very important to me. I'm not a fashion designer; I don't need to change my look every season, doing little flowers one day, then something else the next. It's important for me to hold a steady course, to follow a method, to maintain a certain progression in my ideas and to return to certain aspects, which are also concepts, that can be reworked and sometimes even corrected. It's an acceptance of time. Which I think can be seen in my work—I love everything historical, I love to show old works, but I also take the present into account and I try to guess what the future holds. There's no schiz between the old and the up-to-date.[24]

JO: *You've said, "You've got to make yourself a skin out of art."*[25]

ORLAN: It is not only the hand (as is the case with painters, sculptors and graphics designers) but the entire body that works upon the body. Its representation during surgery becomes my workshop where I elaborate my material or the images which I shall work upon again later. The works I am interested in are first of all determined by certain attitudes, certain strong prerequisite ideas, social projects, a certain way of thinking—whether they are achieved thanks to new technologies or older methods is not without consequences, but it is not the technique that matters in itself, it must not become a prison and/or a comfortable position in which the thought of the artist degrades itself or becomes part of a consensus.

[Orlan references an article by Bernard Ceysson, in which he calls her the ultimate masterpiece.[26] But, above all, Orlan sees herself as a catalyst for debate, which allows her to perceive a difference with regard to who she feels she is. She insists that there is no specific objective to the physical aspect of the facial transformations, and wants to be clearly understood about this point. The plastic results do not interest her at all.[27]

[Dr. Augsburg and I question her more, to find out about the relationship of identity to her changing face. We become obsessed with pressing her on this point. The result? She tells us an anecdote.

[In Paris, in 2001, covering buses and bus stops, there were large photos of an actress with the same hair as Orlan, black on one side and white on the other, like Cruella De Vil of *101 Dalmatians*. Orlan tells us that whenever she is in Paris, people in the streets yell out to her, "Cruella!" Orlan is quite amused by this.][28]

JO: *Other artists who have placed their own image at the core of their work have been criticized for being narcissistic. [Hannah Wilke suffered this criticism until her images became about her ill body.] Although the concepts your work embodies apply to the*

human condition, your image is always the vehicle. How do you respond to the criticism that your work is narcissistic?

ORLAN: I am glad that you pose this question. Some critics with regard to my work or those of other artists that work with their image, say: "It is too narcissistic, it's too exhibitionist." For me this comment is absolutely ridiculous. No one says this about Johnny Hallyday, or Michael Jackson. No one says: "It's terrible, he was in front of 15,000 hysterical people. He changed costumes endlessly. There was fantastic lighting on him, he touched his sex, he gyrated all over the stage. What narcissism, what exhibitionism, all this is terrible!" It's incredible, no one will say this, and yet this is regarding pop art. So then why suddenly, when we're dealing with another form of art, narcissism and exhibitionism become something unbearable? We all need to be a little bit narcissistic, if not, we would be incapable of living.[29]

[Orlan told Dr. Augsburg and me that she has always liked her image. For her entire career she has worked with it in photos and video, both naked and dressed. But by doing the surgeries she put her image on the line. It would have been futile and uninteresting if she had been uncomfortable or unhappy with the way she naturally looked. But this was not the case. The important thing is that she did not feel the need to surgically alter herself, but did it because it was necessary to enact a total requestioning of her own image. Had she had low self-esteem, surgical alteration would have been without any interest. The interesting aspect of her work is that she took a risk by altering a self-image with which she was already happy.][30]

JO: *I know that you see your work as a catalyst for debate. How do you feel about those who dismiss your work, or those who reduce it to sensationalism?*

ORLAN: Often, with regard to the critics of my work, the worst critics, those that scream, those that have violent reactions, often become my best friends, who support me the most. Then, they listen to one of my conferences or they actually take time to come to an expo or read a book on my work. And there are of course people that I will never convince: in art, it's rare to be unanimously applauded. It is true that my work is demanding; it is uncomfortable for everyone, including me.[31]

JO: *With regard to your hybridations, Christine Buci-Glucksmann once said, "There is no simple opposition between the virtual and the real, but the virtual, which is the progress of form and abstraction, transforms the real."[32] But with regard to your work, within this transformation of the real, the material body and representations of the body are not necessarily reflections of one another, because between the two there is a performance of difference. Thus, in your work the relationship between the virtual and real may be the embodiment of (performance of) identity.*

ORLAN: The aim is not to confront what is real with what is virtual—and vice versa— in a sort of endless Manichean and reductive opposition. On the contrary, virtuality mingles with reality as its imaginary part and the reality which I create is not devoid of virtuality: for instance, the scene of a film, of a video, a photographic

frame and so on and so forth, become meaningful because they "stage" life by placing it under a certain scope, in a certain frame. "Art is what makes life more interesting than art itself."[33]

All figurative works can be said to be "virtual." The representation of the Virgin and Child by Jean Fouquet [ca. 1450], for instance, is the portrait of Agnès Sorel. Still we do not see Charles VII's mistress, but a painting.[34]

To return to the consequences of my "and" I will say that the virtual and the real elements, when they are used at the same time, become new ways of obliquely questioning art itself and the world around us.[35]

Such a medley will also be found in the film David Cronenberg has invited me to take part in and whose story is inspired by the "Maifteste d'art charnel." I will play my own character, as in a reality show, but transformed by the imagination and creativity of Cronenberg. It could be possible to ask oneself if the operation in Cronenberg's previous films were real or, on the contrary, if mine was real or not.[36]

[David Cronenberg's script "Painkillers" is about a society without pain, where sex takes place only through surgical procedures; people experience *jouissance*, sex, orgasm through the pleasure of opening the body. Cronenberg has offered Orlan her own role in the film.

[When Dr. Augsburg and I spoke with her in 2001, Orlan suggested that during this film she would undergo her last surgical procedure, a purely poetic one, during which she would defy pain and laugh, speak, and read while her body was opened, then closed back up.][37]

ORLAN: I first thought of including it [this poetic surgery] in the project with Cronenberg, but in fact what would be much more subtle in the Cronenberg film would be to do a fake operation that allows me to let my visual imagination do just what I want. Fiction allows you to take greater liberties on the strictly visual level—yet I'm sure that everyone who knows my work would think it's a real operation! People are always convinced that the surgery-performances they see on video are naturalistic, that absolutely nothing has been reworked, that the videotape is a kind of "snuff movie" even though that's not the case! Because sometimes during the operation I might say to the surgeon, "Careful, do that move again, the camera didn't catch it," or, "Move aside, you're blocking me from the camera," and so on. So we start over, we build the image within the operation itself. We have a specific idea of the images we're looking for.[38]

JO: *One of the questions continually being asked with regard to performance is, How should one think about the documentation of live performance? Is the documentation art, in and of itself, or merely residue of something that cannot be repeated? Peggy Phelan's notion of performative writing—text that does not attempt to document but, rather, performs the thoughts of the spectator—has greatly informed one way of thinking.*

ORLAN: I would also like to mention briefly the exhibition Out of Action by Paul Schimmel in Los Angeles [1998].

It showed works that came from performances and were considered as not very interesting traces as compared with the actual performances themselves (this opinion is all the more biased since it often comes from those who were not interested in the performances either). This exhibition demonstrates . . . that works— like those of Rembrandt, Courbet or Rubens . . . — are results of, traces of a physical action that took place during a certain length of time: a dead trace, masking the artist's work which was to reanimate itself.

When Yves Klein used women as living brushes in his *Anthropométries* [1960], there was a moment lived with the spectators and then the time for exhibition of the work. He was never blamed for (his macho mind apart) having used performances to create works of art that are considered as "normal" through and through; it could be said that his *Anthropométries* are nothing but the resulting marks, the side effects or remnants of the performances.

Such an exhibition demonstrated that the works resulting from performances should be reconsidered because, as a matter of fact, they—like all works of art— come from a process and a series of actions, whether they are public or not.[39]

JO: *More specifically, at the time* Omnipresence *was performed, the video footage and the live performance created a virtual/real feedback loop. But ultimately, wasn't it also performed for the camera?*

ORLAN: I have always sought to erase the limits, to transform reality into virtuality, and vice versa; . . . [*Omnipresence*] took place in an art gallery in NYC and was broadcast in an art gallery in the city itself, but also at the Centre Georges Pompidou in Paris, at the MacLuhan Centre in Toronto. The video image that was seen live by the audience could appear as a fiction, . . . because the operating theatre was also heavily invested by art and imagination.[40]

During the performance, the author is not an actor but a character who is a player physically and psychologically involved in front of one or many spectators, without any disguise of illusion: a real drama is taking place here and now.[41]

It is worth noting that when Barbara Rose tried to publish an article on my work in *Art in America*, the editor demanded the videotapes to check whether the surgical operations had really taken place. She would not trust photographs which, she thought, could have been . . . tampered with.[42]

JO: *For your new ongoing project,* Le plan du film, *haven't you made movie posters for films that don't exist, with the objective of then working backward to construct the films?*

ORLAN: I made movie posters based on a comment by [Jean Luc] Godard, who basically said, "A masterful film is one made back to front, so that in a way it becomes the flip side of cinema." For this project, titled *Le plan du film* (A Shot at a Movie), my idea was to take him at his word. Using my own personal imagery, often based on recycled pics—that is to say, photos that couldn't be used on a poster unless painted or rephotographed and manipulated by computer—I designed posters in

the form of back-lit boxes like the ones you see above movie theaters. So these posters contained some of my own imagery, with credits based on the names of friends who have supported my work. The credits also featured one or two names of real movie stars to make people think that the film really existed. I placed these posters in the window of the "artist's corner" of the underground shopping mall in Paris known as Le Forum des Halles. Passersby then started looking everywhere for the new film by Cronenberg, or the latest film starring Jean-Claude Dreyfus, which they hadn't seen yet but knew must be playing in one of the movie theaters in the mall because they'd seen the poster! I was told that everyone was looking for these films. Parallel to that I did a performance at the Cartier Foundation in Paris, which involved making a large audience think there was a new TV program that would be shot right there that night. The work tried to establish links between contemporary art and the movies . . . so we set up a fake TV studio . . . [and] we found a real emcee. There were also well-known art critics, visual artists, and even actors and directors. I projected the images from the light boxes and everybody pretended that the film existed. The critics said, "I've just come from the premiere and I'll tell you about the film." And then they'd critique it. Everyone in the audience believed them. Then Jean-Claude Dreyfus recounted not only the plot of the film but also stuff that supposedly took place on the set during shooting, his relationship with the director, and why the film represented a turning point in his career. We thus produced a fifty-two-minute tape of an authentically fake TV program that everyone thought was real! Meanwhile, I have another fake DVD in the works—when I manage to find a way to finance it—which this time will have images as well as sound, and which will include the synopses written ex post facto, or "back to front." We also made a trailer for a non-existent film, directed by Frédéric Comtet, starring myself along with Philippe Ramette, Vincent Wapler, Jean-Michel Ribettes, and Yzhou, which we screened at the last Cannes festival, where we also displayed the posters. And finally, we've found a producer to back one of the films. So somebody is actually making it. And in addition to all that, I've met a producer who said he'd back a film if I directed it myself. So right now I'm writing a screenplay based on one of the synopses, and I think shooting will begin at the end of 2004.[43]

Notes

Introduction

1. Orlan, "Conference," trans. Tanya Augsburg and Michel A. Moos, in *This Is My Body . . . This Is My Software . . .*, ed. Duncan McCorquondale (London: Black Dog, 1996), 89.

2. Ibid.

3. See Madan Sarup, *An Introductory Guide to Post-structuralism and Postmodernism*, 2nd ed. (Athens: University of Georgia Press, 1993), 10, 11.

4. Terry Eagleton, *Literary Theory: An Introduction*, 2nd ed. (Minneapolis: University of Minnesota Press, 1996), 147.

5. Orlan, "Intervention," trans. Tanya Augsburg and Michel A. Moos, in *The Ends of Performance*, ed. Peggy Phelan and Jill Lane (New York: New York University Press, 1998), 316.

6. Jacques Derrida, *Of Grammatology*, trans. Gayatri Chakravorty Spivak (Baltimore: The Johns Hopkins University Press, 1982), 154.

7. See Rodolphe Gasché, *The Tain of the Mirror: Derrida and the Philosophy of Reflection* (Cambridge, MA: Harvard University Press, 1986), 230–36.

8. Jacques Derrida, "Speech and Phenomena," trans. David B. Allison, in *A Derrida Reader: Between the Blinds,* ed. Peggy Kamuf (New York: Columbia University Press, 1991), 20–28.

9. See Sarup, 35.

10. Ibid., 40.

11. Maurice Merleau-Ponty, "Eye and Mind," in *The Primacy of Perception*, trans. Colin Smith (1945; repr., New York: Humanities Press, 1962), 163.

12. Orlan, "Conference," 84.

13. Peggy Phelan, *Unmarked: The Politics of Performance* (London: Routledge, 1993), 3.

14. Ibid.

15. Peggy Phelan, *Mourning Sex: Performing Public Memories* (London: Routledge,

1997), 1–2. Phelan writes a story: As a child she had a colorful book of anatomy from which she tore one of the illustrations. She was more fascinated with the hole that was left by the outline of the figure than with the existence of the figure in the book. This is a metaphor for her ensuing discussion on the relationship between performance and the texts about performance.

16. Ibid., 3.

17. The verb "to flay" is used throughout this book to describe the removal of the skin from Orlan's face during her performance surgeries. The visual representation of this process during the surgeries lends itself to this term, which is also used in reference to the martyrdom of, for example, Saint Bartholomew (see Figure 19, chapter 2).

18. Phelan, *Unmarked*, 12.

19. Jacques Derrida created a term, *différance,* which incorporates *difference* and *deferral* into a term that indicates both spatial and temporal difference. Regarding deferral (the *différance* of temporalization), Derrida writes, "The sign is usually said to be put in the place of the thing itself, the present thing, 'thing' here standing equally for meaning or referent. The sign represents the present in its absence. It takes the place of the present. When we cannot grasp or show the thing, state the present, the being-present, when the present cannot be presented, we signify, we go through the detour of the sign. We take or give signs. We signal. The sign in this sense, is deferred presence." "Différance," trans. Alan Bass, in Kamuf, 61.

Regarding difference, Derrida says, "[T]he movement of différance, as that which produces different things, that which differentiates, is the common root of all the oppositional concepts that mark our language, such as . . . sensible/intelligible, [and] intuition/signification." Derrida also states that différance is the production of these differences, a process of differentiation. See *Positions*, trans. Alan Bass (Chicago: University of Chicago Press, 1971), 9; also discussed in Gasché, 198.

20. Derrida, "Speech and Phenomena," 25–27.

21. For example, see Jean-François Lyotard's close reading of Wittgenstein in which he adopts Wittgenstein's language games as a paradigm for thought. Lyotard abandons the grand narratives (universal truths) that Western philosophy is based on. Jean-François Lyotard, *The Postmodern Condition: A Report on Knowledge*, trans. Geoff Bennington and Brian Massumi (Minneapolis: University of Minnesota Press, 1984).

22. Paraphrasing Lynda Nead, Michelle Hirschhorn writes: "By reconceptualizing the scientific mind, Descartes effectively shifted knowledge and reason away from the natural (commonly associated with the feminine) and recast them as masculine attributes. Correspondingly, this process asserted the primacy of the masculine over the feminine, by associating the term 'male' with creativity and rational thought while the term 'female' became aligned with passivity and biological reproduction." Michelle Hirschhorn, "Body as Ready (to Be Re-) Made," in *Generations and Geographies in the Visual Arts: Feminist Readings*, ed. Griselda Pollock (London: Routledge, 1996), 115; Lynda Nead, *The Female Nude: Art, Obscenity, and Sexuality* (London: Routledge, 1992), 22–30.

1. Orlan's Body of Work

1. Tanya Augsburg and Jill O'Bryan, "Orlan: Élements favoris at FRAC Loire" (unpublished review, 2003).

2. Orlan claims to have been protesting both with the feminists and against their militant Marxist and separatist dogma. However, this is a complicated issue. In May 1968 the French feminist movements allied themselves with the Marxists but found misogyny

to be extremely present among the participating members of the Marxist movement. Claire Duchen writes: "French women activists' experience during the May events was similar to that of American women involved in civil rights movements and student politics and to that of British women in the New Left. . . . [A]ssociation with important men was generally women's access route to prominence. Yet once they were involved in politics, the sexual division of labor left something to be desired and the euphoria of the moment was tempered by the anger they felt at the way male militants treated them." *Feminism in France: From May '68 to Mitterand* (London: Routledge & Kegan Paul, 1986), 7.

3. Surprisingly, Orlan writes, "In the sixties, all young [French?] women had to prepare their trousseaus." "Body and Action," in *Orlan, 1964–2001*, ed. María José Kerejeta, trans. Brian Webster and Careen Irwin (Vitoria-Gasteiz, Spain: Artium; Salamanca, Spain: Ediciones Universidad de Salamanca, 2002), 208.

4. Augsburg and O'Bryan.

5. Sarah Wilson, "Histoire d'O, Sacred and Profane," in *This Is My Body . . . This Is My Software . . .*, ed. Duncan McCorquondale (London: Black Dog, 1996), 11.

6. Ibid. *Écriture feminine* is literally translated "feminine writing." Hélène Cixous believes that women's bodies are culturally constructed, that writing is the place of this construction, and that therefore writing by women that aims at altering patriarchal and misogynist images of women is particularly important for women to engage in. See Hélène Cixous and Catherine Clément, *The Newly Born Woman*, trans. Betsy Wing (Minneapolis: University of Minnesota Press, 1986); and Hélène Cixous, *Coming to Writing and Other Essays*, ed. Deborah Jenson, trans. Sarah Cornell, Deborah Jenson, et al. (Cambridge, MA: Harvard University Press, 1991).

7. Orlan, "Body and Action," 208.

8. Orlan, "Facing a Society of Mothers and Merchants," in Kerejeta, 206.

9. Orlan, "Body and Action," 208.

10. Catherine Millet, *L'art contemporain en France* (Paris: Flammarion, 1987), quoted in Barbara Rose, "Is It Art? Orlan and the Transgressive Act," *Art in America*, February 1993, 83–87, 125.

11. Orlan, "Body and Action," 208.

12. Rose, 84. Orlan came in contact with members of Fluxus through Vautier's gallery in Nice (the famous gallery that gave Yves Klein and other avant-garde members their start).

13. Orlan, "Body and Action," 207.

14. Wilson, 11.

15. Orlan, "Body and Action," 208–9. Dupuy invited Orlan to do a performance about one of the artworks exhibited in the Louvre museum, in her series *Une minute, une oeuvre*.

16. Tanya Augsburg, "Orlan's Performative Transformations of Subjectivity," in *The Ends of Performance*, ed. Peggy Phelan and Jill Lane (New York: New York University Press, 1998), 295. Her quotation refers to Parveen Adams, "Waving the Phallus," and Kaja Silverman, "The Lacanian Phallus," both in *Differences* 4, no. 1 (1992): 76–83 and 84–115, respectively. Regarding the woman being the phallus: within the economy of desire the phallus is a transcendental signifier, a signifier of desire. As the man *has* the phallus, he is the object of women's desire; as the woman *is* the phallus, she is the object of man's desire. It replaces the primordial lost object—the mother. See Sigmund Freud, "Female Sexuality" (1931), in *The Standard Edition of the Complete Psychological Works of Sigmund Freud*, trans. and ed., James Strachey (London: Hogarth, 1953–74), 21:132; and Jacques Lacan, "The Signification of the Phallus," in *Écrits: A Selection*, trans. Alan Sheridan (New York: Norton, 1977), 289.

17. In French the word *mesure* translates as "moderation" or "measurement"; *rage*

translates as "rage" or "anger." In 1964 Orlan performed the first in a series of *Orlan-Body Actions*, titled *Action Or-lent: Les marches au ralenti*. She slowly walked between Saint-Étienne's town hall and place Dorian, a daily walk for many of Saint-Étienne's inhabitants, as the route connected the bus and tram terminals. Here the artist's body performed a transforming experience of place, a theme she continued in *MesuRAGEs*. She performed *Action Or-lent* several times, including in Marseille, Toulon, Nice, and Saint-Paul de Vence.

18. Augsburg and O'Bryan.

19. Wilson, 12.

20. Augsburg and O'Bryan.

21. Ibid.

22. Kate Ince, *Orlan: Millennial Female* (Oxford: Berg, 2000), 35. This refers to Irigaray's writing about the possibility of a female imaginary.

23. Wilson, 11. A few of the many other places Orlan has measured include the Guggenheim Museum in New York, the Granville Palace, and Le Corbusier's house in Firminy. Orlan, "Body and Action," 208.

24. Augsburg, "Orlan's Performative Transformations," 298.

25. Orlan, "Body and Action," 208.

26. Wilson, 12.

27. Quoted in ibid.

28. Quoted in ibid.

29. Ibid., 12–13.

30. Orlan, "Conference," trans. Tanya Augsburg and Michel A. Moos, in McCorquondale, 84.

31. Wilson, 13.

32. Ince, 32.

33. Wilson, 13.

34. Eugénie Lemoine-Luccioni, "Essai psychanalytique du vêtement," in *La robe: Essai phychoanalytique sur le vêtement* (Paris: Editions du Seuil, 1984).

35. Wilson, 13.

36. Lemoine-Luccioni, 95, 137.

37. Rose, 86.

38. Ibid.

39. Wilson, 13.

40. The original version of "Donkey's Skin" was published in verse form. Charles Perrault (1628–1703) was a member of the Académie française and a leading intellectual of his time. Ironically, his dialogue *Parallèles des anciens et des modernes* (Parallels between the Ancients and the Moderns) (1688–97), which compared the authors of antiquity unfavorably to modern writers, served as a forerunner for the Age of Enlightenment in Europe, an era that was not always receptive to tales of magic and fantasy.

41. Augsburg and O'Bryan.

42. Ibid.

43. Ibid.

44. Orlan, "Intervention," trans. Tanya Augsburg and Michel A. Moos, in Phelan and Lane, 317.

45. Augsburg, "Orlan's Performative Transformations," 287.

46. The Fontainebleau Diana is also sometimes identified as an anonymous painting. See Rose, 84. Orlan simply refers to the image as "*Diana* of the Fontainebleau School." "Conference," 89.

47. Orlan, "Conference," 84.

48. Regarding the medieval practice of fragmenting the saintly body, Caroline Walker Bynum writes: "Dismemberment is horrible, to be sure; and even more horrifying is rottenness or decay. But in the end none of this is horrible at all. Beheaded and mutilated saints are 'whole' and 'unharmed.' Severed toes [e.g., James the Dismembered] are the seeds from which glorified bodies will spring. God's promise is that division shall finally be overcome, that ultimately there is no scattering. As one of the more conservative [medieval] theologians might have said: Material continuity is identity; body is univocal; the whole will rise and every part is in a sense the whole." *Fragmentation and Redemption: Essays on Gender and the Human Body in Medieval Religion* (New York: Zone, 1991), 294.

49. Wilson describes Orlan's surgical performances in chronological order, and *Cloak of the Harlequin* is deemed the fifth surgery. According to the dates that Wilson gives, this information is correct (Wilson, 15). However, in Orlan's text ("Conference," 92) she briefly refers to this as the sixth surgery.

50. Orlan, "Conference," 92.

51. Ibid.

52. Michel Serres, *Le tiers-instruit* (Paris: Éditions François Bourin, 1991), 92–93. For more about Serres's relationship to Orlan's work, see "EXTRActions" in this book.

53. Quoted in Wilson, 15.

54. Ibid.

55. Orlan, quoted in Margalit Fox, "A Portrait in Skin and Bone," *New York Times*, November 21, 1993.

56. Wilson, 15. Like all of the previous surgeons, Dr. Marjorie Cramer waived her usual $12,000–$15,000 fee, finding Orlan's requests "unorthodox . . . but reasonable and rational" (M. Fox, 8). Orlan's sources of funding come from private benefactors and the sale of artwork resulting from the surgeries: video, photos, mixed-media pieces, reliquaries, and artifacts. Orlan also charges for interviews and earns money through the sale of rights for her photos and videos (Rose, 85).

57. The blue hair is a possible reference to Orlan's *Documentary Study: The Head of Medusa,* done at the Musée S. Ludwig in Aix-la-Chapelle: "This involved showing my sex (of which half my pubic hair was painted blue) through a large magnifying glass—and this, during my period. Video monitors showed the heads of those arriving, those viewing, and those leaving. Freud's text *The Head of Medusa* was handed out at the exit, stating: 'At the sight of the vulva even the devil runs away'" ("Conference," 84). This performance is discussed in chapter 5.

58. Orlan is given anesthesia in the form of a spinal injection. This allows her to direct her performances and to gaze back at the viewing audiences, a fully conscious individual.

59. Orlan, "Intervention," 319–20.

60. Orlan, "Conference," 88.

61. Wilson, 15.

62. Ibid.

63. Lemoine-Luccioni, quoted in Orlan, "Conference," 88.

64. Orlan, "Conference," 88.

65. Orlan, "This Is My Body, This Is My Software," trans. Claudia Hart (Paris: Sipa, November 1993).

66. Rose, 84.

67. Sarah Wilson also makes a point of this interrogation (9).

68. Orlan, "Conference," 91.

69. Ibid., 89.

70. Augsburg, "Orlan's Performative Transformations," 289.

71. "Like the Australian artist Stelarc, I think that the body is obsolete. It no longer is adequate for the current situation. We mutate at the rate of cockroaches, but we are cockroaches whose memories are in computers, who pilot planes and drive cars that we have conceived, although our bodies are not conceived for these speeds." Orlan, "Intervention," 325.

72. Wilson, 15.

73. Orlan, "Conference," 92. Other artists who place bodies in the center of installations include Damien Hirst, who sections the bodies of animals; and Bob Flanagan and Sheree Rose, who planned a video installation upon the death of Flanagan in which a video camera would document the gradual decomposition of his body. In religious iconography there is, for example, the body of Saint Ambrose from the fourth century AD, which is on display in Milan; reliquaries such as the tooth of Mary Magdalene and the tooth of Buddha; and Egyptian mummies. The body of Lenin is an excellent example of the human body as the body politic on display.

74. Wilson, 9.

75. Orlan, "Mise en scene pour un grand Fiat" (1984), in *Orlan, Art Accés Revue* (Stedelijk Museum Amsterdam exhibition catalog), June 1987.

76. Augsburg, "Orlan's Performative Transformations," 307. Marina Abramovic speaks of this as well. For Abramovic this pain comes from Orlan's directly confronting her fears. As soon as she understands that one of her performance ideas contains something she greatly fears, she knows that she has to do it. Marina Abramovic, discussion with Rose Lee Goldberg, New York University Department of Art, New York, February 26, 1999.

77. Augsburg, "Orlan's Performative Transformations," 307.

78. Ince, 128.

79. Kathy Davis, *Reshaping the Female Body: The Dilemma of Cosmetic Surgery* (New York: Routledge, 1995), 169.

80. Ibid.

81. Ince, 127.

82. Davis, 161.

83. My disagreements with Ince are not confined to these. Ince assumes, a priori any discussion (in her very first introductory paragraph), that the remodeling of the face and body is equal to remodeling the identity. *Carnal Art* is a close reading of the unevenness and complexities of the relationship between the body and identity.

84. Orlan, "Carnal Art Manifesto," in *Spain*, 218.

85. Ibid.

86. Ibid.

87. Margalit Fox notes that the artist refused to verify this name.

88. Augsburg, "Orlan's Performative Transformations," 294, citing Jean Paul Sartre, *Saint Genet: Actor and Martyr*, trans. Bernard Frechtman (New York: Pantheon, 1963), 195.

89. Augsburg, "Orlan's Performative Transformations," 294.

90. Orlan, "Conference," 92.

91. Eleanor Antin, quoted in JoAnn Hanley and Ann-Sargent Wooster, *The First Generation: Women and Video, 1970–75* (New York: Independent Curators, 1993), 21. The quotation also appears in Lisa E. Bloom, "Rewriting the Script: Eleanor Antin's Feminist Art," in Howard Fox, *Eleanor Antin* (Los Angeles: Los Angeles County Museum of Art and the Fellows of Contemporary Art, 1999), 166.

92. Howard N. Fox, "A Dialogue with Eleanor Antin," in H. Fox, *Eleanor Antin*, 211.

93. Eleanor Antin, quoted in Bloom.

94. Bloom, 168; Kenneth Clark, *The Nude: A Study in Ideal Form* (New York: Pantheon, 1956).

95. Carolee Schneemann, "Interview with Kate Haug," in *Carolee Schneemann: Imaging Her Erotics; Essays, Interviews, Projects* (Cambridge, MA: MIT Press, 2002), 28.

96. Rebecca Schneider, *The Explicit Body in Performance* (London: Routledge, 1997), 35. "Though she [Schneemann] had been involved in the inception of Fluxus in New York, she was officially excommunicated by Fluxus's founder George Maciunus for 'expressionist tendencies' which he considered messy. Schneemann has written that George Maciunus found her to be a 'terrifying female' and banished her to the Happenings realm, only paradoxically to admit Wolf Vostell and Claus Oldenburg (equally 'messy') as welcome guests. Maciunus printed a note officially excommunicating Schneemann in the dense Flux papers" (189n24).

97. Ibid., 37.

98. Eunice Lipton, *Alias Olympia: A Woman's Search for Manet's Notorious Model and Her Own Desire* (New York: Meridian, 1994), 4. The quotation is also found in David Levi Strauss, "Love Rides Aristotle through the Audience: Body, Image, and Idea in the Work of Carolee Schneemann," in *Carolee Schneemann: Up To and Including Her Limits* (New York: New Museum of Contemporary Art, 1996), 29.

99. Schneider, 28.

100. Ibid., 13. For the term "binary terror," Schneider credits Vivian M. Patraka, "Binary Terror and Feminist Performance: Reading Both Ways," *Discourse* 14, no. 2 (1992): 163–85. Patraka defines binary terror as "the terror released at the prospect of undoing the binaries by those who have the most to gain from their undoing. . . . The terror can issue from how constitutive of identity the binaries are" (176).

101. Schneider, 13. Schneider refers to Georges Bataille, founder of the French Collége de sociologie, and Walter Benjamin, of the Frankfurt school, as the two primary theorists who wrote about the explosion of binaries.

102. Although art and medicine are not an actual binary, it might be argued that the two gazes that they require are. For example, we have already discussed representation as a second skin that invites one into its exterior/interior in order to genuinely experience it. This is in contrast to the disciplined medical gaze, which requires the elimination of emotional experience in order to assume the broadest possible state of intellectual and scientific objectivity. In the case of Orlan, *the physician who would traditionally assume the medical gaze is actually doing the body sculpting.* It should also be noted that outlined in this chapter is a tradition of medical performance and imagery that invades art. Orlan's work is exceptional in that it returns to this tradition.

103. Chris Straayer has pointed out to me that Orlan's use of a surgeon may be a brilliant exploitation of Foucault's author function, which goes way beyond Barthes's notion of the death of the author. Foucault writes in "What Is an Author?" that the name of the author does not function like that of the proper name that belongs to an individual. He goes on to define three selves associated with the name of the author. The first is defined as the contours of the text, which historically shift. The second self is associated with the voice of the author in any given text. This voice is dissimilar to that of the individual writer and the contours of the text. The third ego is that voice which speaks of the goals, that is, problems yet to be solved. The point of Foucault's essay is to eliminate the question, Who is the real author? and to ask instead, What are the modes of existence of this discourse? Where does it come from; how is it circulated; who controls it? and, finally, What matter who's speaking? With regard to Orlan, one could speculate that the author function would incorporate the surgeons and Orlan into a complex amalgam of "I's," voices, and contours, Orlan being both text and pseudoauthor and the surgeon being a type of ghostwriter. Certainly with regard to the original artwork, the author function could be elaborately

expounded upon. For example, the fact that a given painting was painted by van Gogh gives it authority, but as soon as this authorship is questioned, even the level of skill is questioned. See Michel Foucault, "What Is an Author?" in *Theories of Authorship: A Reader*, ed. John Caughie (London: Routledge & Kegan Paul, 1981), 282–91.

104. Schwarzkogler committed suicide at age twenty-eight; Muhl gave up actionism after about ten years but continues to make art—he sees life as art; Brus also continues to make art, primarily in the form of expressionistic drawings; Nitsch continues to perform actions as Orgies Mysteries Theater; see http://www.nitsch.org/.

105. For a solid critical analysis of Carolee Schneemann and many other woman performers, see Schneider. Other excellent criticism includes Peggy Phelan, *Unmarked: The Politics of Performance* (London: Routledge, 1993); Peggy Phelan, *Mourning Sex: Performing Public Memories* (London: Routledge, 1997); Lynda Hart and Peggy Phelan, eds., *Acting Out: Feminist Performances* (Ann Arbor: University of Michigan Press, 1993); Philip Auslander, *From Acting to Performance: Essays in Modernism and Postmodernism* (London: Routledge, 1997); Peggy Gale, *Video Texts* (Waterloo, ON: Wilfrid Laurier University Press, 1995); A. A. Bronson and Peggy Gale, *Performance by Artists* (Toronto: Art Metropole, 1979); Roselee Goldberg, *Performance: Live Art since 1960* (New York: Abrams, 1998); and Paul Schimmel, comp., *Out of Actions: Between Performance and the Object, 1949–1979* (Los Angeles: Museum of Contemporary Art, 1998).

106. Brian Hatton, "Sensuality and Self-Abuse in Viennese Art: The Work of Günter Brus; From Degradation to Spiritual Enlightenment," *ZG* 80, no. 2 (1980): 21.

107. Roswitha Mueller, *Valie Export: Fragments of the Imagination* (Bloomington: Indiana University Press, 1994), xviii. Mueller quotes a 1966 fragment written by the actionists and translated by Mueller from *Wien: Bildkompendium Wiener Aktionismus und Film*, ed. Peter Weibel in collaboration with Valie Export (Frankfurt: Kohlkunstverlag, 1970), 307.

108. Mueller, xvii. See also Hermann Nitsch, *Das Orgien Mysterien Theater: Manifeste, Aufsätze, Vorträge* (Salzburg, Austria: Residenz Verlag, 1990), 33.

109. Hatton, 23. "Endrils" may refer to entrails. "Greenbergian" comes perhaps as a criticism of Clement Greenberg's belief in the superiority of abstraction in painting and sculpture as expressed, for example, in "Towards a Newer Laocoon" (1940), in *Art in Theory, 1900–1990: An Anthology of Changing Ideas*, ed. Charles Harrison and Paul Wood (Oxford, UK: Blackwell, 1992), 554–60.

110. Gina Pane produced work that conflated the private with the public as a political statement regarding identity. In her *Autoportrait(s)* (1973, Stadler Gallery, Paris) she considered her body the art object. She cut her lips and fingers with razor blades. See Kathy O'Dell, *Contract with the Skin: Masochism, Performance Art, and the 1970s* (Minneapolis: University of Minnesota Press, 1998), 47, for a discussion of this performance in relation to Lacan's mirror stage. In other performances she pierced her body with razor blades, thorns, and nails. She used photography and film to recall her performances. Pane died prematurely, in 1990. See *Kroppen som membran / Body as Membrane* (Odense, Denmark: Kunsthallen Brandts Klaedefabrik, 1996).

111. Orlan, "Intervention," 327.

112. For a complete representation of Valie Export's work, see Mueller.

113. Export, quoted in ibid., 29.

114. Export, quoted in Mueller, 33–34.

115. Export, quoted in Mueller, 33–34.

116. Orlan, "Conference," 91.

117. Richard Murphy, *Theorizing the Avant-Garde: Modernism, Expressionism, and the Problem of Postmodernity* (Cambridge, UK: Cambridge University Press, 1998), 261.

118. Ibid., 269.

119. Ibid., 268, 271.

120. Orlan, "Conference," 90. The gallery installation that Orlan mentions is *Entre-Deux*, forty-one panels upon which documentary photographs of her healing face were placed each day in juxtaposition with composite images that she created on the computer.

121. Auslander, 128.

122. Mark Dery, *Escape Velocity: Cyberculture at the End of the Century* (New York: Grove, 1996), quoted in ibid., 132.

123. Kathryn Pauly Morgan, "Women and the Knife: Cosmetic Surgery and the Colonization of Women's Bodies," *Hypatia* 6, no. 3 (1991): 38, quoted in Auslander, 130. Morgan's essay also appears in *Body and Flesh: A Philosophical Reader*, ed. Donn Welton (Malden, MA: Blackwell, 1998), 325–47.

124. Orlan was accused of acting like a star in the online electronic discussion group that followed the conference. See Tanya Augsburg, "Surgical Enhancements," in *Pug: Zine of the Underground Web* 4 (March 1999), http://www.pugzine.com/pug4/enhancement.html. Portions of this discussion were subsequently published in Tanya Augsburg, "Collaboration within the Field," *Drama Review: The Journal of Performance Studies* 39, no. 4 (Winter 1995): 166–72.

125. Jill Dolan, *The Feminist Spectator as Critic* (Ann Arbor: University of Michigan Press, 1991), 11.

126. Elizabeth Grosz, *Jacques Lacan: A Feminist Introduction* (London: Routledge, 1990), 8.

127. Grosz refers to the two accounts as the "realist" and the "narcissistic" views of the ego. The "realist" view of the ego Freud wrote about in "The Interpretation of Dreams" (1900), "The Ego and the Id" (1923), and "An Outline of Psychoanalysis" (1938). The "narcissistic" view of the ego Freud began in "The Three Essays on the Theory of Sexuality" (1905) and developed in "On Narcissism: An Introduction" (1914), "Mourning and Melancholia" (1915), and "The Splitting of the Ego in the Process of Defense" (1938). See ibid., 8–14.

128. Grosz, *Jacques Lacan*, 47.

129. Freud, "On Narcissism: An Introduction" (1914), in *Standard Edition*, 14:77.

130. Ibid., 82.

131. Ibid., 84.

132. Ibid., 89. Freud goes on to say that even for these women who have chosen themselves as their primary love-object, the birth of a child (which comes from their own body) can often become the love-object (90).

133. Grosz, *Jacques Lacan*, 32. Grosz cites, for example, Luce Irigaray's conception of body morphology in "The Looking Glass, from the Other Side," in *This Sex Which Is Not One*, trans. Catherine Porter and Carolyn Burke (Ithaca, NY: Cornell University Press, 1985), 9–22. Irigaray uses Michel Soutter's film *The Surveyors* and the story of Alice in Lewis Carroll's *Through the Looking-Glass* to explore Freud's concept of the relationship between the body and the ego.

134. Elizabeth Grosz, *Volatile Bodies: Toward a Corporeal Feminism* (Bloomington: Indiana University Press, 1994), 32.

135. Freud, "The Ego and the Id" (1923), in *Standard Edition*, 19:25.

136. Ibid., 26. Warren Gorman comments on the homunculus: "The homunculi . . . stimulate the eye, for their visual appearance is that of distorted little male persons, whose deformities are arresting to the studious as well as the curious. The face and the mouth of the homunculus are huge, his forehead is barely present, his hands gargantuan and his

genitals gross. He has a respectably large intra-abdominal area, but he possesses not even a trace of the brain area. . . . Those parts of the body which can neither be seen nor felt do not appear in the motor homunculus and those parts which do not yield sensations of perceived touch are denied a position in the sensory homunculus. Since the brain is hidden from vision, and imperceptive of touch to its matter, we must reluctantly grant that our cherished but imaginary mannequins are not able to represent our brains." Gorman notes that the form of the homunculus is dependent upon the capacity of the subject to be able to see or feel parts of his or her own body. He points out that because we cannot see or feel our brain, it is not included in this imaginary anatomy. *Body Image and the Image of the Brain* (St. Louis, MO: Green, 1969), 193.

137. Jacques Lacan, "Some Reflections on the Ego," *International Journal of Psychoanalysis* 34, no. 1 (1953): 11–17; also discussed in Grosz, *Volatile Bodies*, 39.

138. Grosz, *Jacques Lacan*, 48.

139. "These are in the images of castration, mutilation, dismemberment, dislocation, evisceration, devouring, bursting open of the body, in short, the imagos that I have grouped together under the apparently structural term of *imagos of the fragmented body*." Jacques Lacan, "Aggressivity in Psychoanalysis," in *Écrits: A Selection*, trans. Alan Sheridan (New York: Norton, 1977), 11.

140. Jacques Lacan, "The Mirror Stage as Formative of the Function of the I," in *Écrits*, 4–5.

141. Jacques Lacan, "'The Freudian Thing'; or, The Meaning of the Return to Freud" (1955), in *Écrits*, 134.

142. Jacques Lacan, *The Four Fundamental Concepts of Psycho-analysis*, ed. Jacques-Alain Miller, trans. Alan Sheridan (New York: Norton, 1981), 144, 257.

143. Grosz, *Jacques Lacan*, 48.

144. Ibid., 44. An example of the imaginary anatomy versus biology exists in certain hysterical symptoms. For example, when an arm is paralyzed and the designation "arm" is the imagined designation of the patient rather than the actual biological part, the shoulder may be included. This would indicate the manifestation of a hysterical symptom rather than damage to the appendage, which might not include the shoulder.

145. Ibid., 38.

146. Lacan, "Mirror Stage," 2–3.

147. Lacan, "Aggressivity in Psychoanalysis," 19.

148. Grosz, *Jacques Lacan*, 39.

149. Ibid., 40.

150. Ibid., 48.

151. Ibid., 47.

152. Rosalind Coward and John Ellis, *Language and Materialism: Developments in Semiology and the Theory of the Subject* (London: Routledge & Kegan Paul, 1977), 93.

153. Jacques Lacan, "The Gaze as Objet Petit A: Anamorphosis," in *Four Fundamental Concepts*, 80–81.

154. Maurice Merleau-Ponty, "Eye and Mind," in *The Primacy of Perception*, trans. Colin Smith (1945; repr., New York: Humanities Press, 1962), 163.

155. See n. 136.

2. Looking inside the Human Body

1. Mikhail Bakhtin, *Rabelais and His World*, trans. Hélène Iswolsky (Bloomington: Indiana University Press, 1984), 317–18. Bakhtin goes on to describe renderings of the

grotesque body as cosmological and universal, a predominant part of human representation of itself.

2. Richard Selzer, *Confessions of a Knife: Meditations on the Art of Surgery* (London: Triad/Granada, 1982), 16, quoted in Jonathan Sawday, *The Body Emblazoned: Dissection and the Human Body in Renaissance Culture* (London: Routledge, 1995), 8.

3. Barbara G. Walker, *The Woman's Encyclopedia of Myths and Secrets* (Edison, NJ: Castle Books, 1996), 629. Another meaning of Medusa's veiled face as monstrous appearance has been likened to the menstrual taboo. The notion that the sight of a menstruating woman could, in the famous words of Aristotle, "tarnish a mirror," combined with the belief that Medusa had magic blood that could either create or destroy life, associated her with the moon blood of women.

Also recall that Freud felt that Medusa's head was symbolic of castration, when "a boy who has hitherto been unwilling to believe the threat of castration catches sight of the female genitals, probably those of an adult, surrounded by hair, and essentially those of his mother." Sigmund Freud, "Medusa's Head" (1922), in *The Standard Edition of the Complete Psychological Works of Sigmund Freud*, trans. and ed., James Strachey (London: Hogarth, 1953–74), 18:273–74.

4. The aegis, primarily associated with Zeus and Athena, is a symbol also of a protection or shield. Athena was often portrayed with her aegis bearing the head of Medusa. Athena was the goddess of war, defender and protector, and often the goddess of victory. She was also the goddess of the domestic work of women. She was the virgin daughter of Zeus, who is said to have swallowed his first wife, Metis, when she was with child. Hephaestus split open Zeus's head with an ax and Athena was born full-grown with a battle cry that shook the heavens. George Howe and G. A. Harper, *A Handbook of Classical Mythology* (Hertfordshire, UK: Oracle, 1996), 45.

5. Sawday, 9. Aesculapius (or Asclepius) was the son of Apollo by either Coronis or Arsinoe. The centaur Chiron (or Cheiron) instructed him in the art of healing. His powers were so strong that he could raise the dead. However, Zeus killed Aesculapius with a thunderbolt so that Pluto would not be deprived of the dead. Apollo retaliated by killing the Cyclopes, forgers of the thunderbolt. As a consequence of this act, Apollo served some time on earth as a mortal. The serpent coiled around the staff is the most universal symbol of Aesculapius. Howe and Harper, 42.

6. Sawday, 9.

7. "Kahun Medical Papyrus" or "Gynaecological Papyrus" (1825 BC), trans. Stephen Quirke, Petrie Museum of Egyptian Archaeology, University College London, col. 1, lines 5–8, http://www.petrie.ucl.ac.uk/digital_egypt/med/birthpapyrus.html.

8. Regarding the "womb or matrix of women," Plato says, "The animal within them [women] is desirous of procreating children, and when remaining unfruitful long beyond its proper time, gets discontented and angry, and wandering in every direction through the body, closes up the passages of the breath, and, by obstructing respiration, drives them to extremity, causing all varieties of disease." "Timaeus," trans. Benjamin Jowett, in *Plato: The Collected Dialogues*, Bollingen Series 71, ed. Edith Hamilton and Huntington Cairns (Princeton, NJ: Princeton University Press, 1980), 1210.

9. I first read about the history of the wandering womb in Tanya Augsburg, "Private Theatres Onstage: Hysteria and the Female Medical Subject from Baroque Theatricality to Contemporary Feminist Performance" (PhD diss., Emory University, 1996), 20–21. Soranus lived around AD 98–138 and practiced in Rome. He was part of the "Methodist" sect of physicians, those who focused on regimen and moderation, and was known to criticize famous doctors, including Hippocrates. See John Scarborough, *Aspects of Greek and*

Roman Life: Roman Medicine (Ithaca, NY: Cornell University Press, 1969), 159; and Soranus, *Gynecology*, trans. Owsei Temkin, Ludwig Edelstein, and Alan F. Guttmacher (Baltimore: The Johns Hopkins University Press, 1956).

10. Londa Schiebinger, *This Mind Has No Sex? Women in the Origins of Modern Science* (Cambridge, MA: Harvard University Press, 1989), 161–62.

11. Aristotle, *Generation of Animals*, trans. A. L. Peck (London: Heinemann, 1943), 11–15, 459.

12. Galen, *On the Usefulness of the Parts of the Body*, trans. Margaret May (Ithaca, NY: Cornell University Press, 1968), 2:630, quoted in Schiebinger, 163.

13. Schiebinger, 163; Thomas Laqueur, *Making Sex: Body and Gender from the Greeks to Freud* (Cambridge, MA: Harvard University Press, 1990). Laqueur's book focuses on how the one-sex theory was constructed and reinforced throughout the history of science from ancient Greece into the eighteenth century. The topic is also written about in Augsburg, 21.

14. Laqueur, 98.

15. Ibid., viii. The truth in this statement is backed up with Hegel's words written in 1830: "On the one hand, the uterus in the male is reduced to a mere gland, while on the other, the male testicle in the female remains enclosed within the ovary, fails to emerge into opposition, and does not become an active cerebrality. The clitoris moreover, is inactive feeling in general; in the male on the other hand, it has its counterpart in active sensibility, the swelling vital, the effusion of blood into the corpora cavernosa and the meshes of spongy tissue of the urethra. The female counterpart of this effusion of blood in the male consists of the menstrual discharges. Thus, the simple retention of the conception in the uterus, is differentiated in the male into productive cerebrality and the external viatal [vital organ]. On account of this difference therefore, the male is the active principle; as the female remains in her undeveloped unity, she constitutes the principle of conception." Georg W. F. Hegel, *Hegel's Philosophy of Nature* (1830), ed. and trans. M. J. Petry (London: Allen & Unwin; New York: Humanities, 1970), 3:175. (Note: *The Philosophy of Nature* was written as Part Two of Hegel's *Encyclopedia of the Philosophical Sciences*.)

It is also interesting to note that the following facts, according to Laqueur: until well into the eighteenth century there were still references to the wandering womb; the male was still considered the giver of life, whereas the female contributed the matter and housing for the incubation of the fetus; menstruation was believed to be similar to hemorrhoidal bleeding; there was no word in the vernacular, Greek, or Latin, for the vagina until around 1700 (Laqueur, 16); until the nineteenth century the ovaries did not have a name (Galen referred to an ovary as the *orcheis* [male testicle]; Herophilus, in the third century BC, had referred to ovaries as *didymoi* [twins], which was another Greek word for testicles [Laqueur, 4, 5]); and although Galen corrected Herophilus's error that the fallopian tubes run into the bladder of the female, this did not change his assessment of the female's sex organs as an inversion of those of the male (Laqueur, 5).

16. Sawday, 224.

17. Ibid.

18. This is a woodcut done for the purpose of publication. The drawing of this particular illustration is sometimes attributed to Titian and sometimes to Jan Stefan van Kalkar, a pupil of Titian. This confusion is caused by the fact that there is no credit given to Titian, even though the skill exhibited in the engraving seems to far surpass the skills of van Kalkar. J. B. de C. M. Saunders and Charles D. O'Malley, *The Illustrations from the Works of Andreas Vesalius of Brussels* (1950; repr., New York: Dover, 1973), 25–29. Further explanations regarding this illustration: A skeleton in the center signifies Vesalius's belief

that the study of anatomy begins with the study of the skeleton. The anatomist's dependence on the dissection of animals is indicated by the presence of a dog and monkey. As was the custom until 1584, the public anatomy is taking place outside, and a temporary wooden structure has been erected for this particular performance. In 1584 public dissections were moved indoors (Saunders and O'Malley, 42).

19. Sawday, 219.

20. William Heckscher, *Rembrandt's Anatomy of Dr. Tulp* (New York: New York University Press, 1957), 136n60.

21. The illustrations of the female genitalia as an inversion of the male's were published in Vesalius's *De corporis humani fabrica* (Saunders and O'Malley, 170, 237).

22. Sawday, 214.

23. Ibid.

24. Susan Bordo, *The Flight to Objectivity: Essays on Cartesianism and Culture* (Albany: State University of New York Press, 1987), 108–9.

25. Ibid., 110.

26. Ibid., 110–11.

27. Sawday, 116.

28. Ibid.

29. Michel Foucault, *Technologies of the Self: A Seminar with Michel Foucault*, ed. Luther H. Martin et al. (Amherst: University of Massachusetts Press, 1998), 19.

30. Ibid., 20.

31. "Kahun Medical Papyrus."

32. Andrea Carlino, *Books of the Body: Anatomical Ritual and Renaissance Learning*, trans. John Tedeschi and Anne C. Tedeschi (Chicago: University of Chicago Press, 1999), 125.

33. James Longrigg, "Medicine in the Classical World," in *Western Medicine: An Illustrated History*, ed. Irvine Loudon (Oxford, UK: Oxford University Press, 1997), 26–27.

34. C. H. Kahn, "Ancient Philosophy: Anaximander and the Origin of Greek Cosmology" (1960), in *The Oxford Companion to Philosophy*, ed. Ted Honderich (Oxford, UK: Oxford University Press, 1995), 32.

35. Ibid., 226.

36. Longrigg, 29–30.

37. Ibid., 36–37.

38. Galen, *De anatomicis administrationibus*, K II 220–21, quoted in Carlino, 139.

39. Carlino, 129.

40. Aristotle, *Historia animalium*, 491 at 19 ff., quoted in ibid., 128. Aristotle wrote: "Above all one must observe the parts of man. Just as everyone judges coins on the basis of those we know best, so it is for all things. Man is necessarily among all living things the one with which we are most familiar" (*Historia animalium*, 511 b 13 ff, 513 a 12 f, and 515 b 1, but also *De partibus animalium*, 668 a 21 f., quoted in Carlino, 129).

41. Aristotle, *De partibus animalium* 640 b 34–35, quoted in Carlino, 130, 131.

42. Carlino, 138.

43. Carlino, 131–32. On several occasions Aristotle referred to his *De dissectione*, of which nothing remains, but supposedly it contained many illustrations as well as detailed text.

44. Aristotle, *De partibus animalium*, 645 a 24 ff., quoted in ibid., 132.

45. Aristotle, *De partibus animalium* 645 a 15 ff., quoted in Carlino, 131.

46. Carlino, 122.

47. Celsus, *De medicina*, pars. 23–24, quoted in ibid., 137.

48. Carlino, 5–6.

49. Emilie Savage-Smith, "Europe and Islam," in Loudon, 40.

50. Michael R. McVaugh, "Medicine in the Latin Middle Ages," in Loudon, 56.

51. J. Playfair McMurrich, *Leonardo da Vinci: The Anatomist (1452–1519)* (Baltimore: Williams & Wilkins for the Carnegie Institution of Washington, 1930), 10.

52. Ibid., 11.

53. Ibid., 12–13.

54. The plague dominated Europe from 1348 until well into the seventeenth century. In the Black Death of 1349–53, between one-third and one-half of all Europeans died. Katherine Park, "Medicine and the Renaissance," in Loudon, 66. Park also mentions that dissections were carried out on plague victims (72).

55. Guy de Chauliac, *La grande chirurgie, restitueé par M. Laurens Joubert* (Rouen, 1632), quoted in McMurrich, 13. This is one of the editions of *La grande chirurgie,* which was originally published in 1362.

It is important to point out that "autopsies" were performed strictly to determine the cause of death, whereas "anatomies" were human dissections.

56. McMurrich, 14.

57. Quoted in ibid. The bull is quoted in its entirety in a paper by James J. Walsh, "The Popes and the History of Anatomy," *Medical Library and Historical Journal* 2 (1904).

58. McMurrich, 15.

59. Ibid. The first known hospital was established in Baghdad in the early ninth century. Five more hospitals were built in Baghdad over the next hundred years. In Egypt the first hospital was built in Cairo in 872 (Savage-Smith, 50).

60. McMurrich, 16–17.

61. Ibid., 49.

62. Charles D. O'Malley and J. B. de C. M. Saunders, eds. and trans., *Leonardo on the Human Body* (New York: Dover, 1983), 20.

63. Ibid., 26.

64. Giorgio Vasari, *Lives of the Painters, Sculptors, and Architects* (1568), trans. Gaston du C. de Vere (New York: Knopf, 1996), 1:633–34.

65. Ibid., 1:634.

66. McMurrich, 17.

67. Carlino, 10, citing John of Ketham, *Fasciculus medicinae* (Venice: Gregorio de Gregoriis, 1493).

68. McMurrich points out that the surgeons were sometimes public executioners (10).

69. Carlino, 11–13.

70. Berengario of Carpi, *Commentaria*, fol. Viv., quoted in Carlino, 25.

71. Vesalius, *De corporis humani fabrica* (1543), quoted in McMurrich, 20.

72. Heckscher, 43–44.

73. Ibid., 38 (emphasis added).

74. Ibid.

75. Sawday, 220, referring to Anthony Wood's account recorded in Frances Valdes, "Anatomical Studies at Oxford and Cambridge," in *Medicine in Seventeenth-Century England*, ed. Allen G. Debus (Berkeley and Los Angeles: University of California Press, 1974), 405. Another noteworthy story: "[I]n William Roughead's 1941 *Murderer's Companion*, he unfolds the story of William Burke, an early 19th century Scottish bloke who was in the habit of murdering people to sell their bodies through an intermediary to the anatomy of Dr. Knox in Edinburgh—16 all together. At his public execution the crowd of 25,000 called out—'Burke him, burke him' which gave rise to a new verb in the English language.

Following his public anatomy, his body was flayed, his hide tanned and sold (Roughead inherited a piece of it from his father), and his skeleton placed in the Anatomical Museum of Edinburgh, where it still resided in 1941" (Heckscher, 165). Today the verb *burke* means to extinguish, suppress, or disregard—as in "to burke an investigation," as well as "to execute (someone) by suffocation so as to leave the body intact and suitable for dissection. [After William *Burke* (1792–1829), Irish-born grave robber and murderer.]" *American Heritage Dictionary*, 3rd ed., s.v. "burke."

76. Francis Barker, *The Tremulous Private Body: Essays on Subjection* (Ann Arbor: University of Michigan Press, 1995), 66. This celebratory form of execution is also demonstrated in the Roman amphitheater of "live death."

77. Ibid.

78. Sawday, 189. The overlap of the legal and scientific sanction over the body is still actively enacted. An apt contemporary correlative to the Renaissance dissection theater is located on the National Library of Medicine's Visible Human Project Web site. In order to construct this site, the body of executed murderer Joseph Paul Jernigan was frozen, then cut into 1,871 slices with a laser scalpel. Each slice was then scanned into a graphics program so that one can take a virtual tour of the body. Parts of this project are available on the Web site of the National Institutes of Health, at http:www.nlm.nih.gov/research/visible/visible_human.html. See also Grant H. Kester, "Aesthetics after the End of Art: An Interview with Susan Buck-Morss," *Art Journal* 56, no. 1 (1997): 40.

79. Heckscher, 18.

80. Aloïs Riegl, "Excerpts from 'The Dutch Group Portrait (1902),'" trans. Benjamin Binstock, *October* 74 (1995): 5. In note 3 on this page, Binstock cites William Schupbach, *The Paradox of Rembrandt's "Anatomy of Dr. Tulp"* (London: Wellcome Institute for the History of Medicine, 1982), 7.

81. Schupbach, 16.

82. Ibid., 23.

83. Ibid., 22.

84. Casper Barlaeus, *Poemata*, 4th ed. (Amsterdam, 1645–46), part ii, p. 537, quoted in ibid., 49. Schupbach does not identify the translator.

85. Schupbach, 49.

86. Ibid., 5.

87. Drew Leder, "A Tale of Two Bodies: The Cartesian Corpse and the Lived Body," in *Body and Flesh: A Philosophical Reader*, ed. Donn Welton (Oxford, UK: Blackwell, 1998), 120.

88. Ibid., 121.

89. Judith Fryer, "'The Body in Pain' in Thomas Eakins' *Agnew Clinic*," in *The Female Body: Figures, Styles, Speculations*, ed. Lawrence Goldstein (Ann Arbor: University of Michigan Press, 1991), 237.

90. The phrase "the tyranny of the same" refers to the generalizing indicators of identity, such as of a species or sex. For example, to say that women all have the same body reduces women's identity into one group without regard to race, religion, sexual orientation, socioeconomic strata, or individual experience.

91. The history of the perception of the woman's body as that of a flawed male is briefly outlined at the beginning of this chapter. It is a perception that is renewed throughout history. One example of nineteenth-century research that appeared to prove women's lesser biological status was conducted by Patrick Geddes, a prominent professor of biology. Thomas Laqueur writes that Geddes "used cellular physiology to explain the 'fact' that women were 'more passive, conservative, sluggish and stable' than men, while men were 'more active, energetic, eager, passionate, and variable.' He thought that . . . males

were constituted of catabolic cells, cells that put out energy. . . . Female cells, on the other hand, were anabolic; they stored up and conserved energy." Laqueur goes on to note that even though Geddes was unable to justify his theory, he nevertheless expounded upon sexual difference on the cellular level (6).

92. Ivan Turgenev, *Fathers and Sons* (1861), 155, quoted in Ludmilla Jordanova, *Sexual Visions: Images of Gender in Science and Medicine between the Eighteenth and Twentieth Centuries* (Madison: University of Wisconsin Press, 1989), 1.

93. Sawday, 186.

94. Michel Foucault, *The Birth of the Clinic: An Archaeology of Medical Perception*, trans. A. M. Sheridan Smith (New York: Vintage, 1994), 141. Foucault writes that it became extremely important to be able to distinguish between signs of death and signs of disease in the dissected body; thus the importance for diseased bodies to be dissected immediately after death, before the signs of death interrupted the signs of disease. The "conceptual mastery of death was first acquired, at a very elementary level, by the organization of clinics. The possibility of opening up corpses immediately, thus reducing to a minimum the latency period between death and the autopsy, made it possible for the last stage of pathological time and the first stage of cadaveric time almost to coincide."

95. Ibid., 135–36.

96. Ibid., 141.

97. X. Bichat, *Rechereches physiologiques* (Paris, 1825), 242, quoted in ibid., 142. This description of anatomical death bears a peculiar connection to the illustrations of self-dissection in which it was insinuated that the transition from life to death did not occur in an instant.

98. Elizabeth Bronfen, *Over Her Dead Body: Death, Femininity, and the Aesthetic* (New York: Routledge, 1992), 5.

99. Ibid., 4.

100. Ibid., 10.

101. Fryer, 238.

102. Michael Fried, *Realism, Writing, Disfiguration: On Thomas Eakins and Stephen Crane* (Chicago: University of Chicago Press, 1987), 10–16.

103. Fryer, 244. Fryer notes that the connection between almshouses and hospitals was invaluable as a resource for patients undergoing experimental surgery.

104. David M. Lubin, *Act of Portrayal: Eakins, Sargent, James* (New Haven, CT: Yale University Press, 1985), 32.

105. Laura Mulvey, "Visual Pleasure and Narrative Cinema," in *Feminism and Film Theory*, ed. Constance Penley (New York: Routledge; London: BFI, 1988), quoted in Amelia Jones, *Body Art: Performing the Subject* (Minneapolis: University of Minnesota Press, 1998), 153.

106. Hannah Wilke, "Artist Hannah Wilke Talks with Ernst," quoted in Jones, 182.

107. Jones also points out that Wilke was also interested in marks of ethnicity, "[t]o remember that as a Jew, during the war, I would have been branded and buried had I not been born in America. Starification-Scarification . . . Jew, Black, Christian, Muslim. . . . Labeling people instead of listening to them. . . . Judging according to primitive prejudices." Jones, 183, quoting Hannah Wilke, "Intercourse with . . ." (1977), repr. in Daniels, *Übrigens Sterven*, 266.

108. Hannah Wilke, in Jones et al., "Hanna Wilke's Art," 1, quoted in Jones, 184.

109. Within the fashion industry and pornography there exists an interchangeability of bodies. Indicators of beauty are defined not by individuality but as certain body types that fit the needs of the industry.

110. Joanna Frueh, *Erotic Faculties* (Berkeley and Los Angeles: University of California Press, 1996), 141–42 (emphasis mine).

111. Ibid., 143.

112. Ibid., 145, citing Robin Lakoff and Raquel L. Scherr, *Face Value: The Politics of Beauty* (Boston: Routledge & Kegan Paul, 1984), 14–15.

113. Lucy Lippard, *From the Center: Feminist Essays on Women's Art* (New York: Dutton, 1976), 126, quoted in Frueh, 146.

114. Frueh, 149.

115. Jones, 187.

116. Frueh, 148.

117. Hannah Wilke, interview with Amelia Jones, November 2, 1992, quoted in Jones, 153.

118. Frueh, 149. Wilke used the phrase "beauty to beast" regarding her appearance in conversation with the author [Frueh] in early June 1992.

119. Orlan, "Conference," trans. Tanya Augsburg and Michel A. Moos, in *This Is My Body . . . This Is My Software . . .*, ed. Duncan McCorquondale (London: Black Dog, 1996), 91.

120. Ibid.

121. Carole Spitzach, "The Confession Mirror: Plastic Images for Surgery," *Canadian Journal of Political and Social Theory* 12, nos. 1–2 (1988): 38–50, quoted in Anne Balsamo, *Technologies of the Gendered Body: Reading Cyborg Women* (Durham, NC: Duke University Press, 1997), 56.

122. Spitzach, quoted in Balsamo, 57.

123. Mary Ann Doane, "The Clinical Eye: Medical Discourses in the 'Woman's Film' of the 1940s," in *The Female Body in Western Culture: Contemporary Perspectives*, ed. Susan Rubin Suleiman (Cambridge, MA: Harvard University Press, 1986), 152.

124. Linda Nochlin, *The Body in Pieces: The Fragment as a Metaphor of Modernity*, Walter Neurath Memorial Lectures 26 (London: Thames & Hudson, 1994), 8.

125. Ibid.

126. Charles Baudelaire, "The Painter of Modern Life," in *The Painter of Modern Life and Other Essays*, ed. and trans. Jonathan Mayne (London: Phaidon, 1964), 13, cited in ibid., 24.

127. Nochlin, 34–36.

128. Lisa Cartwright makes a very convincing observation regarding cubism as "a technique for disciplining the unruly dimensional body" by fragmenting its three-dimensional planes and flattening them. She points out that in 1929 the physiologist August Krogh (coauthor, with P. Brandt Rehberg, of "Kinetic Methods in the Study of Capillary Circulation") described a similar unruliness of the body when trying to observe it under a microscope (specifically, he was trying to observe blood traveling though the arteries of the tongue of a frog). Cartwright comments: "It is as if the body is deceptive, even transgressive, simply because it has depth and complexity. Bodily depth causes 'disturbances' in the image field; thus the body must be corrected (rendered flat) by the microscope. Cubism, in this context, becomes a technique for disciplining the unruly dimensional body." Lisa Cartwright, *Screening the Body: Tracing Medicine's Visual Culture* (Minneapolis: University of Minnesota Press, 1995), 95.

129. In keeping with the argument that follows, in her *Untitled Film Stills* series (1978–79), Cindy Sherman plays with a notion of generic roles for women portrayed in films. Her photographs constitute images of grade-B films in which the actresses are interchangeable. The quality of interchangeability allowed her to create these images without

directly referring to specific films. Yet, although she places herself inside of this inter-changeable narrative, her message seems more to be that there is no place for her in these genericized and fetishized female roles.

130. Balsamo, 160.

131. Ibid., quoting Julia Szabo, "The Morphing Pot," *New Woman*, January 1995, 94–95, 114–16. This article associates plastic surgery with the concept of ethnic "morphing." This topic deserves more attention than I can give it in this chapter, which specifically investigates the performance surgeries of Orlan. However, one caption from the "The Morphing Pot" reads, "How the West Has Won: today, more and more Asians are under-going plastic surgery—lifting the epicanthic fold—to 'westernize' their slanted, hooded eyelids." This comment alone implicates the colonialization of the woman's body in the form of an ethnic cleansing via Western notions of beauty, and the capacity to materialize these notions through plastic surgery.

For feminist perspectives on the topic of plastic surgery and women, see Kathryn Pauly Morgan, "Women and the Knife: Cosmetic Surgery and the Colonialization of Women's Bodies," in Welton, 325–47; Balsamo, 56–79; and Orlan, who writes, "My intervention and series of operation-performances have several titles in common: *Carnal Art, Identity Change, Initiation Ritual, This Is My Body . . . This Is My Software . . ., I Have Given My Body to Art, Successful Operation(s), Body/Status, Identity Alterity,* since there are several axes and several possible readings of this work." Orlan, "Conference," 83.

132. Walter Benjamin, "The Work of Art in the Age of Mechanical Reproduction," quoted in *Art in Theory, 1900–1990: An Anthology of Changing Ideas,* ed. Charles Harrison and Paul Wood (Oxford, UK: Blackwell, 1993), 514.

133. Nochlin, 8.

3. Between Self and Other

1. Rebecca Schneider, *The Explicit Body in Performance* (London: Routledge, 1997), 13.

2. Elizabeth Grosz, "Ontology and Equivocation: Derrida's Politics of Sexual Dif-ference," in *Feminist Interpretations of Jacques Derrida,* ed. Nancy J. Holland (University Park: Pennsylvania State University Press, 1997), 75.

3. Jacques Derrida, "Ulysses Gramophone," in *A Derrida Reader: Between the Blinds,* ed. Peggy Kamuf (New York: Columbia University Press, 1991), 580–97.

4. Phallocentrism is the conceptual order in which the phallus takes the place of logos, in which the patriarchal system of representation forces women to be defined in one of three terms of a male economy: (1) women are represented as the negative of men, that is, nonmale; (2) women are represented as the same as men; or (3) women are represented as the complement of men. "In all three cases, women are seen as variations of versions of masculinity—either through negation, identity, or unification into a greater whole. When this occurs, two sexual symmetries (each representing the point of view of one sex regarding itself and the other) are reduced to one (the male), which takes it upon itself to adequately represent the other." Elizabeth Grosz, *Sexual Subversions: Three French Feminists* (Sydney: Allen & Unwin, 1989), xx.

5. Grosz, "Ontology and Equivocation," 76.

6. Ibid., 77.

7. The feminists who might be considered "friendly" to Derrida's work include Grosz, Drucilla Cornell, Gayatri Spivak, Barbara Johnson, Vicki Kirby, and Peggy Kamuf. Those more suspicious of his work include Rosi Braidotti, Alice Jardine, Margaret Whitford, and Luce Irigaray. Margaret Whitford asserts: "One of the points of feminism is that it attempts

to create a space where women can be speakers/agents as women. Derrida's deconstruction of metaphysical identity has had the effect of disconnecting the deconstructor from embodiment . . . [meaning] either sex could adopt 'masculine' or 'feminine' positions, and women—bearing all that it means to be a woman in patriarchy—are once again elided. In this sense, at any rate, the philosopher repeats the familiar gesture of exclusion; to enter philosophy as a woman, one must leave behind embodiment." Margaret Whitford, *Luce Irigaray: Philosophy in the Feminine* (London: Routledge, 1991), 129. This criticism is based on the fact that Derrida (and Deleuze) speaks for and in the name of the female subject by appropriating the woman's right to speak. Grosz points out that Irigaray's resistance to Derrida's appropriation of woman's right to speak is to a certain degree justified: "Just at that moment in history when speaking as a woman finally has some political and theoretical credibility, Derrida, along with Deleuze and others, wants to occupy just the very speaking position that women have finally produced for themselves." Grosz also points out that this criticism is problematic by posing the questions, Can one anchor oneself absolutely in a defined moment of articulation? and Is there a defined boundary between articulating as a man or as a woman? (Grosz, "Ontology and Equivocation," 83).

8. Jacques Derrida, interview by Christi V. McDonald in "Choreographies," in Kamuf, 447.

9. *Dasein* is derived literally from *da* ("there," "here") and *sein* ("to be") and is thus translated as "to be there" or "being there." For Kant and Hegel it meant *determinant being* and the *existence* of God. For Heidegger it means *the being of man*, but it is neutral and does not refer to humankind's consciousness or biology. Ted Honderich, ed., *The Oxford Companion to Philosophy* (Oxford, UK: Oxford University Press, 1995), 176.

10. Martin Heidegger, *Being and Time*, trans. John Macquarrie and Edward Robinson (San Francisco: Harper & Row, 1962), 83. Heidegger also states that the metaphysical structure "that man is, in the first instance, a spiritual Thing which subsequently gets misplaced 'into' space" is a "naïve supposition" (83). "Hence Being-in is not to be explained ontologically by some ontical characterization, as if one were to say, for instance, that Being-in in a world is a spiritual property, and that man's 'spaciality' is a result of his bodily nature (which, at the same time, always gets 'founded' upon corporeality). Here again we are faced with the Being-present-at-hand-together of some such spiritual Thing along with a corporeal Thing, *while the Being of the entity thus compounded remains more obscure than ever*" (emphasis added) (82–83).

11. Grosz, "Ontology and Equivocation," 88.

12. Jacques Derrida, "Geschlecht: Sexual Difference, Ontological Difference," trans. Rubin Berezdivin, in Kamuf, 387–88. Geschlecht translates as "species" or "sex," not referring to any one specifically.

13. Emmanuel Levinas calls us to rethink philosophy by starting with the face-to-face relation and ethically acknowledging the absolutely other, rather than beginning with the ontological presupposition of being as a universal same. The exterior form of the human is conceived as the body, which is also informed and enhanced by language. According to Levinas, the presence of the other is incomprehensible. This is not, however, negative: "Better than comprehension, discourse relates with what remains essentially transcendent." Emmanuel Levinas, *Totality and Infinity: An Essay on Exteriority*, trans. Alphonso Lingis (Pittsburgh: Duquesne University Press, 1969), 195. Levinas creates an ontological ethics based on the face-to-face relation in which being is experienced in relation to the other (in an unequal and infinite responsibility toward the other). In this face-to-face relation, ethics exists prior to being; it conditions being. The priority of being-for-the-other comes before being. Also see Emmanuel Levinas, *Ethics and Infinity:*

Conversations with Philippe Nemo, trans. Richard A. Cohen (Pittsburgh: Duquesne University Press, 1985), 57.

14. It is important to note that "otherness" does not pertain just to women, it also pertains to race, culture, history, and other factors. Although Irigaray is most concerned with women, both Levinas and Irigaray deal with the issue of the other as not specifically relating to women.

Difference, which refers to being other and is the condition of being excluded, is considered a positive place for poststructuralist feminists because it permits outsiders to criticize the overriding structures of patriarchal culture. Thus, being other is more than a place of oppression. It is also being, articulating, and performing that engender openness and diversity. Poststructuralist feminism rejects any universalizing definition of women. Rather, each authentic subject exists underneath a veneer of enculturation. For more on the debate between cultural feminism and poststructuralist feminism, see Linda Alcoff, "Cultural Feminism versus Post-structuralism: The Identity Crisis in Feminist Theory," in *Feminism and Philosophy: Essential Reading in Theory, Reinterpretation, and Application*, ed. Nancy Tuana and Rosemarie Tong (Boulder, CO: Westview, 1995), 434–56.

15. Friedrich Nietzsche, *The Will to Power*, trans. Walter Kaufmann (New York: Vintage, 1968), 270.

16. "For Descartes, in the initial cogito . . . what the *I think* is directed towards, in so far as it lurches into the *I am*, is a real. But the true remains so much outside that Descartes then has to re-assure himself—of what, if not of an Other that is not deceptive, and which shall, into the bargain, guarantee by its very existence the bases of truth, guarantee him that there are in his own objective reason the necessary foundations for the very real, about whose existence he has just re-assured himself, to find the dimension of truth." Jacques Lacan, "The Function and Field of Speech and Language in Psychoanalysis" (1953), in *Écrits: A Selection*, trans. Alan Sheridan (New York: Norton, 1977), 36.

17. Grosz, *Sexual Subversions*, ix.

18. See Carolyn J. Dean, *The Self and Its Pleasures: Bataille, Lacan, and the History of the Decentered Subject* (Ithaca, NY: Cornell University Press, 1992), 4.

19. See G. W. F. Hegel, "Independence and Dependence of Self-Consciousness: Lordship and Bondage," in *Phenomenology of Spirit*, trans. A. V. Miller (Oxford, UK: Clarendon, 1977). Two (equal, mirrored) self-consciousnesses manifest themselves in Hegel's skit as the meeting of two individuals who vie for each other's recognition in a "life and death struggle" (114). A life-and-death struggle ensues as a result of each of these self-consciousnesses desiring to negate whatever is external to it. The possibility of genuine recognition, for Hegel, lies in the confrontation of two potentially free individuals. It is solely dependent upon the presence and perception of the other, and in order to engage in a struggle for freedom, one must put one's life on the line. However, with the enemy the only potential witness to the victory, when he is killed, both recognition and victory become meaningless. Killing the enemy also kills the witness.

During the life-and-death struggle, one individual chooses to surrender himself to servitude rather than death. In doing so, he confirms the freedom of the master by materializing it for him and making it meaningful (113–14). The fact that each believes in his possibility for freedom is crucial to the interpretation of this dialectic. It is the enslavement of the other that makes the master free. However, the choice of the slave to surrender himself does not make the master supreme. Rather, for the slave, it is death that is absolute, as he may have died free but he will not have lived free. For him, the encounter with death has revealed freedom as an abstraction. The slave therefore chooses life rather than what he perceives to be a meaningless form of freedom in death.

The important factor to note about this struggle for recognition is that neither individual earns the satisfactory recognition from the other that he seeks. The master, if he kills the slave, will not have had any recognition, because the only other would be lifeless. And the other, as slave, has lost his freedom and with it the status needed to make recognition of the master meaningful to the master. The futility of the situation comes to light as a surreal irony. All that each of the individuals desired was recognition of their freedom from an other worthy individual. Neither has acquired this.

Further, the slave, although bound to the master, discovers an independence and creativity in his work that allows him to have a permanent relationship with desire insofar as he is creative. Hegel writes: "[I]n fashioning the thing, he becomes aware that being-for-self belongs to him, that he himself exists essentially and actually in his own right. . . . Through this rediscovery of himself by himself, the bondsman realizes that it is precisely in his work wherein he seemed to have only an alienated existence that he acquired a mind of his own. . . . Since the entire contents of its natural consciousness have not been jeopardized, determinate being still *in principle* attaches to it; having a 'mind of one's own' is self-will, a freedom which is still enmeshed in servitude" (118–19). The master finds that his enjoyments of life are unsustainable, for he determines what the slave must do to bring about these enjoyments. The slave is a median between the master and nature. The master can experience (through the slave) only basic levels of satiation of his desires. So, for example, the master is hungry and the slave feeds him. As a result, the master becomes reliant upon the slave, whereas the slave is self-sufficient (111–19).

20. Dean, 5.

21. Ferdinand de Saussure, *Course in General Linguistics*, ed. Charles Bally and Albert Sechehaye in collaboration with Albert Riedlinger, trans. Wade Baskin, rev. ed. (London: Fontana, 1974), 120.

22. Jacques Lacan, *The Four Fundamental Concepts of Psycho-analysis*, ed. Jacques-Alain Miller, trans. Alan Sheridan (New York: Norton, 1978), 204. According to Freud, both boys and girls initially form a natural attachment to the mother, the first love object. The boy wishes to possess the mother and views the father as a rival. At the same time the boy wishes to receive his father's love and, allying himself with his mother, vies for his father's attention, becoming more and more antagonistic toward the mother. Eventually the boy recognizes that the mother has a sexual lack and, fearing castration (by the father), he represses his love for his mother and allies himself with the father, beginning a period of sexual latency. This is sexual love deferred. The boy will eventually have a woman to take the place of the mother. During the period of sexual latency, the boy develops the superego—the internalization of the father's patriarchal values, the Law of the Father. A strong superego is required to adequately assimilate into heterosexual, patriarchal society. Sigmund Freud, "Femininity," in *New Introductory Lectures on Psycho-analysis*, trans. W. J. H. Sprott (New York: Norton, 1933), 118.

The female experience of Freud's Oedipus complex is very different. The girl recognizes that she has been castrated. "They [girls] notice the penis of a brother or playmate, strikingly visible and of large proportions, at once recognize it as the superior counterpart of their own small and inconspicuous organ (the clitoris), and from that time forward they fall a victim to envy for the penis." Sigmund Freud, "Some Psychical Consequences of the Anatomical Distinction between the Sexes" (1925), in *The Standard Edition of the Complete Psychological Works of Sigmund Freud*, trans. and ed., James Strachey (London: Hogarth, 1953–74), 19:192. In Freud's view, girls recognize that they lack the ability to sexually fulfill their mother. They also recognize that their mother also lacks a penis. Finding this lack disgusting, the girl allies herself with the father. Rejection of the mother is,

however, very painful and, in order to compensate, the girl tries to become the abandoned love object (the mother) and vies with her mother for her father's affections. Eventually the girl's desire for her father's penis becomes a desire to have a baby. Girls are forced to give up desiring women and, according to Freud, only ever find fulfillment through motherhood, the baby being the penis substitute. Whereas boys return to desiring women— their primary love object—girls must switch the direction of their desire from women to men. Freud, "Femininity," 121–28.

23. Lacan, *Four Fundamental Concepts*, 131.

24. Ibid., 147.

25. Elizabeth Grosz, *Jacques Lacan: A Feminist Introduction* (London: Routledge, 1990), 74. The Oedipal phase is a gradual distancing of the mother and the child in which the child regards the mother as other. This is also the point when sexual differentiation is determined. At first the child, wishing contact with the mother, also unconsciously wishes to occupy the space of her lack: the phallus. Then, with the intervention of the father, the mother is deprived of the phallic object and the child is deprived of the object of his or her desire. At this point the child passes into the symbolic realm of male language, the Law of the Father. In other words, with the separation of the child and mother, the child chooses the medium of language to communicate to the mother. The child also takes on the Name of the Father. Rosemarie Putnam Tong, *Feminist Thought: A More Comprehensive Introduction* (Boulder, CO: Westview, 1998), 197. Finally the father replaces (for the mother) the phallus as child-object and symbolically castrates the child. This symbolic castration is literalized as a separation from the mother.

Like Freud, Lacan differentiates between the ways boys and girls migrate their way through these phases. When boys separate from their mothers, they ally themselves with their anatomically similar fathers, who represent the symbolic order and language. Rosemarie Tong writes, "Through identification with his father, the boy not only enters into subjecthood and individuality but also internalizes the dominant order, the value-laden roles of society, otherwise termed 'the law of the father.' In sum, the boy is born again— this time to language" (197).

Because girls' bodies do not match those of their fathers, they are unable to fully internalize the symbolic order. Tong points out that this can be interpreted several ways. Either an equation can be made with Freud when he states that the girl is morally inferior to the boy because she is less motivated to internalize the values of the father since she does not fear castration, or women are forced into the symbolic order: "Because women refuse to internalize the 'law of the father,' this law must be imposed from the outside. Women are given the same words men are given: masculine words. These words cannot express what women *feel*, however; they can express only what men *think*. Lacking feminine words, women must either babble or remain silent within the symbolic order" (197).

26. Luce Irigaray, *Speculum of the Other Woman* (Ithaca, NY: Cornell University Press, 1985), 89.

27. Ibid., 165 (emphases mine).

28. Orlan, "Conference," trans. Tanya Augsburg and Michel A. Moos, in *This Is My Body . . . This Is My Software . . .*, ed. Duncan McCorquondale (London: Black Dog, 1996), 88.

29. Warren Gorman, *Body Image and the Image of the Brain* (St. Louis, MO: Green, 1969), 3.

30. Claudine Griggs, *S/he: Changing Sex and Changing Clothes* (Oxford, UK: Berg, 1998), 4–6 (emphasis added).

31. Kate Bornstein, *Gender Outlaw: On Men, Women, and the Rest of Us* (New York:

Routledge, 1994), 94. See also Philip Auslander, *From Acting to Performance: Essays in Modernism and Postmodernism* (London: Routledge, 1997), 138.

32. Bornstein, 228, 238; Auslander, 138.

33. Bornstein, 210–13.

34. Ibid., 52; Auslander, 138.

35. Jay Prosser, *Second Skins: The Body Narratives of Transsexuality* (New York: Columbia University Press, 1998), 2.

36. Ibid.

37. Orlan, quoted in ibid., 61. This quote was associated with the bloodstained robe of the surgeon that was exhibited in the gallery as a relic of the surgery.

38. Orlan, quoted in Louise Gray, "Me, My Surgeon, and My Art," *Guardian*, April 2, 1996, 8, which Prosser cites (61).

39. Prosser, 62.

40. Ibid.

41. Ibid., 64.

42. Ibid., 67.

43. Chris Straayer, *Deviant Eyes, Deviant Bodies: Sexual Re-orientations in Film and Video* (New York: Columbia University Press, 1996), 259.

44. Judith Butler, "The Body You Want: Liz Kotz Interviews Judith Butler," *ArtForum*, November 1992, 88.

45. Prosser, 8.

46. The flip side of transsexual surgery is, of course, the fact that no insurance company recognizes the gender-reassignment procedure as "necessary" and that, therefore, the expensive process can be only privately purchased. My question here is that if the gender-reassignment process is considered cosmetic by the insurance companies, why is it considered medical (indicated by the strict guidelines one must follow in order to be considered) by the technicians and doctors who perform it, and why are these strict guidelines tolerated by those who wish to undergo the procedure?

47. Prosser, 89.

48. Ibid., 90.

49. Tanya Augsburg, "Private Theatres Onstage: Hysteria and the Female Medical Subject from Baroque Theatricality to Contemporary Feminist Performance" (PhD diss., Emory University, 1996), 318. The martyrdom of a saint "produces . . . pure spectacle through acts of humiliation and martyrdom. . . . By assuming a religious identity Orlan seems to have returned to the pre-modern Christian theatrical technique of self-discovery" (322–23).

50. See Les Cemea, ed., special issue, *VST: Revue Scientifique et Culturelle de Santé Mentale*, September–December 1991 (dedicated to determining whether or not Orlan was insane).

4. Interior / Exterior

1. Orlan's *Omnipresence* was performed and filmed on November 7, 1993, in New York. I first viewed the video of *Omnipresence* in the exhibition Endurance: Marathon Endurance Video Screening, at Exit Art, New York, in March 1994. I have subsequently viewed the same video several times at the Sandra Gering Gallery, New York. All references to *Omnipresence* in this chapter refer to this video.

2. Elizabeth Grosz, "Naked" (lecture, Columbia University, January 22, 1998).

3. Orlan, "Conference," trans. Tanya Augsburg and Michel A. Moos, in *This Is My*

Body . . . This Is My Software . . ., ed. Duncan McCorquondale (London: Black Dog, 1996), 83–84.

4. Ibid., 84.

5. Ibid., 93. "Each performance-operation is built on a philosophical, psychoana-lytical, or literary text (e.g., from Eugénie Lemoine-Luccioni, Michel Serres, Sanskrit Hindu texts, Alphonse Allais, Antonin Artaud, Elisabeth Betuel Fiebig, Raphael Cuir, Julia Kristeva)" (90). The Michel Serres quotation, from *Le tiers-instruit* (Paris: Éditions François Bourin, 1991), 92–93, was recited during the sixth performance surgery. For more about Serres, see "EXTRActions."

6. Tanya Augsburg, "Orlan's Performative Transformations of Subjectivity," in *The Ends of Performance*, ed. Peggy Phelan and Jill Lane (New York: New York University Press, 1998), 306.

7. Michelle Hirschhorn, "Orlan," in McCorquondale, 4. I discuss the correlation between the work of Orlan and Artaud in chapter 4.

8. The term *technotheater* refers to Orlan's use of medical and media technologies during her performances.

9. Orlan, "Conference," 91.

10. Tanya Augsburg, "Private Theatres Onstage: Hysteria and the Female Medical Subject from Baroque Theatricality to Contemporary Feminist Performance" (PhD diss., Emery University, 1996), 337.

11. In Artaud's words, such performance is "a theater of blood, a theater which with each performance will have done something bodily to the one who performs as well as to the one who comes to see others perform, but actually the actors are not performing, they are doing." "Letter to Paule Thévenin," in *Antonin Artaud: Selected Writings*, ed. Susan Sontag, trans. Helen Weaver (Berkeley and Los Angeles: University of California Press, 1976), 584.

12. During *Omnipresence* the anesthesia appears to be local, given in Orlan's head near the areas to be worked on. During some of the other surgical performances (e.g., when liposuction is applied), she receives other types of anesthesia, including spinal injections, to numb her body.

13. Antonin Artaud, "To Have Done with the Judgment of God" (1947), in *Selected Writings*, 570–71.

14. Artaud, "Nerve," in *Selected Writings*, 84.

15. However, the optimism of the surrealists, combined with their allegiance to the Communist Party, ran contrary to Artaud's struggle to "remake" himself.

16. Sontag, introduction to *Antonin Artaud: Selected Writings*, xxvii.

17. Antonin Artaud, "Indian Culture and Here Lies" (1947), *Selected Writings*, 540.

18. Ibid., 548.

19. Gilles Deleuze and Félix Guattari, *A Thousand Plateaus: Capitalism and Schizo-phrenia* (Minneapolis: University of Minnesota Press, 1987), 151.

20. My claim that Orlan's body is ahysterical is in direct opposition to Artaud's pro-ject, which I believe was based on hysteria that resonated from his body, and a resulting martyrdom. Orlan does not exhibit any hysteria; any martyrdom that she exhibits is a result of her conceptual forum. For more on hysteria and its absence in Orlan's performances, see Augsburg, "Private Theatres Onstage" and "Orlan's Performative Transformations," 285–314.

21. Augsburg, "Private Theatres Onstage," 337 (Augsburg's emphasis).

22. "I based one of my operations on a text by Antonin Artaud who dreamed of a body without organs. This text mentions the names of poets of his time. Then it enumerates

the times these poets must have defecated, urinated, how many hours were needed to sleep, to eat, to wash, and concludes that this is totally disproportionate to the fifty or so pages of magical production (as he calls the creative act)." Orlan, "Conference," 92.

23. Nicholas Mirzoeff, *Bodyscape: Art, Modernity, and the Ideal Figure* (London: Routledge, 1995), 19.

24. For example, Nero (emperor of Rome in AD 54–68), who had his mother cut open to see where he had lain, whose family was torn apart by power struggles, indulged his horrible curiosity after murdering both his wife and his mother, Agrippa the Younger. His inquisitiveness regarding his mother's womb confronted the sublime and mysterious puzzle of the womb's connection to human creation. These mysteries remained the subject of much speculation until the eighteenth century. The notion that because the uterus was internal and invisible it was somehow intentionally being hidden caused a peculiar suspicion and paranoia that there were other unknown attributes that might have been intentionally hidden inside the woman. Thus the Renaissance dissection theater (for an excellent source on this topic, see Jonathan Sawday, *The Body Emblazoned: Dissection and the Human Body in Renaissance Culture* [London: Routledge, 1995]) and the numerous autopsies performed during the Enlightenment (see Michel Foucault, *The Birth of the Clinic: An Archaeology of Medical Perception*, trans. A. M. Sheridan Smith [New York: Vintage, 1994]).

25. Specifically, Susan Bordo writes about the entrenched history of the woman's body as other: *her* body, feminized as natural and of the earth (that is to say, mortal); *his* body, of the mind, the objective male place, which exists above nature and mortality. *The Flight to Objectivity: Essays on Cartesianism and Culture* (Albany: State University of New York Press, 1987). The topic is also well summarized in Susan Hekman, "Material Bodies," in *Body and Flesh: A Philosophical Reader*, ed. Donn Welton (Malden, MA: Blackwell, 1998), 62.

26. Hekman, 65.

27. Susan Bordo, "Bringing Body to Theory," in Welton, 95.

28. Cybele was the Phrygian mother of all nature and of the gods, the guardian of fertility and of women in motherhood, and was associated with orgiastic festivities. She was identified by the Greeks with Rhea and by the Romans with Magna Mater. The worship of Cybele, however, also spread to both Greece and Rome. George Howe and G. A. Harper, *A Handbook of Classical Mythology* (Hertfordshire, UK: Oracle, 1996), 71.

29. Didier Anzieu, *The Skin Ego: A Psychoanalytic Approach to the Self*, trans. Chris Turner (New Haven, CT: Yale University Press, 1989), 47.

30. Ibid., 51.

31. Freud, "The Ego and the Id" (1923), in *The Standard Edition of the Complete Psychological Works of Sigmund Freud*, trans. and ed. James Strachey (London: Hogarth, 1953–74), 19:26.

32. In opposition to Lacan, and in accordance with Freud's theory presented in "The Ego and the Id," Anzieu places the location of the ego back inside of the body. He disagrees with Lacan's substitution of language for the body as the key material for psychoanalysis: "I myself would oppose the formula: 'the unconscious is structured like a language' with a formulation that is implicit in Freud: 'the unconscious is the body.' The unconscious seems to me to be structured like the body." Didier Anzieu, *A Skin for Thought: Interviews with Gilbert Tarrab* (London: Karnac, 1990), 43, quoted in Jay Prosser, *Second Skins: The Body Narratives of Transsexuality* (New York: Columbia University Press, 1998), 66. Anzieu defines the skin ego as "a mental image of which the Ego of the child makes use during the early phases of its development to represent itself as an Ego containing

psychical contents, on the basis of its experience of the surface of the body" (4). The body and the skin are thus responsible for producing the mental image of the surface of the body. For example, Anzieu maintains that the sense of touch is the first stimulated sense in human experience, because the birthing process is experienced as an extreme massaging of the body (61).

It is interesting to note that Lacan was Anzieu's trainee-analyst. Also, Lacan's first famous case was Anzieu's mother. Lacan treated her very badly. See Elizabeth Roudinesco, *Jacques Lacan*, trans. Barbara Brey (New York: Columbia University Press, 1997), 188–90.

33. Ovid, *Metamorphoses*, in *Shakespeare's Ovid, being Arthur Golding's Translation of the Metamorphosis*, ed. W. H. D. Rouse (1902; London: Centaur, 1961), 128; quoted in Sawday, 185.

34. Immanuel Kant, *The Critique of Judgement*, trans. James Creed Meredith (Oxford, UK: Clarendon, 1952), 90.

35. In Derrida's foreword to Nicolas Abraham and Maria Torok's *The Wolf Man's Magic Word: A Cryptonymy*, he asks the question, what is a crypt with relation to psychoanalysis? The crypt is an architectonic structure that seals the body within. The crypt hides as well as holds a body. The crypt implicates that which it contains, as well as the container itself. Thus, as a metaphor, according to Derrida, the crypt implicates the self, rather than just the unconscious: "The first hypothesis of *The Magic Word* posits a preverbal traumatic scene that would have been 'encrypted' with all its libidinal forces, which through their contradiction, through their very opposition, support the internal resistance of the vault like pillars, beams, studs, and retaining walls, leaning the powers of intolerable pain against an ineffable, forbidden pleasure, whose locus [*lieu*] is not simply the Unconscious but the Self." Jacques Derrida, foreword to *The Wolf Man's Magic Word: A Cryptonomy*, by Nicolas Abraham and Maria Torok, trans. Nicholas Rand, Theory and History of Literature 37 (Minneapolis: University of Minnesota Press, 1986), xv. Derrida points out that the only way to open a crypt is to break in, to force entry, because the purpose of the crypt is to seal off the outside (xiv–xv). Within Abraham and Torok's text, cryptonyms are words that might be seen as hidden word-objects harbored within the traumatic experience that produces the Wolf Man's symptoms. (The Wolf Man is one of Freud's case studies. After being seduced by his sister, the Wolf Man was haunted by images of wolves. See Sigmund Freud, "The History of an Infantile Neurosis" [1918], in *Standard Edition*, 17:1–122.) Abraham and Torok discover correlatives between the German and Russian words for "sister" and "wolf" (16–19).

36. Derrida, foreword, xiv.

37. Deleuze and Guattari, 49.

38. Jill Dolan, *The Feminist Spectator as Critic* (Ann Arbor: University of Michigan Press, 1998), 12.

39. Ibid., 41.

40. Judith Newton and Deborah Rosenfelt, "Toward a Materialist-Feminist Criticism," in *Feminist Criticism and Social Change: Sex, Class, and Race in Literature and Culture*, ed. Judith Newton and Deborah Rosenfelt (New York: Methuen, 1985), xix, quoted in Mary Ann Doane, "Film and the Masquerade: Theorizing the Female Spectator," in *Femmes Fatales: Feminism, Film Theory, Psychoanalysis* (New York: Routledge, 1991), 16.

41. Laura Mulvey, "Visual Pleasure and Narrative Cinema," *Screen* 16, no. 3 (Autumn 1975): 6–18.

42. Teresa de Lauretis, "Desire in Narrative," *Alice Doesn't: Feminism, Semiotics, Cinema* (Bloomington: Indiana University Press, 1984), 1–37. The topic is also discussed in Dolan, 13.

43. Dolan, 14.

44. Doane, "Film and the Masquerade," 22.

45. Ibid., 32. Doane refers to Joan Riviere, "Womanliness as a Masquerade" (1929).

46. Chris Straayer, *Deviant Eyes, Deviant Bodies: Sexual Re-orientation in Film and Video* (New York: Columbia University Press, 1996), 146.

47. For Lacan, the phallus does not refer to a biological organ. It is an imaginary organ and an attribute of power owned by neither the male nor the female. In this regard it is representative of the desire for wholeness; it represents a lack as well as a desire to eliminate the lack. Thus, the phallus is a transcendental signifier, a signifier of desire. As the man *has* the phallus, he is the object of women's desire; as the woman *is* the phallus, she is the object of man's desire. The phallus replaces the primordial lost object: the mother. See Jacques Lacan, "The Signification of the Phallus," in *Écrits: A Selection*, trans. Alan Sheridan (New York: Norton, 1977), 289–91.

48. Dolan, 101.

49. These performances are discussed in chapter 1. There are many other examples that are not mentioned. A few others include Martha Rosler's *Vital Statistics of a Citizen, Simply Obtained* (1977), a forty-minute video in which every part of the artist's body is scrupulously measured; Martha Wilson's *I Make Up the Image of My Deformity; I Make Up the Image of My Perfection* (1974), which explores the image of women that is expected from society; and Lynn Hershman's *Roberta Breitmor's Construction Chart* (1973), which details the application of makeup as the "vital statistics" of numerous ordinary women.

50. A Hollywood example of this phenomenon takes place in the 1997 film *Face/Off* (directed by John Woo [DVD, Paramount, 2002]), when the characters played by John Travolta and Nicolas Cage exchange identities via plastic surgery. The facial skin of both is completely removed. At first, Travolta, a cop, becomes Cage in order to go undercover. Cage's character, a criminal, is left without a face until he insists on having Travolta's face put on him. The difference is that Hollywood does not indulge the spectator in this moment of unidentifiability with a close-up. Rather, Cage's character, at a distance and facing away from the camera, communicates his toughness by smoking a cigarette and demanding that the surgeons perform this surgery.

51. I thank Chris Straayer for pointing out that Orlan's refusal to admit to pain is only one factor in Orlan's ahysterical stance. Equally important is her insistence on consciousness.

52. Mary Ann Doane, "Veiling Over Desire: Close-ups of the Woman," in *Femmes Fatales*, 45–46.

53. Ibid., 46.

54. Ibid., 47–48.

55. Ibid., 54–55. See also Sigmund Freud, *Three Essays on the Theory of Sexuality*, trans. James Strachey (New York: Basic, 1975), 17.

56. Other extreme examples of this phenomenon exist in our culture (e.g., Michael Jackson).

57. Doane, 55–56.

58. Ibid., 56.

5. Beauty / The Monstrous Feminine

1. Gilles Deleuze and Félix Guattari, *A Thousand Plateaus: Capitalism and Schizophrenia*, trans. Brian Massumi (Minneapolis: University of Minnesota Press, 1987), 170.

2. Ibid.

3. Ibid., 172.

4. Ibid., 170.

5. Camilla Griggers, "The Despotic Face of White Femininity," in *Becoming-Woman*, ed. Camilla Griggers, Theory Out of Bounds 8 (Minneapolis: University of Minnesota Press, 1997), 2. The baby monkeys related to the mother object as though it were their mother, but not without consequences; they exhibited "anxiety ridden, disturbed, and . . . protopathological" behavior later on.

6. Ibid., 3 (emphasis added).

7. Ibid., 4.

8. Ibid., 30.

9. Ibid., 31.

10. See the analysis of David Hillman and Carla Mazzio in "Individual Parts," introduction to *The Body in Parts: Fantasies of Corporeality in Early Modern Europe*, ed. David Hillman and Carla Mazzio (New York: Routledge, 1997), xvi.

11. For a brief explanation of Lacan's mirror stage, see chapter 1.

12. Sigmund Freud, "Medusa's Head" (1922), in *The Standard Edition of the Complete Psychological Works of Sigmund Freud*, trans. and ed. James Strachey (London: Hogarth, 1953–74), 18:273.

13. Jacques Lacan, *The Second Seminar: The Ego in Freud's Theory and in the Technique of Psychoanalysis, 1954–1955*, ed. Jacques-Alain Miller, trans. Sylvana Tomaselli (New York: Norton, 1991), 164. Here Lacan is referring to Freud's dream about his patient named Irma, in which Freud examines her throat. This dream proves extremely significant to Freud. In a letter to Wilhelm Fleiss, he writes, "Do you suppose that some day a marble tablet will be placed on the house inscribed . . . In This House, on July 24th 1895 the Secret of Dreams was Revealed to Dr. Sigm. Freud?" See Sigmund Freud, *The Interpretation of Dreams*, trans. James Strachey (New York: Avon, 1965), 138–54; Lacan, 146–61.

14. Hillman and Mazzio, "Individual Parts," xvii.

15. Victor Hugo, *Oeuvres completes* (Paris, 1955) 31:365–66, quoted in Neil Hertz, "Medusa's Head: Male Hysteria under Political Pressure," *Representations* 20 (Fall 1987): 29 (emphasis mine). Subsequent citations of Hugo in this chapter are from the same source, also quoted in Hertz, 29.

16. Hertz, 29.

17. Freud, "Medusa's Head," 215.

18. Orlan, "Conference," trans. Tanya Augsburg and Michel A. Moos, in *This Is My Body . . . This Is My Software . . .*, ed. Duncan McCorquondale (London: Black Dog, 1996), 84.

19. George Devereux, *Baubo, la vulve mythique* (Paris: Godefroy, 1983), 13. Baubo was honored at the Thesmophoria, which was the women's festival of Demeter Thesmophoros.

20. Ibid., 174.

21. The *vagina dentata*, or "toothed vagina," which is capable of castrating and/or devouring men, is a repeating motif in mythology. It is likened to the opening of the gates of hell. In another example, the Greek *lamiae* (translated "lecherous vaginas") are lustful she-demons born of the Libyan snake-goddess Lamia. Lamia is also represented as Kundalini in India, the devourer of men and the mother of all. Barbara G. Walker, *The Woman's Encyclopedia of Myths and Secrets* (Edison, NJ: Castle Books, 1996), 1034.

22. Mikhail Bakhtin, *Rabalais and His World*, trans. Hélène Iswolsky (Bloomington: Indiana University Press, 1984), 337.

23. Mikhail Iampolski, "Physiognomies: Reading Appearances" (lecture, New York University, Fall 1995).

24. See Mary Ann Doane, "Woman's Stake: Filming the Female Body," *Feminism and Film Theory*, ed. Constance Penley (New York: Routledge, 1988); Luce Irigaray, *This Sex*

Which Is Not One, trans. Catherine Porter with Carolyn Burke (Ithaca, NY: Cornell University Press, 1985).

25. Deleuze and Guattari, 171.

26. Rebecca Schneider, *The Explicit Body in Performance* (London: Routledge, 1997), 55–56.

27. C. Carr, "A Public Cervix Announcement," in *On Edge: Performance at the End of the Twentieth Century* (Middletown, CT: Wesleyan University Press; Hanover, NH: University Press of New England, 1993), 176, first published in *Village Voice*, May 1989, quoted in ibid., 76.

28. Schneider, 77.

29. Ibid., 60. Lacan was an avid art collector. *L'origin du monde* (The Origin of the World) caused a scandal when it was painted in 1866 for Khalil Bey, a Turkish diplomat. To create a "hiding device," the painting was enclosed in a panel on which appeared an abstraction of the erotic painting itself. A secret mechanism opened the panel, revealing Courbet's painting. Elizabeth Roudinesco, *Jacques Lacan*, trans. Barbara Brey (New York: Columbia University Press, 1997), 184.

30. Linda Williams, *Hard Core: Power, Pleasure, and the "Frenzy of the Visible"* (London: Pandora, 1991), 49.

31. Freud also wrote about "The Sandman" in his essay "The 'Uncanny'" (1919), in *Standard Edition*, vol. 17. In this version of the story, the father figure appears to Nathaniel as a double figure: one is protective and kind, the other threatens to blind (castrate) him. The son has a great desire for the kind father, which appears in the form of a "feminine attitude"—the doll Olympia.

32. Hal Foster, *Compulsive Beauty* (Cambridge, MA: MIT Press, 1993), 101.

33. Rosalind Krauss, *The Optical Unconscious* (Cambridge, MA: MIT Press, 1993), 172.

34. Freud, "'Uncanny,'" 51.

35. Hans Bellmer, quoted in Peter Webb, *Hans Bellmer* (Paris, 1975), 177.

36. Sigmund Freud, "The Uncanny," in *Studies in Parapsychology*, ed. Philip Rieff (New York, 1963), 40.

37. In his own life Freud experienced the uncanny as the feeling of being haunted by coincidental recurrences. For example, when he visited Greece in 1904, he noticed the frequency with which he encountered the number 62 (on train tickets, in dates, etc.). When he arrived in Athens, his hotel room number was 31 (one-half of 62). For the next five or six years, he was haunted by the number 31. Ernest Jones, *The Life and Work of Sigmund Freud*, vol. 3, *The Last Phase, 1919–1939* (New York: Basic Books, 1957), 391, 399.

38. André Breton, "Second Manifesto of Surrealism" (1930), in *Manifestoes of Surrealism*, trans. Richard Seaver and Helen R. Lane (Ann Arbor: University of Michigan Press, 1969), 123, quoted in Foster, 111.

39. Georges Bataille, *Eroticism: Death and Sensuality*, trans. Mary Dalwood (San Francisco: City Lights, 1986), 144. There are several other factors regarding the relationship of Freud to the surrealists that must also be taken into consideration. First, the surrealists embraced hysteria as "the greatest poetic discovery of the nineteenth century." André Breton and Louis Aragon, "Le cinquatenaire de l'hysterie," *La Revolution Surréaliste* 11 (March 15, 1928). Second, Breton and Aragon were medical students who assisted students of Jean-Martin Charcot. Surrealism embraced hypnosis, whereas Freud was abandoning it. The surrealist adaptation of dream theory was contrary to what Freud believed, even though eventually the surrealist message aided the reception of Freud in France. The surrealists believed that dreams were portents of desire, whereas Freud read dreams as "ambiguous fulfillments of conflictual wishes." Foster, 2.

40. Foster, 115.

41. Theodor W. Adorno and Max Horkheimer, *Dialectic of Enlightenment*, trans. John Cumming (New York: Seabury, 1972), 235, quoted in ibid.

42. Cindy Sherman, "A Woman of Parts," interview by Fuku Noriko, *Art in America* (June 1997): 80.

43. Foster, 114.

44. Luce Irigaray, "The Eternal Irony of the Community," trans. Gillian C. Gill, in *Feminist Interpretations of G. W. F. Hegel*, ed. Patricia Jagentowicz Mills (University Park: Pennsylvania State University Press, 1996), 55–56.

6. Penetrating Layers of Flesh

1. Julia Szabo, "The Morphing Pot," *New Woman*, January 1995, 94–95, 114–16.

2. Orlan, "Conference," trans. Tanya Augsburg and Michel A. Moos, *This is My Body . . . This is My Software . . .*, ed. Duncan McCorquondale (London: Black Dog, 1996), 90.

3. See the section on Jacques Lacan in chapter 1.

4. On sacrifice, Orlan says, "I have given my body to Art. After my death it will not therefore be given to science, but to a museum. It will be the centrepiece of a video installation" (92).

5. Carol Bigwood, "Renaturalizing the Body," in *Body and Flesh: A Philosophical Reader*, ed. Donn Welton (Malden, MA: Blackwell, 1998), 108–9 (emphasis mine). To this effect Orlan declares: "Like the Australian artist, Stelarc, I think that the body is obsolete" (91).

6. Pertinent to this description of Orlan's facelessness is the notion of anamorphosis as it applies to visual representation. Jacques Lacan's description of anamorphosis is as follows: "[There exists] a polished cylinder that has the function of a mirror. . . . [A]round it you put a bib or flat surface on which there are . . . indecipherable lines. When you stand at a certain angle you see [an] image . . . emerge in the cylindrical mirror; in this case it is a beautiful anamorphosis of a painting of a crucifixion copied from Rubens." Jacques Lacan, *The Ethics of Psychoanalysis, 1959–1960*, ed. Jacques-Alain Miller, trans. Dennis Porter, Seminar of Jacques Lacan 7 (London: Tavistock/Routledge, 1992), 135, quoted in Parveen Adams, "The Three (Dis)graces," in *The Emptiness of the Image: Psychoanalysis and Sexual Difference* (London: Routledge, 1996), 128. As a second example of anamorphosis, Lacan refers to Holbein's *The Ambassadors*, a painting in which there is a rendered object that reveals itself as either a blur or a skull, depending on one's point of view—that is, where one stands in relation to the painting. For more on the relationship of anamorphosis to Orlan's work, see Parveen Adams, "Operation Orlan," in *Emptiness of the Image*, 151–59.

7. Parveen Adams, "Operation Orlan" (unpublished version), 151.

8. Adams, "Operation Orlan," *Emptiness of the Image*, 159. An example: Cindy Jackson, who is a daytime talk-show regular, has had many more surgeries than Orlan. Her objective is to enhance her beauty, to retain her youth, and to resemble as closely as possible the Barbie doll. She is most interested in attaining and maintaining her goal image.

9. Ibid.

10. Trinh T. Minh-ha, *Woman, Native, Other: Women, Postcoloniality, and Feminism* (Bloomington: Indiana University Press, 1989), 100, quoted in Amelia Jones, *Body Art: Performing the Subject* (Minneapolis: University of Minnesota Press, 1998), 215.

11. For example, the female body is objectified in cinema and advertising as a commodity, even if only a commodity for the male imagination. In other words, the two pleasures of cinema—termed the scopophilic pleasure and the narcissistic pleasure—are subject to "a world ordered by sexual imbalance . . . [in which] pleasure [has] been split between active/male and passive/female [so that] the determining male gaze projects its phantasy onto the female figure which is styled accordingly. In their traditional exhibitionist role women are simultaneously looked at and displayed." Orlan resists this type of fantastic sexual objectification. Rather, she plays out her performances in the gap between subject and object (of art). The quotation is originally from Laura Mulvey, "Visual Pleasure and Narrative Cinema," in *Film Theory and Criticism: Introductory Readings*, ed. Gerald Mast and Marshall Cohen, 3rd ed. (New York: Oxford University Press, 1985), 808–9, quoted in Dorothea Olkowski, "Bodies of Light: Relaxing the Imaginary in Video," in *Thinking Bodies*, ed. Juliet Flower MacCannell and Laura Zakarin (Stanford, CA: Stanford University Press, 1994), 168. Olkowski points out that, for Mulvey (and most feminist film theorists), "the imaginary is coded as masculine, coded by an oedipal society in which woman is defined only as not-phallic, thus not-male, and it is this failure that, in Western society, becomes the prototype of every other kind of loss" (168).

12. I do not mean to imply here that Orlan is a saint. The word *saint* is used rhetorically. Orlan is a body artist informing her work with iconography and nomenclature associated with saints.

13. "An imago is an unconscious image or cliché which preferentially orients the way in which the subject apprehends other people. In the imaginary mode, one's understanding of other people is shaped by one's own imagoes. The perceived other is actually at least in part, a projection." Jane Gallop, *Reading Lacan* (Ithaca, NY: Cornell University Press, 1985), 61, quoted in Olkowski, 165.

14. Elizabeth Grosz, *Jacques Lacan: A Feminist Introduction* (London: Routledge, 1990), 174.

15. Orlan emphasizes this by using the *Mona Lisa*.

16. Max Ernst, *The Hundred Headless Woman = La femme 100 têtes*, trans. Dorothea Tanning (New York: Brasiller, 1981), 305.

17. Luce Irigaray, "Plato's *Hystera*," in *Speculum of the Other Woman* (Ithaca, NY: Cornell University Press, 1994), 243–364.

18. Ibid., 244.

19. Ibid., 334.

20. Orlan, 91.

21. Irigaray, 331.

22. Ibid.

23. Ibid., 331.

24. Ibid., 355.

25. Ibid., 332.

26. David Moos, "Memories of Being: Orlan's Theater of the Self," *Art + Text* 54 (1996): 72.

27. Orlan, 88.

28. I am taking into account her most recent work, which is virtually created by manipulating images of herself on the computer.

29. Jay Prosser, *Second Skins: The Body Narratives of Transsexuality* (New York: Columbia University Press, 1998), 67.

30. Orlan, 88.

7. A Few Comments on *Self-hybridations*

1. Orlan, "I. Body and Action. II. Triumph of the Baroque," in *Orlan: 1964–2001*, ed. María José Kerejeta, trans. Brian Webster and Careen Irwin (Vitoria-Gasteiz, Spain: Artium; Salamanca, Spain: Ediciones Universidad de Salamanca, 2002), 227, 228.

2. Orlan, "La maïeutique du corps: Rencontre avec Orlan" (interview with Maxime Coulombe), in *ETC: Revue de l'Art Actuel* 60 (December 2002–February 2003): 15; translation of passage by Jill O'Bryan.

3. Orlan, "Body and Action," 228.

4. Orlan, "Orlan mutant" (interview with Virginie Luc), in *Art a mort* (Paris: Éditions Léo Scheer, 2002), 65; translation of passage by Jill O'Bryan.

5. Michel Foucault, *Discipline and Punish: The Birth of the Prison*, trans. Alan Sheridan (New York: Vintage, 1979), 184, quoted in Mary Russo, *The Female Grotesque: Risk, Excess, and Modernity* (New York: Routledge, 1994), 10.

6. Mikhail Bakhtin, *Rabelais and His World*, trans. Hélène Iswolsky (Bloomington: Indiana University Press, 1984), 317.

7. These are my thoughts on painting. They are in direct contradiction to the thoughts of Susan Sontag regarding photography. She feels that what is stressed are immortality and the passage of time. See her *On Photography* (New York: Picador, 2001).

8. Tina Chanter, *Ethics of Eros: Irigaray's Rewriting of the Philosophers* (New York: Routledge, 1995), 181.

9. Emmanuel Levinas, *Totality and Infinity: An Essay on Exteriority*, trans. Alphonso Lingis (Pittsburgh: Duquesne University Press, 1969), 79.

10. Chanter, 182–83.

11. Ibid., 183.

12. Levinas, 299.

13. Sontag, 40.

14. Ibid., 43.

15. Orlan, "Body and Action," 228.

EXTRActions

1. Tanya Augsburg has written about Orlan's work in "Collaboration within the Field," *Drama Review: The Journal of Performance Studies* 39, no. 4 (Winter 1995): 166–72; and "Orlan's Performative Transformations of Subjectivity," in *The Ends of Performance*, ed. Peggy Phelan and Jill Lane (New York: New York University Press, 1998), 285–314. She is now writing a book on cosmetic surgery.

2. Examples of Orlan's writings include "Carnal Art Manifesto," "Intervention" (also referred to as "Conference"), "Search Engine: Picts/New Picts, and Faces," and "The Complex Dialectics of Virtuality and Reality." Recent versions of these texts appear in *Orlan: 1964–2001*, ed. María José Kerejeta, trans. Brian Webster and Careen Irwin (Vitoria-Gasteiz, Spain: Artium; Salamanca, Spain: Ediciones Universidad de Salamanca, 2002). All subsequent sources are works by Orlan unless otherwise noted.

3. "La maïeutique du corps: Rencontre avec Orlan" (interview with Maxime Coulombe), in *ETC: Revue de l'Art Actuel* 60 (December 2002–February 2003): 15.

4. Ibid.

5. "I. Body and Action. II. Triumph of the Baroque," in Kerejeta, 208.

6. "La maïeutique du corps," 15.

7. "Orlan mutant" (interview with Virginie Luc), in *Art à Mort* (Paris: Éditions Léo Scheer, 2002), 62. Special thanks to Bassem Shahin for his assistance with translation.

8. "Body and Action," trans. Brian Webster and Careen Irwin, in Kerejeta, 228.

9. "La maïeutique du corps," 14.

10. "Conference," in *This Is My Body . . . This Is My Software . . .*, ed. Duncan McCorquodale (London: Black Dog, 1996), 91.

11. "La maïeutique du corps," 14.

12. Ibid., 16.

13. "Orlan Interviewed by Hans Ulrich Obrist," in *Orlan: Carnal Art*, ed. Caroline Cros, Vivian Rehberg, Lauren Le Bon, et al., trans. Deke Dusinberre (Paris: Éditions Flammarion, 2004), 200–201.

14. Ibid. See also Michel Serres, *Le tiers-instruit* (Paris: Éditions François Bourin, 1991), 92–93. For more about the performance, see chapter 1 of this book.

15. "Orlan mutant," 65.

16. "Carnal Art Manifesto," in Kerejeta, 218.

17. "Orlan mutant," 65.

18. "La maïeutique du corps," 14.

19. "Orlan mutant," 64.

20. "Carnal Art Manifesto," 218.

21. "Orlan mutant," 63.

22. "Orlan Interviewed by Obrist," 199.

23. "Body and Action," 228.

24. "Orlan Interviewed by Obrist," 198.

25. "Body and Action," 225.

26. Bernard y Joël Savary Ceysson, *Orlan l'ultime chef-d'oeuvre, les vingt ans de pub. et de Cinéma de Sainte Orlan* (Orlan the Ultimate Work of Art: Twenty Years of Publication and the Cinema of Saint Orlan) (Hérouville Saint-Clair, France: Centre d'Art Contemporain de Basse-Normandie, 1990).

27. Interview with Jill O'Bryan and Tanya Augsburg, Arizona State University, Tempe, AZ, February 2001.

28. Ibid.

29. "La maïeutique du corps," 15.

30. Interview with O'Bryan and Augsburg.

31. "La maïeutique du corps," 16.

32. Michel Enrici and Jean-Noël Bret, "Triumph of the Baroque (1974–1985/90): Interview with Christine Buci-Glucksmann, Paris, October 7th, 2000," in Kerejeta, 213.

33. "Body and Action," 227. It is unclear whom Orlan is quoting.

34. Ibid., 229.

35. Ibid.

36. Ibid., 227.

37. Interview with O'Bryan and Augsburg.

38. "Orlan Interviewed by Obrist," 195–96.

39. "Body and Action," 227–28.

40. Ibid., 227.

41. Ibid.

42. Ibid., 228.

43. "Orlan Interviewed by Obrist," 191–92.

Index

C. Jill O'Bryan is an independent art scholar and critic. She received her PhD from New York University.